M.C. Escher's Legacy
A Centennial Celebration

Doris Schattschneider · Michele Emmer (Editors)

M.C. Escher's Legacy

A Centennial Celebration

Collection of articles coming from the
M.C. Escher Centennial Conference, Rome 1998

 Springer

Editors:

Doris Schattschneider
Moravian College
Department of Mathematics
1200 Main Street
Bethlehem, PA 18018-6650, USA
e-mail: schattdo@moravian.edu

Michele Emmer
University of Rome
La Sapienza
5, Piazzale Aldo Moro
00139 Rome, Italy
e-mail: emmer@mat.uniroma1.it

The first printing of this book appeared as hardcover edition, ISBN 3-540-42458-X.

1st edition 2003, 2nd printing 2005

Library of Congress Control Number: 2005928381

ISBN-10 3-540-20100-9 Springer Berlin Heidelberg New York
ISBN-13 978-3-540-20100-7 Springer Berlin Heidelberg New York

Springer Berlin Heidelberg New York
Springer is a part of Springer Science+Business Media

springeronline.com

© Springer-Verlag Berlin Heidelberg 2003
Printed in Germany

Cover design: *design & production GmbH*, Heidelberg
Typesetting: LeTeX Jelonek, Schmidt & Vöckler GbR, Leipzig

Printed on acid-free paper 46/3142ck – 5 4 3 2 1 0

To Valeria

Erwartung...
Erwartung

Celebrating Escher

Doris Schattschneider

The year 1998 saw many centennial celebrations of the Dutch graphic artist M.C. Escher (1898-1972). One of these, an international congress held in June of that year in Rome and Ravello, brought together a wide array of of people who not only appreciate Escher's work, but give testimony to his lasting legacy in art, science, and education.

Shortly before the congress, a review by a *New York Times* art critic had proclaimed Escher "Just a nonartist in the art world." I find the "art world" a funny place – it often seems that if an artist's work is popular with the public, then it must follow that the work is "nonart." The 1998 exhibition "M.C. Escher: A Centennial Tribute" held at the National Gallery of Art in Washington, D.C. drew record crowds – 364,000 people visited the exhibit, more than for any other print show. Perhaps for the "art world," Escher's art is an acquired taste. In retrospect, the official critics may come to see and understand the wonderful qualities in his work that have made it endure. C.V.S. Roosevelt, an avid admirer and collector of Escher's work once remarked, "When an art critic petulantly stamps his foot and remarks he quite despises Escher, one is reminded of the cartoon caption: 'There they go! I must hurry after them, for I am their leader'."

What draws people to Escher's work? I can only hazard a personal and very incomplete answer to that question. I believe the qualities that make Escher's work so appealing are also the ones that inspire and challenge others. Escher was an acute observer, a thinker, a meticulous craftsman, whose prints evoke admiration and wonderment. "Cool!" (rather than "Beautiful!") is an oft-heard remark at Escher exhibitions.

The constant challenge of the artist is to create artifice. Escher created some highly original artifices that tease and enchant. In trying to place him in the spectrum of 20th century art, his work defies categorization. Roosevelt observed:

Regardless of what the world thought of him, Escher imperturbably always went his own way. He reminds us of a modern alchemist ingeniously and fanatically experimenting with his magic balls and mirrors, animals and books, his magic spells and magic concepts. A wonderfully

*obstinate figure, now artist, now thinker, philosopher, and shaman, Escher insisted, "All my works are games, serious games."**

Escher loved to challenge our eyes and understanding by tweaking the certainties of the "laws" that we expect to be obeyed. By working in the plane, he could confound our perception of what is two-dimensional and what is three-dimensional. Not only does he make us wonder at what point does one dimension transform into the next, but he has us ask "what is figure? what is ground?" His device of using interlocking shapes, each shape recognizable on its own, yet each interchangeable in the role of figure or ground, is one of his trademarks. Few artists have been as fascinated by tessellation as Escher was. For him, "regular division" was not an end in itself, but rather a device to express the idea of duality (contrasting opposites), and metamorphosis.

Escher used geometry masterfully in his works. His early scenes of Italian villages clinging to steep mountainsides with valleys sweeping out below seem carefully sculpted from geometric forms. His later works celebrate polyhedra, spheres, knots, and Möbius bands. Geometry works magic in his prints – classical Euclidean geometry, spherical geometry, projective geometry, transformation geometry, hyperbolic geometry, and self-similarity all are skillfully employed to achieve intricate and surprising visual effects. Not only was he a master of the craft of graphic art, he was also (despite his denials) an original researcher in the realm of science and mathematics.

Escher has left us a rich legacy in his work.

This book and CD Rom continue the 1998 celebration of Escher's legacy. The section "Escher's World" contains essays that give deeply personal reflections on Escher's work and stories of those who have literally walked some of the paths trodden by Escher.

It is often said that Escher belonged to no "school" of art and founded no "movement," and so it is assumed that there are no contemporary artists who continue to explore and express in manners directly inspired by his work. In the section "Escher's Artistic Legacy," the large number of artists who speak here and display their work show that assumption is clearly false. Escher's work planted seeds in the minds of these artists, seeds that have borne fruit that is ingenious and original, some employing his careful graphic techniques, others using more modern media, including digital art. They, like Escher, play with illusion, with perspective and projections, with constructions (both real and impossible), with mirrors, with symmetry and division of the plane, and with metamorphosis. They, too, use geometry masterfully, inspired by Escher, yet are guided by ideas that are wholly their own.

Scientists and educators have drawn inspiration from Escher—his works have provided visual metaphors for their theories, raised new questions about

* From the catalog of the exhibition "A Mathematician Views Escher", Moravian College, April 1987.

their assumptions, suggested new problems to investigate, and provided enjoyable explorations for students of all ages. The section "Escher's Scientific and Educational Legacy" contains a variety of essays by scientists (of many disciplines) and educators, a testimony to the enduring influence of Escher's work.

The CD Rom is an extension of the book. It contains color versions of many of the art works that are shown in the book in black and white, as well as additional work by the artists. It gives vignettes of the conference and the breathtaking beauty of the Ravello setting. It also affords a medium beyond print: there are animations, short videos, and interactive puzzles.

Editing this book has been a pleasurable challenge. The authors come from eleven different countries, with many languages and with a myriad of different computer programs that encode word and picture. Yet I have received wonderful cooperation from all, and thanks to email, zip disks, and CD Roms, they were able to quickly respond to the many requests to put this all together. I want to thank Moravian College for its support of my editorial work, making available to me the necessary technology and technological help. Michele Emmer and I are grateful for the encouragement and cooperation of Springer-Verlag, Heidelberg, in making this book and CD Rom a reality.

Bethlehem, August 2001

Escher, in Rome, Again

Michele Emmer

Why a conference and an exhibition dedicated to the works of Maurits Cornelis Escher? Escher had a very strange destiny. His works are probably among the best known in the world. But perhaps his great success and the dispersion of his work all over the world are reasons why his work as a graphic artist is not investigated seriously and not well-considered by historians of art. This is one of the reasons why the idea of organizing a conference and an exhibition of Escher's work was taken up by a Mathematics Department, the Mathematics Department of the University of Rome "La Sapienza."

Among the most popular ideas of our time are multimedia presentations and interdisciplinarity, including the relationships between art and science. Escher, for a great part of his artistic life, was an "attractor" and produced connections among mathematicians, physicists, crystallographers, and experts in visual perception. It is well known that his first important exhibition was mounted during the International Congress of Mathematicians in Amsterdam in 1954.

So here is a conference designed for many to discuss symmetry, visual perception, computer graphics, architecture, history of art, mathematics, and psychology, always having Escher as a starting point. The fact that so many people from different countries and from different disciplines wish to participate in this conference is the main reason for its organization.

The above paragraphs are not my opening to the Escher Centennial congress held in Rome in 1998, but rather they are taken from the introduction I wrote for the catalog of the exhibition of Escher's work held at the Dutch Institute in Rome in March 1985. That exhibition took place during the last international conference on Escher, with lectures in the same "Aula Magna" at the University of Rome "La Sapienza" 14 years ago. The title of that conference was *M.C. Escher: Art and Science* [1]. The 6000 copies of the catalog of the exhibition [2] sold out in three weeks.

I can use the same words to write this introduction to the proceedings of the 1998 congress because now the fascination with the work of Escher is perhaps even greater than 14 years ago, even though much of the world has completely changed. In 1985 there was the Soviet Union and the wall in Berlin. I was very sorry that professor Vladimir Koptsik from Moscow State University, who was an invited speaker for the 1998 congress, at the last moment was not able to attend. I remember very well (and perhaps others who were at the previous conference will also remember), that during the conference in 1985 the Red Brigades killed a professor from our university, professor Tarantelli. The world is really different now, but interest in Escher is still alive and unchanged.

This special congress to celebrate the centennial of Escher's birth was also organized in Rome This is fitting since Escher was in Italy and lived in Rome for many years; for the same reason a session of the congress was organized in Ravello, on the Amalfi coast. And a last, but not least reason: my family name Emmer is originally Dutch and very similar to "Escher."

The 1998 congress differed from the 1985 one in several respects. There were many new faces, including several contemporary artists, as well as some familiar participants. Some participants at the previous conference were not able to attend this one, in particular, my co-editors of the 1985 Proceedings: H.S.M. (Donald) Coxeter, Marianne Teuber, and Sir Roger Penrose [1]. Another difference is that in 1985, Johannes Offerhaus, the energetic and enthusiastic director the Dutch Institute, arranged for the Escher exhibition to be held there and The Queen of Holland came to open the exhibition. Unfortunately, Offerhaus died a few years ago. This time the Dutch Embassy and the Dutch Institute in Rome had no interest in supporting an exhibition. (Ironically, the cultural attaché of the Dutch Embassy, answering my letter of 1996 asking if there would be interest in sponsoring a new exhibition, answered that an exhibition was held in 1985 – of course he did not know I was the organizer.)

This time the M.C. Escher Foundation gave us wonderful support for the art exhibitions in Rome and in Ravello. I want to thank them for their encouragement and cooperation in every aspect of the congress, and their enthusiastic attendance at the sessions. In 1998 we had a *private* three-day exhibition at the *Museo Laboratorio di Arte Contemporanea* of the University of Rome "La Sapienza," held during the congress. Here, along with many of Escher's prints, the work of contemporary artists from many countries was shown, in an *Homage to Escher* [3]. (The exhibit was held despite many difficulties of importing the works of art for the show, thanks to the rules of the Italian and other European Customs). The exhibit in Ravello featured almost exclusively the little-known prints of Escher's beloved Italian scenes. Its opening reception was a special part of the congress session in Ravello, and was open to the public for an extended period. Two different catalogs were printed; one for each exhibition in Rome and in Ravello [4].

I want to thank many people who helped with the hundreds of details of organization of this congress:

First of all Doris Schattschneider. She first presented the results of her study on the symmetry notebooks of Escher at the previous congress; a few years later she published the book *Visions of Symmetry* [5]. Without her handling the personal contacts with all the speakers, exhibitors, and participants, it would have been impossible to organize the congress.

My colleagues Valentina Barucci and Stefania Gabelli for organizing the Rome exhibition and its catalog. Alessandra Seghini, the director of the computer science lab of my department, Alessandro Franchi the computer technician, and Angelo Bardelloni of our library: they solved many seemingly impossible technical problems. The electricians of the Aula Magna, the private cops, the staff of Latour catering. Michele dell'Aquila for the congress web site, Matteo

Emmer for the congress logo, animated on the web site, and shown at the beginning of this preface (yes, he is my son and an architect). Maria Pia Cavaliere and Orietta Pedemonte of the University of Genova, Laura Tedeschini Lalli, of the University of Rome III, who helped with local arrangements and registration. Mr. Bruno, for the Apple computers and the technical help.

The helpful staff of the *Museo Laboratorio di Arte Contemporanea*: Maurizio Calvesi, the director, Francesca Lamanna, Maurizio Pierfranceschi, who was always at the artists' disposal; Linda Riti, Bruno di Martino for the video and film presentations.

The students and graduate students who performed many tasks: Marta Angelilli, Massimiliano Amoroso, Daniela Bassi, Alessia Sao, Monica Amore, Maria Silvia Cosma, Maria Silvia De Angelis, Andrea di Marco, Daniele Mancini.

Mr. Pedrocchi of the travel agency *Touring Viaggi*. And for all local arrangements in Ravello: Eugenia Apicella and all the staff of the *Centro Universitario Europeo per i Beni Culturali*. Francesco Fortunato, Antonio Gisolfi of the University of Salerno, the organization of the concert, the public administration of the City Hall of Ravello and of the Province for their help. In particular for the beautiful weather and the sea. A particular thank you to the Mayor of the town Secondo Amalfitano and to the Soprintendente dei Beni Ambientali, Artistici e Storici di Salerno e Avellino Ruggero Martines.

A very, very special thank you to Mark and Wim F. Veldhuysen, George Escher, and all the Escher family for their unflagging enthusiasm and support.

The congress received financial support from the University of Rome "La Sapienza," the Dipartimento di Matematica "G. Castelnuovo," the National Council of Research C.N.R., the M.C. Escher Foundation, and Michele Emmer.

In the proceedings of the previous conference I wrote, "I would like to thank my son Matteo and my wife Valeria, and in particular my son Tommaso. Without their continuing encouragement (and my friends know how true this is) the congress would never have taken place." I can now reveal that Tommaso was battling leukemia during the conference in 1985; thankfully, he recovered and he is now a medical doctor. It was Valeria who was suffering from cancer during the 1998 conference. She died October 8, 1998. This is why this volume is dedicated to her. I must thank Matteo, Tommaso, and Marta very, very much.

Rome, February 1999

References

[1] H.S.M. Coxeter, M. Emmer, R. Penrose, M. Teuber, eds., *M.C. Escher: Art and Science*, North-Holland, Amsterdam, 1986; IV edition.
[2] M. Emmer, C. van Vlaanderen, eds., *M.C. Escher*, catalog of the exhibition, Roma, The Dutch Institute, 1985.

[3] V. Barucci, ed., *Homage to Escher*, catalog of the exhibition, Università di Roma "La Sapienza," Diagonale ed., Roma, 1998.

[4] M. Emmer, ed., *Escher 1898-1998*, catalog of the exhibition, Centro Universitario Europeo of Ravello, Diagonale ed., Roma, 1998.

[5] D. Schattschneider, *Visions of Symmetry*, New York, W.H. Freeman & Co., 1990.

 ## Note on the CD Rom

When the icon shown above appears at the beginning of an article, it indicates there is additional material by that author on the CD Rom that accompanies this book. The CD Rom contains collections of artwork (in color) by the contributing artists, several short videos, a video-essay based on a letter of M.C. Escher, some animations, and an interactive puzzle.

The CD Rom will run on either a PC with Windows 98 or higher or Macintosh with OS 8.5 or higher, 200 MHz processor or higher, and 800x600 minimum screen resolution with high color setting. It uses Acrobat Reader and Quicktime, which may be installed from the CD Rom if your machine does not have them.

Contents

Preface

Escher's World

Escher's Artistic Legacy

Escher's Scientific and Educational Legacy

Escher's Fondness for Animals*

H.S.M. Coxeter

to Valeria

It is clear from the abundance of lizards and other live creatures in Escher's pictures, that he had a great fondness for animals. An essay written at school [2, p. 16] ends with the words: "While I was sitting so quietly alone, a very small

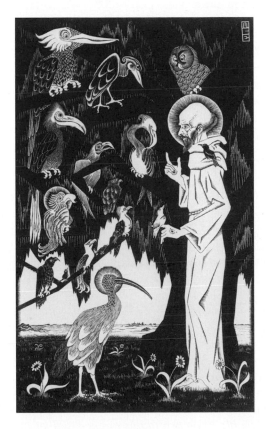

Fig. 1. M.C. Escher, *Saint Francis [Preaching to the Birds]*, 1922. Woodcut

* This article is reprinted, with permission, from the catalog of the exhibition of Escher's work held at the 1985 Escher Congress at the University of Rome. At the request of the editor, George Escher has given some additional remarks.

bird hopped over the snow – perhaps it was a wren. It was enjoying the fine weather; it chirped merrily and blinked at the sun. It skipped towards the water and fluttered about a bit. Then it flew away, so I left too."

Many less familiar birds can be seen in his 1922 woodcut *St. Francis*. Other birds, along with fishes and mammals, are featured in his woodcuts of the Fifth and Sixth *Days Of Creation* [2, pp. 208–209]. In the latter, a white cat is characteristically rubbing its side against Eve's leg, while a white mouse looks on without fear.

In 1924, when he was courting Jetta (who was later his wife) he gave a humorous and intimate account of two lizards mating: "An enormously fat and beautiful gentleman-lizard, speckled green, black and white, lay basking in the sun when a small slim grey lady-lizard came slipping coquettishly from under the dry leaves . . . " [2, p. 26]

The 1935 wood engravings *Grasshopper, Dream* (see page 66), and *Scarabs* reveal the careful precision with which he drew insects [2, p. 263]. This is also seen in the nine red ants climbing on his *Möbius Strip II*, engraved in 1963 (see page 75).

In the beautiful 1955 lithograph *Three Worlds* [2, p. 311], the painstaking care with which Escher drew the big fish is evident in the studies reproduced by Bruno Ernst [1, p. 77] who quotes Escher's characteristic remark: "I was walking over a little bridge in the woods at Baarn, and there it was, right before my eyes. I simply had to make a print of it! The title [*Three Worlds*] emerged directly from the scene itself. I returned home and started straight away on the drawing."

In his 1957 essay on *The Regular Division of the Plane* [2, p. 162] he wrote, "My experience has taught me that the silhouettes of birds and fish are the most gratifying shapes of all for use in the game of dividing the plane. The silhouette of a flying bird has just the necessary angularity, while the bulges and indentations in the outline are neither too pronounced nor too subtle. In addition, it has a characteristic shape, from above and below, from the front and the side. A fish is almost equally suitable; its silhouette can be used when viewed from any direction but the front." These remarks are well illustrated by the 1938 woodcuts *Sky and Water I* and *II* in which we see the paradoxical evolution of dark birds from light fishes [2, p. 275].

In a 1957 letter to his son Arthur, Escher wrote:

The other day I put out a horizontal wire with all kinds of tidbits for the birds, as I do every year at the beginning of winter – a string of peanuts, two balls of fat and some bacon rind from the butcher It is fascinating to see how the tits . . . have to learn every year anew how to peck open the peanut shells and take out the nuts, while hanging upside-down on the string Apparently they are unable to do two things at once, unlike humming birds; while flapping their wings, they cannot peck, and while pecking, they cannot flap their wings. As a result they dangle upside-down with their claws holding onto the string as soon as they start pecking, and then they realize it is quite possible to eat upside-down. At the moment it

is like a circus: the string, bacon rind and ball of fat are all occupied by tits

During his long voyage in 1960 on the freighter *Paolo Toscanelli* from Genoa to Vancouver via the Panama Canal, he wrote [2, p. 110]:

Of all the creatures in the sea, the dolphins [2, p. 205] are the easiest for a ship's passenger to observe. As soon as they notice a ship, they hasten towards it, dozens of them, preferably swimming just in front of the bows . . . close together. Again and again they jump into the air to take a breath, lifting their whole bodies out of the water in a beautiful arc, and then dive back into the sea nose first, or do a belly-flop on the surface of the water; they turn around, showing their white bellies, and you can almost hear them laughing with pleasure At night in a phosphorescent sea they look like firework rockets, trailing long snake-like criss-crossing ribbons of light behind them.

Flying fish . . . become more numerous as the sea gets warmer These small creatures of only seven to sixteen inches must have gathered an enormous speed underwater by the time they jump out. Apparently they can glide up to two hundred yards through the air Their long and beautifully iridescent blue pectoral fins remain still and spread out, stretched as taut as the wings of a glider.

Addendum

George Escher

In a general way father was not fond of animals in the affectionate, ear-rubbing, cuddling or rump-slapping way. He disliked the harsh bark of dogs, their intrusive, slobbering affection, the soulful look of their eyes. The only way he could enjoy a dog's company was from a distance, for example having an unknown one joining him companionably on a walk, trotting inquisitively along the ditch, concerned with its own affairs, not intruding in father's privacy.

At home we had a cat once, never other pets. That cat liked to curl up on father's lap and father liked the smoothness of its coat, its detached, warm, clean tidiness. That cat was black and white, but father would have much preferred if it had been perfectly pitch black, an ideal about which he talked every now and then, but never made an effort to acquire.

Father derived great enjoyment from birds. He could listen with delight to their song, and found something intensely fascinating in their movements, behaviour and the magic of their flight. Some of their charm must have been their tidiness, the play of patterns in their appearance and actions, and their unapproachability.

Tidiness, a sense of wonder, a feeling for patterns, keeping his distance, were all part of father's own nature. These must have determined to great extent what

type of animal he liked best to look at and to identify with. As far as the appearance of birds, fish or lizards in his periodic patterns is concerned, father always maintained that he could do little about that. The rules of tessellation and his desire to make recognizable shapes led almost automatically to that result.

One last remark on Coxeter's observations. Concerning "the painstaking care with which Escher drew the big fish . . . ," it should be noted that carp was copied from a large Chinese fish embroidered in gold, which hung on the wall in his studio.

References

[1] Bruno Ernst, *The Magic Mirror of M.C. Escher*, Random House, New York, 1976.
[2] F.H. Bool, J.R. Kist, J.L. Locher, and F. Wierda, *M.C. Escher: His Life and Complete Graphic Work*, Harry N. Abrams, New York, 1982.

Selection is Distortion

Bruno Ernst (Hans de Rijk)

The first time I visited Escher in his studio in Baarn he was finishing the drawing for *Print Gallery* (see page 80). This was in 1956. I remarked that I did not like the drawing because of the ugly cross that filled the upper left side of the drawing. When I got home, I wrote him suggesting that he might be able to camouflage the cross by letting a clematis climb on it. Just imagine how cheeky that was! Escher was almost sixty, had more than earned his stripes as a graphic artist, and already enjoyed considerable recognition as the creator of very unusual prints. I was thirty and a teacher of mathematics. He wrote me a letter explaining why it was impossible for a clematis to climb on a window frame, and then went on to say that his prints were not meant to create something beautiful, but to evoke a sense of wonder in the viewers.

His reaction was eloquent because it shows how seriously he took the criticism of a young man who hardly knew his work. In a long letter to his son Arthur about my visit, he had not even one word of condemnation of my behavior. He wrote, "He was much interested in my jokes on perspective, and especially in

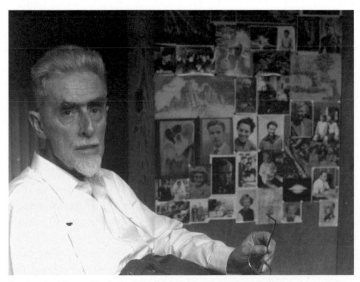

Escher in his studio in Baarn, 1969. Photo by Bruno Ernst

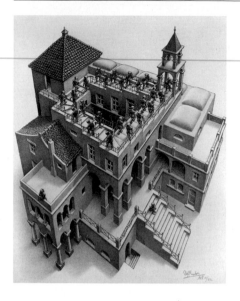

Fig. 1. M.C. Escher, *Ascending and Descending*, 1960. Lithograph

my inversion print *Convex and Concave* ... as well in my regular divisions of the plane." (See [2, pp. 86–87] for a long exerpt from this letter.) Later when I had learned more about Escher's work I realized how stupid my first reaction to his *Print Gallery* had been; now I am convinced that this print is by far one of Escher's greatest achievements.

For a long time my greatest admiration went to Escher's prints with a strange and sometimes impossible architecture and I wrote articles about them in several periodicals. His regular divisions of the plane encouraged me to study this matter in crystallographic publications and I was impressed when I saw how he had worked out this material very systematically in his own way in several workbooks before and during World War II. So strange architectures and regular divisions of the plane were for a long time, for me, the most attractive subjects of Escher's work.

Is it not strange that these two themes most attract people's interest in Escher, so that most of Escher's prints made before 1938 are rather unknown? And also that interest in his later works is limited to fifteen to twenty prints, mainly represented by regular divisions of surfaces and by impossible figures? This has created the image of an Escher who drew divisions of surfaces with lizards, birds, and fishes which miraculously change into other figures, and of an Escher who invented impossible, nonexistent buildings and depicted all sorts of optical illusions. This image is not only one-sided, but also incorrect. It is a distortion which does not do Escher's oeuvre justice; it ignores what Escher wanted to convey through his prints.

Although Escher is identified with impossible figures, he made only three prints which feature impossible figures – *Waterfall, Belvedere* and *Ascending and Descending* – all within the short period from 1958 to 1961 (Fig. 1; also,

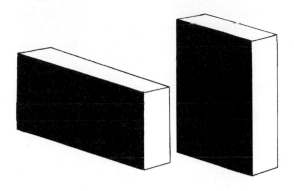

Fig. 2. Two Boxes. Are the black sides equal?

see pages 65, 135). *Belvedere* was based on the impossible cuboid, which he invented himself. The impossible figure on which *Waterfall* was based he borrowed from Penrose and the structure in *Ascending and Descending* was also based on an idea of Penrose. We should add that in this latter print, the way in which Escher worked it out resulted in a curious architecture indeed, yet the underlying construction is not impossible. Impossible figures were first discovered in 1934 by the Swedish artist and art historian Oscar Reutersvärd. But the public was not ready to appreciate such images and moreover Reutersvärd gave his inventions in abstract form, not in prints that suggested a real world.

It is also a misconception that Escher depicted optical illusions. Of course, Escher knew many optical illusions; he was interested in them and enjoyed them as well. Yet he never chose them as a starting point for a print. I will give one example here. In Fig. 2 you see two boxes. Our visual perception tells us that the left one is more elongated than the right. But if you take a piece of paper and cut it so that it exactly covers the black side of the right box you will discover that the same piece of paper also exactly covers the black side of the left box. I asked a friend (Fred van Houten, who has made many impossible figures) to dress up the two boxes so they would appear more realistic. The result of his computer work is reproduced in Fig. 3. Escher undoubtedly would have added this

Fig. 3. Two matchboxes. Fred van Houten

picture to his beloved collection of prints displayed on the door of his cupboard, but he would never have been tempted to make something like this himself. He was occupied with very different things. Dressing up optical illusions was entirely outside of his scope.

Intention and Perception

There will be always a discrepancy between the intention of an artist and the impression and ideas that enter the mind of a spectator confronted with a work of art. In the case of Escher, this discrepancy (or difference) can be large. I will illustrate this with the print *Puddle* (Fig. 4). Most people find this an attractive print. As for composition and mood, it is an attractive print. But the muddy ground, with its small pool of water and tracks made by cars, bicycles, and shoes, is nothing more than the representation of an *idea*, as are the sky, the trees and the sun,

Fig. 4. M.C. Escher, *Puddle*, 1952. Woodcut. Surrounding text by Bruno Ernst

reflected in the pool. What Escher meant to express was the possibility of our perception and the ability to depict different worlds on the same piece of paper. One could even say, although Escher never hinted at this, that the time dimension also makes its presence felt in the print: the tracks in the mud are relics of events which took place in the past. In short, Escher intended to illustrate the remarkable fact that drawing makes it possible to show two different worlds at the same time in the same place. But most of the spectators have another perception and idea: even a puddle on a path along the fringe of a wood is beautiful.

Selection by the Public

The work of Escher is immensely popular. But as I pointed out earlier, this holds only for a limited group of his prints. Three of his little-appreciated prints are *Doric columns* (1945), *Three Spheres* (1945), and *Dragon* (1951). All three express the same fact of two-dimensional representation: while depicting three-dimensional forms from our surroundings or our fantasy, the beholder is actually deceived, because there is no third dimension – everything is flat. In *Doric columns*, Escher first drew two columns twice as long as what you see in the print (Fig. 5). Then he made incisions to trim three-quarters of the columns, folded these parts and made a new drawing of the whole. For most people the result is an enigma. But the message is clear: drawing is an illusion. Or, if one wishes to put it more strongly: depicting is deceit.

In *Three Spheres* the upper sphere is not a sphere at all, but is a flat drawing with circles and ellipses (Fig. 6). Yet our visual system converts the image into a three-dimensional sphere. The middle figure is converted by the viewer into an egg, but Escher has actually drawn the same figure as above it, but now folded.

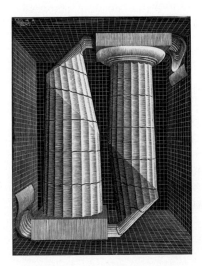

Fig. 5. M.C. Escher, *Doric Columns*, 1945. Woodcut

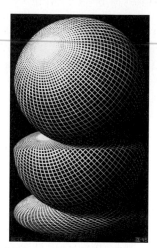

Fig. 6. M.C. Escher, *Three Spheres*, 1945. Woodcut

Fig. 7. Drawing of the three spheres in another position. Bruno Ernst

Finally, at the bottom of the print, the same figure is laid flat to make clear the same message: I draw flat figures but you see three-dimensional objects. (See Fig. 7.) And this is so common that it does not surprise us. But it did surprise Escher and with these drawings he wished to transmit his wonder to the spectator. In *Dragon*, those who do not focus on the incision in the belly of the dragon (and its consequences) miss the point that the dragon is simply a figure in black and white on a flat surface (see page 372).

Selection by the public is, of course, only natural. No one can be forced to like a print or to find it interesting. It is important, though, to point out that such a selection – especially in the case of Escher – gives a false impression of his oeuvre. What he wanted to express thereby suffers from distortion. Those who really want to get to know Escher and his work will have to consider his whole oeuvre and his oeuvre as a whole.

Escher's Intentions

Then what was the intention of Escher and the essence of his work? Before 1937 there was no particular path that Escher followed. It was a period in which he absorbed many impressions and fixed them in sketches, woodcuts, and lithographs. In the approximately 110 prints he made from 1937 onwards, we see a report of a voyage of discovery. Each print can be seen as a page from the 'logbook' he kept up to date during this voyage. What did Escher want to discover?

The first to see Escher's work in the right perspective was his French kindred spirit and life-long penfriend, Albert Flocon, professor at the École des

Beaux Arts in Paris. He had a wide range of interests, but his main work was on perspective. He was the father of curvilinear perspective, with which he could draw scenes with a 180° view [4]. In 1965 he wrote a long article about Escher's work in the art magazine *Jardin des Arts* and he classified Escher among the "thinking artists," also naming Piero della Francesca, Da Vinci, Dürer, Jamnitzer, Bosse-Desargues, and Père Nicon. For these artists, the art of seeing and the representation of what is seen are linked with fundamental research in this field [5]. Figure 8 shows a page from a publication by Jamnitzer which was in Escher's possession [6]. It is a woodcut of polyhedra drawn by Jamnitzer in correct perspective – a product of science and art. It is also clearly the work of a "thinking artist" as Albert Flocon had in mind when he typified Escher as such.

Escher was a scientist in his research and an artist in depicting his findings. For Escher, everything revolved around research into the nature of his job: *depicting*. In doing so he stumbled upon questions like: which possibilities does a flat surface offer if we want to fill it entirely with congruent figures? How he struggled with this problem and the victories he achieved are described in detail in *Visions of Symmetry*, written by Doris Schattschneider [8]. We reproduce in Fig. 9 one of his most attractive and ingenious examples. It is one of the few regular divisions he also used for a print – the color wood engraving *Horseman* (1946) in which a topologically interesting band is rendered. Escher also used his regular divisions in his attempts to visualize the concept of infinity. *Circle Limit III* (1959) is perhaps his most perfect expression of infinity (see color plate 4).

Escher was intrigued not only by the limited possibilities of depicting a three-dimensional world on a two-dimensional surface, but also by the many extra possibilities of expression which are not available to a sculptor who works three-dimensionally. Exploration of those many possibliities was the source of his most

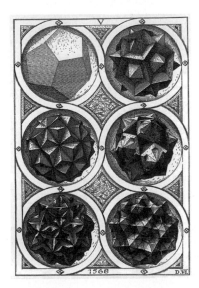

Fig. 8. Polygons in perspective by Jamnitzer, 1568

Fig. 9. M.C. Escher, symmetry drawing no. 67, 1946

famous prints: the strange architecture found in *Balcony* (1945), *Other World* (1947), *Up and Down* (1947), *House of Stairs* (1951), *Relativity* (1953), *Convex and Concave*, (1955) *Print Gallery* (1956), and the three prints discussed earlier, *Belvedere* (1958), *Ascending and Descending* (1961), and *Waterfall* (1961). Here we find Escher's interface with optical illusions, not as a collection of remarkable peculiarities of visual perception as seen in textbooks, but as the predominant optical illusion: flat pictures are converted by our visual system into three-dimensional objects even though these objects do not exist or cannot exist in our real world. We do not notice nor experience it as something extraordinary that *flat pictures are seen as three-dimensional objects*, but Escher reminds us with his prints how extraordinary this phenomenon is, and the incredible results to which this can lead.

Only the Most Perfect Expression

It is remarkable, but entirely in agreement with the nature of Escher's prints as the reflection of his research, that he never repeats himself. He was not much interested in making beautiful pictures, but in depicting newly-found ideas. Therefore he frequently called his prints illustrations of thoughts. Such an idea would sometimes keep him busy for many months and he made a large number of preliminary studies to work out the final presentation in a print. These studies are often so interesting that they could easily be used as the basis for a good print. For example, Fig. 10 shows one of his last preliminary studies of *Up and Down* (see page 29); I completed this sketch myself. Of course this sketch is not an Escher print. He did not use this attempt to express his idea. He wanted a print

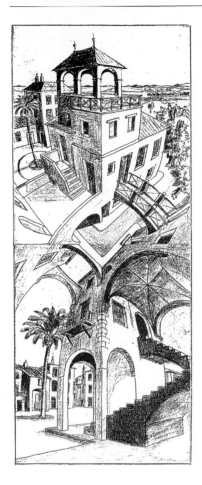

Fig. 10. Preliminary study for Escher's print *Up and Down*, completed by Bruno Ernst

that showed the most perfect expression of his idea and he did not find it worth-while to make a print of what might be a nice subject in itself. After completing a print (which he always found disappointing), he went on with new ideas that often arose during the peace and quiet of carving a woodblock for printing or copying his drawing onto litho stone.

Mapping Escher's Oeuvre

In 1968 I tried for the first time to map Escher's oeuvre in a chart. One wall of my study was covered with reproductions and photos of his prints in chronological order. Making up an inventory gave me insight as to how Escher's interest advanced in time. When I discussed this with Escher for the first time, he laughed about it. But after some time he agreed with my analysis, which you can find in

in chapter 5 of *The Magic Mirror of M.C. Escher* [3]. There I discuss the systematic development of Escher's work and the intentions of his prints. In this article, I can give only a glimpse of what is contained in that discussion.

A New-Found Category of Prints

I would like to take this opportunity to mention a theme from Escher's work which does not appear in my survey of his oeuvre. I had always overlooked it and never discussed it with Escher. He once confided to me "I absolutely cannot draw. Even for the more abstract things like knots and Möbius bands, I first make paper models which I then copy as precisely as possible. It is much easier for sculptors: everyone can mold. I have no problem with molding, but I do with drawing. I find it terribly difficult; I cannot do it well. Drawing is indeed much harder, much more intangible, but you can suggest much more with it."

Of course his lament "I cannot draw" is an exaggeration. What Escher meant was that he lacked the gift of many artists who can effortlessly draw various scenes embellished with humans and animals, without a model. There is a series of prints for which he expressly picked the hardest subjects that make real challenges for an artist. He liked to solve difficult depicting problems in a satisfying way. The fact that I missed this obsession of Escher is strange, for Escher had given me a clear hint when he discussed his print *Spirals* with me. It was difficult for me to decide the place of this print in his oeuvre. Escher told me that he made this print after he had seen a torus made up of spiraling bands in a book about perspective by Daniel Barbaro [1] (Fig. 11). It was intriguing that you could see the inside of the torus, but it annoyed Escher that it was not very well drawn. And so he set himself to do it not only better, but he also made the goal more difficult:

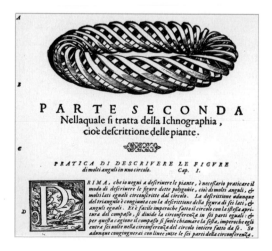

Fig. 11. Torus with spiral bands. Design by Barbaro, c. 1568

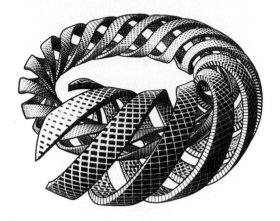

Fig. 12. M.C. Escher, *Spirals*, 1953. Woodcut

he would not depict a simple torus with spiraling bands, but a body that would become thinner and thinner and would keep spiraling back into itself. He made many preparatory studies [7, pp. 166–167] that show how he was a master in making unusual perspective constructions. And the result was a beautiful color wood engraving (Fig. 12). But it was not popular, for Escher sold only three or four prints, and as far as I know he printed only ten.

Escher's fascination with difficult construction problems by which he could illuminate the invisible parts of three-dimensional objects can also be seen in *Two Intersecting Planes* (1952), *Concentric Rinds* (1953), *Three Intersecting Planes* (1954), *Sphere Spirals* (1958), *Four Regular Solids* (1961), and *Knots* (1965). These prints are not his most appreciated. In fact, one is considered to be so untypical "Escher" that the only reproduction you can find is in the full catalog of his work [2] . I think that only a few people have given any attention to

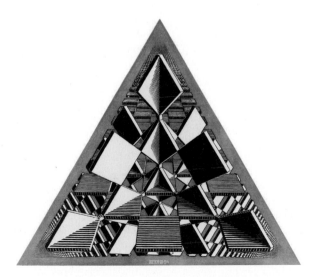

Fig. 13. M.C. Escher, *Three Intersecting Planes*, 1954. Woodcut

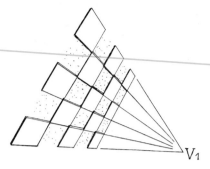

Fig. 14. Drawing of one of the three planes in Escher's *Three Intersecting Planes*

this print: *Three Intersecting Planes* (Fig. 13 and color plate 5). However, I will show you that this print is intriguing and a really "typical" Escher print. There are three planes – white, green, and black – which are perpendicular to each other. In Fig. 14 I drew only the white one. The intersection point of the three planes is at the center of the print. Easy to draw, but not if you want to show the *hidden parts* of the planes. So Escher tried to open up each plane so that you can see the other planes through the holes. Each plane is like a chessboard with only the white squares, where the black ones have been cut out. The plane converges to infinity at the vanishing point V_1. The three vertices of the triangle (that depict the vertices of a tetrahedron) are vanishing points of the three planes.

Perhaps you are not impressed by the result of Escher's effort in this print; nevertheless, such unappreciated prints, perhaps even more than the most appealing ones, show Escher's imaginative ways to help us *see* the ideas he imagines.

References

[1] Daniele Barbaro, *La Practica della Perspectiva*, Venice, 1568–69.
[2] F.H. Bool, J.R. Kist, J.L. Locher, F. Wierda, eds., *M.C. Escher, His Life and Complete Graphic Work*, Harry Abrams, New York, 1982.
[3] Bruno Ernst, *The Magic Mirror of M.C. Escher*, Ballantine Books, New York, 1976. Reprint Taschen-America, 1994.
[4] Albert Flocon and Andre Barre, *Curvilinear Perspective*, University of California Press, Los Angeles, 1986.
[5] Albert Flocon, "À la frontière de l'art graphique et des mathématiques: Maurits Cornelis Escher," *Jardin des Arts* 131 (1965) 9–17.
[6] Wentzel Jamnitzer, *Perspectiva Corporum Regularium*, 1568.
[7] J.L. Locher, ed., *The Magic of M.C. Escher*, Harry Abrams, New York, 2000.
[8] Doris Schattschneider, *Visions of Symmetry: Notebooks, Periodic Drawings, and Related Work of M.C. Escher.*, W.H. Freeman and Company, New York, 1990.

Ravello: An Escherian Place

Michele Emmer

to Valeria

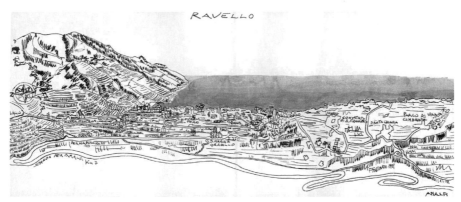

Ravello and the Amalfi coast. Drawing by Francesco Fortunato, 1999

Years ago when Doris Schattschneider was preparing her book *Visions of Symmetry* [9] she sent me a letter asking me if I could help to locate some Arabic mosaics she thought might be in Ravello; she had found loose sketches of them in Escher's materials. I contacted a friend of mine, Francesco Fortunato, an architect who lives in Ravello and is a great fan of Escher, who immediately recognized the sketches by Escher. You can find the original mosaics adorning the pulpit of the *Duomo* in Ravello. Doris thought that it was rare to find Arabic

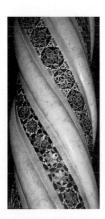

Mosaics on a column of the pulpit of the Duomo of Ravello. Photograph by Doris Schattschneider

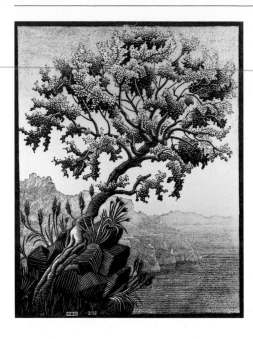

M.C. Escher, *Carruba tree [In Ravello]*, 1932. Woodcut

mosaics or motifs in Ravello. In fact it is not; the Moors occupied the Amalfi coast for centuries. They are part of the history of Ravello, a place so loved by Escher; he was in Ravello many times. In particular, at the Hotel Toro it is possible to see an *Escherian* motif on the wall, made to commemorate his staying there.

Escher and Ravello

Escher visited Ravello for the first time in 1923; he left Pompei on March 14 and took the train to Vietri; from Vietri he took a horse-drawn coach to Ravello. It took three hours to travel the beautiful route along the Amalfi coast. Escher stayed at the Hotel Toro. Here, on March 31 the Umiker family arrived with

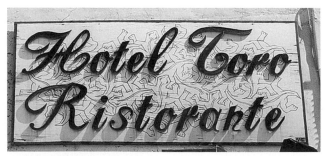

An Escherian motif on the sign of the Hotel Toro. Photograph by Kevin Lee

daughter Jetta, who would later become his wife. Escher was very attracted by the plants and the landscape of the Amalfi coast; after more than two months, he left Ravello in June. In the summer of 1931 the Escher family was again in Ravello. At this time, Escher made many sketches that would become prints of scenes in and around Ravello (see pages 93–95 and color plate 1).

You cannot visit Ravello and not be deeply affected by it. Marjorie Senechal, a conference participant, wrote:

> *Where did he get those staircases, those lizards? Participants in the Escher Centennial Congress in June 1998 had a chance to find out. After three days of lectures, expositions, and discussions in Rome – home to M.C. Escher and his family from 1925 to 1935 – the Congress moved south to Ravello, a small mountain town that Escher had loved. In Ravello, Escher's early prints of Italian landscapes come to life. There one also discovers themes that reappeared later in the consciously geometrical works for which he eventually became world famous: green lizards scurry along stone walls, arches in cloisters recede to infinity, and columns, balconies, and staircases are linked in fantastic architecture.*
>
> *Apalled by the rise of Fascism, Escher left Italy for Switzerland and Belgium, and then returned, for good, to his native Netherlands. But for the rest of his life, those lizards and that architecture insinuated themselves into his woodcuts and lithographs, as in a dream.* [10]

I first had the idea to organize a conference and exhibition to celebrate Escher in Ravello when I visited Amalfi in 1989 to see an exhibition dedicated to the *Grand Tour* that so many artists in the last two centuries had made to Italy. There was a small section of the exhibit dedicated to Escher, entitled *The mysterious world of Maurits C. Escher* [8]. In the catalog it was written that Escher came for the first time to Ravello and Amalfi in 1931. The catalog reproduced Escher's prints of the church and the little town of Atrani on the sea, five kilometers from Ravello.

Escher used many of his drawings and lithographs of the landscape in the south of Italy as a database for his most famous works. When I first encountered Escher's work at the end of the 1960's, as my father is a filmmaker, my idea was to make a movie using Escher's images. I did not know at that time that Escher himself used the cinematographic technique to describe his works [4], [6]. In particular, I was attracted by his *Metamorphose* which is a long horizontal image, a sequence that can be described in animation, as a *perpetuum mobile*, a never-ending movement (page 147). In this print, film could add movement to the original image, so that you could really *see* the animation and transformation, the visual cascade from one image to the next.

The final image of *Metamorphose* is the church of Atrani (color plate 1). *Metamorphose* is a sort of testament for Escher: there is the Italian landscape, his beloved Amalfi coast; there are fishes and birds, which he considered so easy to

design and so easy to recognize; there is the use of symmetry, tessellations taken from his notebooks; and there is transformation, the cinematographic technique that was used already by Giotto, more than six centuries before him. (In 1938, my father, Luciano Emmer, made a documentary film which, through the dissolve technique, made Giotto's figures in his frescos tell their own story [3].)

Ravello

It seems that the small town of Ravello was begun during the sixth century by a band of Romans who were trying to escape the invasion of the Huns, the Goths, and the Visigoths. It is considered that the earliest traces of the recorded history of Ravello are from the ninth century. The first name of the town was Rebello and her inhabitants were called *rebelli* (rebels) because they fought with the powerful nearby town of Amalfi. Later the name became Ravello (beautiful house: *bello*). The town was subdued by Amalfi in the eleventh century. During its greatest time of prosperity in the thirteenth century, Ravello had almost 40,000 inhabitants.

The town was celebrated by Boccaccio in the *Decameron*, in a story dedicated to Landolfo Rufolo.

> *Credesi che la marina da Reggio a Gaeta sia quasi la più dilettevole parte d'Italia; nella quale, assai presso a Salerno, è una costa sopra il mare riguardante, la quale gli abitanti chiamano la costa d'Amalfi, piena di piccole città, di giardini e fontane, e d'uomini ricchi e procaccianti in atto di mercatantia sì come alcuni altri. Tra le quali città dette, n'é una chiamata Ravello, nella quale, come che oggi v'abbia di ricchi uomini, ve n'ebbe già uno il quale fu ricchissimo, chiamato Landolfo Rufolo.* [1]

> Few parts of Italy, if any, are reckoned to be more delightful than the seacoast between Reggio and Gaeta. In this region, not far from Salerno, there is a strip of land overlooking the sea, known to the inhabitants as the Amalfi coast, which is dotted with small towns, gardens and fountains, and swarming with as wealthy and enterprising a set of merchants as you will find anywhere. In one of these little towns, called Ravello, there once lived a certain Landolfo Rufolo, and although Ravello still has its quota of rich men, this Rufolo was a very rich man indeed. [2]

The *Decameron* was written by Giovanni Boccaccio between 1348 and 1353; Boccaccio had a number of friends in Ravello including the grammarian Angelo di Ravello. The hero of Boccaccio's story is based on one Lorenzo Rufolo, who after losing the favour of the Angevin king turned to piracy before being captured and imprisoned in a castle in Calabria, where he died in 1291. The ornate pulput in Ravello's cathedral is dedicated to the Rufolo family.

Amalfi and Ravello had important commercial contacts with the other nations on the mediterranean sea, in particular with the Byzantines and the Moors. Thus

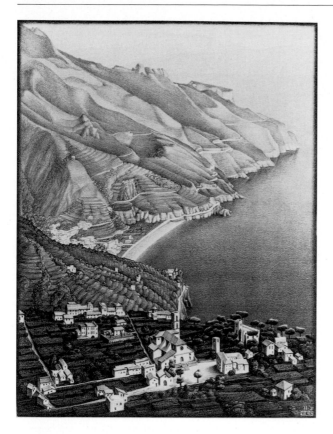

M.C. Escher, *Ravello and the Coast of Amalfi*, 1931. Lithograph

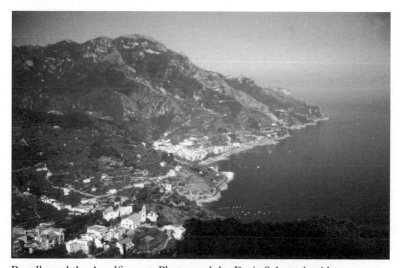

Ravello and the Amalfi coast. Photograph by Doris Schattschneider

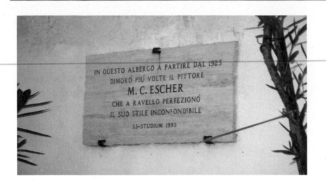

A plaque commemorating Escher's residence in Ravello. Photograph by Doris Schattschneider

the Arabs had an important influence on the culture and the art of the Amalfi coast. The *Pistolesi* 1845 guidebook noted with great admiration that Atrani could easily have been mistaken for a part of Tunis or Algiers. In 1853 King Ferdinando II completed the route from Salerno to Amalfi, the route traveled by Gregorovius in the XIX century on his *Grand Tour* [7]. He visited Ravello and was particularly attracted by the influence of the Moors on its art and architecture. He described the town of Ravello as a typical Moorish town, with towers and houses very close to each other – and the mosaics and the arabesques! Many Arabs, as well as Arab soldiers, were living there.

Gregorovius was especially attracted by Villa Rufolo.[1] The Rufolo family was one the most important families in the town. This palace could be called a little *Alhambra* (and everyone knows very well what a strong impact the *Alhambra* of Granada had on Escher). The composer Richard Wagner also was fascinated by Villa Rufolo. "This is the magic garden of Klingsor!" exclaimed Wagner on May 26, 1880. It was in this place that he wrote the fourth scene of Act II of *Parsifal*. This is one of the main reasons why Ravello holds a famous festival of symphonic music each year (the 1998 festival began with Giuseppe Sinopoli[2] and ended with Zubin Mehta). Wagner's *Parsifal* was on stage in 1997; *Valkyrie* in 1998.

The best way to understand why so many people have been attracted to Ravello is to walk around and discover the secrets of this small town. Several pictures of Ravello are on the CD Rom.

I would like to end with a poem, an Arabic poem, which is possible to find engraved on a stone in *Villa Cimbrone*, one of the most beautiful villas in Ravello: It is from Omar Khayyam's *Rubayyat*, LXXIV, written in the eleventh century.

> *Ah, moon of my delight, that knows no wane*
> *The moon of Heaven is rising once again,*
> *How oft hereafter rising shall she look*
> *Through this same garden after us in vain!*

[1] This is the place in Ravello where the 1998 Escher Centennial congress and the Escher exhibition took place.

[2] Maestro Sinopoli died in Berlin, April 20, 2001.

References

[1] G. Boccaccio, *Decamerone*, seconda giornata, novella quarta, Einaudi ed., Torino, 1955, p. 93.

[2] G. Boccaccio, *The Decameron*, translated by G.H. McWilliam, Penguin Books, London, 1995, p. 92.

[3] L. Emmer, with E. Gras and T. Grauding, "Racconto di un affresco" 1938; new edition after World War II with the music of Roman Vlad.

[4] M. Emmer, "M.C. Escher: Art, Math, and Cinema," in this volume, p. xx

[5] M. Emmer, "Movies on M.C. Escher and Their Mathematical Appeal" in *M.C. Escher: Art and Science*, H.S.M. Coxeter, M. Emmer, R. Penrose, M. Teuber, eds., North-Holland, Amsterdam, 1986, fourth ed. p. 249–262.

[6] M.C. Escher, *Regelmatige Vlakverdeling*, De Roos Foundation, Utrecht, 1958.

[7] F. Gregorovius, *Wanderjahre in Italien*, Lipsia, 1872.

[8] D. Richter, ed., *Alla ricerca del Sud: tre secoli di viaggi ad Amalfi nell'immaginario europeo*, La Nuova Italia ed., Firenze, 1989, p. 227–232.

[9] D. Schattschneider, *Visions of Symmetry: Notebooks, Periodic Drawings and Related Work of M.C. Escher*, W.H. Freeman & Co., New York, 1990, p. 12–13.

[10] M. Senechal, ed. "Parallel Worlds: Escher and Mathematics, Revisited," *The Mathematical Intelligencer*, vol. 21, no. 1 (1999) 17.

Mystery, Classicism, Elegance: an Endless Chase After Magic

Douglas R. Hofstadter

An essay in honor of Bruno Ernst, Hans de Rijk, and Brother Erich –
Escher's three deepest appreciators

A Non-artist's Non-artist?

I am turning the pages of the large volume *M.C. Escher: His Life and Complete Graphic Work*, which I bought many, many years ago. I quickly flip past *Metamorphosis*, *Sky and Water*, *Drawing Hands*, *Relativity*, *Waterfall*, *Belvedere*, *Print Gallery*, and many others – the familiar works that first grabbed me with a sudden, irresistible, visual pull (most of them awarded a full page or at least a half-page in that book), works that truly intoxicated me half a lifetime ago – and my eye is instead caught by much smaller images, images of Mediterranean seascapes or Italian hilltowns, images of a tree or a snow-covered barn, images that seem far simpler and far less eye-grabbing, far less interesting than those for which M.C. Escher has become world-famous.

And yet, in so doing, I feel I am in deeper touch with M.C. Escher than I ever was before, and am appreciating, more than ever before, his artistry. And I use the word very carefully and very deliberately, for M.C. Escher has, perhaps inevitably, come under attack from segments of the contemporary art world as "not an artist." Indeed, in the bookshops of art museums these days, one commonly finds, along with hundreds of books devoted to virtually unknown but terribly trendy contemporary artists, a total blank when it comes to Escher's works.

Writing in the *San Francisco Chronicle* in 1979, the art critic Thomas Albright observed (though not espousing the sentiments himself):

> *Always regarded more coolly by the art world than by the populace, Escher's quirky visual paradoxes are frequently shrugged off by sophisticated contemporary connoisseurs as so much academically executed, illustrative trickery, a more hip version of Norman Rockwell.* [1]

Even more pointedly, a recent review in *The New York Times* of an Escher retrospective in the National Gallery in Washington, D.C. snidely described the printmaker to whose exhibit the gullible, unsavvy Washington public was flocking as "a non-artist's non-artist" [13]. Why would harsh judgments along these lines emanate with high frequency from the pens of the self-appointed Creators and Conservators of Art in the Western World?

Behind the Bandwagon of Cool Dismissal

I can't presume to fathom all the reasons that underlie this collective behavior, but I can still speculate, and so without fanfare, here are some of my guesses as to why a large segment of today's art world pooh-poohs M.C. Escher:

- Some artists and would-be artists are consciously or unconsciously jealous of Escher's popularity and effectively say to themselves (a little like Aesop's fox who couldn't reach the tempting grapes), "Anyone who is that popular couldn't possibly be worthwhile";
- Some artists and would-be artists see in Escher's works "nothing but mathematics" and this "regrettable" link would – by definition! – instantly preclude its having anything to do with Art;
- Since Escher's prints use few colors, and are very precisely executed, they are pigeonholed as being not rich, spontaneous, and sensual but, rather, as austere, constrained, and cerebral (and of course "cerebrality" is the kiss of death in today's art world);
- Various Escher prints were pirated and illegally reproduced on psychedelic posters and rock-album covers in the 1970's and 1980's, a fact that for some people stigmatized his art as a whole, leaving an overall impression that Escher is the artist of preference of the "sex, drugs, and rock-n-roll" crowd;
- Escher standardly called himself a "graphic artist" or a "printmaker"; given, then, that he had confessed of his own free will to his crimes and thus revealed his sinful nature, how could anyone persist in calling him "artist"?

The five negative stances that I have just sketched stem, in the main, from voguish waves that have swept through our culture in the past few decades but that are far from universal; indeed, I have observed numerous times that sophisticated adults from other cultures (e.g., from Eastern Europe or Asia) respond with the same unabashed enthusiasm to Escher prints as I did, when I first saw them.

An Epiphany in the Office of Otto Frisch

The first time I laid eyes on an Escher print is as vivid in my memory as the moment I first heard that President Kennedy had been shot. It was January of 1966, I was twenty years old, and my father and I had just driven up from London (where my parents were spending a year) to the idyllic university town of Cambridge, where he had been invited by his colleague Otto Frisch to give a physics colloquium. Frisch, a gentle elderly Austrian Jew who, as a refugee first in Copenhagen and then in England during World War II, had played a major role in unraveling the secrets of nuclear fission, met us on the ground floor of his building and escorted us upstairs to his office. I walked in and in a flash was bowled over by a stunning drawing in a large dark-brown wooden frame (Fig. 1). I saw white birds flying one way, black birds flying the other way, the two flocks

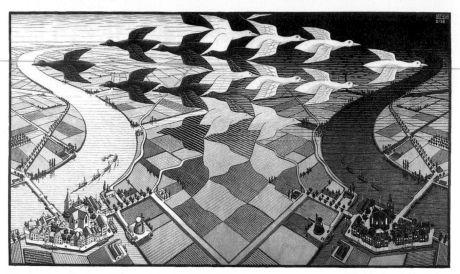

Fig. 1. M.C. Escher, *Day and Night*, 1938. Woodcut

meshing perfectly together to fill up all space. As my gaze drifted downwards, I saw the bird-shapes distorting and turning into a diamond-like grid of black and white fields. To the left of the fields, I saw a peaceful village by a river, basking in bright sunlight, while to their right, I saw a mirror-image village by a mirror-image river, calmed by soft starlight.

I found myself plunged into the mythical world portrayed, and was charmed by the idea of walking back and forth on the little roads linking these two villages, thus easily sliding, in a mere five minutes, between noon and midnight. As I pondered the birds blithely flying above, I wondered, "How could two flocks of birds fly right *through* each other, without even the tiniest space? For that matter, how could they even breathe, with no air between them? And how could three-dimensional birds, roughly half a meter in length, turn into two-dimensional fields, roughly 100 meters on a side?" None of this symmetric picture made any sense, but at some other level, it made *perfect* sense.

I asked Frisch, "What is this?" He replied, "It is a woodcut by a Dutch artist, and I call it 'Field Theory', though its real name is 'Day and Night.' Do you like it?" I replied, "It is amazing!" Frisch then said, "I recently visited the artist, whose name is Escher, in his studio in Holland, and I have his address. If you would like, I'll give it to you, and you can write to him." I eagerly took the sheet he gave me, and in the meantime pondered the nickname that Frisch had given the print.

"Field Theory" was clearly a piece of physics wordplay, since that term is another name for relativistic quantum mechanics, and I knew that one of the key principles at the heart of field theory is the so-called "CPT theorem," which says that the laws of relativistic quantum mechanics are invariant when three "flips" are all made in concert: space is reflected in a mirror, time is reversed, and all

particles are interchanged with their antiparticles. This beautiful and profound principle of physics seemed deeply in resonance with Frisch's Escher print, with its left–right reversal (the mirroring of space), its interpenetrating black and white birds (particles and antiparticles), and its interchange of day and night (which could be taken metaphorically as tampering with time, perhaps symbolic of a flip in the direction of time as one crossed the picture). Moreover, the weird transitional shapes that floated somewhere between pure birdness and pure field-ness had a quantum-mechanical flavor of entities that are neither particle nor wave, and yet are somehow *both*.

MCE: Outcast Poet

Although I am not a mystic, I am nonetheless subject, as are most humans, I would surmise, to occasional flashes of mystical feelings, to a certain irrational sense of cosmic magic and mystery – and somehow this astonishingly original print and Frisch's little piece of wordplay, linking it with the ultimate laws of the universe, touched me very deeply. It is also interesting, and not at all a coincidence, I would say, that when my father and I visited the Frisches at their home later that afternoon, what Frisch chose to play for us on the piano was the Italian Concerto by J. S. Bach, who was by far Escher's favorite composer, and whose name, over a dozen years later, I would link, in the title of my first book, with those of Escher and of Austrian logician Kurt Gödel [8].

There is, I feel, some intangible quality shared by Escher's oft-explored themes of symmetry, reversal, paradox, interpenetrating worlds, flow and meta-morphosis, and ultimately, the overall strangeness of the world, by Bach's ever-fertile contrapuntal manipulations of several interwoven voices, sublimely exploiting inversion, interlocking patterns, and multi-level complexities, all in the honor of an unseen and mysterious Creator, and by the vast and subtle intellectual structures of mathematics and physics that unmask the most hid-den secrets behind the scenes of Nature. When a human creation of any sort – visual, musical, or intellectual – is capable of making millions of humans powerfully resonate to the strange and awesome harmonies lurking in the world around them, it seems to me that that creation epitomizes *art*, in the best sense of the term.

There is something sad, to me, in the fact that so many in the fad-prone art world – though by no means all! – cannot come to grips with the fact that a "mere" graphic artist could have had such an impact on so many people; I find it perverse that, far from lauding this individual, they instead feel compelled to disdainfully turn their backs on his visual creations, to badmouth his style and his achievements, and to expel him symbolically from their community. When the art world chooses to reject one of its most creative members merely because, in exploring idiosyncratic ideas, he managed to engage the imagina-tions of millions, it seems to me a world that has lost its bearings.

But the art world will not, of course, admit that pettiness might play a role in its haughty attitude. No, a loud protest will be raised that Escher was nothing but a mediocre, run-of-the-mill artisan, perhaps skilled as a draftsman, but with almost no sensitivity to line, color, composition, characterization, themes, or anything else that matters in art. He was a trickster who played surface-level games based on fooling the eye, but he had nothing creative or profound to say.

It is at this level that I would like to engage the art world – on its own terms – and in this essay I shall do so, but in order to set the stage, I have to begin where I myself began, which is with my own very meager correspondence with M.C. Escher, first in early 1966 and then in the spring of 1967.

Getting to Know Escher's Output and Style

Within a week or two of my visit to Frisch's office, I had written a short letter to Escher at his home in Holland asking about the possibility of obtaining a print of *Day and Night*, to which I promptly received a terse but amicable reply saying that it was available and its cost was $70. Well, being but a simple student and having no serious income to speak of, I found this was a bit steep, and so I decided against the purchase. However, Escher did tell me in his note that a book of his works was scheduled to appear within a few months, and so I decided to wait for that. Something like a year passed, and finally, with a certain amount of difficulty, I managed to obtain one copy of this book from a small press in Germany. It was filled with magic!

I need not dwell here on my reaction to all the prints reproduced in it, but suffice it to say that on some level, perusing the book felt like reading a science-fiction adventure filled with paradox and illusion. Many of the prints grabbed me intensely, but perhaps my favorite, aside from *Day and Night*, was *Up and Down* (Fig. 2). I could not help but inject myself straight into the picture, imagining myself as the boy sitting on the stairs.

Each time I looked at *Up and Down*, in my mind's eye I would see the boy stand up, walk down a few stairs, then turn right and go down the little flight leading to the basement of the tower, open the door, and then start to climb inside the tower. He would go up one floor, then another, then a third, and then – in some indescribable manner – would find himself upside-down, below ground level, in the basement of the tower he'd just climbed (or one indistinguishable from it). (If you doubt my claim about orientation, compare the windows on the two sides of the tower.) He would then flip himself right-side-up, exit the basement door, and emerge at the bottom of the small flight of stairs, proceed up them, only to find himself back again at the level of the sandy courtyard he had just left.

Would he see himself – or his clone – sitting on the stairs? No, I reasoned, because presumably, the clone-boy would have simultaneously made the same trek (or rather, "the same" trek), and hence would not be around to muddy the fragile waters of personal identity. In fact, the truth of the matter is that the

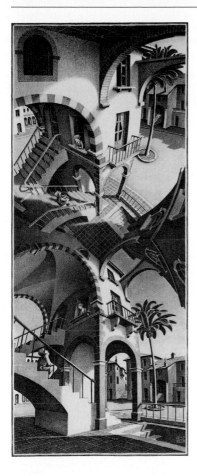

Fig. 2. M.C. Escher, *Up and Down*, 1947.
Lithograph

two clones would have passed each other, though going in opposite directions, halfway up (or down) the tower. I like to think that perhaps the spiral staircase inside the tower is walkable on both sides (much as are two of the straight stairways shown in *Relativity*, page 265), allowing two people to use it at the same time without having any awareness of each other. Of course gravity would have to work in a very subtle way inside the confines of the tower (but then, think of how much subtler gravity's workings must be in *Relativity*!).

Another type of delicious *frisson* came each time I imagined the boy standing on the ground-level patio tiles just to the right of cellar steps, and peering over either of the U-shaped stone arches, one low and one high. (He might have to hoist himself up to peer over the higher one.) Just what would he see? Would he have to hold on for dear life, lest gravity suddenly rip him from off this tiled ceiling and send him reeling downwards to crash head first on the very same tiles, yet three floors below him?

I must say, I loved the mythical setting of this print, especially its warm Mediterranean ambiance: the sandy courtyard, the palm trees in their little

circular plots, the archways lining the courtyard, the staircases, the balconies . . .
I myself grew up in an environment that shared much with this style: the campus
of Stanford University, with its sandstone buildings, hundreds of arches, square-
tiled passages, tiled roofs, palm trees, and so on, and so perhaps I had a natural
affinity for such scenes, but in any case, I was enchanted purely on the architec-
tural level. It was only some years later that I came to realize that Escher had
borrowed many elements of these decidedly non-Dutch scenes from villages in
such places as Malta, Corsica, Sicily, Sardinia, mainland Italy, and Spain.

Disappointment and Captivation

I want to make very clear that I was by no means charmed equally by all the
prints in this first book. Truth to tell, I was rather turned off by the ugly gnome-
like creatures in *Encounter*, the sinister skull at the center of *Eye*, the bizarre
rind-like strips in *Bond of Union*, the frighteningly huge praying mantis in
Dream, and so forth. Moreover, I was distinctly frustrated by the relative sim-
plicity of the shapes and the repetitiveness of some of the tessellations, such as
Whirlpools, *Circle Limit I*, *Flatworms*, and others.

And then there were some images that, though they intrigued and charmed me
with a subtle and novel poetic flavor, still disappointed me for their lack of overt
paradoxicality. I'm thinking, for instance, of *Rippled Surface* and *Puddle*. The
former, however, kept attracting my eye with its elegant stylization of how rip-
ples distort reflections, clearly revealing its creator's fascination for the geometry
that pervades physical phenomena.

As for *Puddle* (page 8), I warmed up slowly to its underdone poetry, defined
by the mingling of many distinct worlds – the moon, the clear sky, the trees, the
mud, the smooth water, and of course the invisible humans, the details of whose
recent comings and goings on foot and on wheels were clearly legible to the in-
telligent eye. So much to take in! The round, round moon, split in two by a spit of
mud jutting out into the shallow water . . . The budding leaves, near and far, on
the tree branches . . . The parallel zigzags of a truck's tire marks, extending into
the puddle . . . The crisscrossing bicycle tracks . . . The walkers' tracks, leading
in opposite directions . . . And forming the upper-left and lower-right edges of
the puddle, two footprints defined by the outline of the water itself . . . This im-
age was permeated by an almost Buddhist sense of calm and serenity, and soon
seemed in its own way just as wonderful as the mind-bending strangeness of
Drawing Hands, *Verbum*, *Metamorphosis*, and others.

Spreading Like Wildfire

Once I had absorbed the contents of this first Escher book, I could see I was dealing with a visual poet whose mind could be carried far along a number of very different directions, and that my first impression had just scratched the surface.

Naturally, I eagerly showed my copy of this exotic book to friends, and to my surprise, several of them asked me if I could get copies of it for them. So I went back to the bookstore that had gotten my copy, and ordered five more. As soon as they arrived, they were snapped up, and then more friends asked for copies. I ordered another ten, and before long, all of those were gone as well. I could see that this little-known Dutch artist had a profound appeal to people of many sorts – especially those who liked intellectual stimulation flavored by strangeness and mystery.

Own Print

Having thus realized that these works had an uncanny power to churn up inquisitive minds, I decided that maybe it would be nice, after all, to have a full-size Escher print on my wall, just as Otto Frisch had had – and so roughly a year after my first letter, I wrote to Escher once again, this time inquiring about the prices of about ten of the prints in the book he had told me about. Once again, his reply was prompt and to the point. *Day and Night* was still – thank God! – in print, but over the course of just one year, its price had gone up from $70 to $125. Whew! I gritted my teeth and wrote out a check for that amount (plus a shipping charge of $5), and within a couple of weeks, it arrived in a stiff cardboard mailing tube, in perfect shape once unrolled.

As for the other works I had asked about, some were out of print and some were still available, but I chose to forego purchasing any more, since my budget was very limited. Of all the works that I could have obtained then, the one I most regret is *Puddle*, which at the time would have cost me another $100. Of course, given today's sky-high prices, that sounds like a joke. Too bad – but at least I did come to own one genuine Escher print with his name penciled in at the bottom, and also the words "Eigen druk" – "Own print." And indeed, to this very day – and to this very night – I still own that very print.

"Gödel, Picasso, Bach: a Preposterously Gauche Bagatelle"

My own personal involvement with Escher took a special turn in the mid-1970's, when I was writing a book focusing on a kind of quasi-paradoxical abstract vortex that I called a "strange loop" – a notion that I had first encountered in

mathematical logic, but whose implications seemed to me to be vast, and in particular to reach out as far as the nature of human consciousness, at whose core I felt I identified such a structure. As I was writing my book – initially given the working title "Gödel's Theorem and the Human Brain" – I noticed that whenever I would write of these "strange loops," one or another visual image would creep into my brain, yet at such a subliminal level that for weeks I was virtually unaware of it. Finally one day, while riding my bicycle, I woke up to the fact that Escher pictures were haunting my mind as I was struggling for words to convey the nature of these bizarre structures, and I realized that it would be distinctly unfair to my readers if I failed to provide *them* with the same concrete imagery as I myself was using in order to visualize these abstractions. And so I decided that my book would have to include a fairly large sampling of Escher pictures.

Since I had already livened up the book by writing verbal dialogues that playfully imitated contrapuntal pieces by Bach, I decided that the strong presence of these two wonderfully deep artistic spirits merited being recognized in the title, and so I switched my book's title to *Gödel, Escher, Bach* – and then, feeling this was a bit austere and cryptic (as well as too foreign-seeming), I appended the subtitle *an Eternal Golden Braid*, which, with its swapping of the initials "G" and "E," did indeed take the first step in creating a potentially infinite braid composed of the three letters "G," "E," and "B."

Most of the Escher prints that I discussed in *GEB* were of the "spectacular" type – those that threw paradox straight in your face and forced you to grapple with it – but there was one chapter in which I spoke about a few of Escher's more subdued prints, such as *Dewdrop*, *Three Worlds*, *Rippled Surface*, and *Puddle*, in fact likening their spirit to that of Zen Buddhism.

For a number of years after finishing *GEB*, I felt that I had essentially "shot my wad" as far as Escher was concerned – I had had my say, and had nothing more to say to anyone about the art of M.C. Escher. But slowly, I kept hearing from various people about their disdain for Escher's art. I will always remember a curator at a museum in Washington, D.C., who told me of her great admiration for my book *Gödel, Escher, Bach*, but insisted nonetheless that I had made an egregious error in choosing Escher as my featured artist; had I known more about art, I surely would have replaced him by Picasso, whose spirit, she explained, was far more in line with those of Gödel and of Bach. How could I have ever seen fit to place a mediocrity like Escher, a mere cipher, on the same plane as that of the titans Gödel and Bach?

I could barely believe my ears. Contrary to her supposition, I was in fact very familiar with Picasso, and though there were some works that appealed to me (and many more that did not at all), I found the spirit of his art to have little if any relationship to the ideas in which my book was grounded. Moreover, I had to chuckle internally at her other supposition, which was clearly that I had begun my book by asking myself the question, "Let's see, now ... I want one mathematician, one artist, and one musician – so which individual from each category shall I pick?" What a distortion of *GEB*!

Far Out, Maurits Baby!

Even my late wife Carol, who was without any doubt one of my staunchest supporters, wavered a bit in her feelings about Escher, although she was by no means a total scorner of his art. (In fact, she was happy to have our dining room decorated with several Escher prints in elegant frames.) When I pressed her about her mixed feelings about Escher, she explained that she had originally seen his art exclusively on psychedelic posters in day-glow colors and so, although she now knew better, she just couldn't divorce it from the world of hippies who would gape wide-eyed at it, drop their jaws, and religiously mutter, "Like wow, man! It's a mind-blowin' turn-on!"

Indeed, in 1969, Escher bitterly complained, in a letter to his son George and daughter-in-law Corrie in Canada:

> *The hippies of San Francisco continue to print my work illegally. I received some of the grisly results through a friendly customer over there. Among other things, such as virulently colored posters, I was sent a forty-eight-page programme or catalogue of the so-called "Midpeninsula Free University," Menlo Park, California. It included three reproductions of my prints alternating with photographs of seductive naked girls.* [2, p. 131]

These words are both amusing and poignant to me, since the San Francisco midpeninsula was precisely where I had grown up and still spent every summer in those days, and I had a couple of friends who were deeply involved in the so-called "MFU" (an institution whose philosophy ran violently against my grain). In fact, I keenly remember how I had run across that specific "course catalogue" and been disgusted with the way in which Escher – someone who at the time I practically regarded as my own "personal property" – was garishly mixed in with tasteless pornography and trendy psychobabble.

I readily admit that, had my first associations with an artist come from perusing such a trashy, trendy catalogue, I very likely would have been turned off just as Carol had been, but I tried to convince Carol, who had specialized in art history at Indiana University, that Escher was not just some sleazy fly-by-night artist who was out to make a quick buck off of trendy young folk eager to gawk at superficial, sensationalistic imagery, but rather, he was someone driven by an insatiable curiosity and a deep sense of esthetics, and whose work had sadly been pirated and exploited in the crudest of contexts. Looking back, I suspect that it was probably in my attempts to convey to Carol my sense of M.C. Escher as *poet* that I first started to perceive Escher's art on a new level, and to articulate why he was so different from a number of latter-day imitators who in the meantime had come along.

We will come to all that in a moment, but before we leave the topic of how Escher's visions lit many people's fires, I cannot resist including a small anecdote that I read in an article by Kenneth Wilkie in the *Holland Herald*

concerning the unlikely interaction between British rock star Mick Jagger and the Dutch artist early in 1969 [14]. The former, hoping to splash an Escher print on a forthcoming record cover, wrote the latter a note that began as follows:

> *Dear Maurits,*
>
> *For quite a time now I have had in my possession your book [Graphic Works of . . .] and it never ceases to amaze me each time I study it! In fact I think your work is quite incredible and it would make me very happy for a lot more people to see and know and understand exactly what you are doing. In March or April this year, we have scheduled our next LP record release, and I am most eager to reproduce one of your works on the cover-sleeve. Would you please consider either designing a "picture" for it, or have you any unpublished works which you might think suitable . . .*

As has already been attested to in previous pages of this essay, Escher was no slouch as a correspondent, and just a couple of weeks later he replied as follows to Jagger's assistant, Mr. Peter Swales:

> *Dear Sir,*
>
> *Some days ago I received a letter from Mr. Jagger asking me to design a picture or to place at his disposal unpublished work to reproduce on the cover-sleeve for an LP record.*
>
> *My answer to both questions must be no, as I want to devote all my time and attention to the many commitments made; I cannot possibly accept any further assignments or spend any time on publicity.*
>
> *By the way, please tell Mr. Jagger I am not Maurits to him, but*
>
> > *Very sincerely,*
> > *M.C. Escher.*

Sublime Minimalism

One of the defining characteristics of good poetry is *terseness*, and another is *elegant ambiguity*, or otherwise put, *polished polysemy* – the cramming of a number of meanings into one well-wrought phrase. I would say that the concluding sentence of M.C. Escher's reply to rock star Jagger fits those criteria perfectly – it is terse and it packs in two meanings beautifully! But there are, needless to say, other media than that of language in which Escher created poetry possessing both terseness and polished polysemy.

Consider the lovely miniature woodcut *Fish*, executed in 1963 (Fig. 3). There are but two complete fish in it, one white and one black, while around them are small fragments of ten additional fish (five white and five black, of course), making twelve *in toto* – three columns with four fish apiece. But the fading-off into undulating watery forms is carried out in the most exquisite and the most symmetric of fashions; even the pair of little wave-fragments seen at the very

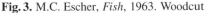

Fig. 3. M.C. Escher, *Fish*, 1963. Woodcut

Fig. 4. M.C. Escher, *Plane-filling Motif with Fish and Bird*, 1951. Linoleum cut

top are echoed precisely at the very bottom. If ever a work of art merited the title "poem," this is it! It is a paragon of compression and concision, and its visual polysemy – the black-fish/white-fish oscillation – is as elegant as could be. To my mind, this miniature represents what creative genius at its absolute peak is capable of, and as such, it is a study from which many artists, young and old, could learn a great deal.

Another miniature that exudes the same sort of subtle charm is *Plane-filling Motif with Fish and Bird*, a linoleum cut done in 1951 (Fig. 4). At first, one might tend to see in this nothing more than a competent though rather uninspired drawing of four identical fish. Only if one's attention jumps from the four white shapes to the central black shape that they collectively define does one discover what is really going on here: a lone bird flying in the opposite direction leaps out at the eye. At the eye, indeed! Yes, I suspect that had Escher not drawn that tiny telltale circle at the eye, the central bird would be so subtle as to elude nearly all viewers. Sheer poetry, once again.

Two other similar studies are worth pointing out and briefly commenting on, as well. *Horses and Birds* is a wood engraving done in the fall of 1949, while the Asselbergs' New Year's greeting card, a woodcut, dates from roughly a year earlier. In the first of this pair, one sees four horses – and yet the fourth one is so cloudlike as to be nearly ethereal; likewise, one sees four birds, but the fourth one has nearly been absorbed into the grass. And in the second of the pair, the sea scene, we clearly recognize five black boats, with a sixth black shape (directly above the lowest fish) constituting the "ghost" of a boat; and in perfect complementarity, we clearly recognize five white fish, with a sixth white shape (directly below the highest boat) constituting the "ghost" of a fish.

There are several touches in the latter study that enhance its charm, such as the increasing realism of the boats as one moves upwards, and the symmetrically increasing realism of the fish as one moves downwards. Thus, for instance, one might say that the "symmetric analogue" to the sharp teeth of the very lowest

fish is the person seated in the back of the very highest boat. These details, like the seagulls in the sky and the jellyfish in the sea, did not have to be added, if all the artist were interested in were a trompe-l'œil effect; but Escher loved the extra detail, the fine touch that in some sense might have seemed irrelevant but that undeniably added flavor.

A Time-reversed Artist's Life

I now wish to slide gradually backwards in time, and in so doing to demonstrate what I think is a remarkable reversal of the usual progression in an artist's life, in which youth's first passionate outpourings are often brilliant and catchy, but in which the fact of aging tends to lead to an ever-increasing level of subtlety and an ever-greater idiosyncrasy of language, which, perforce, usually "speaks" to a smaller and smaller audience. Somehow, in the case of M.C. Escher, the progression seems to have followed precisely the opposite course – namely, whereas the output from his earlier years is imbued with a subtlety that seems to elude most people, it is the products of his later years that seem brilliant and catchy, and that have seized a vast public's imagination.

Intimate Interlacings of Independent Universes

I have already waxed lyrical about the several interwoven worlds in the 1952 woodcut *Puddle*, and in *Gödel, Escher, Bach*, I echoed Escher's own words about the mingled worlds in the 1955 lithograph *Three Worlds*, so I will not do that here. I would instead focus on a seldom-discussed print, the wood engraving *Double Planetoid*, which dates from 1949 (Fig. 5). What we have here is a wonderful science-fiction image of two totally independent yet mutually interpenetrating worlds, one inhabited exclusively by human beings, the other populated exclusively by reptiles of the lizard/dinosaur variety. Each world is, on its own, a perfect tetrahedron – the most elementary of the five regular Platonic solids, having just four vertices, and for its faces having four equilateral triangles.

For the human-populated tetrahedron, the vertices are flag-capped castle towers, and each face contains an essentially circular bridge chaining its three towers together, so that people can freely walk from one "kingdom" to another. Indeed, the careful onlooker will soon spot several individuals in transit from one castle to another, as well as other denizens who sit or stand high on the balconies, and chat or contemplate the scenery.

At the same time, there is another tetrahedral world whose vertices consist of four rugged mountain-peaks, which one might imagine reaching by strenuous rock-climbing, scrabbling up the steep slopes and grabbing at cactus branches –

Fig. 5. M.C. Escher, *Double Planetoid*, 1949. Wood engraving

but of course this world is exceedingly hostile to humans, and there are none in it to thus tempt fate. Who would want to risk being trisected by a tyrannosaurus or trampled by a triceratops? A careful look at this wild world will reveal several different kinds of dinosaurs, and – in slight violation of my reptiles-only theory a few lines back – a mountain goat perched high on a promontory!

Escher leaves totally to the imagination of the viewer the nature of the relationship of these worlds to each other. Their *physical* interaction is mediated by a set of arches and galleries, which allow the dino-world to pass right through the architecture of the human world – and complementarily, by a set of caves and grottoes, which similarly allow the human world to pass right through the dino-world. Not in a single point do the two worlds ever actually touch each other! What an ingenious geometric creation!

But what we do not know is the answer to the questions: *Do the denizens of one world see those of the other? Are the two worlds mutually ignorant, or are they aware of each other?* I do, I admit, have a hunch on this. It seems to me that on one of the high walkways I can just barely make out a person with outstretched arm, pointing something out to a companion, and it would appear that it is most likely a scary, scaly lizard much larger than either of the people, scaling the alpine heights of one of the four mountains – and so, if I had to bet on

it, I would guess that the people are aware of their co-denizens, but they never try to cross over, and perhaps the dinosaurs, too, are dimly aware of strange creatures lurking near them, just as aquarium fish might be dimly aware of people through the glass of their tanks.

Meanwhile, this double world dangles serenely in the blackest of space, with its inhabitants presumably enjoying a very earth-like existence, replete with normal gravity, air, wind and rain, the passing seasons, and of course an abundance of food, fights and rivalries, languages, dialects, passports, armies, wars and diplomacy, flirtations and marriages, temptations, intrigues, infidelity, illness and mortality, and even – for how could it be otherwise? – the rudiments of science as well as art a-plenty. And thus, mightn't one conceivably come across an Escher print – perhaps *Double Planetoid* itself – hanging on the stone walls of one or more of the grand little castles?

This print provides us with an extremely blatant case of intermingling worlds, but Escher's early art is filled with subtler examples of this same kind of vision. Consider the 1939 woodcut *Delft from the Tower of the Oude Kerk* (Fig. 6). What we see here is a panorama of Delft rooftops, interrupted by the pleasingly carved stone railing of the tower, with its flat upper surface and its graceful curved arches. Which world is dominant here? Which is the subject of the study? On the one hand, the lovely medieval town would seem to be the main focus, with the railing being an unwanted but unpreventable intruder (as if the incorrigibly honest artist had no choice but to include the railing in his rendering of reality, simply because it was *there*!); and yet on the other hand, the lovingly detailed portrayal of the railing itself, with all its cracks and flaws, draws one's attention

Fig. 6. M.C. Escher, *Delft from Oude Kerk Tower*, 1939. Woodcut

Fig. 7. M.C. Escher, *Venice*, 1936. Woodcut

quite away from the town, and one's gaze can well dwell on the nearby stone instead.

The truth of the matter is, however, that there is a perfect balance between the two worlds, and that the actual subject of the study, as in *Double Planetoid*, is *coexistence* – in this case, the coexistence of near and far, of light and dark, of solidity and airiness, of one's *own* world (for we can imagine reaching our hand out and touching the railing) and the world of *others* (for we can imagine the people walking the streets of Delft, carrying out their daily duties of shopping, stopping, talking, and walking), but *they* and *we* belong to separate worlds, and never the twain shall meet.

A similar foreground-world-versus-background-world effect gives great interest to the 1936 woodcut *Venice* (Fig. 7), wherein we see, across the serene lagoon, a lovely church steeple rising high above the water, but our view is partially obscured by the wondrous Venetian curvilinear arches, recognizable instantly from their Byzantine-influenced minaret-like negative spaces, and just above them, their four-leaf-clover-shaped holes. Once again, which world is being "foregrounded"? And once again, the answer is that the true point of the image resides in its duality, its ambiguity, its oscillatory nature, never resolved.

Similar near-and-far double-world oscillations are found in the 1937 wood-cut *Porthole* and the 1933 wood engraving *Cloister of Monreale*, Sicily (see page 79). The latter in particular features an exquisite interplay of extreme light and extreme dark, with the sun's rays streaming diagonally across the courtyard, and with delicate swirling lacery adorning the quadruple stone column in the very foreground.

One final example of this "subgenre" that is so characteristic of M.C. Escher's style is provided by his 1933 woodcut *Pineta di Calvi, Corsica* (Fig. 8), which depicts a village perched on a rocky outcropping, seen from across a lake or river, but our clear view of the village is constantly being challenged by the dark-est of dark pine trees – trunks, branches, foliage, and cones. We the viewers

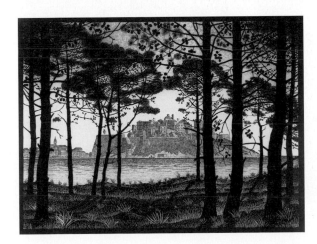

Fig. 8. M.C. Escher, *Pineta of Calvi, Corsica*, 1933. Woodcut

belong to one world – dark, cool, lush, and sinuous – while the far-off village constitutes a world apart – bright, scorched, dry, and rectilinear. Intimate commingling of these opposites is the point of the study.

M.C. Escher's "Magical Realism"

Pineta di Calvi is one of those prints from a period in Escher's life that I consider absolutely magical. I got my first whiff of this facet of Escher when I gazed in fascination at the abruptly plunging hillsides of his 1930 lithograph *Castrovalva* reproduced in the sampler of his work that I obtained in 1966, but since that print had no true companions in the book, it felt more like an exception than a trend, and so I built up only the most rudimentary mental image of M.C. Escher *qua* landscape artist.

It was not until several years later – in fact, in May, 1972, when I got hold of a more comprehensive catalogue of Escher's graphic work, *De werelden van M.C. Escher*, edited by J.L. Locher – that I saw dozens more of these astonishing southern landscapes, and started to realize what a distorted image of Escher's

Fig. 9. M.C. Escher, *Roofs of Siena*, 1922. Woodcut

Fig. 10. M.C. Escher, *Bonifacio, Corsica*, 1928. Woodcut

artistic personality had been given to me, and of course to many others, by exhibits and books that focused so sharply on his paradoxical, illusion-centered works, while ignoring almost totally his deeply lyrical side.

Let me give a personal example. In the same year that I first saw *Day and Night* – in fact, just three months later – my parents and sister and I took a three-week trip through Italy, a few days of which we spent in the spectacular ancient hilltown of Siena, in Tuscany. I fell in love with that town, feeling it was the most romantic place I had ever seen – indeed, I ached in the most acute manner to savor it with a romantic partner. Well, it was only some six years later that I discovered how much my artistic and yearning reaction to Siena was shared by Escher, who made several poetic studies of its narrow, hilly streets and its ancient, haphazard architecture, such as his 1922 woodcut, *Roofs of Siena* (Fig. 9). These studies caught precisely the mood that I had been infected with, yet that I myself could never have possibly verbalized, let alone captured in an image.

The amazing charm of Italian villages that grow up nearly organically fused with the rocks and mountains on which they sit was an endless source of inspiration for Escher, and he made many studies of these miracles of collective invention, showing how they merge so intimately with the nature all about them. Two examples of this obsession of Escher's are his 1928 woodcut *Bonifacio, Corsica* (Fig. 10), showing a village perilously poised high above the sea on the very edge of a cliff that bends inward below it, and his 1929 scratch drawing *Town in Southern Italy*, showing a hillside village set at one end of a long valley that recedes far into the distance, where one sees a snowy mountain chain looming (Fig. 11).

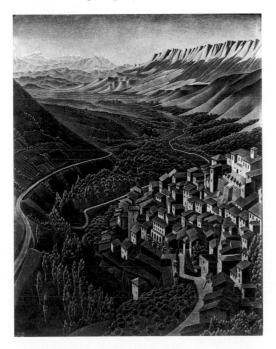

Fig. 11. M.C. Escher, *Town in Southern Italy*, 1929. Scratch drawing (lithographic ink)

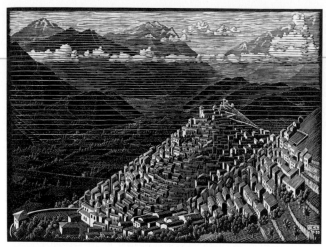

Fig. 12. M.C. Escher, *Morano, Calabria*, 1930. Woodcut

These are the kinds of scenes that have since time immemorial inspired poetic imaginations in the most powerful manner, and yet I have never seen anyone capture quite as clearly their magical feel. Perhaps the most stunning portrait of an Italian hilltown that I have ever gazed upon is Escher's 1930 woodcut *Morano, Calabria* (Fig. 12), which he made from a photograph he'd taken a few months earlier [2, p. 46]. If one compares the photo with the final print, one sees all sorts of devices he has used in order to turn reality into a poem. Metaphorically speaking, Escher quotes very literally, but at the same time he feels free to put in ellipses and to insert his own italics, and in this subtle manner, he turns elegant prose into exalted poetry.

In addition to appreciating the rugged beauty of crag-nestled villages, Escher had a particularly strong affinity for trees and forests, and their softer beauty, too, he was able to turn into quite amazing poetry. Take, for instance, his 1932 woodcut *Carubba Tree*, executed in the exquisite Italian hilltown of Ravello, perched high above the Amalfi coastline, southwest of Naples (see page 18). The play of light and dark here recalls the wonderful stylizations of waves and mountains done by Japanese printmakers such as Hokusai, but the particular gestures and devices are Escher's and Escher's alone.

As we continue our roughly time-reversed projection of Escher's life, we arrive at his surrealistic 1921 woodcut *Wood near Menton*, which has a marvelous, wild, fiery magic to it, mixing pure geometry with the strangest and snakiest of curves (Fig. 13). This, too, is among the Escher prints that I would most have liked to own. It reminds me a little of the experimentations of Escher's compatriot, the painter Piet Mondrian, as he slid slowly but inexorably down a slope leading from pure, old-fashioned representationalism, through a personal type of impressionism, finally to wind up at an unforeseen and unpredictable destination – namely, the highly geometrical abstract style for which he gained

Fig. 13. M.C. Escher, *Wood near Menton*, [1921]. Woodcut

his greatest fame. Midway along this slide, Mondrian produced beautiful surreal visions of trees and forests with marvelous curvilinearities to them, but such visions he eventually left behind; among them were dozens of attempts to capture the "essence of treeness," which I find strangely parallel to this study by Escher.

There is a type of literature that first sprang up in South America and that has since spread to other parts of the world, known as "magical realism," exemplified by the works of Colombian novelist Gabriel García Márquez. The hallmark of this brand of fiction is the scattering, among a perfectly normal series of events, of occasional paranormal occurrences, which are recounted quite blithely and straightforwardly, as if they were just as real and just as ordinary as the events that frame them. For some reason, I have never liked reading novels in this style, and yet, in an admittedly inconsistent fashion, I seem to fall lock, stock, and barrel for the visual way that M.C. Escher found of blending the purely real with the fantastic or the magical. I can't account for this rather irrational discrepancy of my literary and artistic tastes, but there it is anyway.

To conclude this brief discussion of M.C. Escher's visual version of magical realism, and in so doing to unwind the clock even further, I would cite the untitled 1919 woodcut that in my books is simply assigned the stark label *Tree* (Fig. 14). With long and swirly tendril-like branches weaving in and out among one another, this tree stands alone in a vast, barren field, with an eerily glowing moon looming behind it; in the foreground, a baffled human cowers in apparent fear and awe at the miraculous sight. The tree seems to be radiating some kind of magical "vibrations," to use a voguish but apt word. There is a mythical and timeless quality to this strange, unexplained scene. What could Escher have had in mind? Although there is nothing overtly paradoxical or illusionistic here, the

Fig. 14. M.C. Escher, *Tree*, 1919. Woodcut

artist is playing at the verges of rationality, and in this image, one can almost foresee (thanks, needless to say, to knowing the answer!) the directions in which its creator is predestined to travel over the course of his artistic lifetime.

Of an Artistic Corpus and of its Parts

We could travel back still further in time and see how M.C. Escher already, in some of his even more youthful prints, was flirting with mystery and magic, but it is time to draw the line. I confess that it has not been easy to select which prints to discuss, and that I would have liked to give many more examples, but oftentimes concision, though challenging and painful, is the wisest choice.

And so ... What Escher works do I most enjoy looking at today, after having been an MCE aficionado for – horrors! – well over thirty years? The truth of the matter is that these days, I find most pleasure in gazing at his earlier works – his fabulous (in the sense of "fable-like") Italian landscapes, and his studies of interpenetrating worlds – although to be sure, those old latter-day stand-bys *Day and Night*, *Up and Down*, *Reptiles*, *Liberation*, and *Relativity* will never cease to enchant me.

But would I have ever come to appreciate the beauties of those early works, those works that exhibit no "in-your-face" impossibilities or absurdities, were it not precisely for the latter works, the ones that everyone has come to feel are synonymous with the name "M.C. Escher"? That is a probing question. However, an even more probing question is whether I would ever have *encountered* them at all, had he not become world-famous for his later works. And once we open these

questions up, we are led to dealing with some of the most fascinating issues in the philosophy of art and the meaning of esthetics.

To help us grapple with these issues, I will propose two hypothetical variants of M.C. Escher. For convenience's sake, I'll call them "M.A." and "M.B." Like M.C. Escher (but instead of him!), M.A. Escher was born in 1898 in Holland, and lived exactly the same life as did the former – same, that is, until the fateful year 1936, when, tragically, M.A. was struck on his bicycle by a passing train, and died at age 38. Thus all that M.C. Escher had created up till that age, but nothing beyond it, would be the artistic legacy, the full artistic corpus, of M.A. Escher. Sadly, *Day and Night*, *Metamorphosis*, *Belvedere*, and all of those beloved works would simply never have seen the light of day (or night!), all because of the railroad-crossing signal that failed to go off.

Now as for M.B. Escher, he too shared the life story of M.C. all the way up till 1936 (and once again, with all the same artistic output), but then, unlike the ill-starred M.A., M.B. kept right on going strong until the ripe old age of 73 (just as did M.C.) – but here's the key difference between B and C: not even once during his whole long life did artist M.B. Escher feel any temptation to explore overt paradox, tessellation, impossible worlds, dimensional conflict, or any of those themes that today we would tend to identify by the label "Escherian." Instead, M.B. Escher trod the straight and narrow pathway over the next few decades, refining his technique ever further by churning out great numbers of prints of rugged Italian landscapes and charming Italian villages, poetic studies of Spanish and Maltese and Dutch countrysides in the four seasons, Zen-flavored miniatures featuring commingling worlds, and perhaps the occasional study in which elements of order and of chaos are tightly juxtaposed.

The question now arises: What would have been the artistic fates of M.A. Escher and M.B. Escher? Would anyone today know of either of them, or care about them? And in particular, would *I*, had I somehow come into contact with the works of either of these hypothetical artists, love them as I love M.C. Escher's, and would I have felt it was worth my while to spend a good chunk of my time singing their praises in a longish essay?

I must admit, it strikes me as pretty doubtful that the works of either artist would ever have reached my attention, or would even have attracted that much attention outside of those who were *a priori* inclined to be interested in the artist's works – namely, his close friends and relatives, people from the towns that he lived in and drew, and lastly, that small clique of people who always enjoy purchasing inexpensive prints in minor galleries here and there. Very probably, no internationally distributed art book would feature even so much as a single print of M.A. or M.B. Escher.

But why would this be? Aren't M.C. Escher's early prints – the ones that in this essay I have been so oohing and ahhing over – found in widely distributed books? Have they not become justly famous? And so, given their merit, would they not have found their way to publication come hell or high water? Of course, the answer is "no." Would we wish to read biographies of the child who *would* have become Einstein had he not died of typhus at age nine? Of course not; we

are interested in reading about Einstein's early childhood precisely because and only because of what he in fact *would* become and *did* become. Would we wish to read a biography of Albert Einstein, the careful horticulturist who faithfully tended the Basle Botanical Gardens for fifty years after deciding that physics was fun but flowers were *more* fun? Of course not; we are interested in the life of Albert Einstein *only* if he is the Albert Einstein who *didn't* drop physics, and then went on to discover two varieties of relativity, to postulate the photon, and so on and so forth.

The biographies of the nine-year-old prodigy and the dutiful Swiss botanist are, of course, caricatures of the M.A. and M.B. scenarios, since both M.A. and M.B. *did*, by hypothesis, grow up to adulthood and produce considerable bodies of respectable art. However, reaching adulthood and enjoying modest success is one thing, while having a huge skyrocketing career is quite another. There are many artists in the former category, few in the latter. One can hardly dispute the tautology that what M.C. Escher is famous for is the set of works that people know him by, and it seems most likely that Dame Fame would have passed him right by had he either expired on the railroad tracks in 1936, or merely gone on to do "more of the same" for another three or four decades.

And so I think that the question of fame is fairly unambiguous and uncontroversial: M.A. and M.B. would most likely have been very minor figures in the world of art, if not virtually unknown, by this, the year 1999. But saying that and stopping there sidesteps the perhaps more interesting question of whether their works would still have exerted on me, Douglas Hofstadter – had I by hook or by crook come to know them well – that same effect, that same sense of magic and mystery as I now perceive in them. What would I think – indeed, what would I *see*? – when one fine day I chanced to run across the works of M.A. or M.B. Escher on the walls of some small Dutch museum, or flipped by accident to them in the pages of an obscure but finely produced art book?

This is a rather tricky counterfactual scenario, but here's my take on it. I suspect that although I would still like the prints quite well and would feel that they resonated with my own personal love for such things as Italian hilltowns and intermingling worlds, I would probably fail to see the extra levels of magic that I in fact see lurking in them "between the lines," extra levels of meaning that clearly come from my seeing these prints not simply as "some artworks by some Dutch artist," but far more particularly as *works that emanated from the selfsame eye and the selfsame hand of M.C. Escher, paradox artist par excellence.*

In fact, this is in itself a seeming paradox: that my reactions to the wonderful early prints of M.C. Escher are not due solely to the forms and ideas that he put into them when producing them, but are also deeply due to *the artist that he later became and that I came to love.* It is because I fell in love with *Day and Night* and *Up and Down* (etc.) that I can now look at prints like *Pineta di Calvi* and *Morano, Calabria* and see much more magic in them than is, so to speak, "on the surface." I think to myself (mostly unconsciously, to be sure), "These landscapes are by the artist who made *Day and Night* and *Up and Down* and so forth, and I know well that *that* artist had a profound sense for hidden magic, and I can see

glimmerings of that same sort of hidden magic lurking in these two prints, even though it's not in-your-face magic. And therefore these prints, by virtue of being imbued with a subtler version of the same magic as their later-born superfamous cousins, are even deeper and therefore even better than those are!"

Although I have phrased this in an exaggerated, naïve-seeming way, I actually think that such an opinion would be well-founded and utterly reasonable. For the truth of the matter is, we never perceive anything in a purely context-free manner. If you don't play chess, you surely don't see a chessboard in midgame the way a grandmaster does. If you know no Indian music, you cannot form a sophisticated judgment of pieces of Indian music that you hear out of the blue. If you cannot read English, your perception of this page of text is surely very different from that of the woman sitting next to you in the subway train, who (unlike you) is actually *reading* and *understanding* this very sentence, and perhaps snickering at the thought that to someone else, it might look like no more than black marks on a white background. And likewise, if you know no late Escher, your perception of *Pineta di Calvi* and *Morano, Calabria* and such works is inevitably going to be very different from that of someone who knows late Escher well (and who realizes that the different bodies of work are by one and the same person).

For me or for anyone else, perception of the magic that lurks in (or behind) M.C. Escher's early prints would be greatly facilitated and catalyzed by prior experiencing of the magic in his *later* prints. Indeed, perhaps that is the *only* route to seeing their magic.

Musings About the Inevitability of an Artistic Lifecourse

This linkage that I am proposing between "early Escherian magic" and "late Escherian magic" does force one to ask: Are they really *the same* magic? Would the latter necessarily have emerged from the former? Was Escher's artistic pathway inevitable and in effect predestined (barring railroad-crossing disasters and such things)? When we look at early Eschers and late Eschers and claim to see "the same spirit," is it like looking at photos of a teen-age boy and the old man he grew into, and recognizing the same impishness (or the same melancholy spirit) at both ages? Or could intervening events – chance events – have made some crucial difference? Could there really have been an "M.B. Escher," who never found the pathway to paradox – or, if he found it, then never found it tempting?

I wonder, for instance, about Escher's fateful – or *was* it fateful? – 1936 trip to the Alhambra in Granada, Spain. It's easy and tempting to surmise that had M.C. Escher not made that visit, he would never have become obsessed with the "regular division of the plane" and never have done the tessellations that became perhaps his most celebrated trademark. But the truth of the matter is somewhat more complex. In the first place, already at age 22 or 23, in the years 1920–21 when he studied at the School for Architecture and Decorative Arts in Haarlem,

MCE had experimented cautiously with periodic patterns in the plane, as well as with patterns of right-side-up and upside-down faces that together filled up the plane in a figure-and-ground manner. Indeed, Escher himself wrote, "Long before I discovered in the Alhambra that the Moors had an affinity for the regular division of the plane, I had already recognized it in myself." ([2], pp. 162–163, and [5, p. 103]) So there was already in young Escher a latent propensity for studying interwoven planar patterns.

Moreover, his 1936 visit to the Alhambra was not his first visit there, for he had visited it in the fall of 1922 as well. Both times he was impressed by the beauty and intricacy of the tiling patterns on the walls (and ceilings and floors!), but only after the second visit did he catch on fire with these ideas. And yet, most tellingly, Escher's own account of why his artistic passion changed course at roughly this stage in his life does not refer to his rediscovery of the bewitching tilings of the Alhambra, but rather, to the fact that in 1936 he and his wife and sons finally left Italy for Switzerland, then moved to Belgium, and eventually settled in Holland – environments he found rather bland, and about which he wrote, "I found the outward appearance of landscape and architecture less striking than those which are particularly to be seen in the southern part of Italy. Thus I felt compelled to withdraw from the more or less direct and true-to-life illustrating of my surroundings. No doubt this circumstance was in a high degree responsible for bringing my inner visions into being." [6, p. 7]

Escher himself also commented on why he had not pursued his early interest in tilings and tessellations: "In about 1924 I first printed a fabric with a wood block of a single animal motif that is repeated according to a particular system, always bearing in mind the principle that there may not be any 'empty spaces' I exhibited this piece of printed fabric together with my other work, *but it was not successful.*" [italics added]. (See [2, p. 55] and [5, p. 84].) Thus we see that somehow inside M.C. Escher, even from his earliest artistic explorations, there was a latent tendency to explore the ideas of the mature Escher, but a critical factor – and this is perhaps to be decried – was the nature of the public's reception: warm or cold?

In the end, then, it is not easy to tease apart nature from nurture, in the origins of Escher's search for visual magic. However, I personally am of the opinion that one *does* in fact see the seeds of the man in the child, or, as the saying goes, "The child is father to the man." And thus, although I myself concocted the hypothetical M.B. Escher who coincided with M.C. Escher till age 38 but then never explored the further pathways that M.C. Escher did, I intuitively recoil at this scenario, feeling it is in truth incoherent. The real Escher was profoundly predisposed to react to visual mystery and strangeness, and it was, in my opinion, *inevitable* that he would discover many paradoxical visions. For this reason, my fictitious M.B. Escher, although on the surface perhaps a plausible individual, seems to me to be, on deeper and longer reflection, a severe contradiction in terms.

To be sure, once M.C. Escher had become sufficiently well-known, then people came to him and presented him with ideas that he would otherwise never

have heard of, and in this sense his life's artistic pathway did not come *entirely* from within, and was not fully discernable in or predictable from his youthful efforts. Thus, for instance, in 1959 Escher received an article from the British scientists L.S. and Roger Penrose in which they wrote of "impossible objects" and showed drawings of impossible triangles and staircases and such, and from these sparks Escher swiftly created several prints based on them.

Similarly, in 1958, the geometer H.S.M. Coxeter sent Escher an article on symmetry reproducing some of Escher's tessellations, but also containing a section on hyperbolic tessellations. Escher described Coxeter's text as "hocus pocus," but the figures filled him with excitement. Indeed, he wrote to his son Arthur [2, p. 91], "I get the feeling I am moving farther and farther away from work that would be a 'success' with the 'public', but what can I do when this sort of problem fascinates me so much that I cannot leave it alone?" It seems, then, that even fear of failure with the public could be overcome when there was a sufficient amount of inner fire inside his brain – and much the luckier are we all for that!

The Verdict of the Miserable Generations to Come

I never met M.C. Escher personally; the closest I could say I came to doing so was when I met his son George at the Escher Congress in Rome in June, 1998, celebrating the 100th birthday of M.C. Escher. George gave a wonderful talk in which he displayed the fruits of his own passionate search for patterns. The patterns consisted, in this case, of eight cardboard cubes taped together in such a manner that, once all the tape was in place, the resultant constructions could be flexed along their taped edges so as to flip back and forth between two different configurations, each forming a perfect $2 \times 2 \times 2$ cube. There were thousands of possible taping-patterns, and George had systematically explored each and every one of them and had come up with about a dozen or so wildly different solutions, each of which had some wonderful way of turning itself inside out and yet winding up in the end as the same overall shape. The details of this quest, however, are not at all my point; all that I wish to point out is that George had devoted months and months to studying these bizarre objects, and out of his intense devotion to this obscure but elegant puzzle had come some marvelous and totally counterintuitive discoveries, which he demonstrated to us all.

At the end, clearly anticipating the question that we all had formulated in our minds, George remarked, "You may wonder what in the world this puzzle and its solutions have to do with Father. On the surface, nothing at all. But what we have in common is this very down-to-earth manner of grappling with a purely mathe-matical puzzle, turning it into a practical exercise, and exploring every nook and cranny of it in our completely nontheoretical, totally experimental way, trying one thing after another after another. In such a way, we acquire a deep intimacy with the domain, and can make many fascinating discoveries. Whether they have

any importance is of doubt, but we cannot help ourselves. I, just as my father was, am driven by a perhaps silly but absolutely insatiable curiosity. And that is how all this has to do with the artist whom we are here celebrating today."

M.C. Escher, as a young man of 24 suffering the sweet torment of watching too many inaccessible pretty girls prancing all about, no matter where he turned in the wildly romantic city of Siena (as I myself would suffer as well, 44 years later, at nearly the same age and in precisely the same place!), sought refuge from the constant tantalization of Eros in the only way he knew – by plunging himself into his art – and this is what he said, in a letter from Siena to his very close lifelong friend Jan van der Does de Willebois [2, p. 24]:

Many wonderful prints are springing from my mostly industrious hands –
but the question as to whether they contain any beauty, that I shall
leave to be answered by the miserable generations to come.

References

[1] Albright, Thomas (1979). "M.C. Escher: Idiosyncratic Visionary." *San Francisco Chronicle*, August 25, 1979, p. 39.
[2] Bool, F.H., Kist, J.R., Locher, J.L., and Wierda, F., eds., (1982). *M.C. Escher: His Life and Complete Graphic Work*, New York, Harry N. Abrams.
[3] Buresh, J. Scott and Douglas R. Hofstadter (2009). *Encyclopaedia Contrafactualis*, vol. CCXLIV, section 17, article 27b. New Washington: Unlimited Books, Ltd.
[4] Ernst, Bruno (1976). *The Magic Mirror of M.C. Escher*. New York: Random House.
[5] Escher, Maurits Cornelis (1989). *Escher on Escher*. New York: Harry N. Abrams.
[6] Escher, Maurits Cornelis (1960). *The Graphic Work of M.C. Escher*. New York: Meredith Press (reprinted 1996, New York, Wings Books).
[7] Frisch, Otto (1991). *What Little I Remember*. Cambridge: Cambridge University Press.
[8] Hofstadter, Douglas R. (1979). *Gödel, Escher, Bach: an Eternal Golden Braid*. New York: Basic Books.

[9] Kirschbaum-Vishniac, Chérie-Lou (1979). *Gödel, Picasso, Bach: a Preposterously Gauche Bagatelle*. New Tiranë: Baseless Books.

[10] Locher, J. L., editor (1971). *The World of M.C. Escher*. New York: Harry N. Abrams.

[11] Márquez, Gabriel García. *Cien Años de Soledad*. Buenos Aires: Editorial Sudamericana.

[12] Ottolenghi, Maria Grazia (1976). *Tout l'œuvre peint de Mondrian*. Paris: Flammarion.

[13] Smith, Roberta, "Just a Nonartist in the Art World, But Endlessly Seen and Cited," *New York Times*, January 21, 1998, E1, E3.

[14] Wilkie, Kenneth (1974). "The Weird World of Escher." *Holland Herald*, vol. 9, pp. 20–43.

M.C. Escher and C.v.S. Roosevelt

J. Taylor Hollist and Doris Schattschneider

Long before M.C. Escher's art became popular, Cornelius v.S. Roosevelt began collecting it. His collection of prints, obtained directly from Escher in the 1950s and 60s, grew to include articles and books about Escher, correspondence with and about Escher, and Escher ephemera, from authorized (and pirated) reproductions of Escher's prints to gaudy pop items.

Cornelius van Schaak Roosevelt (1915–1991), a grandson of American president Theodore Roosevelt and longtime resident of Washington, DC, was educated at Groton and Harvard, transferring to Massachusetts Institute of Technology where he studied mining engineering. Between 1938 and 1949 he worked for mining companies in Mexico and in Shanghai, with Naval service during WWII in the Special Devices Division of the Bureau of Aeronautics. For most of his professional career, he worked for the United States Central Intelligence Agency (1952–1973) [3]. His principal achievement in the agency was his chairing an interagency committee on technical surveillance countermeasures, which recommended ways of countering electronic eavesdropping.

Known to his friends as 'Corny', he was an avid collector of many items. His collection of Japanese carved ivory netsuke, for example, rivaled the best, and his bibliography of netsuke literature [11], was for years a standard reference for collectors. He was always up to adventurous challenges: archaeological digs in the Middle East; checking out an ancient engine in a Central American jungle for the Smithsonian, scuba diving (even into his later years), gliding, and ballooning in many corners of the globe. He delighted in repairing clocks, and in building, designing and playing with electrical gadgets in his workshop. A story written in

Cornelius van S. Roosevelt in 1978. Photo courtesy of Marguerite Rawdon-Smith

1982 about his workshop in his Georgetown apartment gives a glimpse of how meticulous and organized Roosevelt was. (These traits exemplified his handling of all his collections that would be passed on to appropriate homes at the end of his life – a rare treat for those in museum acquisitions.)

The spare bedroom in Cornelius Roosevelt's Georgetown condominium has no bed, bureau, or slippers. . . . "This is my shop," says Roosevelt, as he leads a guest through his elegantly furnished apartment into the room that is his impeccably organized home workshop. . . . What Roosevelt has created in the 12-by-16-foot room is a multipurpose workshop for small projects in woodworking, metalworking and repair work. . . . And since his avocation is voraciously space-consuming, he met the challenge by creating storage places for every last nut and bolt. . . .

Everything has its designated place. There are special drawers, explains Roosevelt, "for all things to make holes with and all things to drill with." There are cabinets with drawers for the very smallest screws and washers and special compartments for tubes of glue. . . . "I can fix almost anything," says Roosevelt, modestly. "It's lots of fun. My favorite work is either building things or repairing them . . . "

. . . he has been "interested in how things worked" since his child-hood in Oyster Bay, Long Island near his grandfather's Sagamore Hill estate. He remembers learning a great deal about working with his hands from the one-time submarine mechanic, who worked as a chauffeur for his maternal grandmother, and also from the superintendent of their Oyster Bay workshop, who had been General Roosevelt's orderly in Italy in World War I. . . .

In 1952 Roosevelt moved into a Washington apartment but contin-ued his larger carpentry work in Oyster Bay on weekends. . . . "When I first moved to Washington to a one-bedroom apartment, half of my desk served as my shop. When I got a two-bedroom, the guest bedroom doubled as a shop with a convertible sofa for guests. And in 1974, I had a one-bedroom and a two-bedroom apartment combined. Now I have enough space to use one of the three bedrooms as my shop." Since his current apartment has two kitchens, he is able to use one of them as storage space for larger tools. Roosevelt . . . eats virtually all of his meals in restau-rants . . . He has turned off one of his refrigerators, and the other has not a morsel of food; instead it is stocked with "batteries for my dive lights, film, paper for my copier, sodas and seven kinds of beer." [9]

The Roosevelt Collection

Beginning in the early 1950s, Roosevelt began collecting Escher's art. His goal became to own as wide a range of Escher's work that he could gather; this would

become the centerpiece of the Escher collection in The National Gallery of Art in Washington, DC. The National Gallery now owns the largest collection of Escher's art outside of Holland; over 200 original Escher prints were donated by Roosevelt. A few excerpts from the *Washington Print Club Newsletter* in 1974 [1], on the occasion of his donation of his collection to the National Gallery, reveal the story behind the collection.

Though he didn't know it, his [Roosevelt's] fate was sealed in 1954 when he drifted into the gallery of Whyte's Book Store where Escher's first Washington show was on display at a time when the artist was practically unknown in America. There he was sufficiently intrigued by what he saw to buy three items for $12 to $15 apiece. ... [Soon] the American and Dutchman corresponded regularly. The former wanted to learn more about the prints and to make new acquisitions. The latter needed help and advice with the increasing number of requests from Americans who wished to illustrate books, articles, pamphlets and what-not with reproductions of his graphics. Before long Roosevelt became a sort of volunteer Escher agent in his spare time, and handled all but the print-selling end of the artist's dealings with the English speaking world. ... He found himself in touch with more and more people who wanted to reproduce the graphics. Since he already owned many of the major ones, he had them photographed and supplied negatives to those who were deemed worthy with the stipulation that each work had to be identified by its correct title, by the name of the artist and by the collection from which it came. The only fee demanded by the artist and his agent was the price of the negative.

As far as I can tell, Roosevelt answered most of his correspondence personally, referring people to articles, books and other sources, and he made himself available to many enthusiasts who wanted to see and discuss his collection. He also undertook further missions for the artist. ... It was in Roosevelt's apartment that the graphics which appear in the flick [Adventures in Perception] were filmed. Somewhat later he commissioned a Japanese craftsman to carve several of the artist's designs on ivory balls.

... Roosevelt preserved the 300 letters from the Dutchman. In them Escher talks of business matters, discusses his daily life and life in general, goes into many aspects of his prints and his artistic concerns, expresses his low opinion of most contemporary artists, berates those who try to read meanings into his work which he had not intended, comments on world affairs and so on. ... [These letters are] supplemented by the voluminous correspondence Roosevelt carried on with other Escherites ... In addition Roosevelt saved all the printed material on Escher that he could lay his hands on by putting together 12 elegant scrapbooks which contain a heterogeneous assortment of carefully mounted material that documents the printmaker's growing fame.

And just for good measure there are also posters from Escher exhibits, authorized and unauthorized reproductions, some of excellent quality and some hideous, and diverse odds and ends …

By now it should be clear that we're dealing with an indefatigable collector whose happy obsession had taken on an expansive (and expensive!) life of its own. … In short, things were getting out of hand. After Escher died, Roosevelt realized that the time had come to find an institutional home for his gatherings. Several museums were eager to get the prints but unwilling to accept the rest of the material … When Roosevelt learned that the [National Gallery] was developing an important center for art scholarship, and the National Gallery discovered that he wished to turn over everything to just such a place, the result was inevitable.

The first author (Taylor Hollist) never met Roosevelt in person, but did talk to him on the telephone several times and corresponded with him. When Hollist asked Roosevelt for his picture standing next to some Escher prints, Roosevelt sent a copy of a 1974 edition of *Holland Herald*, a news magazine of the Netherlands, which contained Roosevelt's picture in an article titled "The Roosevelt Eschers." A special feature of the magazine was that it contained 27 of the artist's works along with 22 pages devoted to the work, life, and times of Escher (with family photographs).

The second author (Doris Schattschneider) first met Roosevelt in the early 1970s, while his voluminous collection was still housed in his Georgetown apartment. Everything that is noted in the above article about the meticulous documentation and organization of his collection is true – a researcher's dream. Not only were all of the loose materials carefully mounted in tooled leather scrapbooks, but a complete card index of all materials was itself housed in leather binders. Over a period of almost twenty years, there was frequent correspondence between Schattschneider and Roosevelt (with the added trepidation on her part knowing full well that every word she wrote would be preserved in one of those scrapbooks). And indeed, Roosevelt did answer all his correspondence personally and promptly, often hand-written on ancient postcards. On many occasions, Schattschneider did research with his collection in his apartment (although the donation to the NGA was announced in 1974, the transfer of materials occurred over a period of several years). Roosevelt was extremely generous with his time and materials and encouraging of her work. He also added to his collection of "diverse odds and ends" two hand-made original prototype models of her *M.C. Escher Kaleidocycles* [13]. She helped Roosevelt add to his collection of Escher correspondence by others by contacting them and inviting them to donate theirs. H.S.M. Coxeter was one of those who happily obliged.

Roosevelt was so intent on having a complete collection of publications about Escher that he employed a clipping service; the result is an amazingly diverse array of articles from all over the world. He also paid professionals to translate some of Escher's writings from Dutch to English, including Escher's

limited-edition 1957 book *Regelmatige Vlakverdeling* (Regular Division of the Plane). Thanks to Roosevelt, this important essay by Escher was available to researchers (including Schattschneider) ten years before it was published in [2]. After Escher's death in 1972, Roosevelt purchased 24 early prints done between 1917 and 1929, which Escher had given to Bastiaan Kist, a classmate in art school. Correspondence between Roosevelt and Bastiaan's brother, Jan R. Kist, led to the acquisition of these early prints. Also through Jan R. Kist, the original models on which Escher based his woodcut *Knots* were given to the National Gallery of Art. From a historical point of view, the written materials are the most valuable part of the Roosevelt Collection in the National Gallery. Most of the examples cited in this paper are from this collection. The Gallery continues to add relevant materials as they become available; this book will no doubt become part of the collection.

Roosevelt and Escher

In the collection of correspondence there is mention of two occasions when Roosevelt and Escher met in person: in 1960 when Escher lectured at the Massachusetts Institute of Technology in Boston, and in 1968 when Roosevelt went to Holland for an Escher retrospective exhibition in The Hague. Escher's invitation to Roosevelt in a letter dated May 8, 1968 is typically straightforward: "Can we settle your coming at Baarn on Sunday 9, in the late afternoon, to share our (simple) dinner? We eat at about 7 o'clock. If you come at 5 or 5.30, we have time to look after some work which is not exhibited, before as well after dinner. Please write me if you agree. If Saturday suits you better, that is quite all right for us."

A letter of March 7, 1964, illustrates an example of the advisory role that Roosevelt played. He writes to Escher, "You will shortly receive a letter from the Pratt Graphic Art Center in New York asking for your permission to reproduce eight or ten of your pieces for publication. I strongly recommend that you give permission in this case. The Pratt Graphic Art Center is a non-profit educational institution which is very well thought of in graphic art circles in this country." And in a letter of April 21, 1969: "Have you ever considered allowing a textile manufacturer to use some of your space-filling patterns as textile designs? Several of your patterns reproduced in Professor MacGillavry's book make excellent textiles." A letter from Escher to Roosevelt dated 6 May 1966, demonstrates Escher's trust in his American friend, "I stopped selling prints to individual customers and give them Schuster and Michelson's addresses but you are the exception of course." Schuster and Michelson were art gallery owners. The Michelson Gallery of Fine Arts in Washington, DC still sells Escher originals.

Escher often wrote to Roosevelt of his ideas for prints – they shared a common bond of curiosity as to how things got put together. In a letter to

Roosevelt (Nov. 30, 1961), Escher sketched a tribar, an impossible object that had given him the idea for his lithograph *Waterfall* (page 65). Escher explained, "Waterfall, which is brand new, is based on an idea of the two Penroses. It's another of their exciting 'impossible objects,' which I copy here underneath for you. Published in the 'British Journal of Psychology' February 1958. Title of the article: 'Impossible objects: a special type of visual illusion' by L.S. Penrose and R. Penrose. They mention my name also in this article."

Roger Penrose was one of many mathematicians and scientists who would call on Escher. In March 1962, Escher wrote to Roosevelt, "Young Dr. Roger Penrose, son of the London professor paid me a very nice visit with his wife. We had so many things to discuss and so much to tell each other that they lost their plane back to England. I am often struck by the simplicity and childish playfulness of most of these learned scientists and that is why I like them and feel more at my ease with them than my own colleagues."

The correspondence continued into Escher's last years. In a postcard sent to Roosevelt in 1970 (when Escher was very ill), he writes about his new life in a special home for retired artists. The return address is Rosa Spier Huis in Laren, Holland. The card reads, "Dear Mr. Roosevelt, Many thanks for your kind letter of Nov. 12. I should have answered since long, but you have no idea how life is busy here. As soon as I have time, I am at work with re-printing old blocks, never enough to satisfy the demand for prints in the U.S., especially in California last year. But also Michelson bought some 25 copies. I hope that this card reaches you really via Airmail, but I am not quite sure. I am quite very glad and satisfied with my life here: much better than in Baarn! Yours sincerely M.C. Escher".

When Escher wrote about "re-printing old blocks," he meant reproducing by hand his work with a woodblock printing process. When a print is made from a woodblock carved exposing the side-grain, it is called a "woodcut," and when the print is made from a woodblock carved exposing the end-grain (for finer detailed work) it is called a "wood engraving." To make a print, Escher would spread ink over his carved woodblock with a roller, then place a sheet of paper over the woodblock and laboriously rub the paper with a bone spoon, gently pulling back the paper from time to time to see how the picture was progressing.

Some of Escher's letters explain how he would employ symmetry to produce a print and how he would use the same block to produce different colors of figures in the print. His description to Roosevelt in a letter dated February 2, 1962, complete with marginal drawing (Fig. 1) reveals how he printed *Smaller and Smaller* (Fig. 2). (Escher used red and black letters in his note; we use a prime ' to denote red.)

A complete copy of 'Smaller and Smaller', like the one you have, is composed of

(a) *One central part, printed in black and red from two blocks (A and A')*
of which the "black" one is an end-grain Boxwood block of the best available quality, needed because of the extremely minute details.

Fig. 1. Escher's sketch of his method of printing *Smaller and Smaller*. From the Cornelius Roosevelt Collection at the National Gallery of Art Library

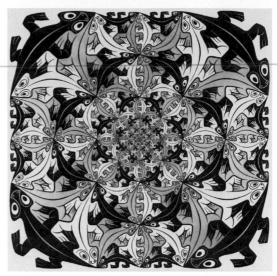

Fig. 2. M.C. Escher, *Smaller and Smaller*, 1962. Woodcut

(b) *Four identical border parts (B and B'), surrounding the center. They are cut in simple side-grain Pearwood blocks.*

Note in Fig. 1 that block A is used once to print the black lizards in the center and block A' once to print the red lizards in the center. Block B is used four times to print the black lizards around the outside, and block B' four times to print the red ones. This scheme gives the outer ring rotational symmetry. Other letters, from Escher to mathematician H.S.M. Coxeter, describe the printing scheme of the woodcuts *Square Limit* (page 232) and *Circle Limit III* (color plate 4).

Escher's work gained popularity in the United States primarily through national press coverage beginning with articles in *Time* magazine in April 1951 [10] and *Life* magazine in May 1951 [14]. Ten years later, *The Saturday Evening Post* [7] had an article, and the cover of *Scientific American* [5] signaled mention of his work in Martin Gardner's column. In 1966, Escher was featured in *This Week*, a magazine with a circulation of 14 million that was distributed with many Sunday newspapers throughout the United States, and Martin Gardner's April "Mathematical Games" column in *Scientific American* was devoted to Escher's work [6]. These articles launched an avalanche of mail to the artist, inquiring about his prints. Escher's letter on May 6, 1966 to Roosevelt laments, "After Mr. Gardner's article, my customers, especially in America, give me no peace."

The Escher drawing that made the April 1961 cover of *Scientific American* bears more comment. Escher's original 1938 drawing [12, p. 130] consists of interlocking blue birds and white birds flying in opposite directions – these same birds are the centerpiece of his print *Day and Night* (page 26). Evidently the

editor at *Scientific American* didn't find the original to be colorful enough, and engaged Mary Russel to freely color the dark birds with several different colors. (The 'colorized' Escher cover can be seen in [12, p. 289].) Escher would never have colored the birds in such a manner. Like a map maker, he preferred the rule of using the fewest number of colors so two adjacent figures did not share the same color [12, p. 55]. Nevertheless, he wrote a gracious letter (dated April 7, 1961) to the editor, Dennis Flanagan, which pointed out a real error. "The different coloured birds on the cover are a very nice and acceptable fantasy. I think that only one mistake was made: in the cover-description on page 4 it is said that the spaces between the coloured birds are filled with white birds of the identical shape. That isn't true, for two reasons. First: as they fly in the opposite direction, a superficial spectator could conclude that they are mirror-reflections of the coloured birds. In that case they would be "similar" but not "identical." Secondly they are not even similar; they are "different"!: e.g. the coloured bird-tails go "up", the white ones "down." Please excuse this hair-splitting; I'm mighty proud of these two reproductions of my work … Would you please transmit my compliments to Mr. Gardner … "

The 1961 column in *Scientific American* by Martin Gardner was about a new geometry text by H.S.M. Coxeter, which (unusual at that time) contained two of Escher's symmetry drawings. Before its publication, Gardner contacted Escher regarding reproduction of Escher's drawing of horsemen (page 12) for his column, and an Escher work for the cover of the magazine. Here's a glimpse of two of Escher's letters.

Escher to Gardner (Jan. 17, 1961), "Let me first tell you that I know your name quite well, not as columnist of 'Scientific American', but as the writer of 'The Annotated Alice'. Prof. Coxeter draw my attention on this book when I was his guest last November and I bought immediately a copy myself, which enjoys me immensely. I am since long an Alice fan, but since I read your annotations, many incomprehensible details became clear! Certainly I should be glad if my round colour-woodcut (which Coxeter calls 'The Miraculous Draught of Fishes' and which I entitle 'Circle Limit III') could be reproduced on the magazine's cover. I think this print would satisfy very well in this special case. Wouldn't it be possible to buy, or to let the magazine buy one of my original copies? Unfortunately it is one of my most expensive woodcuts: a copy costs $70 (extremely difficult and time devouring to reprint). I am ready to send you a copy and I'm sure, that the best result would come from photographing and reproducing directly the original."

Escher to Gardner (Jan. 30, 1961), "Thank you very much indeed for your letter of January 23 … Now let's hope that my 'Circle limit III' (which I am sending you today as registered printed matter, by airmail, packed in a solid cardboard-container) will be no disappointment to Mrs. Gardner and to yourself! You might be curious about the way in which it was designed and printed, so I enclose herewith a copy of my letter to Prof. Coxeter, together with his answer of May 1960. His theoretical explanations are, no doubt, more comprehensible to you than to me. I am and shall ever be a perfect layman in the mathematical field.

It is true that I never could have made this picture if I hadn't <u>seen</u> a schematic figure in one of Coxeter's publications, but as soon as he starts to argue abstractly, with formulas, I'm completely lost. I think he won't believe it but it's a fact."

Gardner's later column in April 1966 [6] reproduced many of Escher's prints, and here Roosevelt played an important role.

Escher to Gardner (Jan. 30, 1966), "It's a most fortunate circumstance that Mr. Cornelius Roosevelt owns a large collection of my prints and that he is ready to lend you the pieces which you need, and that you are willing to take the trouble of a trip to Washington for making a choice; please take all the photographs you need. Mr. Roosevelt since many years has been very kind and helpful towards me. I have met him once in 1960 at MIT, Cambridge Mass., in occasion of a little exhibition of my work and a lecture for prof. Arthur von Hippel's students. He came expressly over from Washington to show the audience his copy of my 'Metamorphose'-strip."

Roosevelt to Escher (February 6, 1966), "Some time ago I had a phone call from Mr. Martin Gardner of the Scientific American magazine, and he told me that he wanted to do an article on some of the technical aspects of your work. Although I had corresponded with Mr. Gardner for several years, I had never met him. In this last instance when he asked if he could use some of my collection of your work in the article, I told him I would be delighted to cooperate but only after you had given him your permission to write the article. A short time ago, Mr. Gardner called and said that you had agreed to his idea. Yesterday he came down to Washington and we spent a most enjoyable day going over all of the 80-odd of your works that I have here. He was most punctilious and showed me your letter before we began! He was accompanied by a photographer which made the whole operation very simple and eliminated the necessity of taking framed prints out of the frame and mailing them up to the magazine. The works he selected for photography were: Knots, Order and Chaos, Encounter, Heaven and Hell, Belvedere, Tetrah. Planet., Waterfall, Double Planetoid, Strip of Mobius, Day and Night, Verbum, Mosaic II, Ascent and Descent, Three Spheres, Mobius Strip, Force of Gravity, Relativity, Reptiles, Predestination, Cube & Ribbons, Hand & Globe, Magic Mirror, Three Spheres II. It is, of course, impossible to tell at present whether he will use three, ten or twenty of these. His editor will have the final say, but I thought you would be interested in the selection he made. I was rather surprised when he wasn't interested in several which I thought would have fitted in with his article, such as 1956 Smaller and Smaller, 1947 High and Low, 1955 Convex and Concave, and particularly 1956 Print Gallery. He said that he was interested only in those about which he had something to say."

Escher to Gardner (April 20, 1966): "I think your article is excellent indeed. It describes my prints very clearly, with details not only interesting for mathematical oriented print-lovers, but also for myself. Though I am particularly glad that you reproduced my last print 'Knots', it is a pity that it is stretched out vertically, so that the two little knots are unreasonably far from the big one. I understand the reason, but better should have been to given 'Three Spheres' a bit less space and to reproduce 'Knots' in its original proportions."

These articles loosed a tide of interest in Escher's work that continued to grow long after Escher's death. Although the Escher Foundation had been formed to handle matters of permissions and licensing, Roosevelt continued to be pelted with requests. Finally Roosevelt removed himself entirely from playing any role of "agent" but did respond to some requests for photos, once permission had been obtained from the Foundation. In a letter to Gardner (Dec. 5, 1980), Roosevelt reported: "During the last few years the questions surrounding Escher copyrights have become so involved that I have completely withdrawn from the picture. Escher's son, George, wrote me several years ago and asked that I continue to make photographs available to publishers."

A Lasting Legacy

What began as a personal interest and grew into an obsession by Cornelius Roosevelt has left the public a lasting legacy that is accessible to all who wish to use the services of the National Gallery of Art. During Escher's lifetime, Roosevelt contributed generous and timely service to the artist (who never wanted to be a businessman), gathered an invaluable archival collection of Escher prints and memorabilia, and preserved numerous published and unpublished written records about Escher. There probably is no other single location where there exist so many original letters to, from, and about Escher. This collection offers explanations of Escher's methods of printing and reveals the sources of some of his ideas. It shows the human side of Escher and those who interacted with him. For Escher admirers, researchers, collectors, students, and current artistic illusionists, it is fortunate that an American engineer working for the CIA took an interest in this Dutch graphic artist by collecting his art, correspondence, and items that most museums would not collect, and then donated it all to the National Gallery of Art.

References

[1] Ruth B. Benedict, "Hooked on Escher," *Washington Print Club Newsletter*, May–June 1974, pp. 12–15
[2] F.H. Bool, B. Ernst, J.R. Kist, J.L. Locher, F. Wierda, *M. C. Escher, His Life and Complete Graphic Work*. New York, Harry N. Abrams, 1982
[3] "Cornelius 'Corny' Roosevelt," *The Daily Telegraph*, Obituaries. London, England, Aug. 16, 1991
[4] Bruno Ernst, *The Magic Mirror of M.C. Escher*. Random House, 1976. Taschen America, 1994
[5] Martin Gardner, "Concerning the diversions in a new book on geometry," *Scientific American*, 204 (1961), pp. 164–175

[6] Martin Gardner, "The eerie mathematical art of Maurits C. Escher," Mathematical Games, *Scientific American*, 214 (1966) 110–121

[7] E.H. Gombrich, "How to Read a Painting," *The Saturday Evening Post*, July 29, 1961, pp. 20–21, 64

[8] J. Taylor Hollist, "Escher Correspondence in the Roosevelt Collection," *Leonardo*, 24, no. 3 (1991) 329–331

[9] Jura Koncius, "Nuts and Bolts in a Georgetown Condo," *The Washington Post*, Sept. 16, 1982, Washington Home; Decorating, p. 12

[10] "Prying Dutchman," *Time*, April 2, 1951, p. 50

[11] C.v.S. Roosevelt, *Netsuke: A bibliography*. Washington DC, published by the author, 1978

[12] Doris Schattschneider, *Visions of Symmetry: Notebooks, Periodic Drawings, and Related Work of M. C. Escher*. New York, W.H. Freeman & Company, 1990

[13] Doris Schattschneider, Wallace Walker, *M.C. Escher Kaleidocycles*. New York, Ballantine Books 1977, Ronhert Park, CA, Pomegranate Artbooks, and Cologne, Taschen Verlag, 1987

[14] "Speaking of Pictures," *Life*, May 7, 1951, pp. 8–10

Escher's Sense of Wonder

Anne Hughes

To me the moon is a symbol of apathy, the lack of wonderment which is the lot of most people. Who feels a sense of wonder any more when they see her hanging in the heavens? For most people, she is just a flat disk now and then with a bite out of her, nothing more than a substitute for a street lamp. [2]

Escher's lament above is mirrored by the exultation of the Zen poet P'ang-Yun: "How wonderously supernatural, and how miraculous! I draw water and I carry firewood." [9] Escher's art and the words of Zen masters bring us into direct contact with the constantly changing process of life which perpetually manifests itself. Zen is sometimes described as moving with life without trying to interpret it, to have an immediate awareness of things as they are.

Alain Bosquet, the French writer and literary critic once wrote, "The poem offers the reader a secular prayer, through which he can imagine new rapports between man and the universe, man and the void, man and himself." [5] Like

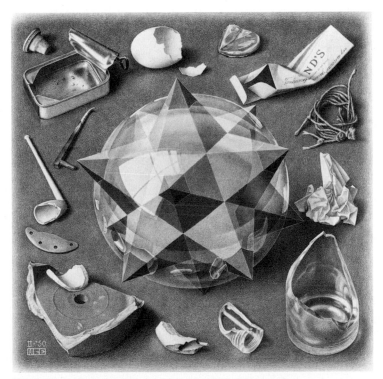

Fig. 1. M.C. Escher. *Order and Chaos*, 1950. Lithograph

poetry, art can offer the viewer a prism through which to imagine these rapports. In this article, we will examine three of Escher's prints from this Zen point of view.

Man and the Universe in Order and Chaos

In Escher's print *Order and Chaos* (Fig. 1) our attention goes at once to the stunning geometric solid in the center. Only later on do we notice that it is surrounded by so-called useless, discarded objects – a remnant of string, a piece of crumpled paper, a broken glass, a metal tip from a shoe, an empty sardine can. If we saw any of these items lying on the street, most of us would probably not give them a second glance. Yet Escher has placed them around his beautifully symmetrical centerpiece. What are they doing there? Let us take a closer look, beginning with the eggshell at the top.

Because it is broken, a typical response is that the eggshell is useless and therefore ugly. But if we look again, without any prior judgment and just look at the object as it is, we begin to notice that the edge of the shell has an unusual pattern going around it and the outside has a certain radiance. The curve of the edge is one that is unique to that eggshell; no other broken shell will ever have that particular shape. Indeed, it proudly asserts its own worth, independent of the egg it once carried and guarded. And it is not the least bit intimidated by the towering solid in the center.

The crumpled paper is on the right – how many times have we thrown away sheets of paper in a similar way? If we examine this sheet, it reveals an intricate pattern of shapes and forms. To some, it suggests a sharp mountain surrounded by pounding waves; to others, it is an elegant piece of garment consisting of folds and creases, to be greatly admired were it made of stone or marble and displayed in a museum.

Directly below is the bottom of a broken glass. The edge has a graceful movement that can be admired from many different angles. One of them is reflected in the center solid. Finally, we notice the bottle cap at the top – battered and crushed, a victim of the many trucks and cars that have driven over it. Yet it retains an unsinkable degree of integrity that refuses to be defeated or to be in awe of the majestic centerpiece.

So it is that each object reveals its own fascinating story, if instead of staring briefly, we really see. A story about the Buddhist priest, Pao-chi, who lived in the T'ang dynasty may provide further insight. One day Pao-chi was standing near a butcher's stall. A customer came to the butcher's stall and said, "Sell me some good meat." The butcher replied, "We don't have any bad meat here." [8] This exchange brought Pao-chi to a sudden realization of the value of all things.

Shundo Aoyama, chief priest of the temple Muryo-ji, interprets the tale in the following way. "When we go into the butcher's shop, we see the various cuts of meat laid out for sale, and the steaks are more expensive than the pot roast or

ribs because we find these cuts to be better tasting. The reason for the latter can be traced to the taste buds on the tip of the tongue. However, if we leave aside our taste buds for a moment and think about the cuts of meat as they formerly were, that is, as parts of bodies of cattle or sheep, there are no gradations of worth. Each cut, no matter from where on the animal's body it comes, once had its own unique function. If we free ourselves from the habit of looking at everything from a human-centered standpoint, a completely different prospect comes into view." [8] Perhaps that is also how we can view the juxtaposition of ordinary garbage and the pristine crystal in Escher's *Order and Chaos*.

Man and the Void in Waterfall

In Escher's print *Waterfall* (Fig. 2) water falls from a tower on the left and then turns a miller's wheel directly below. With a hasty glance, the water seems to flow downward and away from us. However, if we follow the water as it traces out its path, we end up in the exact spot from where the water began – an impossible situation. Then what seems real in this picture? Is it the woman who is hanging up clothes just washed or the man leaning against the wall, gazing up at the sky? We cannot help but wonder how can both the man and woman be so

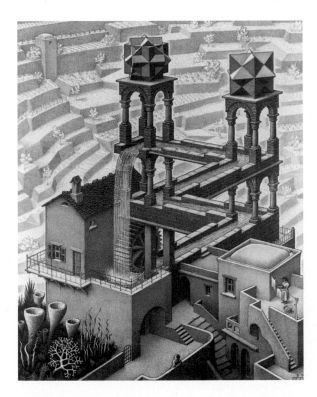

Fig. 2. M.C. Escher. *Waterfall*, 1961. Lithograph

indifferent to the impossible waterfall right in front of their eyes. When they first perceived it, they must have felt somewhat uneasy or even anxious about what they observed and therefore, not at all sure how to respond. The quick way out of this disconcerting uncertainty is to give it a name. "This is a waterfall."

As so often happens, when we give a name or definition to an object, that categorizes it; our attention to it greatly diminishes or even disappears completely. As a result, we lose the opportunity to experience what is going on right in front of us. In this case, we throw away the invitation to let ourselves be in the waterfall, disappearing in the water, letting the waterfall be in us. And in the words of John Cage, an American composer, we have lost the chance "simply to wake up to the very life we're living, which is so excellent once one gets one's mind and one's desires out of the way and lets it act of its own accord." [4]

Man and Himself in Dream

In Escher's print *Dream* (Fig. 3) we see a sarcophagus, its heavy lid mounted by the resting figure of a stone bishop; on top of the bishop is a live mantis. Is the bishop dreaming that he is the *praying* mantis or is the preying mantis dreaming that it is the bishop? Escher's fantasy may appear strange to many, but if we turn back in time to antiquity, we will meet an even more famous dreamer, Chuang Tzu, the philosopher (396–286? B.C. E.).

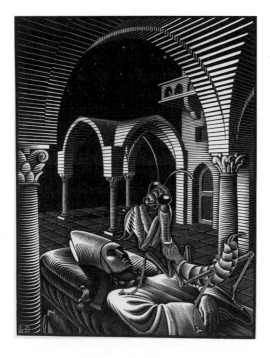

Fig. 3. M.C. Escher. *Dream (Mantis Religiosa)*, 1935. Wood engraving

In his own words, here is his dream. "Once upon a time, I, Chuang Tzu, dreamt that I was a butterfly, flitting around and enjoying myself. I had no idea I was Chuang Tzu. Then suddenly I woke up and was Chuang Tzu again. But I could not tell, had I been Chuang Tzu dreaming I was a butterfly or a butterfly dreaming I was now Chuang Tzu?" [10]

Does the butterfly wonder about its own existence as Chuang Tzu does? For Chuang Tzu's questions about his own existence give him the power to go beyond his ordinary life and "make himself as vast and free as the sky." [7]

Mumon Ekai Zenji (1183–1260) describes in verse what can subsequently happen to all of us:

> *In spring, hundreds of flowers;*
> *In autumn, a clear full moon;*
> *In summer, a cool breeze;*
> *In winter, snowflakes:*
> *With no hang-ups in your mind,*
> *Every season is a good season.* [7]

The geneticist and mathematician J.B.S. Haldane has written, "The world will not perish for want of wonders, but for want of wonder." [1] In our overloaded informational world, Zen helps us recover our sense of wonder by being aware of this moment, now. Escher's works remind us that everything – a dewdrop on a leaf, a puddle left by the rain in the tracks of a tire, a pitch-dark pond seen in the reflection of the moon, or birds appearing from nowhere and then just as quickly disappearing – should fill us with wonder. Escher's sense of wonder at these "ordinary" miracles is conveyed in his work – and we need only become receptive to the world around us to experience something of what he must have felt.

As Escher has perceptively written, "Undoubtedly a good deal of childish wonder is necessary. And this I do possess in fair quantity; wonderment is the salt of the earth." [2]

Acknowledgement

I wish to express my deep gratitude to Saman Lea Liu for her encouragement and discussions in preparation of this manuscript.

References

[1] Clark, Ronald, JBS, *The Life and Work of J.B.S. Haldane*, Coward-McCann, New York, 1969, p. 231.
[2] Ernst, Bruno, *The Magic Mirror of M.C. Escher*, Random House, New York, 1976, p. 17.

[3] Escher, G.A., "Escher at Work," *M.C. Escher: Art and Science*, North Holland, 1986, pp. 26–33.

[4] Page, Tim, "John Cage: The Embodiment of the Avant-Garde," *New York Newsday*, August 13, 1992, pp. 57–59.

[5] Saxon, Wolfgang, "Alain Bosquet, French Writer and Critic," *The New York Times*, Wednesday, April 8, 1998, Section B, p. 11.

[6] Schattschneider, Doris, *Visions of Symmetry: Notebooks, Periodic Drawings, and Related Work of M.C. Escher*, W.H. Freeman and Company, New York, 1990.

[7] Shimano, Eido Roshi, *Golden Wind, Zen Talks*, The Zen Studies Society, New York, 1979, p. 151. March/April, 1998, pp. 57–60.

[8] Shundo, Aoyama, *Judging the Good and the Bad, Dharma World*, Japan, March/April, 1998, pp. 57–60.

[9] Watts, Alan, *The Way of Zen*, Random House, New York, 1989, p. 133.

[10] Wu, Kuang-ming, *The Butterfly As Companion*, State University of New York Press, Albany, 1990, p. 38.

In Search of M.C. Escher's Metaphysical Unconscious

Claude Lamontagne

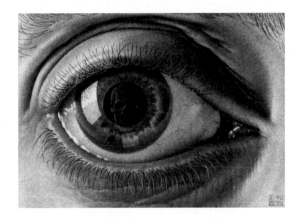

M.C. Escher, *Eye*, 1946.
Mezzotint

*Into that from which things take their rise they pass
away once more, as is ordained, for they make repara-
tion and satisfaction to one another for their injustice
according to the ordering of time.*
– Anaximander

Over the last few years I have grown more and more deeply convinced that
currently held views on nature, whether they emanate from philosophy or from
science, are essentially variations on the themes addressed in the above quoted
excerpt from what is now known as "Anaximander's Fragment," one of the
earliest traces of Western philosophical thought. As Bertrand Russell points out,
commenting on his translation of Anaximander's Fragment, "injustice" seems to
have meant, to Anaximander's contemporaries, something quite different from
what it means today: It meant something like *departure from the necessary
order of things* [5, p. 27]. But this *necessary order of things* includes the equally
necessary *passage of time*, whereby "justice" is granted, whereby *what-must-be*
progressively becomes *what-is*. So "things" *pass*, in cycles of death ("they
pass away ... ") and rebirth (" ... once more"), forms succeeding to forms,
mere stepping stones along pathways leading, beyond the "injustice" of current
limits, ever closer to this absolute truth, this absolute "justice" which
Anaximander named the "απειρον": the "limit-less."

The ways of perception as portrayed by current science fit this picture perfectly. This seems most clearly so in the case of the evolutionary and the functional *temporalities* of the perceptual dynamics proposed by present-day neuroscience and cognitive sciences, which are seen as presiding over multistage reality-constructing computational processes. Within these processes, objects *pass*, lasting but the moment required for computation to turn them into higher-order "truer" ones, which themselves last but the moment required for computation to turn them into yet higher-order, yet "truer" ones, and so on and so forth until a "computational ceiling" is reached! Thus, in a typical mammalian visual system, "points" of light of various intensities and colors first lead to "rectilinear stretches" of contrasting light intensities and colors. These in turn lead to "curvilinear stretches" of contrasting light intensities and colors, and then to "surfaces" of various shapes, and positions, and orientations, and then to "volumes" of various shapes, and positions, and orientations . . . and motions . . . and textures, and so on and so forth.

In this never-ending quest for truth, with every step forward, new meanings emerge, reaching beyond the limiting scope of the previous step. But until "the limitless" is reached, if every single step forward presides over the birth of *actual* meaning, it also, through the very limits inherent to the proposed new order, presides over the death of *potential* meaning, revealing the face of Injustice. Thus, wisdom lies in perpetually putting current order to the trial, maintaining as acute an awareness as possible of both its benefits, as actual order, and its shortcomings, as potential chaos, reaffirming this seemingly inescapable duality of the knowing mind so beautifully made explicit in Karl Popper's Two Theses [4, p. 7]:

> *First thesis: We know a great deal. And we know not only many details of doubtful intellectual interest but also things which are of considerable practical significance and, what is even more important, which provide us with deep theoretical insight, and with a surprising understanding of the world.*
>
> *Second thesis: Our ignorance is sobering and boundless. Indeed it is precisely the staggering progress of the natural sciences (to which my first thesis alludes) which constantly opens our eyes anew to our ignorance, even in the field of the natural sciences themselves. This gives a new twist to the Socratic idea of ignorance. With each step forward, with each problem we solve, we not only discover new and unsolved problems, but we also discover that where we believed that we were standing on firm and safe ground, all things are, in truth, insecure and in a state of flux.*

It is my thesis that M.C. Escher's graphic work testifies to an unconscious and almost exclusive fascination for this fundamental paradox.

Although this thesis will be developed in reference to M.C. Escher's *graphic work*, and although there need not be congruence between meanings

unconsciously woven into works of art and meanings verbally acknowledged by their creators, a short comment concerning Escher's opinions on his works seems warranted here. This comment concerns Escher's frequent insistence, in his writings, on an apparent belief on his part that "you see only what you see," that there is no meaning to his prints beyond the "surface" visual experience which they provoke. That this view was not consistently endorsed throughout all the traces which he has left behind is beautifully argued by Vermeulen in his subjective portrait of M.C. Escher ("I'm Walking Around All by Myself Here") [6]. Moreover, this portrait presents an artist whose psychological dynamics parallel to a stunning degree our knowledge/ignorance or order/chaos paradox-thesis. "Chaos is the beginning, simplicity is the end," quotes Vermeulen from M.C. Escher's 1950 letter to Oey Tjeng Sit, commenting:

> This is how he was. His entire life was marked by resistance to disorder. He feared and loathed it, but his fear and loathing were at the same time part of a love-hate relationship. Witness the following notation he made in his pocket calendar on December 4, 1958: "We adore chaos because we love to produce order." They are two components of one reality, a reality that Escher above all wanted to see as a miracle of harmony. "I try in my prints to testify that we live in a beautiful and orderly world, and not in a formless chaos, as it sometimes seems," he says in 1965. However, in January, 1967, he writes ... "The world in which we live is a hopeless case. I myself prefer to abide in abstractions that have nothing to do with reality."
> [6, p. 142]

Vermeulen sums up Escher's creative dynamics as essentially marked by an inescapable cyclic succession of "fear of chaos, a ceaseless searching for ordering principles, catching these in an image that can be fixed on paper, discontent with the result obtained, uncertainty, distrust of appreciation by others, again an escape from reality, chaos." [6, p. 147]. How much closer to our model of the dynamics of the knowing mind can we get? Especially when we set the "ceaseless-searching-for-ordering-principles" stage of Escher's cyclic creative dynamics against the background of his self acknowledged longing to reach Anaximander's "$\alpha\pi\epsilon\iota\rho\text{o}\nu$", to "approach infinity as purely and as closely as possible" [2, p. 124]. Let us now then turn to Escher's graphic work itself, and see how our thesis can be argued to apply.

Hallways, Stairways, and Archways

Hallways, Stairways, and Archways ... everywhere and always ... , inexorably summoning the eye of the spectator from just beyond its current point of focus, from just beyond the cozy safety of some local perceptual order, luring it with the

promise of a superior perceptual order awaiting his gaze "just round the corner." But what invariably actually awaits the spectator's gaze is the exact opposite: What emerges is but the reaffirmation of what was being left behind, often with a spectacular contradictory twist to it, breaking the spectator's eye's leap forward in mid-air and leaving him both perceptually bewildered and conceptually irresistibly seduced by the metaphysical insight thus offered, ready to be subjected to the experience again. In any given Escher print, this can be experienced once, twice, or many times in a cyclical or recursive manner, along a single perceptual processing path or through some succession of a variety of them. Escher's ingenuity at "perceptual engineering" is staggering: Just about every conceivable "branching node" in the perceptual flow of computation leading from retinal localities to perceptual and conceptual globalities is put to contribution, in *lineages* of prints which themselves branch out and cross one another in ever-surprising ways, and I attempt to characterize here with a selection of several prints.

First, some prints characteristic of the early Italian landscapes and architecture lineage, as a natural matrix out of which emerge the central trio of lineages, namely the Hallways lineage, the Stairways lineage and the Archways lineage. I chose *Street in Scanno*, *Castrovalva* and *Atrani*. *Street in Scanno* (Fig. 1) clearly prefigures all three central lineages with *stairways* as central attraction, leveling to the point of evoking a tiled paving *hallway* in the

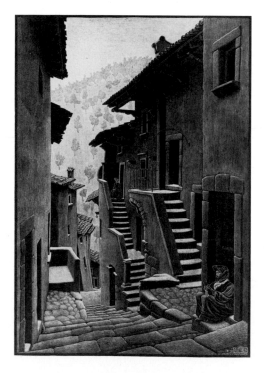

Fig. 1. M.C. Escher, *Street in Scanno, Abruzzi*, 1930. Lithograph

Fig. 2. M.C. Escher, *Castrovalva*, 1930. Lithograph

Street itself and everywhere leading to dark "porchways," direct ancestors of the eventual *archways*. (For a striking photo contrasted with Escher's print, see [3, pp. 46–47].) *Castrovalva* (Fig. 2) reaffirms the central themes of stairways and hallways, but this time somewhat more metaphorically through their landscape respective equivalent: rocky mountain paths (center left of the print) and crop-land geometry (center right of the print). The prefigurative quality of this latter aspect of *Castrovalva* can hardly be better portrayed than by *Day and Night* (see page 26), one of my pure Hallway lineage selections. As for *Atrani* (see page 93), besides its obvious stairways and archway (lower left), its literal use in the *Metamorphosis* prints (amongst my pure Hallway lineage selections) led me to include it in the selection. These selections lead us into the heart of the Hallway lineage, typified by *Metamorphosis II* (see page 147).

Hallways

What characterizes this lineage of prints is Escher's fascination for *The Regular Division of the Plane*, which, through its exclusive concern for the "plane," is wholly concerned with exploring "Two-D-Land," or "Flat-Land," or "Floor-Land," or "Hallways-Land."[1] As proposed above, this exploration

[1] Plane: A flat or level surface, from the Latin "planus" (level), akin to "floor" (Middle English "flor," Old High German "fluor" (meadow), Latin "planus" (level),

essentially aims at cornering the mind's eye of the spectator in its attempts to overcome the "locality" of the current visual experience.

The main "perceptual engineering" technique systematically used in this particular lineage of prints taps into one of the most primitive and basic visual processes: that of contour formation and ensuing figure/ground differentiation. The typical contour-boundaries of the "objects" with which Escher fills his planes are designed in such a way as to deny the observer the possibility of achieving figure/ground closure. This is done by finding ways to design the objects so that what can, for a moment, be assumed to be the *ground* (or background) against which they stand, can also be interpreted, as the mind's eye shifts to a wider field of view, as new instances of the very *figures* whose *ground* they were supposed to be, appropriating the contour-boundaries for re-creating similar objects whose *ground* then becomes what once was the initial *figures*. These initial figures, in turn and following the same logic, resuscitate (at the expense of the newly-formed *figures*) as soon as the visual processing attempts extending its "grounding" hypothesis beyond the immediate contour-boundaries of the new *figures*. This cycle can repeat itself for as long as the spectator enjoys the experience.

This particular perceptual engineering technique, which we might call the *figure/figure* technique, is most effective when the "objects" clearly point to easily identifiable three-dimensional objects which make perfect two-dimensional interconnectedness unlikely to the point of practical impossibility. We are then faced, in this Hallways lineage of prints, with *impossible* two-dimensionalizations of *possible* three-dimensional objects. (The reverse of this, namely the impossible *three*-dimensionalizations of possible *two*-dimensional objects, is of course also exploited by Escher in the form of his famous impossible buildings (e.g. *Belvedere* or *Waterfall*), but these belong to the Stairways lineage of prints, which will be discussed later). Exploiting fully the three-dimensional potential of his *planes*, Escher branches off in two ways. One way involves three-dimensionalizing the plane itself into a curved surface: He uses this technique often enough, I thought, to justify talking about a sub-lineage of prints which I called the Strips lineage. Here, three-dimensionality is allowed for the plane as a whole, granting the mind's eye a reprieve in its search for three-dimensional closure. This, however, lasts but the time required for perceptual processing to attempt extending it to the "contents" of the plane itself, which of course miserably fails as soon as is realized that despite the three-dimensional potential of what they portray, the planar "objects" are at best given an irrelevant "thickness."

To represent the Strips lineage of prints, I chose *Swans*, *Rind*, and *Möbius Strip II (Red Ants)*. With *Swans* [1, cat no. 408], the branching off (from the mainstream exclusive concern for the regular division of the plane) into the Strips

Greek "planasthai" (to wander)). Hence "2-D-Land," "Flat-Land," "Floor-Land" ... and "Hallways-Land." Also, "plane" leads to "planar," ... which leads to "planaria" (or flatworm): See, for instance, *Flat-worms* and *Möbius Strip I*.

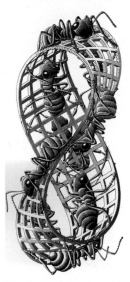

Fig. 3. M.C. Escher, *Rind*, 1955. Wood Engraving

Fig. 4. M.C. Escher, *Möbius Strip II*, 1963. Woodcut

sub-lineage is most obvious: Bending the plane in depth allows the birds some freedom to actually wander in three-dimensional space but they are denied the ability to actually *fly*, their wings remaining irremediably glued to the unremitting two-dimensionality of the plane, however curved. Exposed to *Rind* (Fig. 3), the mind's eye spirals up in space in the hope of a promised volume ... which never materializes. However, in this case, as it unveils the surface features of a human bust, the winding strip does more than allow two-dimensional objects to wander in depth: it actually attempts to carve a full-fledged three-dimensional one, stretching its planar potentialities to the limit, but not beyond, periodically and irresistibly forcing the mind's eye to "peel off."

But it is with Möbius strips that the Strips sub-lineage of prints reaches its conceptual peak, this time forcing *the mind's head* to "peel off" along with the mind's eye, as Escher undertakes to demonstrate that the ultimate two-dimensional impasse is that of the elemental assumption of the two-sidedness of the plane. Möbius strips shatter this assumption, and nowhere as crisply as in *Möbius Strip II* (Fig. 4). In this print, giant ants in full three-dimensions crawl along a closed-loop thick lattice strip with a Möbius twist to it. Locally, all clues suggest canonical three-dimensionality, of both ants and lattice, including the obvious two-sidedness of the lattice with *insider* ants and *outsider* ants alternating ... endlessly! But as the mind's eye crawls along with these alternating *insider/outsider* pairs of insects, it collides head-on with the troubling fact that the *static local* insider/outsider alternation extends into *a dynamic global* insider/outsider alternation. In this more global realm, as they proceed along the endless lattice, insider ants *become* outsider ants and vice versa, forcing the mind's head to acknowledge the necessary single-sidedness of the plane!

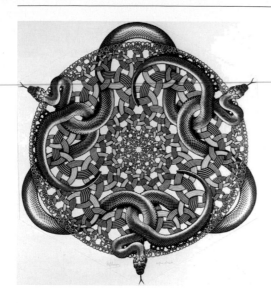

Fig. 5. M.C. Escher, *Snakes*, 1969. Woodcut

The second sub-lineage of prints branching off the Regular-Division-of-the-Plane main trunk of the Hallways lineage involves progressive variations in the *size* of the elements of the plane alongside some combination of the other usual variations in shape and orientation. This seems to have evoked, in Escher's mind, the concept of growth or development (as in *Development II*, and in the *Path of Life* series) and the concept of limit (as in the *Circle Limit* series, and in *Square Limit*). This might well be where Escher's "longing to approach infinity as purely and as closely as possible" is most explicit, albeit still inescapably set within the scope of the cognitive impasses blocking the way. I would argue that here, the cognitive impasse is twofold: First, the blatant limitlessness of the "shrinking" shatters the cognitive security associated with the limiting ability of size. Second, there is this powerful pointer to the third dimension which size carries along, granting Escher yet another means of engaging in this illicit flirting with depth which characterized the Strips Lineage. To represent this sub-lineage of prints, which I call the Vanishing Point lineage, I chose Escher's very last print, *Snakes* (Fig. 5), where the "flat" and the "spherical" are in constant opposition, intimately enmeshed in an inextricable mosaic of "knots" for the mind's eye to unravel.

With *Snakes*, we reach the end of the Hallways lineage of prints.

Stairways

The second of our central trio of lineages, the Stairways lineage, is characterized by Escher's fascination for *volume* as such, or full three-dimensional space. His graphical explorations of "Three-D-Land," or "Fat-Land," or "Rise-Land"

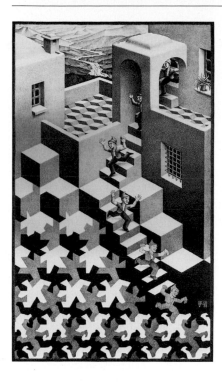

Fig. 6. M.C. Escher, *Cycle*, 1938. Lithograph

clearly hinge, again, on the order/disorder inescapable complementarity. Two main "perceptual engineering" techniques, tapping mostly into what psychological theories of perception call "monocular clues to depth perception," are quite massively relied upon by Escher in this context: (1) The *ambiguous volume* technique and (2) the *impossible volume* technique.

The *ambiguous volume* technique creates graphical forms which force the mind's eye of the observer into cycles of alternating three-dimensional interpretations of the same single set of graphical elements, preventing it from achieving definitive global volume closure[2]. In contrast, the *impossible volume* technique creates graphical forms which, although locally intensely indicative of the presence of volume, deny the mind's eye of the observer access to any form of global volume closure. The strong sense of local three-dimensional order (and consequent expectation of global three-dimensional order) arises from exploiting a third technique which we will call the *simplest form* technique. This technique, partly based on the Gestalt laws of *good figure*, uses highly regular sets of the simplest possible forms, thereby insuring rapid and convincing local volume closure. *Cycle* (Fig. 6) is an ideal print for illustrating the transition from

[2] The ambiguous volume technique obviously is a close cousin of the figure/figure technique of the Hallways lineage, which could have been called the ambiguous surface technique.

the Hallways lineage to the Stairways lineage. It features the cube as simplest form and as ambiguous volume on a background of hallway/stairway ambiguity (with the "cubic tiling" of the terrace at the top, and the flattening of the human figures and their stairway support at the bottom).

The Stairways lineage proper consists essentially of prints such as *Relativity* and *Waterfall* (see pages 265 and 65), portraying mazes of stairways or architectural levels involving volumes which turn out to be not only *visually* ambiguous or impossible but sometimes also *conceptually* so. Indeed, as noted in our comments on Möbius strips, Escher's impasses can lie, beyond the mind's eye's reach, in the *mind's head's* deeper treatment of its visual constructs. *Relativity* is a particularly striking example of Escher's use of conceptual ambiguities and impossibilities: The space portrayed there is a perfectly legitimate global geometrical volume, and, although the task is far from trivial, visual global closure is possible. It is the way in which gravity appears, *conceptually*, to affect the various natural objects (human figures and trees) which prevents closure here. *Gallery* [1, cat. no. 346] offers yet another example of this type of impasse, with gravity exerting its multidirectional pull on somewhat less natural objects (hanging lamps and Persian iron man-birds). This print also features infinite regression in depth, echoing in Three-D-Land the Vanishing Point sub-lineage of Two-D-Land. A second sub-lineage branches off the Stairways lineage's main trunk with Escher's apparent fascination for intersecting planes and volumes, and regular polyhedrons, cast as stars or crystals, or simply as such, as in *Waterfall*, where they dominate, as perfect volumes, the absolute three-dimensional impossibility of the waterway.

Archways

Now the third and final main lineage of prints, the Archways lineage. This takes us beyond the concrete realms of Two-D-Land and Three-D-Land which characterize the first two lineages, into the more abstract and subtle realm of Through-D-Land. Here, the mind's eye is forced *through* space, in search of an ever-receding truth momentarily inhabiting each one of a succession of perceptual constructs which last but the instant required to test the hypothesis that they might be "figure," and to refute it to the benefit of the usual alternate hypothesis, that they are in fact "ground." What characterizes Through-D-Land, however, is that these "grounds" are "*fore*-grounds," pointing to possible "figures" in the space beyond, inevitably occluding and distorting aspects of them in the process. To contrast it with the "figure/figure" technique in tiling, we could speak here of a "ground/ground" technique. So whereas in the case of the "figure/figure" technique the ground-seeking mind's eye is only offered figures, in the case of the "ground/ground" technique, the figure-seeking mind's eye is only offered grounds. *Cloister of Monreale* (Fig. 7) is a beautiful example of the type of architectural perspectives of which Escher seems to have been particularly fond. Here,

Fig. 7. M.C. Escher, *Cloister of Monreale, Sicily*, 1933. Wood engraving

three sets of arches open onto one another as the mind's eye travels in a straight line in depth, from the center of the print and with a slight leftward elevation.

Windows, doorways, porches, closes, and covered alleys can be found everywhere in the Italian Landscapes and Architecture "main trunk" lineage of prints. As Escher's imagination starts playing a more explicit role in his work, purely architectural archways "open" onto more metaphorical ones, first with reflections of various types and then with "prints" as such.

Still Life with Mirror (see page 219) provides a convincing transition from the main architectural Archways lineage to the Reflections sub-lineage. As soon as the mind's eye enters the reflection of the nested archways street, the mirror loses all "framing" ability and hence, since it is but a frame, literally ceases to exist, having achieved its purpose as mere *pointer*, a purpose recursively reinstated in the reflected street's successive archways *leading . . .* nowhere.

Three Spheres II and *Three Worlds* are examples of pure Reflections sub-lineage prints where the mind's eye is repeatedly forced *through* its current locus of interpretation, inescapably drawn forward in its quest for "reality." In *Three Worlds* [1, cat. no. 405], a receding tapestry of dead leaves occluding tree and fish establishes an invisible plane of water pointing beyond and beneath, trapping the mind's eye in perpetual triangulating journeys through reflection and refraction. In *Three Spheres II* (Fig. 8), the ovoid form on the extreme left of the central spherical mirror multiplies pointers . . . to infinity as it turns out to be the reflection on the central sphere of the reflection on the leftward sphere of the reflection of the central sphere itself . . . ! Spherical mirrors give a new twist to Through-D *pointing*: In breaking open the limiting frame of planar mirrors, they

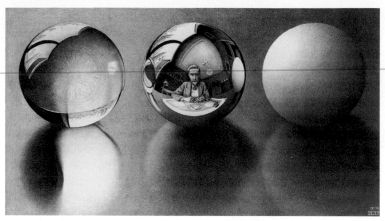

Fig. 8. M.C. Escher, *Three Spheres II*, 1946. Lithograph

reveal more, but they also *conceal* more, as the very *shape* of material objects now suffers distortion in the process.

As final off-shoot from the Reflections sub-lineage, a single print stands out, in the form of a gallery featuring Escher's own prints, reflecting and distorting in yet another infinitely more powerful way, revealing and concealing in yet another infinitely subtler way: Art's way. Relegating *space frames* to the background, *Print Gallery* (Fig. 9) introduces *mind frames*, where the mind's eye is

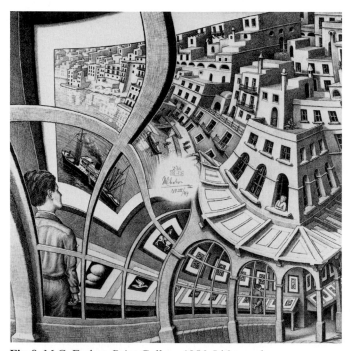

Fig. 9. M.C. Escher, *Print Gallery*, 1956. Lithograph

forced *through* the artist's explicitly acknowledged reformulation of reality. In this print, not *as* print, Escher uses his very own prints, *as* prints, as primary material, recursively "metaphorizing" his very own "metaphorizing" medium as a graphic artist. Breaking loose from the traditional *figure-ground* paradigm, as in an ultimate attempt to convey the essential flavor of the ever-fleeting truth, Escher uses these prints-as-content-of-the-print to set the stage for a *subject-object* paradigm. In this new purely metaphysical paradigm the figure/figure and ground/ground techniques of the concrete figure-ground paradigm give way to a combined subject/subject//object/object technique, where the paradoxical twists traditionally imposed on space open up onto paradoxical twists imposed on mind. Let us have a detailed look at how Escher manages this feat.

As *Print Gallery's* dynamics bring the mind's eye from the entrance Archway in the lower right-hand corner all the way around the enigmatic central "white hole" and back to the entrance Archway, they bring the mind's head to empathetically witness a succession of highly contrasting subject-object relationships. A first one, in the form of a visitor with his hands at his back and looking down at a print displayed on the angled tabletop, states the case in the usual terms: a distinct subject contemplating a distinct object. A second one, in the form of yet another visitor, this time looking up at a print displayed on the gallery's wall, completely restates the case, this time challenging the usual terms: The apparently distinct subject and the apparently distinct object progressively dissolve into one another, as the print-object, unfolding clockwise from the visitor's standpoint, curls back onto itself to strip the visitor-subject of its subjective role, turning it into a mere part of the print which initially was an "exterior" object of contemplation. This pushes the subject-object hypothesis forward, as characterizing what the *newly discovered* print portrays, and infinitely perpetuating subject/object merging cycles around the print, *denying the observer the hope of ever achieving subject/object closure.*

It is with *Print Gallery* that Escher's unyielding obsession with the fundamental paradox of the mutual necessity of order and chaos, of the intimate interdependence of consistency and inconsistency, reaches its most powerful expression. Indeed, his finger also points beyond the limits of the realm of *artistic reality* to those of the realm of *scientific reality*, bringing to the fore one of its most insistently overlooked inconsistent premises, that of the legitimacy of assuming the independence of the respective terms of the subject/object relationship, the so-called "objectivity" of science. In the light of *Print Gallery's* inescapable epistemological circularity, cognitive and neurological sciences' belief in the independence of the observing and of the observed, in the very study of how "observed" emerges from "observing," suddenly loses its obviousness. As the scientist's eye scrutinizes his own generalized "reflection," learnedly labeled "the human visual information processing system," he faces, in a distance that might or might not lie within the scope of his career plan, the very fate of *Print Gallery's* visitor. Here, this fate translates into the inescapability of the human-eye-as-object's claim to the-human-eye-as-subject, the necessity of accepting that, ultimately, *all stimulus* must be *response* ... just as much as

all such response must also be *stimulus* . . . giving a new twist to the sacrosanct *stimulus-response* concept, and turning my very own discourse on its head on the way.

References

[1] F.H. Bool, J.R. Kist, J.L. Locher, F. Wierda, eds. (1982) *M.C. Escher, His Life and Complete Graphic Work*. New York: Harry N. Abrams.
[2] M.C. Escher (1989) *Escher on Escher: Exploring the Infinite*. New York: Harry N. Abrams.
[3] J.L. Locher (2000) *The Magic of M.C. Escher*, New York: Harry N. Abrams.
[4] D. Miller (1985) *Popper Selections*. Princeton: Princeton University Press.
[5] B. Russell (1967) *A History of Western Philosophy*. New York: Simon and Schuster.
[6] J.W. Vermeulen, (1989) "I'm Walking Around All by Myself Here." In M.C. Escher (1989) *Escher on Escher: Exploring the Infinite*. New York: Harry N. Abrams, pp. 139–153.

Parallel Worlds: Escher and Mathematics, Revisited*

Marjorie Senechal

The popularity – and ubiquity – of the graphic work of the Dutch artist M.C. Escher (1898–1972) continues unabated: books on his work remain in print, the public never seems to tire of Escher posters, mugs, T-shirts, calendars, and other paraphernalia, and exhibitions of his work are packed. Over 300,000 visitors attended the six-month "M.C. Escher: A Centennial Tribute" at the National Gallery of Art in Washington in spring, 1998; exhibitions were held in that centennial year in Brazil, Mexico, The Czech Republic, Hong Kong, Great Britain, China, Greece, Italy, Argentina, Canada, Holland, and Peru. "People are attracted like magnets to these works. They come closer and closer and closer, and they stay there an incredible amount of time," says Jean-François Léger of the National Gallery of Canada. "Studies have shown that the average length of time that a gallery visitor will stay in front of a work of art is 17 seconds. But they stay minutes in front of Escher's, and discuss, and comment, and say 'Do you see this, have you seen that?'" What is the magnet, what is the attraction? Is it profound, or is it superficial?

It has become rather fashionable to affect weariness with these questions. Although Escher was "discovered" by research mathematicians (and other scientists) in the 1960's, their – our – enthusiasm for his work has waned as (or because?) the public's has waxed. "Of course, the article contains the inevitable reference to Escher, the philistine mathsman's favorite artist," sniffed an anonymous referee for the interdisciplinary journal *Leonardo* a few years ago [1]. Art critics have been disdainful all along, insisting that Escher will be, at most, a footnote in the history of twentieth century art. But while this assessment may be correct, is it fair? Escher never claimed to be either a mathematician or an artist. "My uncle floated between art and mathematics – those are his words," says his nephew Nol Escher [2]. He was not at home in either world, yet he illuminates a profound relation between them. M.C. Escher's hundredth birthday provided an occasion for the mathematical community to revisit his work and come to terms with it.

The Escher Centennial Congress, held in Rome and Ravello, Italy, June 24–28, 1998, brought together a diverse group of mathematicians, scientists, artists, designers, school teachers, museum educators and others to consider the entire range of Escher's work, "from landscapes to mindscapes," from many

* This article first appeared in *The Mathematical Intellligencer*, vol. 21, no. 1, 1999, in the column series "Mathematical Communities," edited by Marjorie Senechal. It is reprinted here, with minor corrections and updates, with the permission of the publisher, Springer-Verlag.

different perspectives [3]. During that congress I asked a small subset of the invited speakers to explore the reasons for Escher's enduring popularity with the general public in general, and in particular whether his appeal is in any sense "mathematical." The following comments splice together excerpts from two wide-ranging discussions. The participants were George Escher, a retired aeronautical engineer and oldest son of M.C. Escher; István Hargittai, Professor of Chemistry, Hungarian Academy of Sciences, author of numerous books on symmetry; Douglas Hofstadter, Center for Research on Concepts and Cognition, Indiana University, author of *Gödel, Escher, Bach*; Claude Lamontagne, Professor of Psychology at the University of Ottawa; Jean-François Léger, Education Director of the National Gallery of Canada in Ottawa; Arthur Loeb, Professor of Design Science at Harvard University; István Orosz, Budapest, artist (considered by some to be Escher's "successor"); and Doris Schattschneider, Professor of Mathematics, Moravian College, author of *Visions of Symmetry*.

Senechal: *It is a truism that art critics dislike Escher's work but the public loves it. Many people have speculated on possible reasons for the first, but few seem to have seriously considered the second. Today, let's forget about the critics, and consider the public instead. And let's begin in a skeptical vein. I don't know of any other artist's work that has been so commercialized, not even Picasso's. To what extent is Escher's popularity due to the commercialization? Or is the commercial success due to Escher's appeal?*

Hofstadter: You can't just say well, we're going to make all those ties! People aren't necessarily going to buy them.

Escher: Yes, but there was a very organized sales campaign of the Escher concept going on which was invented after father died or maybe even before, by people around him who said, "If we let it go, it will just fall apart." Because of the character of the people involved then and the people involved now, that's what you have: marketing specialists.

Senechal: *Does that explain why other artists, such as Vasarely and Magritte, whose work challenges the imagination in ways somewhat analogous to Escher's, don't have the same mass following? Or is it, at least in the case*

Marjorie Senechal

Douglas Hofstadter

George Escher

of Vasarely, because his geometrical illusions are just abstract figures, not embedded in fanciful worlds?

Lamontagne: Maybe it is partly because they are not marketed the way Escher is, but also there is an immediacy in Escher. Magritte is not as easy to interpret. Escher chose simple things, waterfalls, monks walking. It looks understandable at first – but then you find surprises in it.

Léger: I'm not sure that everybody likes Escher. When we were working on our public programming, we tried to identify who would be most interested in him. We concluded that it would be young adults, who were interested in mind games and things like that. It may be that people become interested in Escher at a certain age, and then their interest fades a bit. Maybe Escher appeals to this group because his work is immediate: what you see is what you get.

Orosz: The most terrible experience for us artists is when a viewer at an exhibition stops for a half of a second in front of our work and then walks on to the next one. This is impossible in front of a print of Escher. And usually I feel, when I see his work in an exhibition or in a book, that after some minutes the picture is not important anymore, the important thing is the thinking, the mysterium. Over time, it will be even more important than the picture. This may be why the publishers use his works in calendars, because people have to live with them for a month at least, and they see it every day.

Hofstadter: I don't remember where I first saw *Metamorphosis,* it was probably in some book, but I remember the fascination of the changing forms. I was never as attracted to the tessellations as much as I was to the metamorphoses, the idea that here is something that is tessellating, but it's changing into something else. And then, on top of that, it changes from being a two-dimensional thing to a three-dimensional thing, and then back into a two-dimensional thing, and then into another three-dimensional thing, and then it winds up being a village that plunges into the sea with chess pieces, and words! There were so many ideas tangled together there in such an elegant and graceful and, again, startling and astonishing manner – that's what grabbed me. It was a two-dimensional, three-dimensional constant interplay and then bringing in these other worlds, like medieval villages, chess, the world of the intellect, the world of the past – a medieval village connotes more than just the past, it again connotes a kind of

Claude Lamontagne Jean-François Léger István Orosz

mystical quality, something that's gone but that radiates a kind of charm that I can't put my finger on very well. And that, to me, was also marvelous.

Orosz: It's not the visual image that is the most important thing, it's something in the mind. Still, it is very easy to speak about the work of Escher, much easier than to speak about abstract or other kinds of art. Somehow it is very close to communication – yet it is not visual communication, nor is it verbal communication.

Lamontagne: With Escher, the revealing that happens in the graphics is always accompanied by a concealing which uncovers itself through time as the visual system seeks interpretations. Escher was an incredible visual engineer; he experimented with just about all the ways in which you can intervene in the visual process to fool the system. I see three directions in his work. One I call "two-D", the tilings; another is "three-D," the impossible figures; and the third is what I call "through-D," like the *Print Gallery*, in which subject and object toggle with one another. The guy looking at the print is an object but when you go back he becomes the subject and then he turns into an object again.

Loeb: We've heard that it's the young people who take to Escher's work. That may be true; as a natural scientist I tend to question these things, but I think it's probably true. At this particular conference we have several much older people but I think that they became interested in Escher when they were younger. It should be possible to find out.

Schattschneider: I think you're right that probably the primary audience is high school and college. I think part of it has to do with the irreverence of some of Escher's art – they say it is "cool," "awesome." But people who like to solve problems, who like to try to figure things out, are immediately attracted regardless of age. I think that's why scientists and mathematicians are so attracted – it's not so much that there is mathematics in it.

Lamontagne: Like most young undergraduate students in the 60's, I got a kick out of Escher, and I had my posters – it didn't turn into mania though. I really enjoyed it for a period, but then I moved on to something else, and I forgot about Escher. Then a few years ago the National Gallery of Canada in Ottawa decided to put up an exhibition and they were looking for someone for the committee who had some knowledge and expertise. Someone in the museum had been one

Arthur Loeb

Doris Schattschneider

István Hargittai

of my students of perception and remembered that I had an interest in knowledge and illusions and vision and that I was at the University of Ottawa, so soon I was back in the Escherian world. I was very happy to be in it: in fact, I found in Escher's work the whole problem space in which I had been playing over the previous 20 years! It has to do with knowledge, with the fragility of knowledge, with the unavoidable hypothetical nature of knowledge. I started looking at the prints from that perspective, trying to see if I could fit them into a unity. I don't have closure on it, but I'm pretty excited about the way it is shaping up.

Hargittai: This kind of discussion inevitably prompts me to ask myself what I like in Escher most, and what I use Escher most for. I use him most for his periodic drawings, but I don't think I like them most. After a while they become very much the same, boring and simplistic. If I could just choose the one thing that I like most, it would be his wild flowers. I started wondering, why do I like his wild flowers so much? It is probably because of my science background: his wild flowers are very geometric, they are stripped of many things, and they seem to me to give a fantastic model of nature. Something is there, it is very important, but many other things are just ignored, as in any very good model. His periodic drawings are extremely useful for me, but in this case "what you see is what you get": after awhile you get very used to it. I always get an uneasy feeling when I see that math teachers are spending I don't know how many class hours on Escher [making tessellations]. I think it's a very good way to make children hate him and that kind of work. In fact, he is a unique artist for the connection between art and science.

Lamontagne: Everybody has seen illusions in psychology books or even more widely available literature, but they are crude. Escher put them into a world that has some cogency, some consistency. He uses a variety of them, some of which don't strike us as being illusions, for instance the way in which he uses the various worlds that point to one another, to make people realize that knowledge cannot be trusted but at the same time, it can be trusted. It can be trusted locally, but there's always a globality that might show that it does not make sense. This local/global relationship is fundamental in cognitive science as well as in mathematics.

Hofstadter: There is, as I'm sure everyone knows, a brand of literature that may have started in South America called magic, or magical, realism, in which there is a mixture of reality and paranormal events. I haven't read much of it; the only time I attempted to read some – Gabriel Garcia Marquez's *One Hundred Years of Solitude* – I found I just couldn't take it, I couldn't stand it. And yet, what is the difference between that kind of literature, which mixes reality with mystical, unexplainable events that violate the laws of physics, and *High and Low*, Escher's print in which the scene is repeated twice, with the boy sitting on the staircase, with the palm trees in the courtyard, the tower that is both going up and down, the windows right side up on one side and upside down on the other side, gravity obviously flowing in two different directions in the same building. In some sense that's magical realism, yet I love that! I don't understand what it is in myself that finds Garcia Marquez uninteresting and silly, yet finds Escher

captivating and mesmerizing. There's a sense of mysticism in it: I think the word mysticism isn't wrong. I'm not a mystic, but there's an appeal to a sense of marvelous mystery, which is also what caught me so much in *Day and Night*, the first Escher print I ever saw. The birds, not only intersecting and forming their own background, but also becoming fields and then day and night in the same place at the same time, all of that was overwhelming. It was so strange and complex and weird.

Escher: Maybe this is because you can look at an Escher print again and again and again, and think about it.

Senechal: *Yes, I think the difference between magical realism in literature and the magical sense in Escher is that as you look at Escher more and more, you begin understand it. You don't see how he could possibly have thought of it, but you do see how it was actually executed. You begin to see, for example, why this seems to be convex when you look at it one way, but concave another, instead of just being baffled by it. You become intellectually engaged in trying to understand Escher, while with Garcia Marquez and the other magical realist writers that I have read, no understanding is possible because there's nothing there to understand. It's just magic.*

Schattschneider: I agree. I don't think that "what you see is what you get" with Escher. I gave John Conway a copy of my book [4], and he later told me that it took him six months to read. I said, "John, if I tell people it took you six months to read my book, no one will open it!" He replied that at first he began to devour it, but then he decided to put it on the piano and only allow himself to turn one page a day, because he really wanted to study it. When he slowed down, he saw things he had never seen before although he had looked at many of these prints and drawings several times.

Léger: My understanding of the expression "what you see is what you get" is that it is immediate, in the sense that the message is all included in the work: you can come to it knowing nothing about art, and still you will get something out of it. You don't have to know what was prior to that, or after that, it doesn't cite somebody else, you can engage in it with no prior knowledge of it.

Hofstadter: And yet, when one knows some of Escher's other works, one reads his landscapes in a way that one might not have read them without that context. One has the sense that this is somebody who appreciates magic. You feel it in that landscape, even though it's not directly there, and even though it was done maybe 20 years before something like *Day and Night*. You feel that same sense of the magical, a sense of engagement, depth, power, space, and space between lines.

Léger: The more I look at Escher, the more I am interested in his landscapes. Even art critics will agree with that. I would wish that that more people would focus on the Italian landscapes.

Escher: Father thought that among all the artists who depicted landscapes, he was nothing special. They were all dedicated people with good eyes, wanting to show what they saw; he was one of thousands. It's only because he switched out of that field that his work in it becomes visible; that's the strangest thing about the

whole phenomenon. Father never considered himself an artist: because he had a certain preconceived idea of what an artist was, he thought he wasn't one, and he couldn't draw anyway. But can you see, through his prints, that he was looking at the world so intensely, with such interest, that it comes through, it resonates, within you: "Oh, so that's what the world can look like!"

Loeb: Maurits expressed surprise to me many times that people were seeing mystical things in his prints. He did not expect that at all. George, did you have any experience with this?

Escher: Well, yes. It was rather funny, the reactions that father got to many of his prints. People saw their own imaginings in them, not what he had sort of meant to say. What he meant to say is what's there, and nothing more, according to him. These other people saw reincarnations and mystical things.

Loeb: Maybe that is the "magic mirror" of M.C. Escher. Maybe that's what we all see: we see ourselves mirrored in his work.

Lamontagne: The question of interpretation is a very subtle one. The attitude that we should not interpret, that we should be cautious, is very naive, because if you have to be cautious when you interpret then you have to be cautious when you think, because thinking is interpreting. To an extent, I'm a Popperian. That is, I agree with the philosopher Karl Popper that all forms of knowledge, including perceptual knowledge, are conjectural or hypothetical and the only way in which we can hope to progress in our understanding is to formulate our knowledge in a falsifiable way [5]. For example, a person coming into a different culture reads it in a way that is refutable through further experience. That is, I think, a better reading than a native reading of it which is not refutable.

Senechal: *Is there anything mathematical in the appeal of Escher, or is that completely beside the point?*

Lamontagne: Perhaps mathematics was to Escher as grammar was to Shakespeare. Mathematics is form.

Hofstadter: At the time I was writing my book, which became known as *Gödel, Escher, Bach* [6], it was not called that at all: the working title was something like "Gödel's Theorem and the Human Brain." As I was writing and writing, I realized that for many of the concepts that I had called "strange loops" or "tangled hierarchies," images that I knew from Escher were appearing in my head, over and over again. For awhile those images just helped me express myself more clearly; they helped me get even more sharply into words what I was trying to get across. But then eventually it occurred to me, my gosh, I should be showing my readers this stuff, I should not be simply having it in my head as a crutch or an aid, I should be sharing this. If it's useful to me as a writer to have an Escher picture in my head, it will be useful for my readers to have it in theirs. At that point Escher became an integral part of the book, and it was about the same time that Bach was entering, for very different reasons. For me, many of the concepts that I was trying to get across, particularly this notion of strange loop, were extremely well represented in Escher's pictures, and they were deeply connected, as I said, with Gödel's theorem and certain things in mathematical logic. I doubt that Escher had those notions in mind explicitly,

but the abstraction that underlies Gödel's proof and the abstraction that under-
lies *Print Gallery* – the idea of a system folding around and engulfing itself, is
the same concept as in a system that can represent its own predicates, a system
that can talk about itself.

Lamontagne: I've been raised in a context of Piagetian thought, in the Piaget
world, which is still quite valid. Piaget talks about adolescence as the period
when cognition opens up to the realm of possibilities. Before that – he calls it
the concrete operational period – the mind is reactive and it can do very fancy
things, but on the basis of actual things, concrete objects. But when you reach the
formal operational stage – which starts around the age of 12 – as you reach 12,
13, 14, the mind opens up. It realizes that there is not only actuality, but that
actuality can lead to potentiality. And so the young minds open up to the fact
that they are what they are, but within the context of a huge combinatorics that
is at the same time physical, social, and psychological. Do you know the test that
Piaget did with mathematics – with permutations and combinations, showing
how kids at the pre-operational level, and concrete operational level, and formal
operational level handle combinatorial tasks [7]? Before adolescence, a child
can compute the number of arrangements of any given number of objects, but
cannot even understand the question if you ask for the number of arrangements of
n objects. Adolescents can think about n. In addition to explaining math under-
standing, Piaget's ideas are beautiful metaphors for the mind in general. When
you get to the formal operational stage, that is, adolescence, then you open up to
the possible and you realize that you are one amongst an infinite set of possibili-
ties. Now, at that age, there is at the same time the fear of losing what you are but
the excitement of discovering what you might be, and what the world might be.
I think that it is in this area that we can locate the great fascination for Escher.

This is our stopping point, but it is not the end. This particular conversa-
tion was one among an infinite set of possible conversations about the work
of M.C. Escher and, more generally, about the deep relations between art and
mathematics and the human mind. Like Escher's visual puzzles, it loops back on
itself, leading us through new landscapes that somehow are familiar. The world
of M.C. Escher and the world of mathematics are parallel worlds.

Photo Credits: Marjorie Senechal photographed by Stan Sherer; George
Escher and Arthur Loeb photographed by Victor Acevedo; István Hargittai
photographed by Magdolna Hargittai; other photos courtesy of the panelists.

References

[1] John Rigby, private communication.
[2] Nol Escher, private communication.
[3] *M.C. Escher: From Landscapes to Mindscapes* was the title of an exhibition held at
 the National Gallery of Canada in Ottawa in 1996.

[4] Doris Schattschneider, *Visions of Symmetry: Notebooks, Periodic Drawings, and Related Work of M.C. Escher,* New York, W.H. Freeman, 1990.

[5] Karl Popper, *Conjectures and Refutations: the growth of scientific knowledge,* London, Routledge & Kegan Paul, 1963.

[6] Douglas Hofstader, *Gödel, Escher, Bach: an eternal golden braid,* New York, Basic Books, 1979.

[7] Jean Piaget and Barbel Infelder, *La genèse de l'idée de hasard chez l'enfant,* Paris, Presses Universitaires de France, 1951.

M.C. Escher in Italy: The Trail Back

Mark Veldhuysen

The coast of Amalfi, *La Costa Divina*, or "The Divine Coast" as it is called in Italy, is truly breathtaking. Huge rocks and cliffs rise out of the sea and strange rock formations hide small bays and caves in which the available light breaks out in magnificent colors. The Amalfi Coast has for centuries attracted artists and writers. In his *Decamerone*, Boccaccio writes about this Amalfi coast, "Happy is the land that has found its literary advocate, for the eye reads in the landscape too." And it was the famous Italian poet Renato Fucini who wrote, "For the Amalfi people who go to paradise, the Day of Judgement will be a day like any other day."

So, as early as the 14th century, the beginning was set for the Amalfi Coastline's fame. Painters, writers, and poets throughout the centuries visited this coast. Among the writers who were inspired here were Maxim Gorky, who wrote his novel *Mother* and Goethe, his *Italian Journeys*. Henrik Ibsen wrote his famous book *The Doll's House* on this coast, D.H. Lawrence his *Lady Chatterley's Lover*, and for Richard Wagner, it provided the scene for his second act of *Parsifal*: "The Magical Gardens." Various painters also visited these regions: William Turner, Pablo Picasso, John Ruskin, and Antonio and Franceso Mancini. No wonder that this coast inspired Maurits Cornelis Escher to spend many months in this region, drawing and sketching.

On the 18th of January 1923, he wrote to his friend Jan van der Does: "Rarely, if ever, have I felt calmer, more pleased, more content than in recent times. Many wonderful prints are springing from my mostly industrious hands and the question whether they contain any beauty, I leave to be answered by the miserable generations to come." [1, p. 24].

These "miserable generations to come" have journeyed to this part of Italy to see with their own eyes some of the places they so admire in Escher's prints and to look at the sites that inspired him more than 70 years ago. It is indeed amazing that after all these years, the villages, streets, and landscapes that M.C. Escher drew, have hardly changed at all. Of course, not everything has stood still. Flats have been built, more houses have been added, roads have been paved, but mostly the landscape hasn't changed all that much.

M.C. Escher's father wrote in his diary on the 19th of March 1923: "Late that evening we received a letter from Mauk [the family name for his son], from Ravello, where he had arrived from Naples. He had traveled by train to Vitré and from there went the last three hours along this beautiful coast in a carriage over a long, winding road, which is largely built over viaducts."

Fortunately, now there are cars and people don't have to travel in a carriage or on the back of a donkey. Traveling this road, the first town that looks familiar

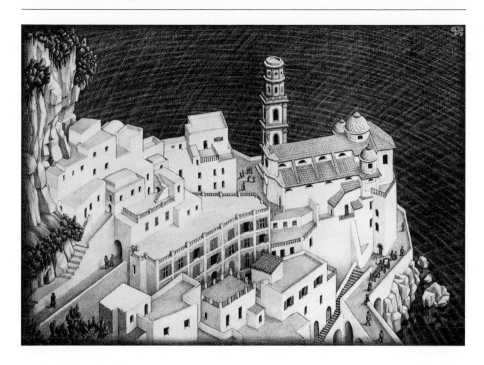

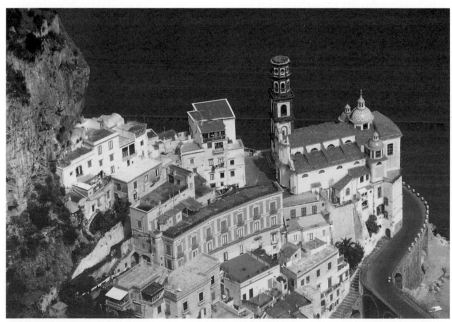

Top: M.C. Escher. *Atrani, Coast of Amalfi*, 1931. Lithograph.
Bottom: Atrani, Amalfi Coast. Photo © Mark Veldhuysen

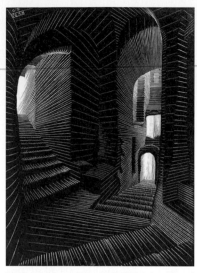

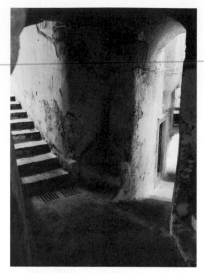

M.C. Escher. *Covered Alley in Atrani*
(Coast of Amalfi), 1931. Lithograph

Covered Alley, Atrani.
Photo © Mark Veldhuysen

 is Atrani. Familiar, because it is depicted both in Escher's *Metamorphosis* print and in his lithograph *Atrani*.

 To photograph Atrani from the same spot at which Escher must have sketched the drawings for his lithograph means climbing steep slopes and trotting through bushy hills-but then you get this spectacular view of Atrani. It is all still there – the dominant church, the same houses with a few add-ons – but more than 60 years have passed and it looks like the world has stood still. Even the sea looks the same.

 On the 4th of August 1931, Escher's father wrote of a visit with his son: "In the afternoon I saw Mauk's work on the stone with lithographic chalk: it is a view from a high rock, of Atrani, near Ravello. Many houses and a church with the sea as background. A dark sea, with two wave systems that cross each other."

 There can be little doubt from the photo that this is the spot from where M.C. Escher made his drawing.

 Atrani itself, where the famous print *Covered Alley* was made, is a maze of small alleys and steps, seemingly without rationale. One house is consrructed, so it looks, on top of another. The roof of one house *is* actually the floor of yet another. Alleys wind themselves underneath the various houses and seem to stop, only to continue after climbing some further steps. It is like walking in a gigantic maze – now in the sunlight and two minutes later without any light at all. Any urban planning committee would be amazed at how this town was built.

 But the covered alley does exist, as well as the dilapidated houses Escher turned into another lithograph. 'Dilapidated' means "in a bad state of repair" or "falling to pieces."

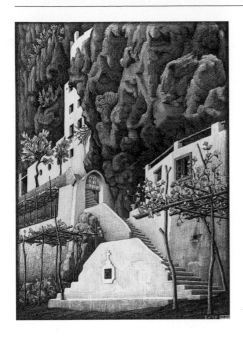

M.C. Escher. *San Cosimo, Ravello*, 1932. Lithograph

This can be said for a lot of the houses in Atrani, but the original dilapidated houses still stand after 60 years. Certainly, they need some repair and some paint, but they are still standing, although it is no longer possible to photograph them from the same angle.

A little further along the winding road lies Ravello, a town in which Escher often stayed, living at the Albergo dell Torro. Here Escher made a woodcut in which he plays with light and dark: the interior of a church called Porta Maria dell'Ospidale. This church is no longer in use and is closed to the public. It is built into a rock and if one doesn't know it's there, it cannot be found. The walls are green with dampness, with water seeping along them, and it is very chilly inside. In his wood engraving, Escher cheated a little, because it isn't possible to physically get back far enough in the church to make a photograph exactly like the print.

A little South of Ravello, there lies a small village called San Cosimo. It was here that Escher often met with Don Pantaleone, the pastor of the little church depicted in his lithograph *San Cosimo, Ravello*.

Of one of these visits, Escher wrote:

"I often visited Don Pantaleone, the old priest of a small church that is perched against a cliff like an eagle's nest, three hundred meters above the water. In front of the church is a tiny little square that gives a spectacular view over the dark blue Mediterranean sea. Once, when I had climbed those long steps and arrived at the square, I saw Don Pantaleone getting a shave in the cool shade of the face of the cliff. He sat in an old armchair, just in front of the open door to his church. That was another of those sights one never forgets – the way that old man in his grubby

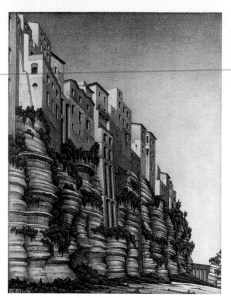

M.C. Escher. *Tropea, Calabria*, 1931. Tropea, Calabria.
Lithograph Photo © Mark Veldhuysen

cassock, with his head tilted backward, had his white stubbly beard shaved off. The silence of this warm spring afternoon was only broken by the scraping sound of the razor and the chirping of the crickets, and the air was heavy with the scent of orange blossoms." [1, p. 109].

The church no longer exists. A new one is built, made of concrete. The whole inside of the church is covered with an array of silver arms and legs and some plaques. Any ailments that involve arms or legs means visiting this church to pray and get better. As thanks, donations are made of small silver arms or legs. The walls are covered with them.

Walking back to Ravello from San Cosimo and looking to the right, another familiar print, the *Hamlet of Turello* comes into view. The exact spot from where Escher must have sketched is still there – the wall, the derelict building – just as it was all those years ago. This gives a whole new meaning to 'following in someone's footsteps'!

M.C. Escher also made various lithographs in the south of Italy, in Calabria, which is a vast, dry and barren country. Hardly any tourists go there since the landscape is not all that great, the roads are bad, the people poor and there are few hotels. Tropea is one of the towns in that region which Escher depicted in a lithograph. It is built on a rock and over the centuries a maze of little streets has sprung up. Unlike the people in the mountains, the people of Tropea are silent and unhelpful, but the steps going down to sea level are easy to find. Again, basically nothing has changed during the years. Even the old aqueduct is still there.

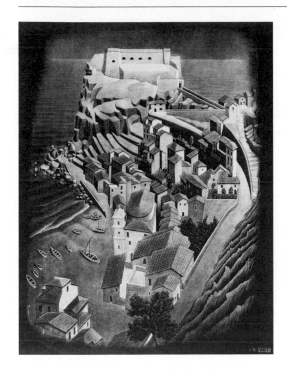

M.C. Escher. *Scilla, Calabria*, 1931. Lithograph

Scilla, Calabria.
Photo © Mark Veldhuysen

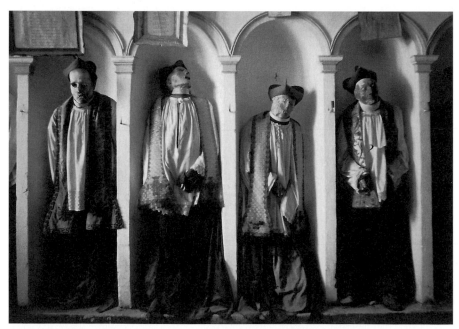

Top: M.C. Escher. *Mummified Priests in Gangi, Sicily*, 1932. Lithograph.
Bottom: Mummified Priests in Gangi, Sicily. Photo © Mark Veldhuysen

Further south lies Scilla. Here one sees the church, the garrison, and the sloping road leading towards the garrison. Now, comparing my photograph with the lithograph, it looks like another church has been built at the top, a church we miss in Escher's lithograph.

Sicily was another part of Italy visited by Escher. One site he selected for a print was the small village called Castel Mola, with Mt. Etna in the background, still smoking. A nice image, which should be easy to find. However, it is just not possible to photograph the exact view as portrayed by Escher in his lithograph since there is no mountain to stand on behind Castel Mola in order to get the same view! Escher made his lithograph in the same fashion as 17th century Dutch engravers who made birds-eye views. In the northern part of Sicily lies the town of Cefalu with its large cathedral, easily identifiable, as it totally dominates the city. Here Escher made another print in which high and low are strongly present.

M.C. Escher portrayed various churches in his lithographs, but hardly ever an interior. One interior scene, however, is quite fascinating. It is in a cathedral in Gangi, a mountain village in Sicily. One day when Escher visited Gangi, some street urchins asked him if he wanted to see some dead priests. A somewhat morbid idea of fun perhaps, but as the unusual always fascinated him, he quickly agreed. He followed the boys, who, with a large key, opened a crypt underneath the cathedral. There he indeed found some dead priests and made sketches for his lithograph. These mummified priests are still there. The crypt is now closed but the photograph gives a glimpse of what Escher saw in 1932.

Some seem to jump out at you. They are all mummified and are wearing their original clothing. All is relative, as Escher depicted on his lithograph. At the bottom of the print, he added the message that in Latin reads *Ite, Missa Est*. Indeed, Mass is over.

And it was about Italy that Escher wrote to his friend Bas Kist:

> *I regret that you cannot accompany me on this trip. Every spring I make a journey to refresh my body and spirit and collect subjects for the work of the following months. I don't know of any greater joy than wandering over the hills and through valleys from village to village, to feel unspoiled nature around me and to enjoy the unexpected, in the greatest contrast to life at home. When wandering, it seems like a dream, although unpleasant things – bad food and a bed with lice – are one of the inevitable conditions of this enjoyment! Often I think about travelling like this in the future with my sons. That must be a great joy!* [1, p. 34]

References

[1] F.H. Bool, J.R. Kist, J.L. Locher, and F. Wierda, eds., *M.C. Escher: His Life and Complete Graphic Work*, New York, Harry N. Abrams, 1982.

Islamic Patterns: The Spark in Escher's Genius

S. Jan Abas

It is generally known that Escher was influenced by Islamic patterns. In fact Islamic patterns played a key role in his personal "metamorphoses" which transformed his art. In this article I will first highlight the impact of Islamic patterns on Escher's artistic development and correct some major misconceptions about the driving psychology behind these patterns. After that, I will show some examples of my own art which sets out to develop and extend Islamic patterns. I will also explain what inspires me.

Escher's Deepest Inspiration

Although Escher explored a variety of distinct modes in two and three dimensions, his consuming passion continued to be the *periodic division of the plane.* Writing on the subject he enthused [4, p. 35], "This is the richest source of inspiration that I have ever met." Escher displayed a predisposition to explore tessellations from the earliest time in his career. In 1922, while still learning graphic arts from S. Jessurun de Mesuquita at the School for Architecture and Decorative Art in Haarlem, he produced the early woodcut *Eight Heads* [2, cat. no. 90], demonstrating his innate fascination with rhythmic repetitions. It was this seedling which eventually blossomed into his unique art and it was the very same interest which remained a focus of attention throughout his life.

Although it is true that Escher was inspired right from the start to create space-filling rhythmic designs on plane surfaces and worked on them from the early 1920s, he nevertheless failed to produce anything of significance until 1937. As Bruno Ernst remarks [4, p. 36], "Escher made tremendous efforts to express a rhythmic theme on a plane surface, but he failed to bring it off. All he could manage to produce were some rather ugly, mis-shapen little beasts."

The *metamorphosis* of Escher the artist, which resulted in the transformation of his ugly ducklings into fascinating swans, occurred when Escher made his second visit to the Alhambra in 1936. There, together with his wife Jetta, the artist made a concentrated study of Islamic tilings. Thus it was in the Alhambra, through his analysis of Islamic patterns, that Escher found his "richest source of inspiration." (See [2], [4], [10].) Escher acknowledged and paid tribute to the artists of Alhambra when he wrote [4, p. 37], "The Moors were masters in the filling of surface with congruent figures and left no gaps over. In the Alhambra, in Spain, especially, they decorated the walls by placing congruent multicolored pieces of majolica together without interstices."

Fig. 1. By introducing a few circles to an Islamic geometric tessellation, we can easily suggest animated creatures

It is not at all difficult to see how abstract Islamic geometric designs triggered Escher's imagination into visualizing fish, birds, lizards and other creatures. In Fig. 1, I have added to the purely geometric tiling from the Alhambra only a few circular shapes in appropriate places; this addition easily suggests living creatures. This is how figurative designs on carpets have evolved. With a little bit of imagination one can visualize a variety of living forms contained in the geometrical outlines of such tilings.

This is how Escher's art was born. His early sketchbooks clearly show how he often began with a strictly geometric tessellation and aded a few curved lines to suggest a living shape. He then worked at it until he had the very recognizable living shapes he desired. In [10] the reader will find several examples of Escher's early numbered drawings where he documents the design from the Alhambra source from which it was derived.

A Common Misunderstanding About Islamic Patterns

Although Escher mastered the geometrical structures of Islamic patterns, he assumed that geometry was forced on Islamic art by religious proscription. Lamenting this, he wrote [4, p. 37]:

> What a pity it was that Islam forbade the making of "images."
> In their tessellations they restricted themselves to figures with
> abstracted geometrical shapes. So far as I know, no single Moorish
> artist ever made so bold (or maybe the idea never dawned on him)
> as to use concrete, recognizable figures such as birds, fish, reptiles,
> and human beings as elements of their tessellations.

The first thing I would say is that, I for one am grateful that the walls of Alhambra are not covered with birds, fish, reptiles, human beings and other living creatures. I rejoice in the purity, simplicity and elegance of abstract geometrical shapes. In fact I find it rather puzzling and something of a contradiction that Escher said what has just been quoted, for he himself was lyrical about the non-figurative geometrical shapes, the regularity and the spatial

constraints displayed by crystals. Escher was himself absolutely thrilled by precisely the qualities which gripped the imagination of the Moorish artists. He himself saw something spiritual and beyond the human world in the very same attributes. He wrote [4, p. 93], "There is something breathtaking about the basic laws of crystals. They are in no sense a discovery of the human mind; they just 'are' – they exist quite independently of us."

Many people quote Escher's lament ("What a pity . . . ") out of context, that is, they think that Escher believed that Islamic artisans and artists were forbidden to make any life-like images. But his lament is specifically about the regular repeating mosaics and patterns that are found so abundantly in Islamic decoration. In fact, Escher was aware of the fact that the Koran did not forbid making images, and that the prohibition of such images was contained in tradition and other holy writings. Here is what Escher wrote about this in his 1957 book *Regular Division of the Plane* [2, p. 162]:

> *I have often wondered why, in their decorative zeal, the designers of patterns such as these never, as far as I know, went beyond abstract motifs to recognizable representation. This does not detract from the beauty and ingenuity of their creations, in which more and less complicated systems can already be distinguished. . . . The figure in C [an Alhambra tessellation], in particular, reminds me of 'something I know' – a hammer, a bird, or an aeroplane.*
>
> *As it is precisely this crossing of the divide between abstract and concrete representations, between 'mute' and 'speaking' figures, which leads to the heart of what fascinates me above all in the regular division of the plane, it is important to discover whether there are actually reasons why figurative representations are not found anywhere.*
>
> *. . . Regarding the Muslims, I gained my information from someone who is more familiar with the subject than I. The following is an excerpt from his letter:*
>
> *'I have found an article by the great Islamic scholar Professor C. Snouck Hurgronje (in his* Miscellaneous Writings II, *pp. 453 ff), from which I gather that there is no prohibition in the Koran concerning the depiction of living creatures, but that it is based on the sacred text (*hadith*) which reads: "He who makes images will suffer the most severe punishment on the Last Day." This refers to the makers of images, while a text about the presence of images in houses reads that "the angels of mercy do not enter dwellings where there are images."'*
>
> *'The orthodox writings completely confirm these texts. They describe the creation of images of well-loved or respected people as an abomination, because they see it as the root of idolatry. Moreover, depicting anything that has been created is an imitation of*

the work of Creation and can therefore only be a caricature. This kind of presumption is wrongful in the eyes of God, and on the Last Day the wretched image-makers will be required to blow life into their creations. This is the theory; in practice, however, it is different and even the various books of law make concessions, which in general terms boil down to the idea that if an image is made or put in such a place that it will be treated or touched without respect – for instance, pictures on carpets that are trodden underfoot or cushions that are sat upon, or in corridors or places where it would be impossible for them to lead to idolatry – the use of images is not forbidden. This applies to the user, not to the maker; for the maker, the letter of the law applies . . . '

'In countries like Persia and India these commandments were set aside on a large scale; however, I do not know what the situation was in countries where the law was adhered to more strictly, in Arabia for example, and presumably also in Moorish Spain. In Persia and India not only were animals depicted quite freely, but also people, and even the Prophet, not to mention the rulers, military leaders, important officials, etc., although this was mainly in miniaturist art.'

'Thus there was a prohibition, not in the Koran but in the religious tradition, for the maker and the user with regard to the representation of living creatures. It was thought to conflict with the ideas on the work of the Creator, which cannot be equalled by mortal man, any such attempt only leading to caricature.'

So although Escher was correct that the Moorish artists restricted their tessellations to mosaics of non-figureative shapes, there was not a total prohibition of life-like pictures. Indeed works by Moorish artists that show scenes of battles, lion hunt, boar hunt, council meeting and other events can be found in the very Alhambra where Escher learnt his craft (see, for example [6]). The ceiling in the Alhambra's *Hall of Kings* is covered with excellent life-like

Fig. 2. A section of the ceiling in the Hall of the Kings in the Alhambra

portraits of the Kings of Alhambra; Fig. 2 shows a portion of that ceiling. The fact is that there is a vast body of figurative work by Muslin artists. Apart from the Persian miniatures, which, granted, are stylized and flat, there are a large number of realistic life-like pictures that have been executed with great virtuosity and naturalism. The reader will find many fine examples of these in [11].

No! The explanation that geometry was forced on Islamic art by religious dogma is itself just a dogma. It may suffice at a very superficial level, but as I will show, it misses out entirely the actual mechanisms which caused Islamic art to turn to geometry, Arabic calligraphy, star-shaped polygons, interlacing, and tessellations over large surface areas.

The Driving Mechanisms Behind Islamic Art

I would like to point out five different major influences which, in my view, forged Islamic geometric art.

1. *No image of God except Light.* The central reason for the substantially non-figurative nature of Islamic art arises from the fact that Islam offered no image of God. Indeed, it arose on its very first dawn with a burning passion to destroy idolatry and replace all anthropomorphic images of God with a single abstraction. For a Muslim, unlike a Christian or a Hindu, God did not, and would not at some future date, choose to become *flesh*. The only material image of God that a Muslim is prepared to employ is that of *Nur*, meaning light. *Allahu Nurus Samawat Wul Ardh* – God is the light of the heavens and earth – proclaims the Koran.

2. *God spoke in Arabic.* Although, according to Muslim belief, God did not become *flesh*, 'He' nevertheless spoke in a human tongue. He chose to address his penultimate message to the human race in Arabic[1]. For this reason the Arabic language and its script carry a godly attribute for all Muslims. Unlike Christians, Muslims recite their holy book and say their prayers in Arabic, no matter in which country they live and no matter what their mother tongue. This language triggers in them feelings of holiness and closeness to God.

Escher, understandably, failed to appreciate the significance of the fact that the Alhambra is covered not only with geometric shapes but also with Arabic calligraphy. Had Escher seen the Alhambra through Muslim eyes, he would have been struck by the frequent occurrence of the Nasrid motto *Wala Ghalib Ala Allah*, which means Allah is the only victor (see Fig. 3). He would have noted that Arabic calligraphy always occupies a higher placement in space than do the geometric tilings.

3. *Geometry is spiritual.* Long before the birth of Islam, several of the classical Greek philosophers had associated religious and mystical qualities with geometry. The abstract definitions and logical consistency of the subject had

[1] Actually, according to Muslim belief, God did not communicate directly with prophet Mohammed, but through the Angel Gabriel.

Fig. 3. The Nasrid motto, *Wala Ghalib Ala Allah*, (*Allah is the only victor*) is inscribed everywhere in the Alhambra

been seen as pointers to a perfect world underlying gross reality and hence pointed to the gods. "God ever geometrizes," Plato had proclaimed.

Imbued as they were with the idea of an abstract God, Muslim intellectuals found such notions of Greek geometers immensely agreeable. They immediately concurred that geometry offers the unifying intermediary between the material and the spiritual world. This appeal led to the books of Euclid and Pythagoras being among the very first to be translated into Arabic. Starting with large-scale translations of these in the 8th century, the appreciation of geometry grew and became rapidly and widely established in the Islamic world [7]. Galileo, the founder of modern scientific method, wrote [8, p. 47]:

> *Philosophy is written in this grand book, the universe, which stands continually open to our gaze. But the book cannot be understood unless one first learns to comprehend the language and read the letters in which it is composed. It is written in the language of mathematics, and its characters are triangles, circles, and other geometric figures without which it is humanly impossible to understand a word of it; without these one wanders about in a dark labyrinth.*

Muslim scholars proclaimed that [3, p. 7]:

> *... the study of sensible geometry leads to skill in all the practical arts, while the study of intelligible geometry leads to skill in intellectual arts because this science is one of the gates through which we move to the knowledge of the essence of the soul, and that is the root of all knowledge.*

Muslim artists became hooked on triangles, circles and other geometric figures.

4. *Passion for and reliance on stars.* Monuments left behind by people of the stone age bear witness to the fact that human interaction with the heavens has a long history. People of ancient civilizations such as the Babylonians, Egyptians, Indians, Mayans, and Chinese, were all dedicated observers of heavenly bodies and sought to be guided by them in religious as well as practical matters. Not surprisingly, star shapes have a universal attraction. One only has to look at the flags of nations to verify this.

The people who embraced Islam were not only heir to this ancient tradition, but had even greater need to consult the stars. Many of them dwelt in deserts and their way of life involved nomadic wandering over large areas of land. The Arabs were also adventurous seafarers and sailed over considerable distances. Both kinds of travel demanded skillful observation of the heavens for navigation.

Furthermore, Islam enforced a unique requirement on the faithful. Whether on land or sea, a Muslim has to know, five times a day, the exact direction in which to pray. All this made the stars extraordinarily significant to the early Islamic cultures. The Koran abounds with verses which conjure up powerful images on the theme *Allah it is who hath set for you the stars that ye may guide your course by them amid the darkness of the land and the sea* (V:98).

In Islamic culture, astronomy satisfied religious, practical, and intellectual needs. The first observatory which gathered together eminent astronomers from many lands and conducted systematic observations was built at Maraghah in Iran in the 13th century. Many stars were named by Muslim astronomers and continue to be known by their Arabic names. From the 9th century onwards, when Ptolemy's work was translated into Arabic, until the latter part of the 15th century, astronomy remained the most passionate intellectual activity in the Islamic world [7]. Instruments such as the *Astrolabe* and words such as *Almagest* are reminders of the Islamic legacy in the subject.

5. *Experience of carpet weaving and tent dwelling.* For the majority of people today, carpets represent the most *Islamic* of Islamic art forms. They are sought after by connoisseurs as works of art, by the rich for interior decorations, and by investors for financial gain. Many who have no appreciation of other Islamic art forms, such as calligraphy, nevertheless crave a Persian carpet.

Carpets reflect the nomadic tent-dwelling origins of many of the populations who embraced Islam. The craft of carpet weaving has been practiced throughout the Middle East and the Caucasus region for a very long time. In particular, the nomadic tribes of Central Asia, Persia and Afghanistan have been producing carpets for thousands of years. Figure 4 shows the central portion of the *Pazyryk rug*, now kept in the Hermitage Museum in St. Petersburg, Russia; it has been dated as being around 2400 years old. It was found in a tomb unearthed by Russian archaeologists in 1947 in the Pazyryk Valley in the mountainous Altai Range in southern Siberia.

Carpets and rugs have served many purposes for these people. They have been used as floor coverings, prayer mats, tent decorations, canopies, and as symbols of power, privilege and riches. They have been ceremoniously laid to pay respect to royal thrones and seat honored guests. They have played a prominent role in the celebration of weddings and feasts. Carpets undoubtedly represent the most ancient and the most meaningful art form in the nomadic tent-dwelling environment.

And what does carpet weaving involve? As Fig. 4 abundantly shows, it involves interlacing to produce tessellating repeat patterns, i.e. the practice of the very same skills that were exercised in the Alhambra. It is also a fact that although carpets have been produced for a very long time and embody all forms of Islamic art – abstract geometric, floral, figurative and arabesque – the abstract geometrical patterns have the longest history.

With the knowledge of these five influences on Islamic art, it now becomes possible to shed the 'dogma' about the origins of Islamic art and identify the actual key factors which led to its concentration on geometrical patterns. Until

Fig. 4. The central portion of the *Pazyryk rug*, dated as being around 2400 years old

very recently, the major concern of art in every culture has been the depiction of the deity and Islamic art was similarly concerned. Since Islam offered *light* as the only material image of God and since the light of heavens is created by stars, one would expect Muslim artists to employ star shapes and radiating lines (to mimic the behavior of light) to portray God (see [1]).

Since geometry was seen as the intermediary between the material and the spiritual world, one would expect Islamic art to concentrate on geometry to portray perfection. Since the Arabic language evokes a sense of holiness to Muslims, one shouldn't be surprised to find it being employed for inspirational purposes in Islamic art. In fact, Arabic calligraphy is regarded by Muslims as the most exalted art form.

Since abstract interlaced infinite repeat patterns on carpets and rugs have been an integral part, from ancient times, of the life and culture of people who embraced Islam, we should expect to see them on other surfaces which came to replace carpets and rugs. Since the covering of surfaces with tessellations is a tradition that goes back to a nomadic tent-dwelling past, we should not be surprised to discover that the walls of Islamic buildings are covered with tessellations.

To conclude, Islamic art did not take the route it did through the *fear of God*. It did so through the *love of God*. It did so to depict perfection and to point to an orderly world beyond gross and chaotic reality. In doing so it utilized and developed those elements that were most meaningful for its purposes and those art forms and traditions which had played the most central role in the life and culture of its people.

The Inspiration for My Art

In 1964, when I was a graduate student of University College London, I set out with some other fellow students to drive to Southern Morocco and explore parts

of the Sahara desert. On the way we stopped in Granada and like other visitors to this city, I went to gaze at the Alhambra. I was utterly mesmerized. It was love at first sight. I had read that when the Moghal Emperor Babur first saw Kashmir, he cried out

Agar Firdaus Ber Ruye Zamin Ast, HAMIN ASTO HAMIN ASTO HAMIN AST.
(If Paradise exists on the surface of this earth, IT IS HERE IT IS HERE IT IS HERE.)
I found myself repeating Babur's words. I had never seen such grace, such colors, such proportions, such patterns, such calligraphy, such shadows, such delicate plaster, such intricate tiles, such magical gardens, such sunlit patios, such shady courtyards, such flowing waters, such bubbling fountains . . . What creatures had made this palace, I wondered. I was greatly moved to know that I was born in the culture whose people had created this paradise. I could hear ancestral voices commanding me: "study these patterns . . . cherish them . . . extend them . . . go away and build a new Alhambra."

Although I was smitten by geometrical patterns in the Alhambra as long ago as 1964, it was not until 1986 that I could find the time to study them. I was employed as an applied mathematician and spent the first part of my career working in computational physics. But I never forgot the Alhambra. Gradually, from physics I drifted into computer science and computer graphics. I could now justify doing research into patterns of beauty. After a second visit to the Alhambra in 1985, I began my study of Islamic patterns using computer graphics. My book [1] is a direct result of this long-held passion which shows no sign of subsiding. The book is dedicated to my mother and to "those who conceived and built the Alhambra."

Thus, I have this much in common with the great Escher: I also found my deepest inspiration in the Alhambra. My first visit inspired and enchanted me but it was the second visit, twenty-one years later, that triggered my transformation. Like Escher, my artistic education began in earnest with analysis and reproduction (using computer graphics in my case) of the patterns of the Alhambra.

What is My Art About?

It is important to say in a finite number of words what my art is about, but it is driven by two global passions. These are: (i) to discover beauty in the unity of science, art, philosophy and 'religion' and (ii) to rejoice in my cultural heritage and to develop it further. Islamic art satisfies me in both these quests. It does so because it deals in pattern, symmetry, replication, and 'word' and these four elements offer the most potent mixture for the celebration of unity that we can discover. It is unlikely that many readers of this book need to be told about the significance of pattern and symmetry in offering unity. So I will say nothing about these and refer the reader to Chapter 2 of my book [1], where I have

developed the topic. I will make only a few brief remarks about the other two elements.

The act of replication is synonymous with life. Life began on planet Earth, when somehow, about four thousand million years ago, a molecule learnt to replicate itself. DNA was born. The simple act of replication is the most miraculous in the whole universe. In Islamic art, replicating pattern has been used to symbolize the infinite. It relates something static, limited, definite, and transient, with that which is dynamic, unbounded, infinite, and eternal. For these reasons, replication speaks to me about life, sex, DNA, 'God,' infinity, and immortality.

The celebration of the 'sanctity of the spoken word' through calligraphy is another feature of Islamic art which lends itself to profound interpretation. Spoken language is the unique characteristic of the human species. It was the development of the power of speech in our brain, a million or so years ago, which gave us our capacity for self-awareness and for an awareness of a world beyond that of immediate experience to which other creatures are confined. It was acquisition of language which separated our brain from the brains of all other species and set us on the road to culture, civilization, technology, and the trip to the moon.

It amazes me that despite the Bible's proclamation *In the beginning was the word and the word was with God and the word was God*, Western art has failed to celebrate 'the word.' In the West, calligraphy has always been seen and continues to be seen as a mere craft. In contrast, in the Islamic world, calligraphy is regarded as the highest art form. For me, it symbolizes human consciousness, human intelligence, human moral sense, and all else that we humans possess over and above other animals.

Some Examples of My Art

I conclude this article by showing some examples of my art. It needs to be made clear that all my work originates through the use of computer graphics. So far those pieces which I have produced entirely through my own labors have all been in the form of prints. However, through collaborating with other skilled persons I have been able to transform some of my computer-graphics conceptions into ceramic tiles and murals, sculptures, wall hangings, and other realizations. The interested reader may like to visit my Web pages for more examples of my art: www.bangor.ac.uk/IslamicArt, and www.islamicart2000.com

Figures 5 and 6 are intended to show some of the ways I am developing Islamic patterns beyond their simple Euclidean two-dimensional periodic origins. Figure 5 shows a complex non-periodic tessellation which gives rise to a five-pointed star, a revered symbol in Islamic culture which appears on the flags of the great majority of Islamic nations.

Traditional Islamic art has not utilized the concept of sculpture. This is one of the areas I am currently developing. The object at the left in Fig. 6 shows an example. Another area into which I am extending Islamic patterns is that of

Fig. 5. S.J. Abas. A new non-periodic Islamic tiling

hyperbolic geometry. This is of special significance in a book about Escher. The image at the right in Fig. 6 shows the transformation of an Islamic pattern from Euclidean into hyperbolic space.

Figure 7 shows examples of my conceptions created in media other than computer prints. The left figure shows a new pattern that has been transferred to ceramic plates, ceramic murals and glass. The right figure comes from extending a classical flat Islamic design into three dimensions and is typical of those that have been turned into wall hangings. The pattern shown uses stylized *Kufic* script to transcribe 'Ali,' the name of Prophet Mohammed's son-in-law. Ali was the fourth Caliph and is highly revered by the Shia sect of Muslims.

My two works in color plates 30 and 31 are intended to show examples of the kind of globally unifying themes in which I am most interested. The most profound question that concerns the individual is the question: *Who am I?* Reli-

Fig. 6. S.J. Abas. Extensions of Islamic patterns to a three-dimensional surface and to the hyperbolic plane

Fig. 7. S.J. Abas. Work translated from computer graphic prints onto other media

gion, philosophy, mysticism, literature, poetry, science and art all address this question. In color plate 30 I show one of my efforts to portray this question. This piece I have called *Tu Kisti?*, which in Farsi means *Who art thou?* The calligraphic inscription on the top cube transcribes a verse by the Pakistani poet Allamah Sir Mohammed Iqbal (1875–1938), which translates as:

> *Who art thou*
> *That the blue skies*
> *Have opened for thee*
> *A thousand starry eyes?*

Color plate 31 shows a version of my work which I call *The Islamic Ferric Wheel* [1, p. 40]. It sets out to celebrate the discovery, through applied science, of a beautifully symmetric structure, namely that of the molecule $[Fe(OCH_3)_2(O_2CCH_2Cl)]_{10}$, known more simply as the Ferric Wheel. The molecule was synthesized by the American chemists Stephen J. Lippard and Kingsley L. Taft in 1990 in their efforts to understand certain chemical reactions that occur in biological systems. Such structures have been explored in Islamic patterns [1, p. 41] and are strikingly beautiful. Writing in *Scientific American* [5, p. 70], the chemist Roald Hoffmann, who won the Nobel Prize in Chemistry in 1981, had this to say about the Ferric Wheel:

> *– for me, this molecule provides a spiritual high akin to hearing a Haydn piano trio I like. Why is this molecule beautiful? Because its symmetry reaches directly into the soul. It plays a note on a Platonic ideal. Perhaps I should have compared it to Judy Collins singing "Amazing Graze" rather than the Haydn trio. The melodic lines of the trio indeed sing, but the piece works its effect through counterpoint, the tools of complexity. The ferric wheel is pure melody.*

Acknowledgments

The tessellation shown in Fig. 5 was discovered in a collaborative study of Penrose patterns with Jaime Rangel-Mondragon [9]. Figure 6 originates from a collaboration with Gareth Williams; I am also grateful to him for his general help in program development for my art work. The calligraphy in color plate 30 was transcribed in its original form by the calligrapher Aziz Ahmed of London. Finally, I thank Dr. Ibrahim Sheikh of Manchester for supplying me with a photograph of the Kings of Alhambra for Fig. 2.

References

[1] Abas, S.J. and Salman, A. S, *Symmetries of Islamic Geometrical Patterns*, World Scientific Publishers, Singapore, 1995.

[2] Bool, F.H., Kist, J.R., Locher, J.L., and Wierda, F., *M.C. Escher, His Life and Complete Graphic Work*, Harry Abrams, New York, 1982.

[3] Critchlow, K., *Islamic Patterns: An Analytical and Cosmologcal Approach*, Thames and Hudson, London, 1976. Paperback edition 1983.

[4] Ernst, B., *The Magic Mirror of M.C. Esher*, Ballantine Books, New York, 1976.

[5] Hoffman, Roald, "How Should Chemists Think?," *Scientific American*, vol. 263, no. 2 (1993) 66–73.

[6] Murphy, J.C., *The Arabian Antiquities of Spain: The Alhambra*, James Cavanah Murphy, Granada, 1987.

[7] Nasr, S.H., *Islamic Science: an Illustrated Study*, World of Islam Festival Publishing Company, London, 1976.

[8] Opper, J., *Science and the Arts: A Study in relationships from 1600–1900*, Associated University Presses, Cranbury, New Jersey, 1973.

[9] Rangel-Mondragon, J. and Abas, S.J., "Computer Generation of Penrose Tilings," *Computer Graphics Forum*, vol. 7, (1988) 29–37.

[10] Schattschneider, D., *Visions of Symmetry: Notebooks, Periodic Drawings, and Related Work of M.C. Escher*, W.H. Freeman & Co., New York, 1990.

[11] Welch, C.W., *Imperial Mughal Paintings*, Chatto & Windus, London, 1978.

Space Time with M.C. Escher and R. Buckminster Fuller

Victor Acevedo

Escher as Inspiration

My first memory of seeing M.C. Escher's work was in the mid-sixties, at age 10 or 11, when I pored over a Time-Life series book – I recall seeing his prints *Relativity* and *House of Stairs*. I didn't realize then how profoundly Escher's work would affect my life's path.

Like Escher, my serious artistic interest was first aroused by an art class in high school (in Alhambra, a small town near Pasadena, California). I often think about the uncanny synchronicity of the town's name. A few years after this, I saw the large Escher retrospective exhibition held at the Museum of Science and Industry in Los Angeles, and was fascinated by his images. Soon after, I was introduced to the book called *The World of M.C. Escher* [6].

Perhaps the first real connection of my art to that of Escher began with my pilgrimage to the Alhambra, in Granada, Spain, in July 1977. I arrived at the Alhambra in the early hours a bit under the weather; I thought for sure that I had a cold or flu. But amazingly, it seemed that after hours of exposure to the calm and harmonic resonance of the palace and gardens I felt completely well.

As Escher had done before me, I had come to view the encyclopedic and miraculous array of periodic tilings that adorn the palace. It was fantastic and amazingly inspiring. What I didn't expect was a perceptual ontological epiphany. Standing at one of the portals overlooking the city, I looked through a large plate of contemporary safety glass which most likely was placed to prevent young children from falling to their death. However it also had a phenomenological function. It reflected superbly an adjacent section of an intricate Moorish tessellation and in effect, transparently composited it over the viewable scene below, comprised of buildings, plant life, and rock formations in the distance (Fig. 1). It was here in an instant, that the essential pictorial metaphor of my œuvre was born.

In 1978, I acquired two more books about Escher and his work: *The Magic Mirror of M.C. Escher* [3] and *Fantasy and Symmetry: the Periodic Drawings of M.C. Escher* [7]. I would peruse these again and again as I strove to unlock Escher's secrets. Another book acquired that year was *The Tao of Physics*, by Fritjof Capra [2]. *The Tao* ... exploded my outlook and gave me a comprehensive conceptual basis on which to support the theoretical aspects of my work. Its premise is that the world-view and, specifically, the general description of sub-atomic phenomena by Western particle physicists, is becoming almost interchangeable with the description of reality found in the major forms of Eastern mysticism.

Fig. 1. Tessellated overlay in a glass reflection at a portal in the Alhambra, July 1977

Capra's systematic comparison of the two disciplines implies a compelling cosmography that is captured in Escher's zoomorphic tessellations. Here, seen as both a perceptual phenomenon and a graphic metaphor, Escher's work points to a visual art that both embodies and is an artifact of a multisensory and metaphysical "seeing." For example, Escher's print *Reptiles* (see page 307) illustrates quite nicely the dynamic tendency of subatomic events and also lifeforms to appear and disappear, their vital patterns and symmetry temporarily discerned as they emerge from and return to an underlying morphogenetic field. Some Eastern mystics would call this field the "void-matrix." In this case, *Reptiles* is only a metaphor. In the *real* world, a form's properties aren't as easily discerned when they're resident in the void. I would imagine that their past or future life symmetries are remapped across space-time. In a related connection, it is interesting that in 1961 Chen Ning Yang used Escher's pattern No. 67 of glide-reflected horseman (see page 12) to illustrate his application of apprehended symmetry operations in his exploration of particle physics.

The Quest to Understand Escher's Method of Tessellation

Although I had struggled to understand Escher's technique of making tessellations by working over the MacGillavry book, I was unable to grasp the essentials

Fig. 2. An example from Escher's notebooks revealing the underlying structure of a tessellation

from that technical text. In the summer of 1979 I had the opportunity to spend a week in the Hague, where, with the permission of the Gemeentemuseum, I finally was able to learn from Escher's original notebooks. I knew that Escher and his wife had made copies of the Moorish tessellations at the Alhambra, so I thought I might study Escher's notebooks and build on what he did with the patterns. For seven days straight, I made hand-transcriptions of Escher's personal notebooks, and during that time, I finally unlocked (for me) Escher's tessellation methods. (The full content of the notebooks was published in the 1990 book *Visions of Symmetry* [9].)

It was the dot-to-dot coordinates on graph paper that revealed how the zoomorphic perimeter of Escher's figures were constructed (Fig. 2). Escher's dot plotting and connecting curves that outline animal perimeters have much in common conceptually with computer-generated vector graphics. The underlying cartesian grid of his graph paper is not unlike the underlying pixel grid employed in digital raster graphics. Moreover, the nature of the patterns' figure-ground perceptual duality is a striking metaphor for the on-off phenomenology of the digital domain in general.

Tessellated Overlays

About eight months before seeing Escher's notebooks, I made my first attempt to use a tessellated overlay on an image, as inspired by my perceptual experience at the Alhambra. This was the oil on canvas called *Napoleonic Seal* (Fig. 3a).

I based this neo-surrealist work very loosely on Leonardo's *The Last Supper* but I featured a pagan effigy of an animal-like god at the center. If you interpret the triangular seal's fins as the corners of a hat, then the figure at the center of the table is a conquering imperial hero (Napoleonic). If you read them as fins, then it is a victimized Seal lying prostrate on its dry-docked "Waterloo," as it was in its original source image. It seemed an apt metaphor for the bittersweet paradox of human experience and the fate of some of our greatest saints.

a

b

Fig. 3. (**a**) Victor Acevedo, *Napoleonic Seal*, 1979, Oil on canvas. (**b**) A detail of the tessellated overlay in this work

The use of an overlay of periodic pattern (Fig. 3b) can be seen on the three "extraterrestrials" in the lower right corner of the composition. Embedded in the head of the alien on the right is an array of cubic blocks familiar from psychological perception studies of convex/concave and used by Escher in his print *Metamorphosis II* (see page 147).

An Alternative Approach to Zoomorphic Tessellation

In April 1980, I produced the pencil drawing called *Four-fold Rotational Wasp - Fish Orifice Covet* (Fig. 4). It began as the basis of a grayscale study for my color class at Art Center College of Design and was the first complete work that was a direct result of my study of Escher's notebooks. Structured on a 5×7 matrix of squares, this composition was intended to combine three different types of pictorial idioms: surrealist allegorical figuration, nonobjective geometry, and Escher-like zoomorphic tessellation.

It was seeing and transcribing an insect pattern from Escher's notebooks that inspired me to create the 4-fold rotational wasp. I could have easily emulated the figure-ground interchangeability of Escher's zoomorphics, but I felt my work would have seemed too derivative. I decided to adopt an open-packed style. My rationale for this was based on looking at photos of groups of parachutists holding hands as they floated down. I noticed the abstract interstitial spaces between the figures – here you don't see the figure-ground toggle. Curiously, at the time, I did not reference the ubiquitous use of open arrays as seen in textile pattern design, especially with botanical motifs.

Fig. 4. Victor Acevedo, *Four-Fold Rotational Wasp: Fish orifice Covet*, 1980. Graphite on paper

For my own zoomorphic tessellation I experimented with a looser calli-
graphic approach to the linear perimeters of figures and used erratic color
schemes. The underlying drawing would be periodic but the coloration was
somewhat randomized. (See the *Slated Breakfast* color study on the CD
Rom.) In the tessellation study for the painting called *Synchromesh Cezannic
Kennedy* there are permutations and anamorphs of a 3-fold rotational bird
pattern (Fig. 5b). I always thought it unfortunate that the intricate crystalline
effect of this "neo-expressive tessellation meltdown" was never as crisp in the
final painting (Fig. 5a). This effect is almost like administering a wave filter in
Adobe Photoshop. If you look at the final canvas, this pattern appears almost like
an impressionist's version of its original tight-knit faceting.

a

b

Fig. 5. (a) Victor Acevedo, *Synchromesh Cezannic Kennedy*, 1982.
Oil on canvas. **(b)** Study for this work. Graphite on paper

From Polygons to Polyhedra

In the Spring of 1980 I saw a diagram in *Polyhedra: A Visual Approach* [8]. This convinced me to expand my study of polygonal periodic tilings to include the exploration of space filling and open-packed polyhedral nets or arrays. I had already become aware of Escher's interest and work with polyhedra by reading chapter 14 "Marvelous Designs in Nature and Mathematics," in *Magic Mirror*. Space-filling polyhedra are the logical 3D counterpart to plane-filling polygons, which are the underlying support to Escher's zoomorphic work. Although

a

b

Fig. 6. (**a**) Victor Acevedo, *Approximately Noon Onward: Icosahedronic Moment*, 1981–3. Oil on canvas. (**b**) Sculptural study for this work. Folded postcards

contiguous face-to-face zoomorphic polyhedra are theoretically possible, their complexities most likely require computer graphics with a time-based system of interlace to be realized in a satisfying manner.

Sometime later I acquired a copy of the book *M.C. Escher Kaleidocycles*, co-authored by Doris Schattschneider [10]. Inspired by her Escher-based development of tessellation-covered polyhedra, I began to use the technique in preliminary sculpture studies for drawings and paintings. However in most cases I used "texture-mapping" that was nonperiodic or made up of bits of the surrounding pictorial evironment itself. My painting *Approximately Noon Onward: Icosahedronic Moment* (Fig. 6a) made in 1982–3 included a cluster of icosahedra which I first rendered as a sculpture by folding up a group of ordinary picture postcards (Fig. 6b).

The tessellation study for *Sad Voyeur Watching Orthogonal Womanhood* shows orthographic perspectival cubical clusters housing zoomorphic data (Fig. 7). I enjoyed the self-similarity and tension between the hexagonal hous-

a

b

Fig. 7. (**a**) Victor Acevedo, *Sad Voyeur Watching Orthogonal Womanhood*, 1982. Oil on canvas. (**b**) Tessellation study for this work. Graphite on paper

ings for the cubes and their corresponding rotational symmetry. This study was inspired by the well-known interpenetrating golden mean rectangles that can be used as scaffolding to circumscribe an icosahedron.

The Influence of R. Buckminster Fuller

It's hard to describe the effect that Buckminster Fuller had on me. He certainly changed my life – for the better. I had the great fortune to be with him many times in various settings: everything from being one of an audience of thousands to one on one, all during the last six months of his life. It certainly was an extraordinary time. I've never met anyone like him before or since; I feel he is one of the most remarkable human beings I've ever met – a kind of Roshi or holy man and yet "the high priest of technology," as he was described on the front page of the *Los Angeles Times* at the time of his death in July 1983.

I had first heard of him in 1969 through my older brother David, but it wasn't until 1980 that I started actively reading and studying Fuller's books. I recommend *Synergetics* [4], [5] to anyone interested in form and structure, from metaphor to architecture. It's one thing to be fascinated with polyhedra and their spatial and aesthetic properties. It's quite another to find, as I did in Fuller, an awesomely comprehensive cosmography utilizing their topological properties as tools for modeling micro and macro energetic phenomena.

It was Fuller's isotropic vector matrix (IVM) – a spatial network made up of closely-packed tetrahedra and octahedra – that I have found the most applicable to my work so far. This close-packing appears in Escher's 1959 lithograph *Flatworms* [1, cat. no. 431] in the strange underwater labyrinth which the creatures inhabit. As Escher would make geometrical models to inform and enliven his graphic work, I did as well. Around this time, I built my own model of this structure out of wood and styrofoam (Fig. 8). Another polyhedral space filler I've utilized in net form is the truncated octahedron.

An important aspect of Fuller's work that is relevant to visual art is his geometry. Based on triangulation and sphericity, it offers a graphic language

Fig. 8. Victor Acevedo, *Isotropic Vector Matrix*, 1983. Wood and styrofoam

that is non-cubist and non-cubical. It includes Euler's polyhedral topology of visual experience which consists of line, crossings and windows (i.e. edges, vertices and faces). This updates the 19th-century's geometric tool set of "cylinder, sphere and cone" and its resultant legacy, the 20th-century's lexicon of graphical abstraction based on Cubism.

Since 1982, from traditional painting and drawing to digital media, I have utilized the isotropic vector matrix or "octet truss" as a way to explore graphical phenomenology. On the symbolic level, a graphed IVM can represent the *void-matrix* – the universal substrate, paradoxically oscillating between eternal emptiness and the fullness of an all-pervasive potentiality – the source for the perpetual cosmic dance of life and death of all forms.

This metaphysical read of the IVM comes from my study of *The Tao of Physics*. In 1983 my graphical worldview was reaffirmed by reading *The Holographic Paradigm and other Paradoxes: exploring the leading edge of Science*, edited by Ken Wilber [11]. It encouraged me to continue to make art that is about the underlying structural nature of things. One particular essay, "A Multidimensional View," by William A. Tiller, was to profoundly affect my thinking. Tiller postulates that space is a six-dimensional Euclidean space articulated as a close-packed hexagonal lattice with active nodal points. This sounded very much like a partial description of Fuller's vectorial matrices.

It was a simple intuitive jump to replace my tessellation overlays with polyhedral overlays and to render the closely-packed volumes as skeletal polyhedral nets, allowing the interpenetration to be seen. What inspired this was the many color plates in the back of *Synergetics 2* illustrating various localized polyhedral domains nesting perfectly in an aggregate IVM. They suggested a new paradigm for reworking my figure-ground cartography. Two of my works that employ this graphical effect can be seen on the CD Rom: *Macro Synapse – Cuboctahedron Periphery* (1982) and *Void Matrix Lattice* (1983).

Computer Graphics

By the end of 1983, I was winding down fast from the use of traditional media and began learning a new tool set: computer graphics. I first sat in on a brief computer graphics workshop held at the Long Beach Museum of Art Video Annex. The following year, in Los Angeles, I took a class at West Coast University with computer art pioneer, Tony Longson, that entailed programming simple graphics on a VAX mainframe. Later I studied the PC-based Cubicomp, an early desktop 3D modeling and animation system. In 1985, I landed my first job in computer graphics, working as a digitizer at Laser Media.

What I consider my first successful computer graphic image is called *Ectoplasmic Kitchen*, produced in 1987 (color plate 23). Combining influences from both Escher and Fuller, this work combines open-packed zoomorphics enclosed in a synergetic great-circle spherical domain. The symmetric Escher-

Fig. 9. Victor Acevedo, *The Lacemaker*, 1997. Computer graphic

like creatures are arranged about 3-fold rotation centers and emerge from an underlying triangular and hexagonal grid.

It is significant that using computers to make images rekindled my fondness for utilizing zoomorphic tessellation. The software's ability to easily replicate forms and perform symmetry operations such as rotation and translation made repeating patterns a quite natural thing to do. Escher's work in many ways prefigures the advent of digital art. Another parallel with digital art practice is Escher's production of multiple prints of an image, which suggests the possibility of the eventual apotheosis of the print, or computer *graphic* art, over painting. The current high-art value system based on the one and only original artifact can be gradually revisioned by the multifold potential of digital originals. The printouts of images that are created digitally can be considered productions, not reproductions, as in the case of traditional media art work that is digitized and then printed. Facilitated by digital imaging technologies, it's easy to predict a future where we'll see a significantly greater distribution of affordable serious visual art to an unprecedentedly large world-wide audience.

Since my early experiments with computer art on early PCs, I've continually updated my hardware and software. Conceptually, I continue to employ polyhedral nets that interpenetrate my figurative subjects, persevering with the metaphor born of that significant experience in 1977 at the Alhambra. The prospect of exploring this concept in time-based and interactive modalities is still there waiting to be done.

I close with a final image, *The Lacemaker* (Fig. 9 and color plate 24), an homage to the famous 17th-century painting by Johannes Vermeer. The original photograph at the heart of my image was taken on New Year's Eve 1995. It was not consciously posed; I caught my subject emulating the posture of *The Lacemaker* simply by happenstance. This underscores my interest in everyday life as seen, recorded, and then digitally refashioned into a kind of metaphysical photographic archive.

It's difficult to find Escher's oeuvre cited as an integral part of the mainstream story of 20th century art. However one could argue that along with Picasso, Pollock, Dali and Warhol, he is one of the most famous artists in the world. In

spite of his omission from the literature of high-art history, his work has been distributed to a mass audience via popular culture. Moreover, Escher's work continues to be studied, referenced and purveyed by the intellectual communities of mathematics and science. These very communities are today being actively sought out as the proliferation of computer graphics causes the art world to look more and more at technology.

I have always maintained that the graphical and mathematical territory that Escher first explored and charted in the 20th century will remain, in spirit, a wellspring of significant inquiry now and well into the future.

References

[1] F.H. Bool, J.R. Kist, J.L. Locher, F. Wierda, eds., *M.C. Escher, His Life and Complete Graphic Work*, New York, Harry Abrams, 1982.
[2] Fritjof Capra, *The Tao of Physics*, Boston, Shambhala Publications, 1976.
[3] Bruno Ernst, *The Magic Mirror of M.C. Escher*, New York, Random House, 1976.
[4] R. Buckminster Fuller, *Synergetics*, New York, Macmillan Publishing Company, 1975.
[5] R. Buckminster Fuller, *Synergetics 2*, New York, Macmillan Publishing Company, 1979.
[6] J. L. Locher, ed., *The World of M.C. Escher*, New York, Harry N. Abrams, 1971.
[7] Caroline MacGillvary, *Fantasy and Symmetry: the Periodic Drawings of M.C. Escher*, New York, Harry Abrams, 1976.
[8] Anthony Pugh, *Polyhedra: A Visual Approach*, Berkely, University of California Press, 1976.
[9] Doris Schattschneider, *Visions of Symmetry: Notebooks, Periodic Drawings, and Related Work of M.C. Escher*, New York, W.H. Freeman, 1990.
[10] Doris Schattschneider and Wallace Walker, *M.C. Escher Kaleidocycles*, New York, Ballantine, 1977. New edition, Rohnert Park, Pomegranate Artbooks, 1987.
[11] Ken Wilber, ed., *The Holographic Paradigm and other Paradoxes: Exploring the Leading Edge in Science*, Boston, Shambhala Publications, 1982.

Between Illusion and Reality

Sandro Del Prete

An acquaintance of mine first drew my attention to the pictures of M.C. Escher in 1979, when I had almost finished my first book [3]. It was profoundly moving for me to discover that I was not the only one to have such "crazy" ideas in his head with the ability to express them on paper. I was certain that M.C. Escher and I were kindred spirits, for our minds seemed to operate and analyze in a very similar way. Therefore I was able to understand very well what M.C. Escher must have felt when he began to deconstruct everyday phenomena, giving artistic expression to newly perceived laws, achieving astonishing effects with unusual combinations translated on to paper in ever more novel ways. Whatever could have triggered M.C. Escher to look at things in this way?

For me, it came through watching a chameleon. I asked myself what view of the world this little animal must have, being able to see in front and behind at the same time! So, I also tried to set down double views and perspectives on paper. It is very clear that I have been just as fascinated by the pictures of M.C. Escher, and he later influenced and inspired me greatly!

However, there is one very particular feature in both Escher's pictures and mine. For me, the idea behind the picture is the most important factor, and this cannot be copied. The idea gives the picture its meaning. In the introduction to his first book, Escher makes clear that his prints "were made with a view to communicating a specific line of thought" [1]. In his many descriptions and explanations of his work, both in lectures and in writing, he made clear his wish to express ideas as visual images. Naturally, technique and talent are essential to translate an idea to an image on paper.

There are differences between Escher's work and mine, however. I try to create aesthetically beautiful pictures with attractive, and sometimes humorous, characters. For this reason, you will find very little mathematical precision in my pictures, something that is always present in Escher's work. In this respect, he is truly a master who cannot be surpassed.

Although he often felt alone on his chosen artistic path, his work has inspired several contemporary artists. He can no longer be regarded simply as a minor figure in the history of art. Today, a hundred years after his birth, he stands at the center of a movement which has drawn artists from all over the world. These artists are not mere Escher imitators, but inspired by his spirit and his work, give original expression to their own ideas.

I offer four of my drawings to the reader as examples.

Sandro Del Prete, *The never-ending staircase – Hommage à Escher*, 1998. Color drawing

This building consists of four towers. However, the strange aspect is that every tower appears to start from the tower beneath it, and it is impossible to find which is the uppermost and which is the lowermost. The viewer can follow the staircase which leads "up" from one tower to the next without ever reaching the "top."

Sandro Del Prete, *The twisted monastery*, 1998. Color drawing

Small ledges support the foundations of this monastery. The foundations them-selves comprise books stacked on top of one another, symbolising the knowledge on which the monastery is founded. However the construction of this monastery is twisted to such an extent so as to appear somewhat mystical. The viewer sees monks hauling up a basket filled with vegetables; their vertical rope appears to affirm that the rear part of the monastery is actually foremost.

Sandro Del Prete, *The curved chessboard*, 1983. Stone lithography

This chessboard appears curved at the center because the figures below stand on one side of the board, and those above stand on the other side. All lines, however, are drawn dead straight and parallel. The ladders appear twisted in spite of this. The curvature of the board is created solely in our imagination and by our perception of what is logical.

Sandro Del Prete, *Between illusion and reality*, 1995. Color drawing

Stone blocks arranged into an immense yet ruinous wall form the boundary between these two worlds. It is an illusory construction made from stones weighing several tons, yet some of them seem to dissolve into thin air. This monument to the past thus gives rise to the perpetual question: What is illusion, and where does reality start?

References

[1] M.C. Escher, *The Graphic Work of M.C. Escher*, New York, Meridith Press, 1960. New York, Wings Books, 1996.
[2] Sandro Del Prete, *Illusoria*, Bern, Benteli Verlag, 1987.
[3] Sandro Del Prete, *Illusorismen, Illusorismes, Illusorisms*, Bern, Benteli Verlag, 1981

Painting After M.C. Escher

Jos De Mey

My title has dual significance : painting "after," or "from" Escher, and painting "as" Escher.

At the outset, it should clearly be pointed out that M.C.Escher did not make any paintings during his professional career as an artist. His complete works are limited to drawings and prints – lithos, woodcuts and wood engravings, some rare etchings, and a few that use other printing techniques. Although there were some commissioned designs for public buildings that involved painting panels or walls, *paintings*, by which I mean artworks designed and painted on canvas, panel, or paper, simply do not exist. That does not mean, however, that M.C. Escher hasn't influenced artists in general or any painter in particular.

In light of these observations, "painting as Escher" isn't really an appropriate theme for my essay. So how about painting "after" or "from" Escher?

After having observed all the adapters of Escher I know, I find that there are few painters among them. Artists working with paint on canvas or panel seem to practise almost exclusively the pure non-figurative genre. I believe (if I'm not mistaken) this kind of art would not have been appreciated by Escher. I'm even convinced of the fact that if the meticulous Escher had ever painted, his technique would certainly have had similarities with mine. Carelessness in brush technique, neglecting details, negligent composition of materials, erroneous usage of colors – these would never have ocurred in the hypothetical works of Escher. (Although I've heard or read somewhere that Escher was partly color-blind!)

Lacking directly comparable paintings, I decided to search for basic figures that Escher and his followers used when composing 'impossible pictures.' I purposely use the term "composing" here. Neither the works of Escher nor his followers are thrown impulsively on canvas. Thinking through the composition thoroughly and trying it out in several preliminary studies are indispensable ingredients in the birth of an Escherian work.

The potential for making 'impossible' pictures is limited: they depend on fairly rare geometric configurations. Escher (and others) borrowed most of the basic figures from others, reworking them into concrete, figurative forms. This is where we touch on the thorny problem of the boundary between exact (theoretical) science and art. Or to put it as a question: when does a scientific model become art? The solution to this problem I leave to specialized art critics but I would certainly like to point out that few (or perhaps no) scientific theorists have ever produced art of quality.

By now I think it has become clear to you, respected reader, that my essay is restricted to impossible figures or impossible constructions. However, my introduction to the works of Escher had nothing to do with impossible figures.

The Path to Painting Impossible Figures

In 1956, in the Museum of Applied Art in Ghent (Belgium), I saw a series of Escher's prints. Among them were *Dewdrop*, *Rippled Surface*, and *Puddle*, which made a deep impression on me (Fig. 1; see also page 8 and [1, cat. no. 367]). Reflecting the attitude of official art authorities towards Escher's work, this first and only exhibition of M.C. Escher in Ghent was not shown in the Museum for Fine Art, but in the Museum for Ornamental or Applied Art.

At that time, design (of furniture) was still my main occupation. I also held a strong, rather theoretical, interest in painting and sculpture. Three years later, in 1959, I read the famous Penrose's article in the *British Journal of Psychology*, in which they exhibited the impossible tribar and other impossible constructions. This first contribution about impossible figures would later become an important influence in my decision to exchange interior architecture and design for the risky profession of a painter.

As a lecturer at the Royal Academy of Fine Arts and later at the Higher Institute for Architecture, I was, apart from being a teacher of interior architecture and furniture design, also responsible for classes on the theory of color and on design technique. The mathematical basis of harmony of forms in art was always in the forefront of these subjects. The possible applications of Fibonacci series, the Golden Ratio, and other mathematical-aesthetical systems were discussed in this course, organised as a discussion-forum. We focused especially on the Swiss group of "Concrete Kunst:" Max Bill, Karl Gestner, and Richard P. Lohse (see [4]).

It was also there that I began to take an interest in the boundary between art and science. Several antipodal ideas arise in the search for this difficult limit :
– picturesque versus pictural (or the colorful scene versus the art of painting)
– the means versus the objective

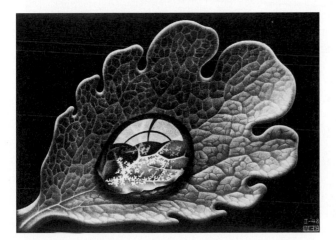

Fig. 1. M.C. Escher, *Dewdrop*, 1948. Mezzotint

Fig. 2. The dual stairs or "Schröder's Steps." This drawing was the inspiration behind Escher's lithograph *Convex and Concave*

- the basic scheme versus the result
- the technique versus the art
- mathematical art or artistic mathematics.

(See [8] and [9].)

When I decided in 1968 to leave interior architecture and design for the free art of painting, I wanted to depict things that can only exist as "picture." What I was going to depict in my drawings and paintings had to be infeasible or unrealizable. So I inevitably arrived at Impossible Figures. This was probably a reaction to my previous compelling duty to always draw things that techniquely and spatially had to be 'correct,' 'measurable,' and 'realisable.'

A first basic scheme was the famous *dual stairs* (Fig. 2) of which I drew and painted a series of variations for a whole year (Fig. 4). The next step was

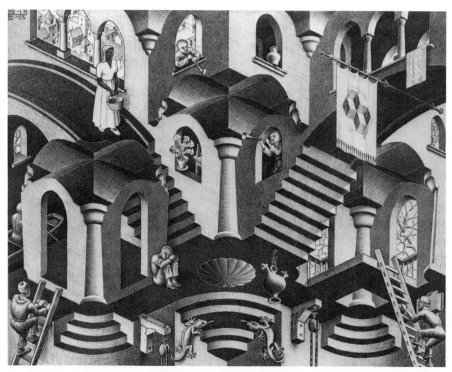

Fig. 3. M.C. Escher, *Convex and Concave*, 1955. Lithograph

Fig. 4. Jos De Mey, variations on the "Schröder's Steps," 1969

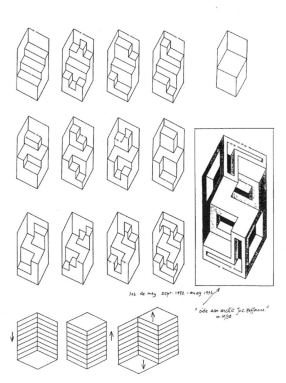

Fig. 5. Jos De Mey, different variations on the Thiéry figure from 1895 and (right) drawing *Ode to Architect J. Hoffman*, 1972–1973

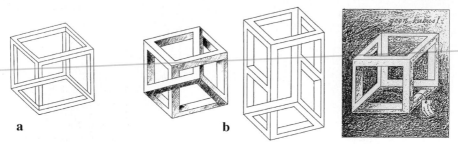

Fig. 6. (a) The impossible cube as Escher drew it in preliminary studies for *Belvédère*. (b) Jos De Mey, the impossible cube and variations on that theme, 1974–75

the *Thiéry figure* of 1895, some variations of which are reproduced in Fig. 5. A typical application of the Thiéry figure is at the right of Fig. 6: my 1972 *Ode to architect J. Hoffmann* number 10/38.

The Escher lithograph *Convex and Concave* (Fig. 3) plays with the dual stairs and the kind of Thiéry figure that is reproduced on the flag at top right in the print. Escher explained this convex/concave dichotomy in a letter to his son Arthur in 1954:

> *Convex and Concave* ... *is concerned with the widely known phenomenon of spatial suggestion which can be imagined as convex or concave, as desired. In the middle of the picture I draw the shapes in such a way that the observer may just as well see them convex as concave; to the right I force him to see things in a convex way (e.g. "cube from the outside"; to the left, he has to view things in a concave way ("cube from the inside"). [1, p. 79]*

On further consideration, one could suggest that the Thiéry figure in perspective was used as a starting point for the 1947 Escher lithograph

Fig. 7. Jos De Mey, *Die Unterweisung der Messung und seine Folge (The result of the theory of measuring)* (after A. Dürer), 1988. Acrylic on canvas

Up and Down (see page 29). The small floor a little above the middle of the picture is the double-use surface in the Thiéry figure; here it is simultaneously a floor or ceiling.

All the works from the early years of my painting career are abstract and very often reversible, both horizontally and vertically. Later I made more realistic reproductions, still with the abstract "things" but now resting on firmer ground. The base component from that period is the *impossible cube*, which also appears frequently later on. In Escher's vignette *Man with Cuboid* (see page 375), this cube is not completely impossible. It still shows two normal faces – the bottom and the top (Fig. 6a).

Around 1975 I drew several new versions of the cube in which all the surfaces were impossible. And even better: there are no longer any real clear-cut surfaces. All the aspects of the cube flow into one another. It could be described as a Möbius strip in the form of a cube (Figs. 6b and 7). I'm probably not the inventor of this fully impossible version, but in 1975 I was aware only of Escher's drawing and interpretation.

Escher's Influence

There are only a few prints by Escher that can be related directly to my works. The most important is *Belvedere* for which the impossible cube served as a starting point (Fig. 8). The small man on the bench contemplating the absurd cube in his hands, as well as the sketch in the foreground on which the ribs of

Fig. 8. M.C. Escher, *Belvedere*, 1958. Lithograph

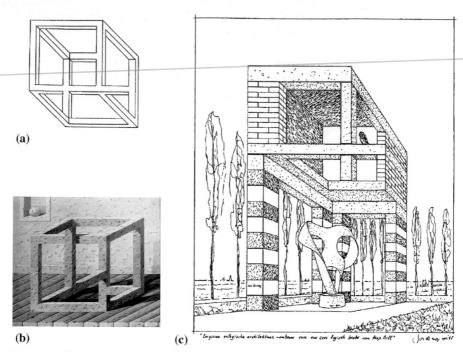

(a)

(b) (c)

Fig. 9. Jos De Mey. (**a**) A normal cube with impossible connections, 1976. (**b**) *Souvenir of Margriet*, 1977. Acrylic on canvas. (**c**) *Rather Illogical Architecture – Surrounds for a Very Logical Figure of Max Bill*, 1998. Drawing

a cube are drawn with their hazardous crossings, are the keys to understanding this enigmatic construction.

Closely related to the impossible cube is *the normal cube with impossible connections* (Fig. 9a). I'm not acquainted with any works of Escher based on this impossible figure. That's why two of my works reproduced here give reference to other artists (Figs. 9b and 9c).

Apart from the impossible cube we can also make the impossible square and the impossible rectangle (Figs. 10a, 10b). As far as I know Escher used neither

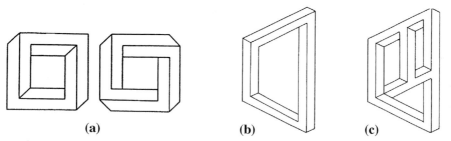

(a) (b) (c)

Fig. 10. (**a**) Two variations of the impossible square. (**b**) An impossible four-beam figure with a perspective effect. (**c**) An impossible four-beam figure with impossible connections

Fig. 11. Jos De Mey, *Curious Wagtail in a Strange Small Window*, 1977. Acrylic on canvas

of these figures in his works. Some of my works utilize this motif, appearing in several variations, frontally as well as in perspective (Fig. 11).

We have seen that apart from the completely impossible cube there can exist also a possible cube with impossible connections. That is also true for the impossible rectangle where a *possible rectangle with impossible connections* can be devised (Fig. 10c and color plate 21).

Finally there is the *impossible triangle* of the Penroses, already mentioned above, and also a little bit from Oscar Reutersvärd (see page 205). Escher used this feigned triangle as a starting point for his 1961 lithograph *Waterfall* (see page 65). The great number of preliminary studies [3, p. 89] show the long and difficult process Escher went through before he finally obtained a clear image of his idea. My own drawings based on the impossible triangle (Fig. 12) are much more simple than Escher's intricate picture.

To make the series of basic figures complete I would like to mention so-called "multiple surfaces." That term was invented by Bruno Ernst (Hans de Rijk) to be able to interpret my works better [2]. He states "a multiple surface looks in a certain place in a drawing or painting like only one flat surface ; put in another place in that same picture it is like two or more flat surfaces. This is the oldest type of impossible figure (i.f.) that was , often unintentionally and unconsciously, put into the pictures." [2, p. 62]

Fig. 12. Jos De Mey. LEFT: *An Awkward Drilling Platform*, 1987–1990. RIGHT: *A Latent Threat for an Unstable Construction*, 1995. Ink drawings

Fig. 13. Bruno Ernst, the history of a multiple surface, 1986

In Fig. 13, you can see Ernst's depiction of how this can originate. In my ink drawing of 1983 (Fig. 14) there is only one surface on the upper part of the wall. This surface multiplies itself on the ground to four walls that stand at different distances from the viewer and that enclose a rather large space like a summerhouse.

My last two illustrations (Fig. 15 and color plate 22) give a glimpse of my design technique.

These drawings show how, beginning with a scheme of Reutersvärd, I finally reach an apparently possible pictural figure by reversing, broadening, and narrowing, then finally by using perspective with the viewing angle that of a standing person's eye. That final figure could be used as a basis for a painting or an elaborated drawing.

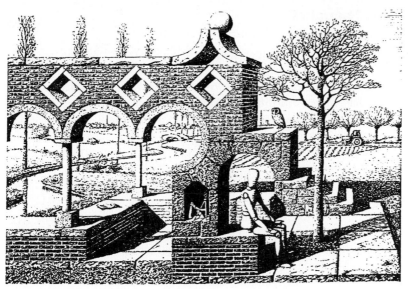

Fig. 14. Jos De Mey, *Carefully Restored Roman Ruin in a Forgotten Flemish Locality with Oriental Influences*, 1983. Ink drawing

Fig. 15. Jos De Mey, starting from a scheme of Reutersvärd, developing into painting projects, 1991

Some Final Thoughts

It is probably useful at this point to quote Escher himself, *"Always try to do that which seems too difficult for you; try to exceed your supposed limits."* (from a letter to his son George on June 29, 1969) [10]. Escher always wanted to do just that: what was, in fact, too difficult. Was it ambition? Yes, but not primarily that. It was a typical inner passion that is so characteristic of the real artist. His willpower, his stubborn perseverance and his enormous skill made it possible for him to convert visionary images into clear images. It was often at the expense of sleepless nights and eternal experimenting in order to finally achieve the fragile balance between inner rest and creative expression. He was looking for balance but always preserving emotions.

Escher also always tried to bridge the opposition between abstract and figurative. His works (and also mine) are *figurative in form but abstract in meaning*. In other words: a figurative representation of abstract ideas.

In a lecture in Amsterdam in 1963 he explained that subtlety is also necessary. "In my opinion an impossible situation only really stands out when the impossibility is not immediately obvious... There should be a certain mysteriousness that does not immediately hit the eye." [1, p. 147]

The link between Escher and the scientific world was his insatiable urge to know everything. In this he resembled what a scientific investigator should be. Escher and his adapters belong to the category of "thinking artists" such as many great artists before them were and many still are. These are artists who investigate systematically the surounding world in an artistic-methodical way. The strong need for studying *the phenomenon of human perception* is another characteristic that Escher and his followers have in common. In this, they put the liability of that perception in perspective.

Without M.C. Escher, my works as well as those of many other artists would certainly have been completely different. Nevertheless I think I can say that I have been using enough different pictural elements and techniques to distinguish my paintings clearly from the works of Escher. My intention is to elaborate his ideas, using new approaches and a more painted elaboration. The architecture, the scene, the figuration, and the application of colors in my works are strongly related to my own Flemish present and past. It is striking that Escher rarely made use of Dutch scenery. Apart from *Day and Night* with its bird's-eye view of a typical Dutch landscape, his architecture, scenery, and figuration are almost exclusively southern, and in particular, more Italianesque.

I especially try to respect Escher's attitude towards art. His searching for exactitude and the best possible technical quality when conceiving and realising his works have always been an example for me. I also want to express my gratitude to Bruno Ernst who has often helped me with his analytical understanding and comments on the things that I instinctively put on paper or canvas. I also want to emphasize strongly that I am not, even less than Escher was,

a practitioner of exact science. If I was, I would never make any art, even less paint...

Fortunately there are scientists who are interested in art. Science can, to a certain extent, be considered as art. I see myself as an artist with a certain interest in science. I'm probably a scientific artist but I'm certainly not an artistic scientist.

References

[1] F.H. Bool, J.R. Kist, J.L. Locher, F. Wierda, *M.C. Escher, His Life and Complete Graphic Work*, Harry Abrams, 1982.

[2] Bruno Ernst, *The Eye Beguiled*, B. Taschen Verlag Köln 1992.

[3] Bruno Ernst, *The Magic Mirror of M.C. Escher*, Ballantine Books, New York, 1976. Reprint, Taschen-America, 1994.

[4] Karl Gerstner, *Kalte Kunst*, Niggli Verlag Schweiz 1957.

[5] E.H. Gombrich, *Art and illusion*, Phaidon Press London 1959, Pantheon New York 1961.

[6] J.L. Locher, ed., *The World of M.C. Escher*, Harry Abrams New York 1972.

[7] L.J. Penrose and R. Penrose, "Impossible Objects: A special type of illusion," *British Journal of Psychology*, v. 49 (1958) 31.

[8] Andreas Speiser, *Die Mathematische Denkweise*, Birkhauser Verlag Basel 1952.

[9] Hermann Weyl, *Symmetry*, Princeton University Press, 1952.

[10] Unpublished materials in the Escher archive, Haags Gemeentemuseum, Holland.

M.C. Escher: Art, Math, and Cinema

Michele Emmer

Computer graphics can provide not only a pure visualization of many well-known phenomena but also provide a new way to study mathematical problems, and in particular, geometrical ones. It can be said that a new branch of mathematics has been developing in the last few years, called "Visual Mathematics" [6]. The great potential of computer graphics as a new exploratory medium was recognized by mathematicians soon after the technology became available. As display devices and programming methods grew more sophisticated, so did the depth and scope of applications of computer graphics to mathematical problems. This does not mean that there is no longer any room for handmade drawings and illustrations on mathematical topics by artists and mathematicians.

One of the most interesting examples of the relationship between art and mathematics is illustrated in the life and work of the Dutch graphic artist M.C. Escher. This topic has been revisited many times in my project "Art and Mathematics," which began in 1978. That project has produced movies, videocassettes, software, and many "traditional" papers and books over the last twenty years. In this project, I produced a film and a video on Escher's work that feature commentary by mathematicians Sir Roger Penrose and H.S.M. Coxeter and also by the crystallographer Caroline MacGillavry [4]. In making the video, the idea was to make all the animations using the original drawings of the Dutch artist, in order to make a film "à la mode d'Escher." Computer graphics was not known to Escher because he died in 1972, before this technology was widespread.

Conferences and exhibitions have been also organized with the cooperation of mathematicians, scientists and artists. An international conference, "M.C.Escher: Art and Science" was held in Rome in 1985 [3], and in 1998 the Escher Centennial conference in Rome and Ravello focused on the visual, mathematical, and artistic aspects of his work. (A website for the congress was maintained: http://mercurio.mat.uniroma1.it/escher98/)

The Graphic Artist M. C. Escher (1898–1972)

Maurits Cornelis Escher was born in 1898. His tale is quite unusual: for a long time, his work was almost completely unknown and unappreciated. During his 20 years spent in Italy, he had only a handful of exhibitions. At a certain point in the 1960s, however, his fame began to grow, especially among scientists, mathematicians, physicists, and crystallographers. The history of the relationship of Escher with scientists (mathematicians in particular) is quite interesting in terms of understanding how the Dutch artist thought of his work. The first large exhibi-

tion of his work was held during the International Congress of Mathematicians in Amsterdam in 1954. This show, besides introducing Escher's work to mathematicians, also gave Escher a chance to meet H.S.M. (Donald) Coxeter and Roger Penrose, with whom he developed long and fruitful relationships.

In the introduction in the catalog of the 1954 exhibition, mathematician N.G. de Brujin wrote that it was not only Escher's geometrical patterns that interested him, but that he was fascinated by finding the same imagination that is at work in mathematics, and which for many scholars, represents the most interesting part of their work. De Brujin added that the congress participants would find themselves surprised to recognize their ideas expressed in such a different way from the usual. Obviously, even then, mathematicians were aware of the fact that Escher was no mere illustrator of scientific and mathematical ideas, but expressed something at a deeper level in an unusual way.

Escher defined himself, and not unreasonably, as a graphic artist. In his acceptance speech upon receiving the Culture Prize of the city of Hilversum in 1965 he explained:

> *If I am not mistaken, the words "art" and "artist" did not exist before or during the Renaissance: there were simply architects, sculptors and painters, practising a craft.*
>
> *Print-making is another of these honest crafts, and I consider it a privilege to be a member of the Guild of Graphic Artists. Cutting with a gouge, engraving with a burin in an absolutely smooth block of polished wood is not something to pride yourself on – it's simply nice work. Only as you get older, it's slower and more difficult and the chips don't fly around the workroom quite so wildly as they used to.*
>
> *Thus I am a graphic artist with heart and soul, though I find the term "artist" rather embarassing.* [1, p. 125] and [7, p. 22]

The fundamental event in his life, Escher said, was in 1938, when the Escher family had left Italy after a long stay. "In Switzerland, Belgium and Holland I found the outward appearance of landscape and architecture less striking than those which are particularly to be seen in the southern part of Italy. Thus I felt compelled to withdraw from the more or less direct and realistic illustration of my surroundings. No doubt this circumstance was in a high degree responsible for bringing my inner visions into being." [8, p. 7]

All his works illustrated in his first book *The Graphic Work of M.C. Escher*, except for the first seven, were done with the idea of communicating a detail of these interior visions. "The ideas that are basic to them often bear witness to my amazement and wonder at the laws of nature which operate in the world around us. He who wonders discovers that this is in itself a wonder. By keenly confronting the enigmas that surround us, and by considering and analyzing the observations that I had made, I ended up in the domain of mathematics. Although I am absolutely without training or knowledge in the exact sciences, I often seem to have more in common with mathematicians than with my fellow

artists." [8, p. 8] These last two comments by Escher summarize perfectly the relationship that the artist established with the scientific community. That Escher himself thought of scientists as his privileged audience is beyond doubt.

Escher died in 1972 and thus never had a chance to witness the boom in popularity that his woodcuts and lithographs have experienced. Today, his work is known throughout the world by everyone, from designers to computer graphics experts, from scientists to psychoanalysts, from students to architects. Escher the artist enjoys enormous enduring popular recognition with scarce consideration by art historians.

Escher: the Video

The title of the first book containing the collected works of Escher, *The World of M.C. Escher* [10], is very appropriate. Escher created his own world of meticulously constructed images, a magic world at once fantastic and imaginative but also realistic, coherent and detached, observed with an eye apparently lacking in emotion. Escher was an artist of minute details, tiny elements which create instability and disturb the apparent calm of the whole. Regarding this, mathematician C.P. Bruter wrote that the eye creates local images which, little by little, are projected onto a common receptacle and probably reproduced several millions of times. The construction of these individual maps, defined by the trajectories outlined by the viewer's eye movements, enables one to construct an image of the surrounding space that is stable and well ordered. Escher's drawings only *appear* to be strange, since each individual image faithfully represents reality. [2, p. 222]

This is the first reason for using a movie camera to examine Escher's work: cinematic technique first of all lets us concentrate attention on what the filmmaker wants us to see. The film forces us to look at Escher's world as if we were part of it. We are not distracted by anything else. The second reason is that Escher's drawing technique is very precise and detailed. Cinematic technique allows us both to isolate these minute details and also to magnify them many times in order to appreciate the precision of the artist's method. Another important element in using film is the fact that a movie forces those who look at it to see things passing quickly on the screen in a definite order. Many of Escher's works are like a story that develops and must be observed in the sequence suggested by Escher himself. In these several ways, the movie camera permits a very precise and accurate analysis of Escher's works.

Escher himself suggested the use of cinematic technique. In his book *The Regular Division of the Plane* he wrote:

> *In this book it is the images and not the words that come first...*
> *For me it remains an open question whether the play of white*
> *and black figures as shown in the six woodcuts of this book*

pertains to the realm of mathematics or that of art . . . [1, p. 155]
and [7, p. 92]

*. . . the first woodcut . . . show[s] clearly that a succession of
gradually changing figures can result in the creation of a story
in pictures. In a similar way the artists of the Middle Ages
depicted the lives of Saints in a series of static tableaux. . . . The
observer was expected to view each stage in sequence. The
series of static representations acquired a dynamic character by
reason of the space of time needed to follow the whole story.
Cinematic projection provides a contrast with this. Images
appear, one after the other, on a still screen and the eye of
the observer remains fixed and unmoving. Both in the medieval
pictorial story and in the developing pattern of a regular divi-
sion of the plane the images are side by side and the time factor
is shifted to the movement the observer's eye makes in following
the sequence from picture to picture.* [1, p. 158] and [7, p. 98]

A very significant example of "a succession of gradually changing figures"
which sums up the various aspects noted by Escher, is given by his *Meta-
morphose* prints. In particular, his *Metamorphosis II* seemed to me a perfect
cinematic sequence. I have used the animation of this work as the final sequence
of the video. In his section entitled "Metamorphosis" in *Regular Division of the
Plane*, Escher describes one of the sequences of images in this work as follows:

*First the black insect silhouettes join; at the moment when they
touch, their white background has become the shape of a fish.
Then figures and background change places and white fish
can be seen swimming against a black background. [A]
succession of figures with a number of metamorphoses acquires
a dynamic character. Above I pointed out the difference between
a series of cinematographic images projected on a screen and
the series of figures in the regular division of plane. Although in
the latter the figures are shown all at once, side by side, in both
cases the time factor plays a role.* [1, p. 170] and [7, p. 120]

In 1964 Escher visited his son George in Canada. He had been invited by
several organizations in the United States, including the Massachussets Institute
of Technology and Bell Laboratories, to give presentations on his work. Shortly
after arriving in Canada, Escher had to be admitted to Saint Michael's hospital
in Toronto for an emergency operation. All speaking commitments had to be
canceled, and Escher would never again have a chance to give his carefully
prepared lectures. In his usual meticulous manner, he had written out the
complete English text of his lectures and these texts have been preserved. They
were published in 1989 in *Escher on Escher: Exploring the Infinite* [7]. The
chapter entitled "The lectures that were never given" contains this lecture. (We
should note that the lecture was given, but not by Escher. The notes and lecture
slides were sent to Arthur Loeb at Harvard, who gave the lecture at Ledgemont

Laboratory in Lexington, Massachussets in Escher's absence.) The final part of
this lecture was dedicated to *Metamorphose II* (a large, continuous reproduction
of this work may be found in [11].)

*I propose to round off this talk by showing you a woodcut strip
with a length of thirteen feet. It's much too long to display in one
or even in two slides, so I had it photographed in six parts, which
I can present in three successive pairs and which you are invited
to look at as if it were one uninterrupted piece of paper.*

*It's a picture story consisting of many successive stages
of transformation. The word "Metamorphose" itself serves as
a point of departure. Placed horizontally and vertically in the
plane, with the letters O and M as points of intersection,
the words are gradually transformed into a mosaic of black
and white squares, which, in turn, develop into reptiles. If
a comparison with music is allowed, one might say that, up to
this point, the melody was written in two-quarter measure.*

*Now the rhythm changes: bluish elements are added to the
white and black, and it turns into a three-quarter measure. By
and by each figure simplifies into a regular hexagon. At this
point an association of ideas occurs: hexagons are reminiscent
of the cells of a honeycomb, and no sooner has this thought
occurred than a bee larva begins to stir in every cell. In a flash
every adult larva has developed into a mature bee, and soon
these insects fly out into space.*

*The life span of my bees is short, for their black silhou-
ettes soon merge to serve another function, namely, to provide
a background for white fishes. These also, in turn, merge into
each other, and the interspacings take on the shape of black
birds. Then, in the distance, against a white background, appear
little red-bird silhouettes. Constantly gaining in size, their
contours soon touch those of their black fellow birds. What then
remains of the white also takes a bird shape, so that three bird
motifs, each with its own specific form and color, now entirely
fill the surface in a rhythmic pattern.*

*Again simplification follows: each bird is transformed into
a rhomb, and this gives rise to a second association of ideas:
a hexagon made up of three rhombs gives a plastic effect,
appearing perspectively as a cube. From cube to house is but
one step, and from the houses a town is built up. It's a typical
little town of southern Italy on the Mediterranean, with, as
commonly seen on the Amalfi coast, a Saracen tower standing
in the water and linked to shore by a bridge. [It is the town of
Atrani.]*

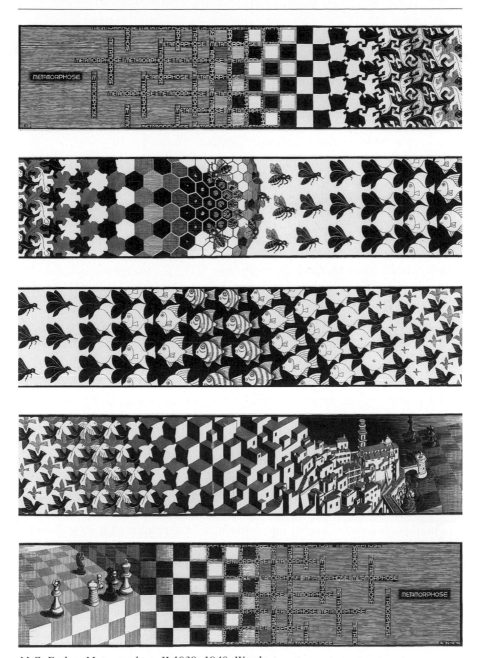

M.C. Escher, Metamorphose II 1939–1940. Woodcut

> *Now emerges the third association of ideas: town and sea are left behind, and interest is now centered on the tower: the rook and the other pieces on a chessboard. Meanwhile, the strip of paper on which "Metamorphose" is portrayed has grown to some twelve feet in length. It's time to finish the story, and this opportunity is offered by the chessboard, by the white and black squares, which at the start emerged from the letters and which now return to that same word "Metamorphose."*
> *Thank you very much for your attention.* [7, pp. 48–53]

So ends Escher's lecture.

When I was making my video I was not aware of this lecture text, but my idea was exactly that described by Escher, perhaps even more: not only a story, but what in cinema is called a storyboard, a precise description of a sequence to be filmed, usually given by drawings and words. So I used Escher's original wood-cut as a storyboard for making the animation of *Metamorphose*. What Escher had to describe in words, because it was impossible with slides to continuously show the complete ribbon of the print to the audience, I could describe in the movie without any words, using just the animation to follow the continuously changing forms in the woodcut, accompanied by music, another suggestion by Escher himself! To paraphrase Escher, we can say: In this film it is the images and not the words that come first. (A short excerpt from this video is on the CD Rom.)

Of course filming is not just only a way to *analyze* Escher's works. As I pointed out in my essay "Movies on M.C. Escher and their Mathematical Appeal" [5], by filming the prints and drawings we arrive at something new: the images flow quickly by; they are in movement, not just statically side by side. We have taken Escher's suggestions and extended them to a world of Escher, or better, a world according to Escher, which moves and changes in three-dimensional space. Cinema is illusion, and Escher's technique suggests we not only analyze but reinvent, starting from his ideas.

An important part of Escher's art is his incredible graphic technique. In order to display his ability, I spent a week in the Geementemuseum in Den Haag in Holland to make careful pictures of the original works of Escher as part of the preparatory work for the video. When you make an animation, you need to construct the drawings for the animation frame by frame. Of course you cannot use Escher's orginal drawings and woodcuts and cut them in pieces! So after making the pictures of the originals, designers who were expert in animation used the pictures to make hundred of drawings in order to subdivide the works of Escher into small parts to be put together again in making the movie animation. So it can be said that the animation was made using not only the written suggestions of Escher but the animations were made "à la mode d'Escher"! The collections of drawings made to produce the animations for the movie are an interesting example of drawings in which geometry, design and cinema are combined.

A Final Comment

In the last few years my video on Escher and others in the series "Art and Mathematics" have been distributed and used in schools, universities, cultural institutions, museums. They have been used for educational and cultural purposes. But the video of Escher also received awards as a film. This gave affirmation to my first ambition: to make a film that can be seen by almost everyone. A film on mathematics, art and culture, visually interesting and attractive. As any film must be, and mathematics can be too!

References

[1] F.H. Bool, J.R. Kist, J.L. Locher, and F. Wierda, eds., *M.C. Escher: His Life and Complete Graphic Work*, New York, Harry N. Abrams, 1982.

[2] C.P. Bruter, *Topologie et Perception*, Maloine-Doin, Paris, 1976, vol. II.

[3] H.S.M. Coxeter, M. Emmer, R. Penrose, M. Teuber, eds., *M.C. Escher: Art and Science*, Amsterdam, North-Holland, 1986.

[4] M. Emmer, *The Fantastic World of M.C. Escher*, video, 50 minutes, Film 7 Intl., production 1994. English: USA and Japan – Acorn Media; other – Springer-Verlag, Berlin. Italian, French, and Spanish: M. Emmer (http://space.virgilio.it/m.emmer@virgilio.it).

[5] M. Emmer, "Movies on M.C. Escher and their Mathematical Appeal," in [3], pp. 249–262.

[6] M. Emmer, ed., *The Visual Mind: Art and Mathematics*, The MIT Press, Boston, 1993.

[7] M.C. Escher, *Escher on Escher: Exploring the Infinite*, New York, H.N. Abrams, 1989.

[8] M.C. Escher, *The Graphic Work of M. C. Escher*, Meredith Press, 1960 (reprinted 1996, New York, Wings Books).

[9] M.C. Escher, *Regelmatige Vlakverdeling*, De Roos Foundation, Utrecht, 1958; translated Regular Division of the Plane and reprinted in [1], pp. 155–173, and in [7], pp. 90–122.

[10] J.L. Locher, ed., *The World of M.C. Escher*, 1972.

[11] J.L. Locher et al., *The Magic of M.C. Escher*, New York, Harry N. Abrams, 2000.

Organic Structures Related to M.C. Escher's Work

Tamás F. Farkas

Escher as Inspiration for Research

M.C. Escher interpreted three-dimensional spatial structure with the help of the living world – fauna, flora and human figures. His spatial forms behave in a unique way: they appear to be realistic, but they cannot be constructed in the real three-dimensional world. This visual phenomenon, illusion in the plane, was approached from different viewpoints by Escher. In representing spatial structures Escher utilized the Penrose triangle and the Möbius band. I have dealt with representing these "organic" forms in the plane, defining rules for organization of basic structures. Designing and experimenting with such organic structures has become an especially exciting field for basic research.

Here I introduce the basic principles that may help you recognize and understand the different areas of my investigations. I have defined five main fields of inquiry that intersect with art and science.

1. Continuous stereoscopic configurations. These are generally prismatic figures intersected by a square. These occur in M.C. Escher's prints *Möbius Strip I* [1, cat. no. 298] and *Möbius strip II* (page 75), and *Waterfall* (page 65).
2. Visual and logical relationships between stereoscopic configurations; organizing modular systems into adjacent figures. Examples are given by M.C. Escher's prints *Stars* [1, cat. no. 359] and *Belvedere* (page 135)
3. Visual and logical organizations of stereoscopic formations usually created from cubes or short prismatic units such as in M.C. Escher's print *Cycle* (page 77)
4. Organization of stereoscopic figures into systems similar to stairways as in M.C. Escher's print *Ascending and Descending* (page 6).
5. Symmetrically recurring plane and stereoscopic formations filling the plane and space. (These configurations may be multiplied in all directions of the space, filling the surface accordingly.) M.C. Escher's print *Metamorphose II* (page 147) is an example.

My Spatial Art

I have been concerned with researching and making artistic presentations of strange stereoscopic configurations since 1972. To date, I have designed about 1,500–2,000 impossible forms.

Fig. 1. Tamás F. Farkas. LEFT: *Celtic XII*, 1996. RIGHT: *Celtic VIII*, 1996. Graphics on paper

The main direction of this research is developing the so-called continuous stereoscopic configurations of type 1. Their primary characteristic is that one, two, or three lines form the structure. The line describes a recursive spatial path in the plane. The rectangular prism looks real, and usually moves in all directions of the given space, in 90° steps. The viewer can comprehend the movement of spatial structure in the picture series *Celtic XII 96* (Fig. 1, left). Forms follow each other playfully underneath and above. Similar rules describe the structure of *Celtic VIII 96* (Fig. 1, right, and color plate 28), where a star-structure becomes a continuing spatial formation. Here the stream is also a self-recurring one. In some places within the form, the configurations cover each other in short sections, but they do not cross one another or join each other. Many of them are organized on a hexagonal grid, while even more follow a triangular or rectangular net.

In works of type 2, the stereoscopic configurations diverge, cross, and connect with each other. Lateral faces appear simultaneously; usually the cubes or prismatic parts connect to each other, creating an impossible figure. They appear on a hexagonal net, but they also exist on triangular or rectangular nets. If we start from the center of *Atlantis VI 86* (Fig. 2, left), we perceive the space in all directions. The joining of the cube-like formation is not real, and that is why we discover six projections of it. The effect of *Magical Space 86* (Fig. 2 right) is like revolving a frame from one view to another.

Stereoscopic configurations, cubes and prisms create a unified system by touching each other or merging into one another in works of type 3. The basis of structures originating in this manner is determined with a special spiral or circle.

Fig. 2. Tamás F. Farkas. LEFT: *Atlantis VI*, 1986. RIGHT: *Magical Space*, 1986. Oil on canvas

Fig. 3. Tamás F. Farkas. LEFT: *Crystal-M 18*, 1986. RIGHT: *Pyramid*, 1997. Oil on canvas

The spiral could have one, two, three, or even six arms. In these works, one may discover several lateral faces simultaneously. Cubes are compressed in a special way in *Crystal-M 18/86* (Fig. 3, left), creating an unreal three-dimensional formation, as they grow out from each other. Here, one can discover six frontal views, or a spiral track of a crystal-like construction.

More complex stairway figures usually organize themselves into one system in works of type 4. We may either go round on the steps of these stereoscopic configurations, or move forward to the center. *Pyramid 97* (Fig. 3, right, and

Fig. 4. Tamás F. Farkas, *Dynamic Pattern II*, 1990. Oil on canvas

color plate 29) contains three Penrose triangles which are combined with an impossible staircase construction. If we go around the outside of the structure, we don't feel its unreality – it looks like a "buildable" form, but trying to get to the center provides the disappointment of three-dimensional reality.

In works of type 5, we find repetition of plane or stereoscopic configurations on the surface. The plane figures are generally situated so as to be equidistant from one another. One form may repeat itself, or three of them may create a basic system in which the forms traverse each other. The stereoscopic figures are able to cause similar effects. The system can continue in all directions to fill a two-dimensional plane in a regular and symmetric manner. Therefore, the system is continuable and expandable to infinity. The form of the figures can differ several times, and so we can discover one, two, or three forms within one system. *Dynamic Pattern II 90* (Fig. 4) can be "read" in many ways.

We owe deep thanks to M.C. Escher for opening the gate to an extremely exciting and varied world, and enlarging the borders of visual perception with his work.

The works shown here, along with many more, are shown in color on the CD Rom.

Reference

[1] F.H. Bool, J.R. Kist, J.L. Locher, F. Wierda, eds., *M.C. Escher, His Life and Complete Graphic Work*, Harry Abrams, New York, 1982.

Extending Escher's Recognizable-Motif Tilings to Multiple-Solution Tilings and Fractal Tilings

Robert Fathauer

Tiling of the plane is a theme with which M.C. Escher was preoccupied nearly his entire career as an artist, starting around 1920. He was particularly interested in tilings in which the individual tiles were recognizable motifs, and kept a notebook in which he enumerated over 130 examples of this type of design [9]. Many of these were incorporated in finished woodcuts or lithographs. Notable examples include *Day and Night* (1938), *Reptiles* (1943), *Magic Mirror* (1946), *Circle Limit IV* (1960), also known as "Heaven and Hell," and the *Metamorphosis* prints of 1937–1968.

Of Escher's numbered examples, all but the last are isohedral tilings. This means that a symmetry operation that maps a tile onto a congruent tile also maps the entire tiling onto itself. Escher's lone non-isohedral design, executed in 1971, was based on a wooden puzzle given to him by the thereteical physicist Roger Penrose [9, pp. 318–319]. Penrose's and Escher's tiles were derived by modifying the edges of a 60°/120° rhombus. The four edges of the rhombus were each replaced by the same polygonal curve, but in four different aspects, related to each other by rotations and glide reflections.

Another theme that intrigued Escher was the depiction of the infinite in a finite print. All of Escher's numbered examples of recognizable-motif tilings can be continued to infinity; i.e., they tile the infinite Euclidean plane. A number of Escher's finished prints depict tiles that diminish to infinitesimally small size, for example, *Square Limit* (1964), *Smaller and Smaller* (1956), *Path of Life I* (1958), and *Path of Life II* (1958) (see pages 232, 58, and [3, cat. nos. 424, 425]). Other prints in this class employ hyperbolic geometry, where the infinite plane is represented in a finite circle. His four *Circle Limit* prints of 1958–1960 are in this class (see the article by Douglas Dunham, pp. 286–296). Though the concept of fractals as such was not known to Escher, these prints possess one characteristic of fractals: they exhibit self-similarity on different scales, near the edge of the circles.

Two mathematical advances that took place in the 1970's have interesting applications to tiling. Because Escher died in 1972, he was not able to employ these in his work. The first is the discovery by Roger Penrose of a set of two tiles that can tile the plane in an infinite number of ways, none of which are periodic [6]. The second is the development and formalization of fractal geometry, largely by Benoit Mandelbrot [7]. In this article, I will show new Escher-like tilings using both Penrose tiles and fractals.

Recognizable-Motif Tilings Based on Penrose and Related Tiles

There are three versions of the Penrose tiles. The first, known as P1, contains six different tiles [6]. Penrose later succeeded in reducing the number of tiles to two. In the set P2, these two tiles are commonly referred to as "kites" and "darts," while in the set P3, the tiles take the form of two rhombi. In all three sets, markings or distortions of the edges are necessary to indicate matching rules that force tilings constructed from the sets to be non-periodic. Tilings formed by all three sets are characterized by regions of local five-fold rotational symmetry.

Penrose was acquainted with Escher, so it was almost inevitable that Penrose would try his hand at a recognizable-motif tiling based on his non-periodic tiles. He used the P2 kite and dart version of the tiles, and converted these to fat and skinny chickens [5]. I have also used the kites and darts as the basis for a recognizable-motif tiling, making a Phoenix bird from the dart tile and a scorpion and diamondback rattlesnake combination from the kite tile (Fig. 1; a color print based on these tiles can be seen on the CD ROM). Note that there are short edges and long edges in the kite and dart tiles, each length appearing four times. These two lengths of edges are modified independently to create recognizable motifs.

There are several characteristics that I feel a recognizable-motif tiling should possess if it is to be as esthetically pleasing as possible. Escher touches on some of these in his writings. These are:

(a) The different tiles should be oriented in a way that makes sense. For example, if one of the tiles is the view of a creature from above, then other

(a) **(b)**

Fig. 1. (**a**) Modification of the Penrose kites and darts to form scorpion, diamondback rattlesnake, and Phoenix bird tiles. (**b**) A portion of a tiling based on these tiles

tiles in the tiling should also be viewed as from above. If side views are depicted, then gravity should be in the same direction for all the tiles.

(b) The motifs for the different tiles should be complementary. For example, different types of sea life, or possibly opposites such as angels and devils.

(c) The different tiles should be commensurately scaled. That is, if a tiling is made up of one tile depicting a horse and another a man, then the two should be related in size in a way similar to real horses and men.

Note that the scorpion and rattlesnake tiles in Fig. 1 violate the third rule, as a real scorpion is smaller than a rattlesnake. Penrose's tiling of chickens is likewise not completely satisfactory, as the chickens are shown in side view, but gravity points in different directions for different chickens. Violating the rules above makes tilings seem less natural, less an extension of nature. Escher's work for the most part conforms to these rules, but there are some exceptions. These include his drawing number 72 ([9], p. 174), in which fish appear of comparable size to boats, and his drawing number 76 ([9], p. 177), in which birds appear of comparable size to horses.

One area Escher didn't explore was the design of recognizable-motif tilings that could be assembled in different ways. The Penrose tiles are not the only tiles that fall in this category (see, e.g., related early work by Bøggild [2]), but they provide a convenient starting point for such explorations. As a departure from the Penrose tiles themselves, I examined alternative matching rules for the Penrose P3 rhombi, which have angles of 72°/108° and 36°/144°. In this case, a single line segment occurs eight times as an edge of the tiles, as shown in Fig. 2, where a notch in the line indicates orientation. When the tiles are assembled, the notches must fit into one another.

If one examines a single rhombus, allowing only rotations of notched edges, one finds 16 combinations of edges, of which 10 yield distinct tiles. There are then $10 \times 10 = 100$ distinct pairs of rhombi with notched edges. If one also allows glide reflection of the edges, there are $4^8 = 65,536$ combinations, not all of which yield distinct pairs of tiles, of course. Four of these pairs of tiles are shown in Fig. 2; one pair is the Penrose set P3. Another of these pairs was used to create a set of tiles I call "squids" and "rays." Two tilings constructed using

Fig. 2. Four sets of matching rules for rhombi with angles of 36°/144° and 72°/108°. (a) A pair that tiles only periodically (except for trivial variations). (b) A pair that tiles only non-periodically (the Penrose set P3). (c) A pair that tiles both periodically and non-periodically; used for "squids" and "rays." (d) A pair that doesn't tile at all

Fig. 3. Two tilings constructed from the "squids" and "rays" tiles. The left one is periodic, while the right tiling, with five-fold rotational symmetry, is non-periodic

this set are shown in Fig. 3. Note that the squid and ray tiles meet all three of the criteria listed (a) – (c).

In addition to the Penrose tiles, with their characteristic five-fold ($n = 5$) rotational symmetry, analogous sets of rhombic tiles can be constructed for other values of n [11]. I have also explored matching rules and recognizable-motif tiles for $n = 7$ and $n = 12$. The rhombi for $n = 7$ are shown in Fig. 4, along with insect-motif tiles based on these. The same line segment appears twelve times as an edge in these three tiles. The rhombi for $n = 12$ are shown in Fig. 5, along with two reptile-motif tiles for each rhombus. The same line segment appears

Fig. 4. Rhombi and insect tiles for the $n = 7$ analog to the Penrose tiles. From top to bottom the tiles represent a beetle, a moth, and a bumblebee. The angles of the rhombi are approximately 25.7°/154.3°, 51.4°/128.6°, and 77.1°/102.9°

Fig. 5. Rhombi and reptile tiles for the $n = 12$ analog to the Penrose tiles. From top left to bottom right the tiles represent two tadpoles, a snake, a Gila monster, a horned lizard, a frog, and a toad. The angles of the rhombi are 30°/150°, 60°/120°, and 90°/90°

Fig. 6. Two periodic tilings that can be constructed with the tiles of Fig. 5

24 times as an edge in these six tiles. Two tilings constructed from these tiles are shown in Fig. 6.

A different approach to realizing multiple-solution recognizable-motif tilings is to creatively combine simple geometric tiles. Penrose modified his set P1 by replacing straight-line segments with arcs of circles as one means of enforcing matching rules [6]. By combining these tiles six different ways and adding internal details, the tiles shown in Fig. 7 are obtained. Color plate 15 shows a portion of one of many possible tilings that can be constructed with this set of tiles. While the tiling of color plate 15 is non-periodic, this set allows periodic tilings as well.

(a) (b)

Fig. 7. (**a**) A portion of a curvilinear version of the Penrose set P1. (**b**) Six tiles constructed from this set: a butterfly, a caterpillar, a ladybug, a flower, a single leaf, and a group of three leaves

It should be noted that John Osborn has independently done related work on recognizable-motif tilings with multiple solutions [8]. He has used Penrose tiles and other rhombi as templates. Penrose's chickens, two designs by Osborn, and several of the author's designs have been commercially produced as puzzles[1].

Recognizable-Motif Tilings Based on Fractals

The recognition of fractals as a distinct branch of geometry was significant for several reasons. It led to a new way of viewing the world around us, in which the fractal nature of coastlines, tree branches, and other objects has been recognized and characterized. In addition, the Mandelbrot set and related mathematical "beasts" have revealed visually intriguing constructs [7]. These are created by iteration, which is the repetitive calculation of a formula until it converges to a result. While Escher built some fractal character into his prints, he lacked the insight and vocabulary provided by Mandelbrot's work.

To clarify the degrees and ways in which fractals can be employed in recognizable-motif tilings, I would like to group these in four categories. The term "bounded tiling" as used here refers to a tiling that is fully contained in a finite area by means of the motifs becoming infinitesimally small at the boundary, while an "unbounded tiling" would cover the infinite Euclidean plane. A "singularity" is a point at which the motifs become infinitesimally small, so that any finite area containing that point contains an infinite number of tiles. Finally, a "self-replicating" tile is one that can be subdivided into smaller exact replicas of itself. The four categories are:

(1) Bounded tilings with non-fractal tiles and non-fractal boundary.
(2) Bounded tilings with non-fractal tiles and fractal boundary.
(3) Unbounded tilings with fractal tiles that are not self-replicating.
(4) Unbounded tilings with fractal tiles that are self-replicating.

Escher's *Square Limit* and *Circle Limit* woodcuts are all of type (1). My *Bats and Owls* print (Fig. 8) is also of this type. One distinction is that in *Bats and Owls* there are singularities in the interior of the tiling as well as on the boundary. Note that the boundary of this tiling is an octagon, but not a regular one. The ratio of the long side of the octagon to the short side is $\sqrt{2}{:}1$ (the octagon can be obtained by dividing a square into a 4×4 grid of equal squares, then cutting on the diagonals of the four corner squares, leaving the center half of each original edge).

An example of a bounded tiling of type (2) with non-fractal tiles and fractal boundary is in Fig. 9. A quadrilateral tile is used as the basis for a seal motif.

[1] Penrose's designs have been produced as puzzles by the English company *Pentaplex*, Osborn's by the American company *Damert* and by himself, and Fathauer's by the American company *Tessellations*.

(a) (b)

Fig. 8. (a) Tiles on which *Bats and Owls* is based, and their relation to right triangles.
(b) Robert Fathauer, *Bats and Owls*, 1994. Screen print

(a)

(b) (c)

Fig. 9. (a) Tile on which *Seals* is based, and its relation to a quadrilateral. **(b)** The first
six generations of the quadrilateral tiles comprising a one-tenth wedge of the overall tiling.
Rotating this group nine times by an angle of 36° about the point *P* produces the full tiling.
(c) Robert Fathauer, *Seals*, 1993. Screen print

The overall tiling, which has ten-fold rotational symmetry, is made up of an infinite number of generations of successively smaller quadrilaterals. The boundary bears some similarity to a cross section of a head of cauliflower, which is often used as an example of a fractal-like structure occurring in nature. It cannot be seen on the scale shown here, but this tiling actually fails by overlapping of tiles in the tenth generation. However, there are related tilings that exhibit neither overlaps nor gaps with an infinite number of iterations [4]. Another example of a print based on a tiling of type (2), with a fish motif, are on the CD Rom.

Two examples of type (3) unbounded tilings with fractal tiles are in Figs. 10 and 11. Both of these designs have singularities distributed throughout the tiling, and both tilings if expanded would cover the infinite Euclidean plane. In Fig. 10, a "root three" rectangle (with long side to short side ratio of $\sqrt{3}$:1) is used to form a fractal tiling by repeated subdivision. With an infinite number of subdivisions, the tiling possesses an infinite level of detail and can therefore be expanded to fill the Euclidean plane without loss of detail. The simplest distortion of this rectangle, taking triangular notches out of the top and bottom edges, automatically leads to an infinite number of triangular protrusions on the side edges as a consequence of the construction of the tiling. Color plate 16 shows a tiling constructed using the serpent tile of Fig. 10.

Fig. 10. (a) The first, second, third, and seventh steps in generating an infinite fractal tiling from a rectangle with a long side to short side ratio of $\sqrt{3}$:1. (b) Tile on which *Fractal Serpents* is based, and its relation to one of the rectangular tiles in (a). Making the two long triangular notches in the top and bottom of the rectangle (middle figure) automatically creates the smaller triangular protrusions on the sides as a consequence of the fractal construction. This makes each individual tile a fractal object

Fig. 11. (**a**) The starting cross and first, second, and third steps in generating an infinite fractal tiling. (**b**) Primitive mask motif based on the cross in (**a**). Making a rounded notch in the top of each mask automatically creates an infinite number of rounded protrusions along the sides of each mask. (**c**) Robert Fathauer, *Fractal Masks*, 1995. Woodcut

(a)

(b)

Fig. 12. (a) The starting square and first three iterations used to generate a fractal self-replicating tile. (b) An approximation of the fractal tile after five iterations, with interior details added to suggest a dragon motif

The geometry in Fig. 11 is closely related to that in Fig. 10. In this case, however, a cross is replicated and reduced in size to fill a square area. Only in the limit, after an infinite number of steps, is the square completely filled. Again, since there is an infinite level of detail, the crosses can then be expanded to fill the Euclidean plane. To form a tiling with recognizable motifs, the cross is replaced with a group of four primitive masks. Note that each mask is a fractal object, with an infinite number of rounded protrusions on the sides of each mask that result from making a single rounded notch in the top of each mask.

An example of a fractal tiling of type (4) is shown in Fig. 12. The tile is generated iteratively according to an algorithm described in the mathematics literature [1], [10]. With each iteration, the last shape is reflected about a vertical axis and replicated eight times, and these nine shapes are then placed in a particular arrangement. After an infinite number of iterations, a fractal tile is obtained that is self-replicating. That is, the tile can be subdivided into nine smaller replicas of itself that are reflected, or 9^2 still smaller replicas of itself that are not reflected, or 9^3 even smaller replicas of itself that are reflected, and so on.

Categories (3) and (4) might not have been fully satisfying to Escher, whose motivation for exploring fractal-like tilings was to fully contain an infinite tiling in a finite area. However, he surely would have enjoyed the complexity and fascinating forms found in fractal tiles, as well as the new way of looking at nature afforded by fractals. The four categories listed above are not the only possible types of tilings based on fractals. One can only speculate as to whether they are the sort of tilings that Escher might have made had he had access to the vocabulary of fractal geometry.

By exploiting new mathematical discoveries unknown to Escher we can create recognizable-motif tilings that are quite distinct from Escher's work. This is particularly significant because of the thoroughness with which Escher explored the aspects of tiling that were known to him.

References

[1] C. Bandt, "Self-similar Sets 5. Integer Matrices and Fractal Tilings of R," *Proc. Amer. Math. Soc.*, v. 112 (1991), 549–562 .

[2] J.K. Bøggild, "Breeding Tessellations," *Math. Teaching*, v. 90 (1980), 31–36.

[3] F.H. Bool, Bruno Ernst, J.R. Kist, J.L. Locher, F. Wierda, *M.C. Escher: His Life and Complete Graphic Work*, New York, Harry Abrams, 1982.

[4] Robert W. Fathauer, "Fractal Tilings Based on Kite- and Dart-shaped Prototiles," *Computers and Graphics*, v. 25 (2001), 323–331.

[5] Martin Gardner, "Extraordinary non-periodic tiling that enriches the theory of tiles," Mathematical Games, *Scientific American*, v. 236, no. 1 (1977), 110–121. Reprinted and updated in *From Penrose Tiles to Trapdoor Ciphers*, W.H. Freeman and Company, 1989, pp. 1–29.

[6] Branko Grünbaum and G.C. Shephard, *Tilings and Patterns*, W.H. Freeman and Company, New York, 1987.

[7] B.B. Mandelbrot, *The Fractal Geometry of Nature*, W.H. Freeman and Company, New York, 1982.

[8] John A.L. Osborn, "Amphography, the Art of Figurative Tiling," *Leonardo*, v. 26 (1993), 289–291.

[9] Doris Schattschneider, *Visions of Symmetry: Notebooks, Periodic Drawings, and Related Work of M.C. Escher*, W.H. Freeman and Company, New York, 1990.

[10] Andrew Vince, "Replicating Tessellations," *SIAM J. Discrete Mathematics*, v. 6 (1993), 501–521.

[11] E.J.W. Whittaker and R.M. Whittaker, "Some Generalized Penrose Patterns from Projections of *n*-Dimensional Lattices," *Acta Cryst.*, v. A44 (1988), 105–112.

A Circle Limit in Stone

Helaman Ferguson with Claire Ferguson

Escher Connection

From its home at the Mathematical Sciences Research Institute (MSRI) in Berkeley, California, the *Eightfold Way* overlooks the mountains adjoining Grizzly Peak and San Francisco Bay. It is a polished tetrahedral form carved out of white Carrara marble, cupped in a black serpentine column and centered in a tessellated disc of stone tiles: the disc is subtitled *Circle Limit 7* (Fig. 1).

It would be convenient in a volume dedicated to M.C. Escher's Centennial for me to say my *Circle Limit 7*, a hyperbolic tessellation, was wholly inspired by Escher's *Circle Limit I, II, III, IV* series. This was not at all the case. Both Escher and I responded aesthetically to the same mathematics. The mathematics includes the geometry of the Poincaré disc model of the hyperbolic plane as initially developed by R. Fricke and F. Klein. Later-generation sources were H.S.M. Coxeter for Escher and W. Thurston and J.H. Conway for me. In this respect, our respective work is somewhat irrelevant: it is the mathematics that provides the jewels just waiting for an artist to set into a crown. Both Escher and I were developing core mathematical ideas of the geometry of fractional linear transformations. The wonderful idea is that there are more triangles in hyperbolic space, and hence more symmetries, indeed multiply-periodic noncommutative symmetries. This means there are more regular tilings possible in hyperbolic geometry. However, in assigning the subtitle *Circle Limit 7* to the base platform of the *Eightfold Way* sculpture, I am most definitely inspired by Escher's

Fig. 1. The *Eightfold Way* and its platform component hyperbolic disc, *Circle Limit 7*. Photograph taken from an upper window in the MSRI building

picturesque *Circle Limit* titles. This came after the fact, as did the realization that perhaps *Circle Limit 7* is the first circle limit in stone and the largest physical Poincaré disc anywhere.

Aesthetic Concepts

The name *Eightfold Way* arises from the remarkable paths traced by the incised and excised pattern over the hand-polished marble. This same combinatorial pattern persists when tracing the paths of the tessellated base *Circle Limit 7*. If the observer runs her finger along any groove or ridge, alternating left and right turns at each corner, then in eight pivots she will return to her starting point. The name *Circle Limit 7* for the two-dimensional base on which the three-dimensional sculpture is mounted was chosen not because it is the seventh of a series of circle limit prints (Escher's names merely numbered the order in which he made his prints), but rather because it is a hyperbolic tiling by regular heptagons (seven-sided polygons).

The creative process that released the abstract ideas encased in this eons-old stone combines the analysis of science with the emotion of the artist to produce a symphony of elegant counterpoint. Gothic tracery and Alhambra tilings unite in this one work. As noted earlier, *Circle Limit 7* was inspired by the same mathematics of hyperbolic geometry that inspired M.C. Escher when he created his *Circle Limit* series of four woodcuts. In Michele Emmer's video [5], H.S.M. Coxeter discusses his interaction with Escher on this series of prints. Escher had earlier made several prints in which figures repeated on a smaller and smaller scale towards the center of the print. Until he saw Coxeter's paper that depicted a hyperbolic tiling of triangles, Escher had not been able to do a print in which the figures repeated outwards, forever diminishing in size, to the edge of the circle limit. I myself don't fault a draftsman, however gifted, for not discovering non-euclidean geometry in the course of doing a woodcut. (For Escher's *Circle Limit* prints, see articles in this book by H.S.M. Coxeter, Douglas Dunham, and Victor Donnay; also see [1, 6–8, 16].)

The base platform of the *Eightfold Way* makes a direct visual connection with Escher's circle limit woodcuts. The cover image of Marvin Greenberg's book [13] is the geometric backbone of Escher's *Circle Limit IV*. This was modelled on a tessellation of the hyperbolic plane by 45°–45°–90° triangles which are pairings of the alternately-colored 45°–45°–90° triangles in Fig. 7 of the paper by Coxeter [2] – the figure that so influenced Escher. This figure contains the solution to Escher's problem of infinite repetition radiating outward to a limiting circle and is the precise mathematical source of his *Circle Limit* series. Escher's wonderful woodcuts came after his recognition of the solution and an unthinkable amount of painstaking labor.

One general theme reflected in my *Eightfold Way* sculpture is that topology has an underlying rigid geometry and vice versa. The rigid geometry in this case

is expressed by the hyperbolic tiling *Circle Limit 7*. This geometry-topology theme has arisen repeatedly in the last couple of centuries in mathematics, from Euler to Poincaré, Klein, and Fricke. Recently the theme has been developed extensively in the work of William Thurston and others [17]. For more about the mathematics of Klein's quartic Hurwitz surface which inspired this three-dimensional sculpture and two-dimensional hyperbolic disc, see the entire book referred to in [12]. Some of these ideas have been developed further in [10] and [11].

Hyperbolic Precursors?

Sand paintings are a traditional Buddhist art form. The sand version of the Eight-fold Path mandala involves arcs of circles in a disc arrangement suggesting a connection with the hyperbolic disc (see [14]). There are interesting mirrors that I have seen at the Art Institute of Chicago where the back of the mirrors have hyperbolic-like arrangements of arcs of circles. They are made with Dragon arabesques, Eastern Zhou Dynasty, Warring States period or early Western Han Dynasty, 3rd/2nd century B.C. These artifacts are gifts of the S. M. Nickerson Endowment. Again, these circle arc forms are suggestive of hyperbolic disc constructions. Could these have Eightfold Path origins? Had Escher seen those images? Had Poincaré, for that matter?

Getting the Circle Limit into Stone

Early in 1992, Bob Osserman, a co-director at MSRI, pressed upon me the suggestion of a hyperbolic disc platform for the marble sculpture *Eightfold Way* that had been comissioned for MSRI. He did this by faxing me various images from Klein and Fricke. I hesitated only because this desirable feature would exceed the budget given by the donor. When Bob assured further funding, I yielded to his insistence.

It was important to specify exactly in computer form the hyperbolic tiling blocks. In October 1992, I visited MSRI and worked with Silvio Levy on finalizing the tile data for input to the PC system which controlled the water-jet I was planning to use to cut the hyperbolic tiles. I had worked out my own *Mathematica* programs for tiling the Poincaré disc with regular 120° heptagons, but these programs were not PC-compatible. Silvio had been through something like this before when he generated an automatic version of Escher's *Circle Limit III* (see [15]).

Developing the hyperbolic platform in stone required some pretty extensive computer logistics and special material handling. The heptagonal prism with 120° angles had to fit the real size of the conformal Poincaré disc that

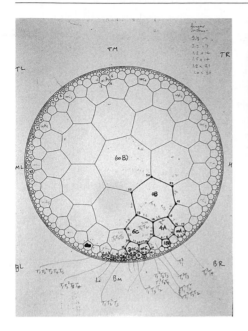

Fig. 2. Silvio Levy's *Geomview* picture of the heptagonal tiling of the Poincaré disc. The tiles outlined are a fundamental set of those to be cut in stone

Fig. 3. *Circle Limit 7*, the hyperbolic tiling of heptagons installed and curing at MSRI. The earthquake-stabilization hole in the middle is not yet drilled into the concrete pad and footings

would mathematically scale with the rigid central hyperbolic regular heptagon. The next difficulty was cutting the hundreds of heptagonal tiles in stone to the desired precision of a few thousands of an inch. I solved the precision problem with computers and water-jet cutting technology.

Silvio saved the project a great deal of time by adapting the Geometry Center's word-generation programs to extract the postscript form to the input data I needed for the water-jet programs. The water-jet system is a robot system which responds only to a meticulously prepared set of instructions (Fig. 2).

The black stone in the hyperbolic platform base of the *Eightfold Way* is one of the many forms of the mineral serpentine, a magnesium silicate related to granite in its plutonic or subterranean origins, but a compacted mineral talc with small rhomboid crystal size. Also called steatite, serpentine comes in a wide spectrum of quality and hardness. The softer steatites, which may contain asbestos-type fibers, are called soapstones. Because this mineral is impervious to heat and chemicals, it was carved by some of our more ancient ancestors into utensils, and is used today to line steel furnaces, build efficient wood stoves, and provide laboratory table tops. Some varieties are as hard as granite but with a finer grain. I desired one of these hard, dense black types, deposits of which occur in the Blue Ridge mountain area of Albemarle County in Virginia. I used this material for

the fluted heptagonal prism and for the heptagonal tiles. This serpentine is hundreds of millions years old, a suitable material to express mathematical ideas of timeless beauty and power.

To accomodate the circle at infinity (the boundary of the disc) there are 14 disc rim or corona stones. Interior to that are 217 hyperbolic heptagon stone blocks. Each heptagon has seven interior angles, each 120°. The 217-tile ensemble has 23 dark and 194 light serpentine heptagons surrounding a center prism with an exact conformal heptagon base. Given the role of Janos Bolyai in the early history of non-euclidean geometry (see [13]), I thought it would be appropriate to have someone of Hungarian heritage set this non-euclidean geometry disc. This really did happen, perhaps by accident. The tiles were finally set in May 1993 by an old-world tile man suitably named Lajos Biczo. Joe Christy of MSRI facilitated the setting of the tiles and protected them like a mother hen while the grout cured. The rest of the sculpture could not be installed until the tile setting and grout were thoroughly cured (see Fig. 3). The final installation of the complete *Eightfold Way* was in August 1993.

Water-Jets

The abrasive Colorado River carved the Grand Canyon out of solid rock. Looking over the south rim at the tiny filament of water glistening in the sun far below, I mused about capturing that sort of power in my studio. Close up, the thin stream of a water jet is no larger than the observed sliver of that distant river. The noise of the water jet seems to compress millions of years of erosion into a few seconds of roaring tornado sound, churning the catch chamber below into white water. This violent roar comes from a filament of water issuing from a diamond orifice under a pressure of 55, 000 pounds per square inch. When I used a water-jet to cut the stones for the *Circle Limit 7*, this device was still somewhat experimental. Since that time it has become a common industrial tool, used to cut all manner of materials from textiles to five-inch thick steel. Water-jets are not suitable for carving; they cut clear through – the tiny water-jet explodes from one side of the material to the other (Fig. 4).

Water-jet devices are also robots in the strict sense that they respond to a predetermined straight line program which allows no variation. All motions have to be calculated in advance. How does one debug a water-jet? A complete set of 232 blocks were first cut from 3/4 inch plywood in a debugging run. This set of wooden hyperbolic tiles was then assembled before cutting the serpentine stone (Fig. 5).

The final stones, counting the prism, were 24 black and 208 green serpentines. The Virginia green in this case was actually a bit harder stone than the black and the greens tended to be the smaller stones. All the heptagons were cut to great accuracy with seven circular-arc geodesic edges and seven 120° interior angles (Fig. 6).

Fig. 4. Water-jet robot in the process of cutting out one of the serpentine blocks for the hyperbolic tiling. This set-up, part-holding, and cutting process had to be done over 232 times

Fig. 5. To debug the water-jet program, a full set of wooden blocks was cut and then assembled

Fig. 6. The full set of stone tiles as cut by the water-jet robot. Note the dark cluster in the middle and the corona stones on the rim. The cluster "lifts" and "sews up" into the tessellated tetrahedroid which forms the white marble component of the *Eightfold Way*

The cutting itself took about a week for both the debugging run with plywood and the actual cutting of the stones. One of the most difficult parts of the cutting process was to figure out how to hold the part to be cut. Part-holding became more challenging for the smaller heptagons in both the wood and the stone.

Triskelions

The heptagons in *Circle Limit 7* imply seven-fold symmetry. With 120° corners, each heptagon vertex forms a triple point or a triskelion with the edges of its three neighbor points. The grooves or ridges of the three edges are curved to meet the neighbor point. In the lifting of the system from the platform to the marble, there are 56 points, 84 edges, and 24 heptagons. Thus in the marble part of the sculpture there are 56 triskelions in all, even though they can be thought of as coming from infinitely many in the hyperbolic disc. In carving this marble, I used a small plexiglass equilateral triangle as apattern to keep these triskelions under some equiangular control. This was a loose qualitative 120° consideration which rhymes with the more exact quantitative 120° triple points of the *Circle Limit 7* base platform.

The triple-point symmetry is literal in the quantitative two-dimensional *Circle Limit 7*, the base upon which the sculpture rests. Here the triple points are embedded in a system of infinitely many triple points. An infinite discrete group can be associated with this platform. This infinite group acts by hyperbolic transformations on the hyperbolic plane and has a fundamental domain of exactly 24 heptagons. In this case, there are 23 darker heptagons grouped around the one dark polished stone heptagonal prism in the center of the hyperbolic disk. The triskelions have been cut to have metrically accurate 120° angles. The discrete group transforms the fundamental domain in such a way that certain edges are identified. Indeed, the identification is given by the *eightfold way* path sequence of left and right described earlier. The transformations sew up the 24-heptagon domain into a surface of genus three, namely, the marble surface lying above the fundamental domain.

The boundaries of the 24 white marble heptagons carved into the tetrahedral form are articulated as either ridges or incisions. The incisions, or cuts, define the doubled outside boundary of the lower fundamental domain. The ridges on the marble also (compared to the incisions just described) form edges of heptagons. These ridges correspond to the geodesic arcs in the hyperbolic plane which lie inside the fundamental domain (the cluster of darker contiguous heptagons).

Unlimited Prints!

Developing the circle limit of heptagons of the Circle Limit 7 was very different from Escher's technique of creating woodblocks for his prints. I believe Escher

would have been delighted to use today's computer technology. After cutting the wood blocks of the heptagonal disc tiling I made six large (6′ × 6′) canvas multicolor rubbings of the hyperbolic tesselation. By now, many people have made crayon and paper rubbings of the stone hyperbolic platform *Circle Limit 7* in its setting at MSRI. I personally encourage people to do those rubbings. They are easy to make and can give a frameable result to take home to share the joy of the thing. Like most graphic artists who limit the number of prints they make, Escher drilled holes in his circle limit wood blocks to prevent more impressions from being made. There are no limits to the number of impressions to be taken from the circle limit of heptagons of the *Circle Limit 7*.

Location

The *Eightfold Way* sculpture with its *Circle Limit 7* base is permanently installed in the southeast patio area of the Mathematical Sciences Research Institute, located in the east hills of the campus of the University of California at Berkeley, 1000 Centennial Drive. Also located on Centennial Drive to the north is the Space Science Laboratory. Centennial Drive winds up the hills from the Berkeley campus past the Berkeley labs up to the Lawrence Hall of Science. Across the street from LHS are parking lots for MSRI and SSL; there is also a trail leading up the hill to MSRI through the scrub and scree from those parking lots. The telephone number for MSRI is (510) 642 0143 and their web site is www.msri.org.

References

[1] F.H. Bool, J.R. Kist, J.L. Locher, and F. Wierda, *M.C. Escher, His Life and Complete Graphic Work*, Harry Abrams, New York, 1982. See pages 97, 320; 98, 322; 319; 320.

[2] H.S.M. Coxeter, "Crystal Symmetry and its Generalizations", *Transactions of the Royal Society of Canada*, 3 (51) 1957, pages 1–11.

[3] H.S.M. Coxeter, *Regular Polytopes*, Dover Publications, Inc., New York, 1973, pp. 24–25 and p. 32.

[4] H.S.M. Coxeter, *Non-Euclidean Geometry*, Mathematical Association of America, Washington, D.C., 6th Edition, 1998.

[5] Michele Emmer, *The Fantastic World of M.C. Escher*, VHS Video, Film 7 International, 1980 and Media Acorn, 1994. Springer-Verlag, Berlin, 2001.

[6] M.C. Escher, *Escher on Escher, Exploring the Infinite*, Harry N. Abrams, New York, 1989, pages 42, 43, 126.

[7] M.C. Escher, *The M.C. Escher Sticker Book*, Harry N. Abrams, New York, 1995. Contains *Circle Limit III* (fishes) and *Circle Limit IV* (angels and devils).

[8] M.C. Escher, *The Graphic Work of M.C. Escher*, Meredith Press, New York, 1960. Benedikt Taschen Verlag GmbH, 1992. See page 10 and plates 22, 24, 25.

[9] Claire Ferguson, *HELAMAN FERGUSON: Mathematics in Stone and Bronze*, Meridian Creative Group, 1-800-530-2355, Erie, Pennsylvania, 1994.

[10] Claire Ferguson, *The Hyperbolic Quilt*. Quilt and paper for Phyllis Cassidy's Non-Euclidean Geometry class, Smith College, 1997. Unpublished.

[11] Helaman Ferguson, *The Great Figure Five*. Computer graphics color image of the hyperbolic checkerboard of pentagons, with the figure 5, "moving, tense, unheeded," rumbling through the hyperbolic plane. A 1996 response (finally) to the imagist poem by William Carlos Williams and the subsequent painting by his friend Charles Demuth. Unpublished.

[12] Helaman Ferguson with Claire Ferguson, "Eightfold Way: The Sculpture," in *The Eightfold Way: The Beauty of Klein's Quartic Curve*, Silvio Levy, ed., Mathematical Sciences Research Institute Publications, vol. 35, Cambridge University Press, 1999, pp. 133–173.

[13] Marvin Jay Greenberg, *Euclidean and Non-Euclidean Geometries. Development and History*, W.H. Freeman & Co., New York, 1996.

[14] Silvio Levy, "Automatic Generation of Hyperbolic Tilings," in *The Visual Mind: Art and Mathematics*, Michele Emmer, ed., The MIT Press, Cambridge, Mass., 1993, pp. 165–170. (I have a polaroid from the Geometry Center dated November 1991 of Silvio Levy's full-color computer-generated version of Escher's Circle Limit III.)

[15] Claude B. Levenson, *Symbols of Tibetan Buddhism*, Editions Assouline, Paris, 1996, Chapter 3. The Wheel of the Law. p. 21 (facade on a temple) and p. 22 (sand drawing on the ground).

[16] Doris Schattschneider, *Visions of Symmetry: Notebooks, Periodic Drawings, and Related Work of M.C. Escher*, W.H. Freeman, New York, 1990. Chapter 5: Notes on the Drawings pp. 284–322.

[17] William P. Thurston, *Three-Dimensional Geometry and Topology*, vol. 1, edited by Silvio Levy, Princeton University Press, 1997.

Portrait of Escher: Behind the Mirror

Kelly M. Houle

From the first time I encountered M.C. Escher's work, I began to think about the possibility of hidden worlds. Even as a child, I wondered if there would ever be a moment when I would suddenly "find" the fourth dimension, the way I had discovered so many of the mysterious worlds within Escher's work, or if I would ever discover that I had a twin who had been living life as my mirror reverse. I became fascinated by the process of discovery and the feeling of sudden realization when I came to understand one of Escher's many illusions. Now, I have the same reaction to anamorphic art.

Anamorphosis, translated from the Greek roots "ana", meaning again and "morphe", meaning form, refers to an image that is literally "formed again". This process of distorting an image so dramatically that its correct dimensions are only reconstructed when the viewer changes his or her perspective just as dramatically, allows two different interpretations of a single image. Anamorphosis provides a specialized means for creating ambiguous images which, for me, symbolize many of the mathematical and philosophical paradoxes I have often tried to visualize. The lucid mirror reflection with its grossly deformed cylindrical projection is a metaphor for the existence of multiple geometries, higher dimensions, and order that resides within a seemingly chaotic system. Anamorphic art, combined with the right subject matter, alludes to the coexistence of opposing

A Fashionable Lady

Fig. 1. *A Fashionable Lady*, cylindrical anamorphosis (without mirror), c. 1900. Reproduced from [6], with permission

truths, and the notion that reality depends on the perspective system used by the observer. In Escher's work, as with anamorphosis, perspective is relative. It is this property of anamorphic art that echoes the same themes that characterize Escher's work: hidden worlds, impossible worlds, and the infinite. For this reason I chose Escher as the first subject in my series of anamorphic portraits.

Anamorphic Evolution

For centuries, anamorphic art has been used for a variety of purposes by artists within mathematical and scientific circles. The few artists who possessed an understanding of the optics involved in anamorphic construction kept their equations, grids, and mechanical drawing devices as well-guarded secrets [1, p. 1]. Considered magical, early mirror anamorphoses (which first appeared between 1615–1625) gained a mystical following and were even used in religious

Fig. 2. Jean François Niceron, *Anamorphic grid for cylinder and anamorphosis of Saint Francis of Paola*, 1638. Reproduced from [1], with permission

conversion by European missionaries. The cylindrical anamorphosis *Crucifixion* from about 1640 is an example of an early anamorphic painting with a religious theme [1, p. 148]. In the early 1900s anamorphic art experienced an increase in popularity. Seen as toys, these optical diversions became very popular, and proliferated to the point of excess. The drawings featured ordinary objects and cartoon-like caricatures of people and animals (Fig. 1). By this time, the subject matter had become devoid of any philosophical or poetic depth. Even the reflected images were flat and two dimensional. Eventually the technique suffered from overuse, and anamorphic art virtually disappeared from the eye of the mainstream public.

Today, the process of creating anamorphic images no longer remains a secret (see inset "How Cylindrical Mirror Anamorphoses Work") and anyone with patience or the right computer software can distort an ordinary drawing or photo so that it can be viewed reasonably well with a curved mirror. A recent book, reminiscent of those in the early 1900s, has cartoon-like circus images to view with an enclosed mylar mirror along with explanation of how to produce original anamorphic images with a simple grid [7]. The challenge to the anamorphic artist today is to use anamorphosis as a tool to convey a vision, the way Escher used the tools of impossible figures, tessellations, and reflections to express his ideas about the possibility of simultaneous worlds, the nature of infinity, and the sometimes ambiguous nature of spatial relationships. Escher's work challenges the viewer to look at a situation from many points of view at once. Anamorphosis does the same thing.

I use a combination of methods to create anamorphoses. First, I transform the image from a Cartesian coordinate grid to a modified polar grid similar to the one described in Jean François Niceron's 1638 text *La Perspective Curieuse*. [6, p. 162–167]. (See Fig. 2.) I combined what I could gather from my own rough translation of the French text by Niceron with what I knew about optics to design a set of polar grids that are mathematically exact based on the diameter of the mirror I want to use, the size of the drawing, and the average height of the observer. I use the grids to plot several points and lines from the original sketch by hand until I have a basic outline of the subject. I prefer not to use a computer to create my anamorphoses. Over time I have found that an exact coordinate translation is not always pleasing to the eye. I like having the freedom to modify my design while looking into the cylindrical mirror. I check the reflection constantly to make sure that my drawing has been accurately and effectively translated into its mirror reflection. I have found that anamorphic images, especially those that occupy 360 degrees, are in many ways more like sculpture than drawing. The act of making adjustments to the drawing while walking around it helps me to better create something that will be experienced in three dimensions.

Once I have plotted the image carefully, I look into the curved mirror to complete drawing. Many times I finish this stage without looking directly onto the surface of the drawing itself. This results in a collection of apparently random brushstrokes, abstract geometric shapes and swirls, depending on the amount of

detail I want in the finished piece. Although I know from experience what shapes and subjects work best, I rarely know exactly how a particular image will look once it has been distorted. Often, I am surprised by the result.

Anamorphic Escher: Strange Symmetry

Catoptric anamorphosis, the type of anamorphosis that requires curved mirrors to interpret the purposely skewed perspective, allows the viewer to see an image and its distortion simultaneously. This type of anamorphosis is especially reminiscent of Escher's prints that include mirror reflections, and carries the same suggestion of hidden worlds. Because anamorphosis makes it possible for an image to exist in two forms at the same time, it provides a concrete, visual model of the idea that there may be several ways to interpret an object or event, that there may be some hidden structure in things that at first seem random and meaningless.

It has been said that Escher's work concerning the infinite tiling of the plane was his way of searching for order in a chaotic world. Escher once wrote, "I try in my prints to testify that we live in a beautiful and orderly world, and not in a formless chaos, as it sometimes seems." [5, p. 21] The anamorphic transformation of chaos to order echoes Escher's inner struggle against the entropic nature of the universe, and the solace he found in the existence of natural crystalline structures which mysteriously arrange themselves to form regular geometric patterns. Similarly, in anamorphic transformation, the melted, formless streaks on a flat surface rise like steam, assembling themselves to compose a recognizable image in a third dimension. This change from a flat drawing to a form that has height and depth reminds me of many Escher prints that show creatures emerging from a two-dimensional plane to begin a life cycle in three-dimensions, and then returning to the flat plane again. The action of taking the cylindrical mirror and placing it on the surface of the anamorphic distortion causes a kind of metamorphosis of the flat drawing into its reflection. Like Escher's prints, anamorphosis is about becoming rather than being, a way of showing progression from one form to another. The mirror creates a path for this process, a window to the possibility of other universes. In seeing an anamorphic distortion along with its representational reflection, it seems possible to visualize order residing within apparent chaos. Between the realms of order and chaos stands the monolithic anamorphoscope, a cylindrical mirror that has the power to rearrange and make sense of an abstraction. Placing the mirror properly allows patterns to emerge from the flat painting and appear in its reflection. The mirror gathers up the formless sea of lines into a perceivable image. It becomes a tool that changes the amorphous wisps into recognizable figures. Looking into a cylindrical mirror, the viewer may expect to see his own reflection. Instead, he or she discovers some parallel, yet otherwise imperceptible, universe.

How Cylindrical Mirror Anamorphosis Works

The Law of Reflection

A cylindrical mirror distorts information in two different directions. To see why this is true, look at the cylinder from two different points of view...

The side of the mirror is straight, like the surface of a flat mirror...

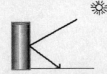

but its edges are rounded, like the surface of a curved mirror.

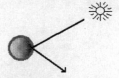

In both situations, the angle of incidence is equal to the angle of reflection. In the case of a curved surface, these angles are measured from a line tangent to the curve at a specific point.

The Cone of Vision

Light rays travel to our eyes in straight lines from all directions. The area of the pupil is small compared to the area from which light may travel. This causes an effect called the "cone of vision."

The cone of vision causes some interesting patterns when combined with the way light is reflected in curved mirrors. Rays (shown as traveling from the pupil) strike the surface of the mirror at various angles.

This pattern shows the radial reflection of light due to the law of reflection for curved mirrors and the cone of vision.

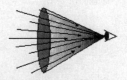

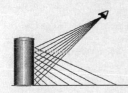

This pattern shows how light rays spread out as they strike farther and farther from the surface of the mirror due to variation in the angle of incidence.

The anamorphic transformation produces a set of polar coordinates that return to their rectangular origins when viewed with a cylindrical mirror.

rectangular grid

polar grid

By including the mirror, the artist provides the key to solving the riddle of the anamorphic distortion, just as Escher lets us in on the secrets behind his paradoxical drawings. As Bruno Ernst observed of Escher, "He asks us to admire the puzzle but no less to appreciate its solution." [3, p. 64] The presence of the solution within the puzzle of Escher's work creates a kinship of understanding among those who are familiar with it. When we see what Escher wanted us to see, we are surprised, amused, enlightened. Like Escher, we then want to let others in on the secret, to feel the companionship of shared appreciation of the explanation.

> *Escher builds the impossible according to a strictly legitimate method that everyone can follow; and in his prints he demonstrates not only the end product but also the rules by which it was arrived at. ... (Escher's) impossible worlds are discoveries; their plausibility stands or falls by the discovery of a plan of construction, and this Escher has usually derived from mathematics.* [3, p. 66]

Anamorphic art has the same effect on those seeing it for the first time. The anamorphoscope performs the same function as Escher's mathematical framework by providing a code for deciphering the anamorphosis.

Escher made several drawings depicting the effect of curved mirrors on surrounding objects. In the lithographs *Still Life with Reflecting Sphere* (Fig. 3) and *Three Spheres II* (see page 80), Escher shows how a convex spherical mirror distorts recognizable objects. The horizontal and vertical lines of a room, for example, become transfigured as the entire space surrounding the mirror is compressed into a compact sphere. Objects no longer resemble themselves, as the familiar architecture becomes warped.

The most surprising aspect of anamorphosis is that it appears to perform the reverse operation by returning familiarity to a purposely distorted form. The

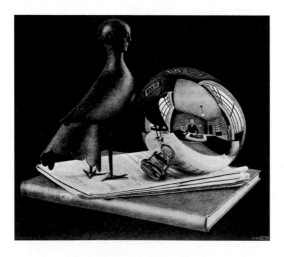

Fig. 3. M.C. Escher, *Still Life with Reflecting Sphere*, 1934. Lithograph

effect of a curved mirror seems more astonishing when a recognizable image appears from a distortion. Whether the curved mirror deforms or restores familiarity, it shows the existence of contradictory realities: the world outside the convex surface and the world within the reflection. For my portraits of Escher, I chose two images that showed Escher looking at his own reflection in a spherical mirror. One was from a photograph taken of Escher and the other was Escher's self-portrait *Hand with Reflecting Sphere* (Fig. 4).

Escher I: Double Reflection (An Anamorphic Portrait)

When making self portraits, artists often include artifacts in the image to emphasize an aspect of their profession or personality. In his lithograph *Hand With Reflecting Sphere* Escher chose to emphasize his own hand. George Escher wrote that his father's print Drawing Hands (Escher's depiction of his own hands drawing themselves into existence) was "a true self portrait" of his father.

> *Father's hands are the feature of him which I most vividly remember. Looking at their precise movements, neatly arranging tools, sharpening gouges and chisels with rhythmic motions, preparing wood to a smooth, velvety finish, I could sense the pleasure that this activity gave him.* [4, pp. 8–9]

Escher often expressed that he preferred to be known as a graphic artist, a printmaker, a craftsman. Escher's inclusion of his own hand in the print forces us to imagine the meticulous nature of his occupation as a graphic artist, and makes us very aware of his existence as he draws his own reflection.

Escher chose to draw his reflection as it was distorted by a curved mirror, an object that appears several times in his work. A spherical mirror forces anyone looking into it to remain immovably in the center of the reflection. Escher himself noted that "Your own head, or more exactly, the point between your eyes, is in the center. No matter how you turn or twist yourself, you can't get out of that central point. You are immovably the focus of your own world." [5, p. 60] In this case Escher's "world" was his studio, a place where he would allow himself to become lost in other worlds, where the laws of physics no longer reigned. Escher holds his "world" in his hand. In this sense he has given himself complete control over this part of his life. Escher's prints were his to manipulate without the restraints of gravity or the chaos he felt within the realm of human existence.

Escher does not include other people in this illustration of his world. His work left him outside the mainstream circles of mathematics and art. He did not feel a connection with other artists or other aspects of the art world, and he felt that the mathematical side of his work was on the periphery, a secret garden into which he was the first and only soul to venture. "I walk around all alone in this beautiful garden, which certainly does not belong only to me, but whose gate is open to everyone. I feel a revitalizing yet oppressive sense of loneliness." [2, p. 156] The presence of the mirror in his self portrait sets up a boundary

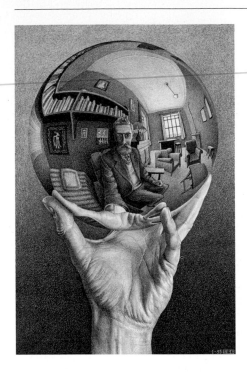

Fig. 4. M.C. Escher, *Hand with Reflecting Sphere*, 1935. Lithograph

between Escher's inner life (where his imagination was free to explore without the constraints of conventional time and space), and the outside world. The place where Escher's hand meets the surface of the mirror is the link that connects the two worlds. His craft was his means of expressing questions, and possibly answers, about the paradoxical nature of time and space to a world of grateful admirers, many of whom he would never know.

In *Escher I: Double Reflection*, an anamorphic projection of Escher's *Hand with Reflecting Sphere* (Fig. 5), a second mirror boundary stands between our world and Escher's. Escher's self portrait, as he drew it, exists in the reflection of a cylindrical mirror. Its anamorphic distortion from which the reflection is generated extends outward from base of the cylinder. Escher's portrait is re-formed in the reflection with his hand extending both inward and outward from the base of the cylindrical mirror. The seamless worlds flow from one to the other with Escher's hand as the bridge in between the two realms: our three-dimensional world, and the world of Escher's drawings.

Escher plays with our perception of the dimensionality of objects in the lithographs *Magic Mirror* (page 221) and *Reptiles* (page 307) by manipulating light and shadow. He explained

> *The flat shape irritates me – I feel like telling my objects, you are too fictitious, lying there next to each other static and frozen:* <u>*do*</u> *something, come off the paper and show me what you are*

capable of! ... So I make them come out of the plane. Not, of course, in reality, On the contrary, I am deliberately inconsistent, suggesting a plasticity in the plane by means of light and shade ... My objects, given life in a fictitious way, are now able to proceed as independent plastic creatures, and they may finally return to the plane and disappear into their place of origin. [2, p. 168]

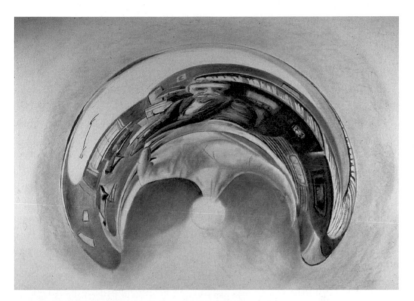

a

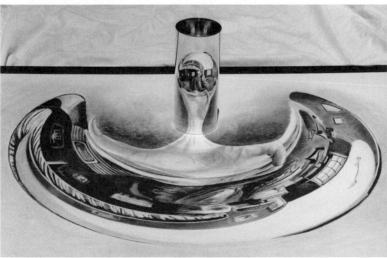

b

Fig. 5. Kelly M. Houle, *Escher I: Double Reflection*, cylindrical anamorphosis, 1998. Charcoal on illustration board. (**a**) Without mirror. (**b**) With mirror

Looking at an anamorphic distortion without the cylindrical mirror in place, the flat drawing appears to be composed of two-dimensional shapes. The original image of Escher's hand holding a reflective globe, which was drawn according to the rules of light and shading, has been bent around a central point. In the distorted anamorphic drawing, the forms appear to lose their depth because there is no longer a consistent light source. We are used to light traveling in a straight line from a point source and falling on objects from one particular angle. When the original image is bent and stretched into a circular swath, the shadows seem to fall in all directions. When the curved mirror is used to reflect the anamorphic distortion, the forms take on the familiar rules of light and shading that make them seem three-dimensional. The reflection now appears more realistic and three-dimensional than the anamorphic distortion. However, anamorphosis (like all drawing techniques) is deceptive. The flat drawing is the true three-dimensional object. The drawing has length and width and the thin layer of charcoal on the heavy tooth of the paper adds the third dimension of height. The reflection, like a shadow, exists in only two dimensions.

Escher II: Infinite Reflection (The Continuity of Self And Space)

My second anamorphic portrait of Escher is based on a photograph of Escher looking at his own reflection in a spherical mirror ([2], frontispiece). Similar to his self portrait *Hand With Reflecting Sphere*, this photograph shows Escher absorbed in the contorted space of the spherical reflection from a third person's point of view. Like the photographer, we are seeing Escher's profile as he gazes into the mirror. *Escher II: Infinite Reflection or The Continuity of Self and Space* (Fig. 6) is a cylindrical anamorphosis of this famous photograph.

I went through several preliminary anamorphic sketches of this photo, but none of them produced the effect I wanted my portrait of Escher to have. Escher's work is startling, and I wanted something that would surprise and shock a person seeing this piece for the first time. I knew I finally had the right idea when the image of an *infinite* portrait of Escher woke me from my sleep one night. I had visualized Escher's profile reflected on one side of a cylindrical mirror (Fig. 6b). As the image progressed 90 degrees counterclockwise, the scene would change to show Escher with the spherical mirror in his hand, looking at his own reflection (Fig. 6c). Progressing another 90 degrees, only the spherical mirror would be visible (Fig. 6d). The question in my mind was how to connect the whole thing so that it would be a seamless portrait. The answer was enough to jolt me from my sleep. I saw the back of Escher's head reflected in the same sphere (Fig. 6e). With this design in mind, I sketched what I had dreamt about.

The process of making a continuous anamorphic drawing is more complicated than the first type mentioned earlier in this article where there is only one point where the image appears in its correct dimensions. Constructing a 360-

degree anamorphosis requires at least four places where the continuous image has the correct perspective. This process requires a grid similar to the four-point perspective system described by Dick Termes in his article *The Geometries Behind My Spherical Paintings* ([9], p. 244; also see his article in this book, p. 275). The result, a continuous, infinite, anamorphic portrait of Escher, possesses the property of infinity similar to many of Escher's designs, and therefore evokes similar reactions by those who see it.

Escher found many ways to express the concept of infinity in his prints. Tessellations in the form of circle limit designs, Mobius strips, and the cyclical regeneration of forms were some of the ways he was able to express the idea of

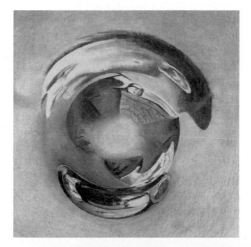

a

b

Fig. 6. Kelly M. Houle, *Escher II: Infinite Reflection*, cylindrical anamorphosis, 1998. Charcoal on illustration board. (**a**) Without mirror. (**b**) View 1, Escher's profile. (**c**) View 2, Escher with mirror. (**d**) View 3, spherical mirror. (**e**) View 4, back of Escher's head

c

d

e

Fig. 6. (continued)

infinity in two dimensions. He also experimented with ways to show infinity in three dimensions.

> *Instead of leaving the plane only in imagination ... it is possible to do so in reality. I do not mean that the figures should step out of the plane completely as separate individuals... What I have in mind is the possibility of bending and folding the picture plane itself.* [2, p. 169]

Escher looked for ways he could express infinity in a three-dimensional object without compromising his profession as a graphic artist working in two dimensions. He decided that tiling the surface of a sphere to form a continuous, three-dimensional tessellation was the most perfect way to express infinity, but he knew there was no way to bend a flat piece of paper into a sphere. He suggested that it was possible to bend a piece of paper into a cylinder so that the ends would join to form a seamless tessellation. A cylindrical mirror provides a way of bending the picture plane similar to this method described by Escher. However, by using anamorphic techniques, it is possible to form a continuous, infinite image in three dimensions without changing the shape of the paper.

In addition to visualizing the concepts of infinity and the simultaneous worlds through cylindrical anamorphosis, this art form has allowed me to express another Escherian theme: impossible worlds. In *Escher II*, I have depicted a situation that can neither exist in three-dimensional space nor be represented using traditional methods of drawing in two dimensions. Using optical illusions, one may draw structures that are impossible to build, such as the Penrose tribar. However, even with these methods it is not possible to draw a spherical mirror that can reflect both a man's face and the back of his head at the same time. Such events, reserved for descriptions of life in higher dimensions, *can* be represented anamorphically with a cylindrical mirror.

The mirror is the pivotal element in anamorphic art. Without it, an anamorphic projection may seem meaningless unless the artist disguises it with familiar objects or scenes. Even then the piece is fragmented without the mirror. A world exists in another form that we are unable to perceive. The anamorphic mirror extends the viewer's senses, allowing him or her to see beyond the confines of human perceptual boundaries. In Escher's print *Relativity* (see page 265), he hints that there may be creatures living out their lives in universes parallel to ours, that the empty space around us may be filled with activity when seen from another point of view. It is interesting to note that these beings exist in opposing spaces. Every "up" staircase has a "down" component in an opposite dimension. Like this print, an anamorphic drawing suggests that a mirror image of our world may exist, and could possibly be seen once we develop the tools to detect it.

The beauty of catoptric anamorphosis and Escher's work lies in the ability of each to unify apparently dichotomous truths. The viewer experiences two simultaneously existing, yet different, realities. Instead of being mutually exclusive, dualities such as chaos and order, infinity and boundedness, become intertwined. Each one is necessary for the other's existence. They are integral, interconnecting parts of the same whole.

References

[1] Jurgis Baltrusaitis, *Anamorphic Art*, Chadwyck-Healy Ltd., Cambridge 1976.

[2] F.H. Bool et al, eds., *M.C. Escher: His Life and Complete Graphic Work*, Harry N. Abrams, New York, 1982.

[3] Bruno Ernst, *The Magic Mirror of M.C. Escher*, Random House, New York, 1976; Taschen America, 1994.

[4] George Escher, *Escher and Rome*, Catalog of the M.C. Escher Centennial Congress, University of Rome, La Sapienza, Rome, 1998.

[5] M.C. Escher, *Escher on Escher: Exploring the Infinite*, Harry N. Abrams, Inc., New York, 1989.

[6] McLoughlin Bros., *The Magic Mirror, An Antique Optical Toy*, Dover Publ., New York, 1979. Plates originally from The Magic Mirror, or Wonderful Transformations, a boxed set of color plates, c. 1900, now in the Gold Collection of Toys, Museum of the City of New York.

[7] Ivan Moscovich, *The Magic Cylinder Book*, Tarquin Publications, Norfolk, England, 1998.

[8] Jean François Niceron, *La Perspective Curieuse*, Chez Pierre Billaine, Paris, 1638.

[9] Dick Termes, "Geometries Behind My Spherical Paintings," *The Visual Mind: Art and Mathematics*, Michele Emmer ed., MIT Press, Cambridge 1993.

Life After Escher: A (Young) Artist's Journey

Eva Knoll

Expressing the influence of Escher on my own work is akin to testing a new medical discovery without a control group. I have been exposed to his work for as long as I can remember, and certainly for as long as I've had an active interest in art, making it difficult for me to imagine a world without his work. That is not to say that he has had no impact; some directions I have been exploring were clearly visited by him first; other influences are more subtle.

The most obvious influence is certainly visible through my early experimentation with space-filling shapes. (see Figs. 1 – 3). The object of much of my early work was to explore the structure of two-dimensional space. In fact, Escher, one of the first artists whose work I searched out and studied, also served to teach me a very basic understanding of art. It is through his work, at first, that I became aware of the importance of this underlying structure in art work. Escher didn't just attempt to copy nature as he saw it. He succeeded in exploring the structure of his visual world, and how it would look if he put it together in a different way. His was also the work that allowed me to understand that art, at least visual art, is really the result, one might even say the by-product, of the explorations which are the real interest of the artist. Some of his illusionary work, for example, is really the result of his playing with the 2-D representation of 3-D and how he can stretch it. After so many centuries (until the Renaissance) of trying to represent reality as accurately as possible, artists such as Escher could now *mis*represent reality, deliberately and with perfect control. The most important impact this discovery had on me was that it justified the experimental and at times rather eclectic nature of my work.

Fig. 1. Eva Knoll, *Frost on a Window*, 1994. Mixed media

Fig. 2. Eva Knoll, Tiles with quasi-ellipses, 1992. Acrylic on ceramic

Fig. 3. Eva Knoll, *Balance*, 1993. Adhesive plastic on glazed ceramic tiles

Fig. 4. Generating rules: vocabulary and syntax (from [8])

This experimental outlook turns my work into a continuous process that really only makes sense as a whole; in other words, my work is really a single piece which can only be truly understood viewed in its entirety. Although it is unfinished as yet, here is a glimpse into its current state.

Early Work

My early experiments with space-filling shapes were very methodical, using a square grid, a simple vocabulary, and a set of transformations. The vocabulary comprised simple straight lines joining certain vertices of the grid and quarters of circles inscribed in squares of side length 1, 2 or 3 (Fig. 4). The syntax of transformations comprised all the symmetries of the square grid, including translation, reflection, rotation and glide reflection. I rendered these patterns in color in more formal pieces like the one in color plate 12 and Figs. 5 and 7. In some

Fig. 5. Eva Knoll, *Study in Green*, 1998. Aquarelle

Fig. 6. Eva Knoll, Triangular Pattern, 2001. Computer generated

Fig. 7. Eva Knoll, *Depth Perception*, 1995. Sand-blasted glass and adhesive plastic

instances, having found many patterns that were "cousins" in that they differed only in one aspect of vocabulary or syntax, I would combine them into one piece, reminiscent certainly of Escher's *Metamorphosis II* (page 147).

Although there are occasional pieces designed to recall natural phenomena (the patterns in the background of color plate 13 resemble waves – all the more because they were rendered in shades of blue), most of the time, I deliberately stayed away from figurative art, choosing instead to focus on the structure of space. This conscious decision reflects some of my other influences, in particular, my cultural heritage and my upbringing. Ties with Switzerland through my family, structural engineers in previous generations – these certainly affected my work. The link with Switzerland is revealed if we take a short trip through the art history of the last centuries. As mentioned before, until the Renaissance, the main focus of artists was to represent reality as accurately as possible. With the rise of modernity, this interest changed direction. Some movements, like Surrealism, tried to represent the world of dreams. Other artists experimented with moods and feelings engendered by what they saw. Still others focused on abstract art, where the interpretative element is entirely gone and forms are valued for their intrinsic beauty and not in relation to others [11, p. 62]. The artists of that movement were trying to achieve for the visual arts what had been taken for granted in music for a very long time:

> *Depuis des siècles [...] la musique est par excellence l'art qui exprime la vie spirituelle de l'artiste. Ses moyens ne lui servent jamais, en dehors de quelques cas exceptionnels où elle s'est écartée de son propre esprit, à reproduire la nature, mais à donner vie propre aux sons musicaux.*[1] [14, p. 59]

[1] For centuries [...] music is the perfect example of art which expresses the spiritual life of the artist. The musician's means, aside from a few exceptional cases where music moved away from its spirit, are never used to reproduce nature, but to give life to musical sounds.

The Abstract movement quickly branched out into different directions. The one that interests us here is the Constructivist Movement, begun in Russia, continued in Germany (where it paralleled the Bauhaus), and finally reaching, in some form or another, most of Europe, as well as North and South America. The Constructivists, instead of representing the known universe, sought to *construct* a new world in their art which would only loosely share its structure with the one we know in order that:

> *released from its attachments to natural phenomena and bound to natural laws, this art gives the feeling and shaping mind, the creative imagination, the greatest possible freedom. This art demands three things from the observer: constant refinement of the senses, serenity of spirit, and alertness of mind. And to those who are willing to learn its language, it returns these three things, the most precious that we can possess, with interest: refinement of the senses, serenity of spirit, and alertness of mind.* [12, p. 142]

Because of its very general mandate, the Constructivist Movement was interpreted very differently in the countries that welcomed it. In Switzerland, in particular, artists searched for a self-expression which would bring an art that is

> *non-figuratif entièrement conçu avant son exécution, dont chacun des éléments plastiques [...] est choisi et justifié en fonction de règles simples, établies la plupart du temps selon des lois mathématiques et physiques et s'appuyant souvent sur la théorie de la forme.*[2] [3, p. 9]

This passage describes the intentions of the Swiss Concrete Art Movement centred in Zurich and led by such artists as Max Bill, Richard Paul Lohse, Camille Graeser, and very marginally, Hans Hinterreiter. I, of course, did not become aware of this heritage until years later, when I had to explore the antecedents of my formal research in graduate school. It is a curious phenomenon to get acquainted on a conscious level with an art that has had an unconscious influence for such a long time, and to find out that I was not the only one who eschewed the figurative in order to focus more sharply on the structural.

Besides studying the structure of space in two dimensions, I became very interested in the interpretation of color, not on a symbolic level, but in terms of its perception, depending on such factors as juxtaposition, form, and identity. The identity of color itself has an impact in the sense that blue, for example recedes, while yellow or red come forward. Further, a circular patch of red and a triangular patch of red do not produce the same impact. Finally, a specific color will appear differently when juxtaposed with a color opposite or adjacent in the spectrum. This experimentation is better accomplished, once again, without the distraction of figurative or symbolic representation. Color plate 14 shows some results of these experiments. The thirteen paintings all use the same design,

[2] non-figurative, entirely conceived before its execution, each one of its plastic elements chosen and justified through simple rules, mostly established according to mathematical and physical laws and often based on the theory of form.

but vary in their colors, demonstrating the influence of color choice on perception. Despite the richness of these two areas of exploration, after about 10 years I needed a new direction, a universe that would show me new things about the structure of space.

New Challenges

Looking for a new direction, I considered at first following the same path I had before, substituting the regular triangular grid for the square grid in the design of my space-fillers. Despite some interesting results (Fig. 6), this new realm proved disappointing, not challenging me enough. I decided instead to explore the structure of 3-D space. Early signs are visible that I was to head that way eventually. In Fig. 7, for example, the pattern called for a spacial layering of its variations in order to show their relationship. The pattern and its variations were layered by using a 7-mm thick pane of glass on the front and back on which the different patterns were applied. This emphasized not only the relation between the two patterns, but created a depth effect that is all the more striking when viewed up close and in real life (the parallax effect adds an interesting dimension).

From the beginning of my systematic explorations of the structure of space, the three dimensions proved much more complex to comprehend than expected. Perhaps due to my almost exclusively planar geometrical experience, I had begun to take for granted the snug fit of regular geometric objects. Since both squares and equilateral triangles (as well as hexagons) tile the plane, I assumed that cubes and regular tetrahedra must each fill space. That is of course only true of the cube: regular tetrahedra need the help of regular octahedra to properly fill space. I discovered this fact the hard way, when I transferred a design from an inexact paper model to a precisely-shaped lathed wood piece. Figure 8 illustrates my attempt at showing the beginning of tetrahedral space filling: join five tetrahedra at a common edge, effectively using the common edge as an axis

Fig. 8. Eva Knoll, Five rotated tetrahedra, 1993. Lathed wood

Fig. 9. Eva Knoll, *Folded 2-space*, 1996. Acrylic paint and paper

of rotation. Then rotate each tetrahedron around the opposite edge. This process would only work if five regular tetrahedra placed in this manner spanned 360°. Unfortunately, a few degrees render this untrue except in an inaccurate model: regular tetrahedra do *not* fill space! In Fig. 8, the tetrahedra had to be deformed slightly before they could be rotated about the second set of axes. This early experiment demonstrated the need for a more careful exploration of the structure of space. Indeed, if my experiences with planar geometry were to come to any use, I needed to find a link between the two universes, a kind of metaphorical gateway, a method.

To find this link, I went looking for objects and methods that involved an in-between world, of two-and-a-half dimensions. Origami is a good example of such a world. I set out to discover how a medium that can be considered two-dimensional (paper) acts in the three-dimensional world. Figs. 9 and 10 show some of the results of my experiments: Folded two-space shows the interesting way in which concertina folds can, without running parallel, remain coplanar. Figure 10, a sampling of origami experiments starting with a circular piece of paper, shows the structure of a finite circle (as opposed to the infinite circle of space-fillers), as well as some of its behaviour in space. This early experimentation with circular origami inspired Project Geraldine that I am still involved with at present, which I will describe later.

Origami, even if it allows the creation of objects that exist in three-dimensional space, remains a tool that defines surfaces, not volumes. Parallel to these explorations, I had not completely forsaken my space-fillers. Why not, then, find a vocabulary and syntax (just like I had in 2-D), that would allow me to fill 3-D space at will? Returning to the design parameters I had been using for 2-D space filling, I set out to translate them into their 3-D equivalents. The syntax was easy to translate: instead of using the symmetry groups of the square grid, I would use the symmetry groups of the cubic grid. As for the vocabulary, that would pose a more complex problem. First, I simplified my vocabulary so that it would include only the elements that were entirely comprised inside one square (Fig. 11a). Then I set out to find all the surfaces that cut through a unit cube given that the said surface intersects the faces of the original cube in one of the curves of Fig. 11a. Although the number of these surfaces is limited, it was soon obvious that the search for all of them would be futile. An additional parameter needed to be established. Advised by John H. Conway, I decided to limit

Fig. 10. Eva Knoll, Origami decorations, 1997. Paper

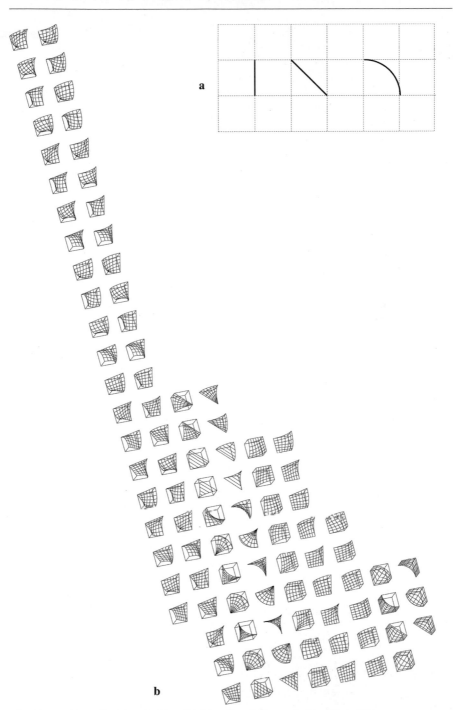

Fig. 11. (**a**) Simplified Vocabulary. (**b**) 91 cubes: 3-D vocabulary (from [8])

Fig. 12. 3-D Space-filler 1
(from [8])

my search to the surfaces that, following the previously defined criteria, would
be bounded by only three or four of these curves (Fig. 11b). Once the vocabu-
lary and syntax were established, I found myself with a complete medium for
the design of 3-D space-fillers!

Figure 12 illustrates a simple example of such a space-filler composed only
of eighths of a sphere of unit radius and their complementary elements (D-2 and
E-2 from Fig. 11b). These explorations, accomplished as part of my Masters'
thesis, were made using SGDLsoft, a very powerful computer-modelling pro-
gram developed at the Université de Montréal. Unfortunately, static computer
modelling does not easily allow for the playing around with 3-D objects that is
required to determine more elaborate space-filling compound elements using the
vocabulary and syntax described above.

The second part of my Masters' project involved testing the method of trans-
fer I had just developed on an independent system. I chose for this *Opus 84*
by Hans Hinterreiter, a round painting with a diameter of 82 cm, depicting
a deformed regular space-filling pattern [2, p. 31]. This painting proved an
interesting challenge with its layers of patterns and its high level of complexity.
In fact, the painting was so rich in its own right that the 3-D version became too
complex to be fully grasped (even the computer was not powerful enough!).

Returning to the circular origami exploration, I discovered that beginning
with the circle allowed me to subdivide my paper accurately into a regular
triangular grid (because $\sin 30° = 1/2$), opening the door into triangular grid
spaces. Soon thereafter, I found that I could use this method to construct deltahe-
dra (polyhedra composed exclusively of equilateral triangles) [4, p. 78, 142]. It
was thus that *Geraldine* was built (Fig. 13) [9]. Thanks again to John H. Conway,
I learned that she was in fact an endo-pentakis-icosi-dodecahedron.

The interesting aspect of this experiment was the process of transformation
between the flat triangular grid and the assembled deltahedron. Practical consid-
erations came into play and forced additional steps in the process. After forming
the first dimple by folding and tucking in the extra 60° of paper, I realized that
I would end up with so much extra paper inside the polyhedron, that I would not
be able to close it. This problem prompted me to cut off some of the excess, leav-
ing enough to provide a tab to help with the stability of the shape. Repeating this
process until the polyhedron was finished, I disassembled it again and was left

Fig. 13. *Geraldine*, assembled (Endo-Pentakis-Icosi-Dodecahedron), 1998. Paper model

Fig. 14. *Geraldine* "snowflake" fractal net, 1999. Computer generated

with a strange snowflake-like shape with its own aesthetic (Fig. 14)! Using this method to construct a deltahedron is meaningful because every cut made in the "snowflake" directly reflects the shape of the polyhedron, allowing the builder to experience the building of the shape in a new way.

The flat shape is built by subtraction, each cut corresponding to a 5-vertex on the assembled polyhedron. This new link between the plane and space has prompted further experimentation to find other deltahedra and their corresponding "snowflake," even to systematic exploration of the mathematics of these shapes [9]. In the meantime, a version of the project was completed out of material used for making kites, using 1-meter-edge triangles. It is now being used in a special project in mathematics education at the Rice University Math School Project in Houston Texas in joint work with mathematician Simon Morgan (Fig. 15). The set was first used in a participatory event at "Bridges: Mathematical connections in Art, Music and Science" in July 1999 at Southwestern College in Kansas where the audience was actively involved in the construction process, experiencing first-hand the relationship between the two forms of the object. This is the first work of mine that is intended to be experienced through its building

Fig. 15. *Geraldine*, assembled, 1999. High-tech textile and carbon fiber

process. Participating in the process is important because it gives the opportunity to understand the shape of the polyhedron and the nature of space, the subject of much of my work.

Future Endeavours

Although my work certainly has a distinct 'air de famille,' it is difficult to say what is still to come. There are many possible directions still to be explored, and every one has unlimited potential. My approach is definitely experimental, and an interesting consequence of my focus on the process is that I will often let my hands do the figuring out, observe the phenomenon from outside in a practical manner and then try to understand on a rational level what is occurring. This leaves much room for serendipity, certainly, but has given interesting results so far. Stylistically speaking, this has assuredly taken me far away from Escher. After all, I come after him, and I am not a printer by training. Though I respect Escher immensely for what he has given us, I do not intend to imitate him, but rather to build from where he left off. This is equally true of the Constructivists, and of other media and traditions such as origami, which I seem to be following a bit as well.

References

[1] Albers, J., *Interaction of Color*, New Haven, Yale University Press, 1975.
[2] Albrecht, H.J. and Koella, R., *Hans Hinterreiter*, Buchs, Zurich, Waser, 1982.
[3] *Art Concret Suisse*, mémoire et progrès, Dijon, Le coin du miroir, 1982.
[4] Cundy, H.M. and Rollet, A.P., *Mathematical Models*, rev. ed., Oxford Press, 1961.
[5] Gerstner, K., *Die Formen der Farben*, Frankfurt, Athenäum, 1986.
[6] Grünbaum, B, and Shephard, G.C., *Tilings and Patterns*, New York, W.H. Freeman, 1987.
[7] Hinterreiter, H., *Die Kunst der reinen Form*, Ibiza, Ediciones Ebusus, 1948.
[8] Knoll, Eva, *Transfert de 2-D en 3-D de l'Opus 84 de Hans Hinterreiter,* Master's thesis, Université de Montréal, 1997.
[9] Knoll, Eva, "Decomposing Deltahedra," *Proceedings of ISAMA 2000*, Albany, New York, 2000.
[10] Knoll, Eva, "The Shape of the Perimeter determines the Possibilities," *Proceedings of the 3rd International Meeting on Origami Science, Mathematics, and Education*, 2001.
[11] Rickey, George, *Constructivism, Origins and Evolution*, rev. ed., New York, George Braziller, 1995.
[12] Rotzler, Willy, *Constructive Concepts*, Rizzoli, New York, 1989.
[13] Senechal, M., "Which Tetrahedra fill Space?," *Math. Magazine*, 54 (1981) pp. 227–243.
[14] Vallier, Dora, *L'art Abstrait,* New York, Orion Press, 1970.

Sharing some Common Interests of M.C. Escher

Matjuška Teja Krašek

I have often wondered at my own mania of making periodic drawings.
What can be the reason of my being alone in this field?
Why do none of my fellow-artists seem to be fascinated
as I am by the interlocking shapes? – M.C. Escher [7]

Escher's questions (above) would probably be different today if he were still among us. Today many more people share Escher's fascination with interlocking shapes. This was evident in June 1998 in Rome and Ravello at the congress which celebrated the occasion of 100 years since his birth. People in many professions met there with one common starting-point – the life and art of M.C. Escher. Why would people in disparate professions (artists, scientists) come together to talk about his art or to make an "Homage to Escher" with their own art works? I believe it is because we, like Escher, are curious about the laws of nature, and seek for beauty, harmony and order. And certainly because we are fascinated by his artistic work.

Escher's passion was patterns, periodic drawings which he called "regular divisions of the plane." He also experimented with some nonperiodic tilings. As R.A. Dunlap writes, "Although he did not experiment with quasiperiodic tilings of the Penrose type, some examples of nonperiodic tilings which exhibit five-fold symmetry are known." [2] Two examples of Escher's nonperiodic tilings are a mezzotint *Plane Filling I* (1951) representing thirty-six different creatures, and a lithograph *Plane Filling II* (1957). Escher described his work with non-periodic tilings as his "(secondary) hobby for irregular fillings." [8] The only

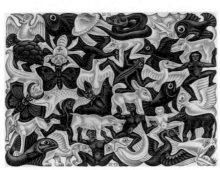

M.C. Escher, *Plane Filling I*, 1951. Mezzotint

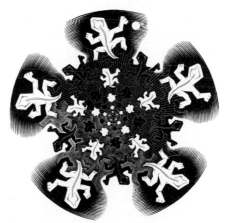

M.C. Escher, *Development II* (first version), 1939. Woodcut; never printed

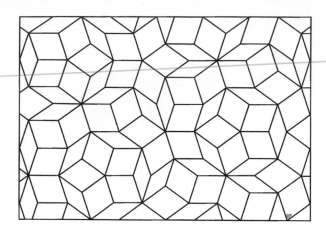

Fig. 1. A Penrose tiling (P3)

known example of Escher's attempt at a nonperiodic tiling which exhibits five-fold symmetry is a carved block of wood that evidently was not printed (see below). However, this carving became a basis for his woodcut *Development II* (1939). More about Escher's interest and use of fivefold symmetry in his other art works can be found in [2].

The discovery and creation of patterns began a very long time ago. Recognizing patterns in nature and their surroundings was necessary for human beings to survive (the changes of seasons for example). When humans began to make clothes, pottery, buildings in which to live, or adornments for their bodies, they created new patterns. From the ancient stone pavements to the sophisticated computer-generated patterns of today, people want to divide the plane and seek for order. They also seek for patterns that are not expressed in tangible objects, such as patterns of behavior, emotions, and beliefs.

The golden mean, fivefold symmetry, self-similarity, and inward infinity are some of the characteristics that are found in nature, art, and science that also influenced Escher's creativity. These also interest me as a painter. All these are present in Penrose aperiodic tilings and in three-dimensional quasicrystals. My favorite description of Penrose aperiodic tilings is Martin Gardner's: "most patterns, like the universe, are a mystifying mixture of order and unexpected deviations from order." [4] I think this is one of the reasons for the beauty of these particular patterns.

Let us examine the Penrose tiling P3 (Fig. 1) in which the tiles are Penrose rhombs – a thick one and a thin one. These two shapes are derived from a regular pentagon from which the special characteristics of the tiling are inherited. The golden mean appears in this pattern in various ways, as do fivefold symmetry, self-similarity, and the possibility of endless dissection of the figure into similar ones on smaller and smaller scales – what I call "inward infinity." To tile the plane with these two rhombs, following the matching rules that produce the aperiodicity, is a process not without difficulties. As those who have tried to put the pieces together know, all can go well for awhile, and then you may not be

Fig. 2. Teja Krašek, *Quasicrystal World*, 1996. Acrylic on canvas

able to continue the pattern. And for a painter, there is an additional challenge: to tile within a rectangular frame so that its edges cut the tiles in some regular, not random way. One of my solutions can be seen in *Quasicrystal World*, which was exhibited at the exhibition "Homage to Escher" at the Escher centennial congress (Fig. 2 and color plate 25). In this painting the edges of the frame cut the tiles in half or in quarters. Here the basic composition of the tiles has bilateral symmetry. However, the arrangement of colors does not respect this symmetry completely, deviating deliberately from it according to a particular order. The use of opposite pairs of colors (orange-blue and red-green) supports the composition.

To explore relations between the two Penrose rhombs and the regular pentagon, we first draw a quasicube composed of two thick rhombs and one thin rhomb (Fig. 3). In this drawing, two (left and right) pentagons interlace (each is shown in dashed outline), producing a thick rhomb as their intersection. Then we draw a grid inside the cube and with its help we explore what can be found there (Fig. 4). In the left thick rhomb of this cube, there are 18 pentagons, each with a pentacle inside, and they diminish to the opposite corners of the rhomb. These overlapping pentagons easily tile the plane of the rhomb, organized like rings of a chain. In the words of Ernesto Cesaro: they are "reduced by an appropriate factor." [6]. The appropriate factor here is the golden ratio. The thick rhombs that separate the two positive-negative halves of this pattern also follow this principle. And we know that we can draw inside each regular pentagon or its inscribed star smaller and smaller stars and pentagons *ad infinitum*.

The right thick rhomb of the quasicube in Fig. 4 shows how the quasicubes can progressively reduce in size from the center to the corners and, conversely, into the center. The rhomb could be completely filled with the smallest cubes which have the same characteristics and contain the same information as the whole image. Here we can see how thin and thick rhomb are related: if a thin one is diagonally placed into the thick one, the ratio of the side of the thick rhomb

Fig. 3. A quasicube of Penrose rhombs

Fig. 4. Teja Krašek. Filling the quasicube with self-similar patterns

to the side of the thin one is the golden mean. This interplay can go on forever, producing self-similarity. The upper thin rhomb of the quasicube in Fig. 4 also shows relations between the two rhombs. Here thick ones are placed into the thin one and they diminish into the corners, reduced each time by a scale factor of the golden ratio. Each of these thick rhombs could also be filled with the designs present in thick rhombs below. There is another series of diminishing rhombs in the center of the image that divides it from top to bottom. *Quasicube V* is a color painting of a quasicube that shows relations between the shapes we have discussed (Fig. 5 and color plate 26).

Fig. 5. Teja Krašek, *Quasicube V*, 1997. Acrylic on canvas

In Fig. 6 (I), at the center, we have a decagon consisting of Penrose rhombs; this configuration can be found in the Penrose tiling P3. In this drawing, the star of five thick rhombs is filled with the help of the drawing in Fig. 4. In addition to all the relationships we have noted in Fig. 4, here there are also golden triangles and elements of the Penrose tiling P2, known as "kites and darts." And if we pay particular attention to the quasicubes in this drawing we see that they can be perceived both as convex and concave, similar to the phenomenon of the Necker cube.

In Fig. 6 (II) we can observe a decagon in which a regular pentagon is drawn. Into it a pentagram is placed and we can see the many relations with Penrose rhombs. In Fig. 6 (III) these relations are now shown as a net. Here there are patterns that become smaller and smaller, scaled by the golden mean, producing self-similarity. Into each smallest decagon in the center of a star a smaller version of the whole net could be placed and this interplay could be repeated again and again forever.

Fig. 6. Teja Krašek. *Interplay of Penrose tiles, I, II, III*. Drawings

Fig. 7. Teja Krašek, An ambiguous figure. Drawing

We know that dividing the plane into smaller and smaller similar forms was one of Escher's passions. Some of his beautiful solutions to this problem can be seen in his prints *Development II* (1939), *Smaller and Smaller* (1956), *Path of Life I* (1958), *Path of Life II* (1958), *Path of Life III* (1966), and his color drawing *Butterflies* (1950).

In the quasicube there are other interesting aspects to observe in addition to relations between shapes. For example, we can find ambiguous figures or impossible objects. If we choose one of the Fibonacci numbers (for instance 21 cm) for the lengths of the sides of the Penrose rhomb, we can observe how the lengths of some line segments in a composition approximate successive numbers in the Fibonacci sequence (Fig. 7). Some similarities with the work of Josef Albers can also be found here. In his work *Trotz der Geraden* (1961), for example, he created an impossible figure, that is, a perceptually unstable composition. In this type of art work, Albers was interested in the movement of the observer's eye as

Fig. 8. Teja Krašek, A perceptually unstable composition, 2000. Computer graphics

Fig. 9. Oscar Reutersvärd, *Opus 1 n° 293 aa*, 1934. Drawing

his mind tries to grasp the whole image. Similar effects can be observed in my Figures 7 and 8 (some variants in color can be seen on the CD Rom).

Albers made several variants of his compositions – *Structural Constellations*, 1957/8, for example. Creating variants when some particular problem is already solved is one of the differences between artists and scientists. Escher also created variants and was interested in making optically contradictory compositions or "impossible objects," just as Oscar Reutersvärd was. Reutersvärd's artwork *Opus 1 n° 293* aa (1934), Fig. 9 [3], inspired my work shown in Fig. 10. In his drawing, Reutersvärd used equal rhombs for the cubes which form an impossible object, while I use thick and thin Penrose rhombs which build quasicubes. If we compare my impossible figure with Reutersvärd's, we see that mine seems to have a mirror-image right side added. There is another interesting thing about Fig. 10: the composition is ambiguous. When you stare for a while at a certain point (the top of the lowest quasicube in the middle column), all

Fig. 10. Teja Krašek, Impossible figure from quasicubes, 1996. Silkscreen

cubes suddenly transform from convex into concave and the whole composition assumes quite a different character. If at first we perceive the composition as an (impossible) object consisting of (apparently) solid cubes, now it is transformed in our minds into a composition made of boxes missing two front walls.

With colors, we can express other relationships and highlight shapes which can be found in a quasicube; we can produce depth, heighten ambiguity, and create interesting compositions. Some of the effects that I found interesting can be seen on the CD Rom.

An artist's task is to transform invisible thoughts into visible expressions and share them with other people. By studying different kinds of patterns we can somethimes reveal systems hiding in our universe. In order to know them better, we need cooperation between people through sharing various kinds of knowledge. M. C. Escher showed us with his own example in interacting with scientists and mathematicians that such cooperation can be fruitful for everyone who participates. And I think that the congress dedicated to him confirmed this, as does this book.

Acknowledgement

Support of the Ministry of Culture of the Republic of Slovenija is gratefully acknowledged by the author.

References

[1] F.H. Bool, B. Ernst, J.R. Kist, J.L. Locher, F. Wierda, *Escher. The Complete Graphic Work*. Thames and Hudson, London, New York, Harry N. Abrams, 1982.

[2] R.A. Dunlap, "Fivefold Symmetry in the Graphic Art of M.C. Escher," *Fivefold Symmetry*, ed. I. Hargittai. World Scientific Publishing Co., Singapore, 1994, p. 490.

[3] B. Ernst, *The Eye Beguiled. Optical Illusions*. Benedict Taschen Verlag, Koln, 1992, p. 69. Originally published as *Het begoochelde oog*, 1986.

[4] M. Gardner, *Penrose Tiles to Trapdoor Ciphers and the return of Dr. Matrix*. The Mathematical Association of America, Washington D.C., 1997, p. 9. (First ed. W.H. Freeman, New York, 1989.)

[5] I. Hargittai, "Real Turned Ideal Through Symmetry," *Symmetrie in Geistes- und Naturwissenschaft*, ed.R. Wille. Springer-Verlag, Berlin, Heidelberg, 1988, pp. 155, 156, 157.

[6] R. Hemmings and D. Tahta, *Images of Infinity*. Tarquin Publications, Norfolk, UK, 1995, p. 52.

[7] C.H. MacGillavry, *Symmetry Aspects of M.C. Escher's Periodic Drawings*. A. Oosthoek's Uitgeversmaatschappij , Utrecht, 1965 (republished as *Fantasy and Symmetry*, Harry Abrams, New York, 1976), preface.

[8] D. Schattschneider, *Visions of Symmetry: Notebooks, Periodic drawings, and Related Work of M.C. Escher*. W.H. Freeman and Company, New York, 1990, p. 306.

New Expressions in Tessellating Art: Layered Three-Dimensional Tessellations

Makoto Nakamura

When I came across Escher's tessellating art more than 20 years ago, it made a strong impact on me. Since then, I have been working on tessellating art myself. Like Escher, I have used my tessellations to create art that is fanciful, and in which tightly-packed creatures metamorphose or break out of their confined space. Some of my tessellating art has been expressed in screen process printing and sculpture, but most of my work is paintings. One example of my early work, *Wind and Wave*, is shown in Fig. 1; color plates 10 and 11 show this and another scene. In these works, you need to look closely to find the many tessellations that comprise the scene. Many more examples of my tessellation art (in color) are on the CD Rom.

My most recent work is to extend the idea of tessellation to three dimensions. In this article, I will give a brief explanation of my "layered three-dimensional tessellation" work, in which tiles take on thickness and form layers that fill space. Alternating layers are actually different tessellations – the figures that fit together to make them are not merely thickened planar tiles that fit together to form a thickened plane, as can be easily done with any shape that can tile the plane. Each figure, as you will see, fills part of three separate layers in the space-filling tessellation.

This art form would be better presented in an animation than in still pictures, but I hope that from my computer-drawn images of the three-dimensional forms and their construction, you will be able to understand the essential ideas.

Fig. 1. Makoto Nakamura, *Wind and Wave*, 1993. Gouache

Layered Three-Dimensional Tessellation - Dogs

· Construction of Plane tessellation
Rectangular type Parallel movement

The basic principle of each individual figure is to make the "body" and the "sub-body" (such as limbs and ears) which is attached to the body, in two layers. Most importantly, the body and the limbs are made of two separate boards in the basic patterns by using surface tessellation technique.

· Construction of Layered tessellation

This layering is so that the sub-body will fill up the space created in the adjacent sub-body layer.

· Construction of Individual object

In fitting together the tiles, in the sub-body layer, an ear belongs to the body below and a hind leg to the body in the adjacent layer.

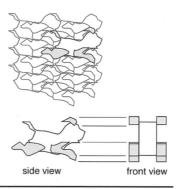

Fig. 2.

Each tile is a figure (usually an animal), built in three separate layers, each layer cut from a thick board. The middle layer I call the *body*. The body is sandwiched between two other layers, which I call the *sub-body*. The sub-body usually consists of parts such as limbs and ears, which come in mirror pairs that are attached to opposite sides of the body. For each figure, the body and the sub-body are cut from two separate boards; their basic patterns are determined by making two planar tessellations. The tiles having the outline of the body make one tessellation, while the tiles having the outline of the sub-body make the second tessellation. The patterns must be designed so that simultaneously, two criteria are satisfied: (1) the sub-body parts must fit in the right positions on the body and (2) in the layering of the figures, the sub-bodies from the layer below will exactly fill up the spaces in the adjacent sub-body layer above. In some patterns, the sub-body is half the area of the body and in others it has the same area as the body. In fulfilling (2), the rule that is sometimes followed is that the ear belongs to the body below and hind leg to the body in the adjacent layer above. Such shifting of the sub-body parts between the layers can be designed quite freely – this is a main characteristic of layered three-dimensional tessellation.

In Fig. 2, diagrams outline how a dog figure (individual object) is designed for a layered tessellation, and how the two separate tessellation layers of body and sub-body fit together to form the layered space-filling tessellation. This typifies the process of designing such tessellations.

There are many variations possible in these layered tessellations. The tessellations in the two different layers (body layer and sub-body layer) can be of entirely different types (as planar tessellations), and also, layers can be stacked in different ways. For example, layers of the same tessellation (for example, the body layer) will alternate in stacking, and can be stacked with or without shifting, or can be rotated with respect to each other, or can be placed so that one is the mirror image of the other. Figure 3 outlines five variations of layered three-dimensional tessellations. The dog tessellation in Fig. 2 is shown here as type (B). More detailed explanations follow for the other four types of layered tessellations described in Fig. 3: (A) *Dinosaur* and (C) *Cat* are in Fig. 4, (D) *Wild Goose* and (E) *Frog* are in Fig. 5. Finally, in Fig. 6, we give examples of two other layered tessellations with different layering properties. *Rabbit* utilizes a tessellation which has 90° rotations, with the sub-body half the size of the body and in the layering, shifted in part. *Pegasus* (with flying figures, rather than Escher's rearing ones – see page 309) has 180° rotations in the planar tessellations as well as between layers, hence has 180° rotations on four separate axes. These and additional layered tessellations can be seen in color on the CD Rom.

It is probably hard to appreciate these layered three-dimensional tessellations by just seeing a mass of individual objects form a three-dimensional block. To really understand them and to appreciate them, it is essential to use a dynamic form of presentation to show free shifting and transformation taking place between individual objects and the solid mass into which they coagulate.

Some Variations on a Type of Basic Pattern

Here are some variations on one type of basic pattern. These are examples of when the body, which is the basic element of the object, is designed in a translation, or parallel movement pattern in one layer in the layered three-dimensional tessellation. Even though the body is fixed to one shape, the limbs and other parts subordinate to the body can be divided and shifted quite freely. From these examples, you can see that you have more freedom in choosing a drawing method you wish to use than in the division of a plane surface. There are also variations other than these.

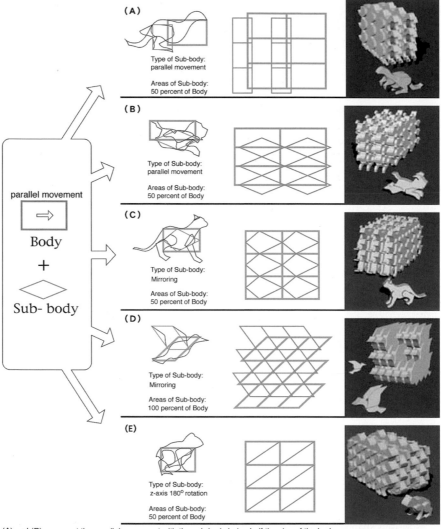

(A)

Type of Sub-body:
parallel movement

Areas of Sub-body:
50 percent of Body

(B)

Type of Sub-body:
parallel movement

Areas of Sub-body:
50 percent of Body

parallel movement

⇨

Body
+
Sub- body

(C)

Type of Sub-body:
Mirroring

Areas of Sub-body:
50 percent of Body

(D)

Type of Sub-body:
Mirroring

Areas of Sub-body:
100 percent of Body

(E)

Type of Sub-body:
z-axis 180° rotation

Areas of Sub-body:
50 percent of Body

(A) and (B) represent the parallel movement with the sub-body being half the size of the body.
They are classified in the same group but are shown here as examples of the different styles of shifting.

Fig. 3.

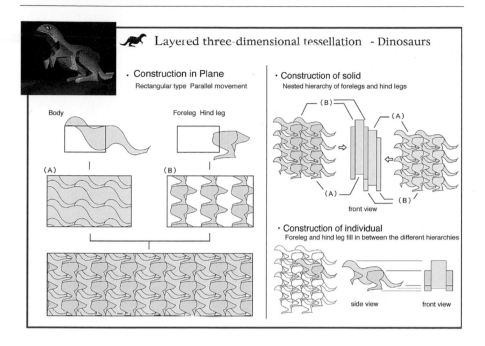

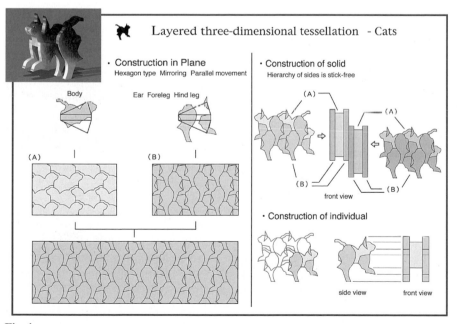

Fig. 4.

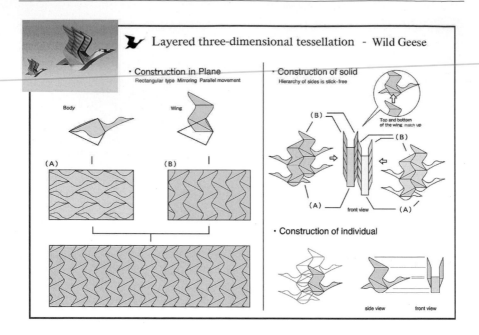

Layered three-dimensional tessellation - Wild Geese

· Construction in Plane
Rectangular type Mirroring Parallel movement

· Construction of solid
Hierarchy of sides is stick-free

Body

Wing

(A)

(B)

Top and bottom of the wing match up

(B)

(B)

(A)

(A)

front view

· Construction of individual

side view front view

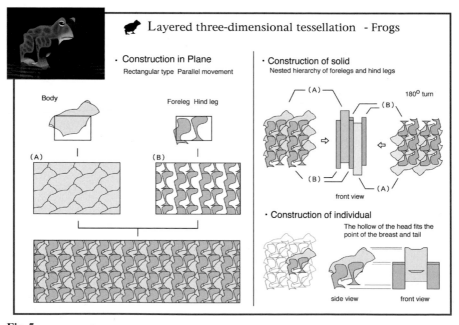

Layered three-dimensional tessellation - Frogs

· Construction in Plane
Rectangular type Parallel movement

· Construction of solid
Nested hierarchy of forelegs and hind legs

Body

Foreleg Hind leg

(A)

(B)

(A)

(B)

180° turn

(B)

(B)

(A)

front view

· Construction of individual
The hollow of the head fits the
point of the breast and tail

side view front view

Fig. 5.

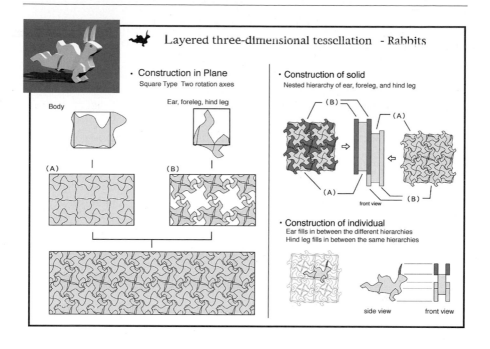

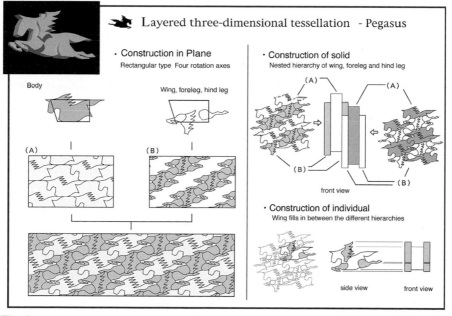

Fig. 6.

As I mentioned earlier, this art form would be best presented in an animation. The spread of personal computers in recent years will serve as a major factor in making this possible.

The layered three-dimensional tessellation can also be used as a puzzle, an application other than an animation. If the joints of the animals are made kinetic by the modification of some parts, the mass object itself can be a three-dimensional jigsaw puzzle.

However, I find what is most fascinating about layered three-dimensional tessellations is the pleasure of creation. This is certainly what sustained Escher's interest in tessellation. At present there are quite a few people enjoying the creative game of making planar tessellations, and I am one of them. I believe the layered three-dimensional tessellation technique, which can challenge anyone, will bring new pleasure to them.

The Mirrors of the Master

István Orosz

"Lo specchio e il maestro dei pittori"
"The mirror is the master of the painter"

It is Leonardo da Vinci who writes these words [1]. For Leonardo, mirror is not only a symbol of an everyday object or a useful tool. In these few words we can discern the eternal question of art: the dilemma of showing illusion and essence, the transcendent and empirical world. Mirror is the starting point of every visual presentation – to hold up a mirror to the world to face itself is the most ancient metaphor of art.

Mirror and master. For me these words have recently gained a personal meaning. I was just preparing for the Rome congress commemorating the hundredth anniversary of Escher's birth when I received a letter from Bruno Ernst, Escher's close friend. He sent me a pencil sketch showing a mirror and a gate, but disposed in such a clever manner that the scene behind the opened gate can only be seen in the mirror (Figs. 1 and 2). Originally he offered the idea to Escher. He suggested that Escher make a graphic work based on the sketch but the ailing artist could not carry it out. Obviously the opportunity to try the impossible, to imagine myself in Escher's place, fascinated me. What would he have done with the idea, how would he have developed it further, had he had the strength to work on it? While I was making rough sketches based on Ernst's idea, I had the feeling that Escher's eyes were following me – from the anamorphic viewpoint of another dimension.

Fig. 1. Bruno Ernst: The Magic Gate and the Mirror, pencil sketch

Fig. 2. Reflection scheme constructed on the basis of the Bruno Ernst sketch

The obvious first step before getting to work seemed to be to study Escher's pieces in connection with mirrors, and then those of Bruno Ernst in which mirrors and reflection play an important part. Then finally to collect my own memories: to review what I had already done with mirrors. It was unavoidable to also recall some other mirror depictions in art history, partly as reference point, or simply because I could not escape their influence on me.

In the first step of my study – examining Escher's work with mirrors – Bruno Ernst's writings helped me. As is generally known, Ernst classified and grouped Escher's works during Escher's lifetime and was in constant consultation with the artist. [2] The first category was entitled *Penetration of Worlds*. The prints in this group, just a dozen in number, are all mirror depictions. We could further divide this category in to two separate groups: the convex surface mirrors and the spherical mirrors that are simultaneously self-portraits.

The message of the mirror self-portraits is not difficult to interpret, especially in light of Leonardo's words. But if we wish a more precise explanation, it is worth recalling a notable mirror painted about five hundred years earlier, not far from Escher's homeland. This is the famous convex mirror hanging in the center

of Jan van Eyck's painting, just behind the *Arnolfini-couple* (Fig. 3). In the mirror you can easily recognize the painter just leaving the room. On the wall above the mirror there is a notice in Latin: *"Johannes de Eyck fuit hic"*. *Johannes de Eyck has been here.* Let us try to interpret the mysterious text along with the mirror as if we put the elements of a puzzle together. It would go together like this: *Johannes de Eyck has been the mirror here.* This is not only the philosophy of the younger van Eyck, but also that of art in general, and the most explicit formulation of the artist's role. So according to Jan van Eyck, the artist is nothing else but the mirror itself, and this idea is expressed by Escher's spherical mirror self-portraits as well.

It is also worth examining the painting of the Arnolfini Portrait because we can consider it as an early expression of the idea suggested by Bruno Ernst. To show a hidden part of the scene by means of a mirror: this was Jan van Eyck's idea. Something very similar happens in the *Las Meninas* painted by Diego Velazquez (Fig. 4). In fact, if we change the position of the painter and the couple we get nearly the same setting. Velazquez shows only the reflection of the otherwise invisible Royal couple. They are represented in the mirror hanging on the back wall of the atelier and we understand that they must have been standing in the unrepresented foreground just at the same place where we, the viewers, are standing now (Fig. 5). Both pictures are among the most enigmatic paintings of European art and the most important message they convey is to make perceptible the escape from a traditional depiction of space.

Fig. 3. Jan Van Eyck. *Giovanni Arnolfini and his Bride*, 1434

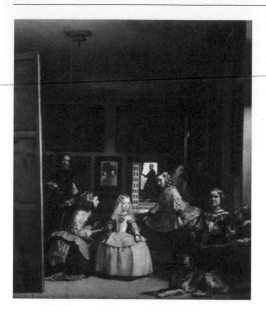

Fig. 4. Diego Valazquez. *Las Meninas*, 1656

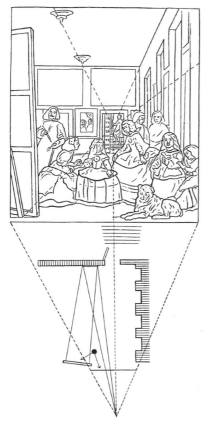

Fig. 5. The reflection scheme of the painting *Las Meninas* by Diego Velazquez

Mirrors and Perspective

A second type of mirror depiction is characterized by the approach Escher used in his lithograph *Still life with Mirror* (Fig. 6) and in his woodcut *Still life and Street*. In both works the external space appearing in the mirror and the internal space surrounding the mirror is united in one single coherent view. The perspectives of both the spaces outside and inside the mirror lead to one common vanishing point so naturally that we can only guess we are already "inside" and just stepping through the surface of the mirror as if we had joined the ancient Chinese painter Vu Tao-ce [3].

Mirror and perspective are inseparable from the beginning. Let me refer to the famous experiment of Brunelleschi with the mirror and the hole in the picture and in which he is said to have demonstrated perspective for the first time. In that picture he delineated the Florentine Baptistry viewed from the main door of the cathedral. We know from the contemporary accounts and memoirs [4] that there was a small hole in the middle of the painted panel. The spectator was required to stand in the doorway of the cathedral and to peer through that hole from the back of the picture at a flat mirror held in such a way as to reflect the painted

Fig. 6. M.C. Escher. *Still Life with Mirror*, 1934, lithograph

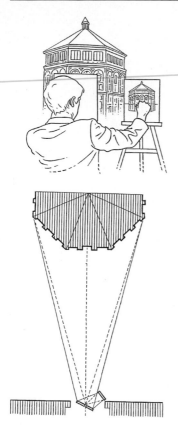

Fig. 8. Comparing the holed picture to reality with the help of a mirror

Fig. 7. The scene sketch of the Brunelleschi experiment: the making of the first perspective picture with the help of two mirrors as I imagine it

surface. If the mirror was removed, the viewer could see the Baptistry itself so did not notice any change. The descriptions of witnesses were recorded to document and to understand the demonstration, but there is no indication in the memoirs how Brunelleschi constructed the geometry of the painting in order to create the illusion of the space. Art historians suppose that in this work Brunelleschi used the technique of linear perspective: the same procedure that was described by Alberti about twenty years later. [5]

I believe that Brunelleschi used a mirror not only for the demonstration, but for the creation of the illusion as well. It is clear from Manetti's memoir that the picture itself was painted onto a mirror. [6] It makes sense to paint a picture on a mirror if the image appears as a reflection in the mirror – the painter merely needs to copy that reflection onto the surface of the mirror. During this procedure it is most important to keep in mind the viewpoint of the observer. In order to fix the same point of view, the most practical solution is to peer at the mirror with only one eye, through a hole in fixed position. Presumably Brunelleschi used a setting of mirrors when he made the "first perspective". When I attempted to draw the scheme of that assemblage, I found that this is not far from the idea in Ernst's sketch (Figs. 7 and 8).

The discovery of perspective, or rather the fact that Renaissance artists began to apply perspective so it became part of European thinking, brought about a crucial change not only in art, but in the philosophical sense of self as well. The consequences of that invention can hardly be overestimated. The world as it had been commonly perceived and experienced by everyone suddenly changed. Let us imagine the grids with which one constructs perspective, the often-mentioned pyramid of Alberti. This is the configuration of visual rays on a plane as they proceed from an object into the eye in a pyramidal form. If we move to the right or to the left, or viewpoint changes so no longer is anything we see eternally fixed. The infinity of the world is there at the base of the pyramid of rays, and at its opposite end, at the apex of the pyramid there is that certain point, our eye, what we may call the Archimedean point. And so there we discover the Self. The invention of perspective, the idea of infiniteness and the sense of personality as being alone are all pieces of the same story, begun in Italy. And in this continuing story, in its twentieth century chapter, Escher played a main role. Perspective, infinity, personality: he weaves these three elements *ad absurdum* in his art.

Mirrors and Illusion

Another use of mirrors by Escher can be seen in his lithograph *Magic Mirror*, made in 1946 (Fig. 9). In this print especially, the shape of the mirror and its diagonal placement reminds us most of the Bruno Ernst sketch. As if it had been inspired by Lewis Carroll tales, the magic mirror wittily transforms reality and

Fig. 9. M.C. Escher. *Magic Mirror*, 1946, lithograph

illusion into each other. The little winged fairy creatures are going round and round in an endless procession. The mirror in the center of the picture is their place of birth and rebirth. They step out from the mirror into reality as three-dimensional beings. In the lithograph, the task of the magic mirror is to reflect reality and to create new reality all at the same time. Bruno Ernst possibly wanted to refer to this, to the creation of new reality when he chose the title *Magic Mirror* for his book on Escher [7].

When the Bruno Ernst sketch in Fig. 1 was drawn (or at least when Ernst showed it to Escher more than twenty years after the print *Magic Mirror* was finished), the master was already interested in other things. Perhaps foremost was "impossible objects". From 1958 to 1961 he produced his three significant lithographs *Belvedere*, *Waterfall* and *Ascending and Descending*, which are considered the height of the oeuvre. The *"most Escherish Eschers"*, as Bruno Ernst put it, are probably the best known faces of the artist. These are drawable but unrealizable forms in the three dimensional world. "Whoever Makes a Design without the Knowledge of Perspective will be Liable to such Absurdities as are shewn in this Frontspiece" was written by Hogarth in 1754 under one of his engravings in which he collected the most preposterous impossibilities (allegedly he wanted to make a dilettante aristocrat appear ridiculous) [8]. At nearly the same time the Italian architect Piranesi made his *Imaginary Prisons* [9] in which he broke with traditional perspective views, constructing for the first time whimsical dreamlike spaces, in which walls, arches, and columns do not obey the academic rules of geometry but rather the impulsive expression of the artist.

For Escher, the constructing of impossible objects probably meant an escape from the burden of formal geometry, but it did not mean getting rid of the rules as in the case of Piranesi, and it did not mean the parody of paradoxes as with Hogarth. "If you want to express something impossible, you must keep to certain rules," he said in one of his lectures. [10] I think we may suppose that if Escher had dealt with Ernst's offered idea, he surely would have made use of his experience gained while drawing impossible forms. We may also suppose this because later Ernst himself turned in that direction. I do not know if the discussions between Ernst and Escher played any part in the fact that in his photographs Ernst analyses the connections between impossible objects and their reflections. In one of Ernst's works he builds up – seemingly precisely – the best-known and most simple impossible object, the *Penrose tribar* [11], but the strangeness he creates become obvious only when it is viewed in a mirror placed beside the object. The angle of the mirror reveals that the slats that make up the tribar are twice broken and twisted (Fig. 10). I feel a sickening uncertainty when I see the same set of objects in different roles in a second photo. Here, by changing the position of the camera (which is our point of view), the object seen in the mirror becomes impossible. The conclusion might be that the impossible is true and the real is false.

Other artists as Shigeo Fukuda and Sandro del Prete also notice that forms considered impossible are not realizable, but only for a traditional and conven-

Fig. 10. Bruno Ernst. Photograph of an impossible tribar, 1985

tional way of thinking. In a more cunning view – if you like, with *anamorphic* vision – they are not unreal [12]. It is not by chance that I use the word *anamorphosis*. [13] I admit I have been dealing with this field of art for over a decade. Anamorphosis was developed at the time of the High Renaissance and art works employing this technique were popular in the 16th and 17th century. The technique has been more or less forgotten since that time. Art historians use this word for distorted figures without meaning which gain their message only when viewed from a particular angle or through a special lens or in the surface of a mirroring object. Perhaps my mirror games and experiments gave Bruno Ernst the idea to send me the drawing originally meant for Escher. The mirror cylinder of the anamorphoses, and the mirror appearing in the Ernst's sketch fulfill, in fact, the same function, as both make the hidden meaning of the picture visible. In the first case the mirror is part of the drawing while in the second case it is a real object which is independent of the picture. The crucial difference is not this, but the character of the picture appearing in the mirror, "the picture in the picture." In contrast to the two-dimensional reality of the drawing, the image of the anamorphosis is just a virtual phenomenon, which is not obvious either in the flat figure in the print or on the surface of the mirror placed onto the print. "Two and a half-dimensional speculation," we can say, referring to the two Latin words *speculum* and *speculari*, meaning *mirror* and *thinking*. Thus we may interpret the connection between them as: *to think means to reflect*. This way, reflecting and thinking are two parts of equation – this message is also included in Leonardo's words on the master.

Mirrors in My Work

From among my works prepared for the Escher Congress I think the etching *The Well* (Figs. 11 and 12) is the nearest to realizing Bruno Ernst's idea, at least if I think of his notion to show a fairy-tale landscape behind the gate. The Amalfi bay coast is an enchanting fairytale-like place and it was an exceptionally special place for Escher who has described his beautiful time spent there. In my print, I designed the front side of the gate in the wall so as to embed Escher's self-portrait of 1934, which can be made visible in a mirror cylinder placed on the drawing of the well. (In other words, it can only be seen anamorphically). I have mentioned that towards the end of his life, impossible spaces and objects attracted Escher. I, too, have been attracted to the depiction of impossibilities. In my work *Up and down* (Fig. 13) I tried to draw an impossible mirror which is able to show or reflect the two staircases behind two doors opposite each other. *The Swan* (Fig. 14) is also an example of a paradox of reflection. Not only is the reflection of the bird strange (the left and right sides are changed), but also the impossible pavillion seems to be possible when it is reflected on the surface of the lake.

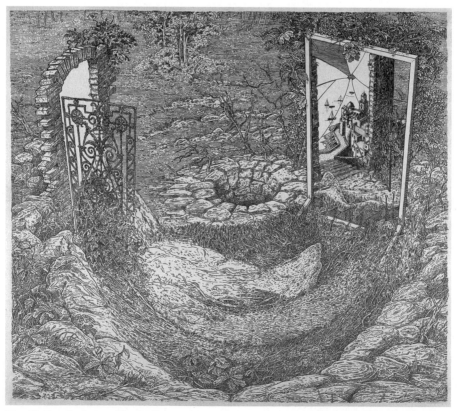

Fig. 11. István Orosz. *The Well*, homage to M. C. Escher and Bruno Ernst, 1998, etching

Fig. 12. István Orosz. *The Well*, 1998, etching with mirror cylinder

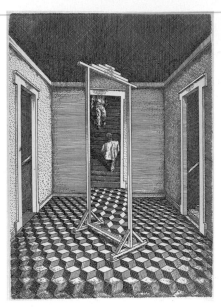

Fig. 13. István Orosz. *Up and Down*, 1998, etching

Fig. 14. István Orosz. *The Swan*, 1996, etching

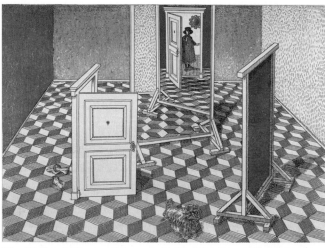

Fig. 15. István Orosz. *Johannes de Eyck fuit hic*, 1997, etching

Fig. 16. István Orosz.
Arnolfini-anamorphosis,
etching, 1996

Johannes de Eyck fuit hic (Fig. 15) is the title of my drawing that uses elements of the Arnolfini painting; here I attempt to show the world behind the door with the help of two mirrors. My *Arnolfini anamorphosis* (Fig. 16) is a sort of "double reflection". I meant to present the famous spherical mirror – hanging in the background of the Van Eyck picture – in such a way that the viewer should recognize the distorted figures only on the surface of a special mirror cylinder. My *Escher-anamorphosis* (Fig. 17) is also a kind of "double reflection". I anamorphically distorted one of his self-portrait lithographs framed in a circle so

Fig. 17. István Orosz.
Escher-anamorphosis
(for Kelly Houle)
etching, 1998

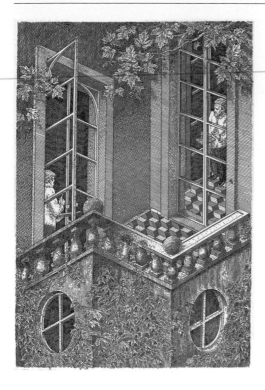

Fig. 18. István Orosz. *Balcony*, 1997, etching

that the original image can be recaptured only in the reflection of a mirror cylinder. (I dedicated this work to Kelly Houle who made several interesting examples of double reflections and anamorphoses.) In my etching *Balcony* (Fig. 18) I have studied the reflection coming from a combination of two viewpoints realized in a paradoxical space.

Although I began with a study of Escher's works, and the Ernst sketch greatly influenced my way of thinking, still (unconsciously or perhaps consciously) I have created my own independent works. In following my own way, I wanted to be faithful to the mirror. Let me quote Leonardo again: *"L'ingegno del pittore vuol'essere a similitudine dello specchio"* [14]. That is, *"The spirit of the painter must become similar to the mirror."* Leonardo makes clear that very human attitude in which we as individuals refer to everything in relation to ourselves, that is, as a reflection in a mirror. We are unable to see, to feel, to perceive anything objectively, separated from ourselves. To think, to write a poem, to create a piece of art, or to look into a mirror, these are basically all the same. When we wish to find the spirit of Escher's work, I feel it is important to realize the individual gesture of turning to the mirror. In this gesture, one cannot be an outsider; so Escher gave up depicting a certain part of the world he saw. For me, Leonardo's words say that in the mirror of my works Ernst is reflected in a way, and he is there in Escher's work, and in Escher's work Leonardo's face also dawns a bit. And so on.

References

[1] Manuscript from 1492. Paris, Institut de France.

[2] F.H. Bool, J.R. Kist, J.L. Locher, and F. Wierda: *Leven en werk van M.C. Escher*. Amsterdam: Muelenhoff, 1981; (English version: F.H. Bool, Bruno Ernst, J.R. Kist, J.L. Locher, F. Wierda: *M.C. Escher: His Life and Complete Graphic Work*, New York: Harry Abrams, 1982.)

[3] According to an old Chinese legend Vu Tao-ce (a painter in the VIII century) did not die. When he was old he painted a beautiful fresco in the Palace of the Emperor he entered into the picture and disappeared among the hills.

[4] The picture was lost very long ago. Antonio di Tuccio Manetti wrote the most detailed recollection of the demonstration in his biography of Brunelleschi, c. 1480.

[5] Leon Battista Alberti: *De pictura* (On Painting) 1435–36. This is the first written recording of how to draw a linear perspective construction. The book was dedicated to Brunelleschi.

[6] Maneti's explanation is not very precise: "he (Brunelleschi) used burnished silver, so that the air and natural skies might be reflected in it; and thus also the clouds, which are seen in that silver, are moved by the wind when it blows."

[7] Bruno Ernst: *De toverspiegel van M.C. Escher*, Amsterdam, 1976. (English version: Bruno Ernst: *The Magic Mirror of M.C. Escher*, New York: Random House, 1976.)

[8] Frontispiece to John Joshua Kirby's book: *Dr. Brook Taylor's Method of Perspective*, London, 1754.

[9] *Grotteschi Invenzioni capric di Carceri*, c. 1745.

[10] Escher's lecture in Hilversum, 1963.

[11] The tribar or Penroses' triangle was first published as an illustration of L. S. Penrose and R. Penrose, "Impossible Objects: A Special Type of Visual Illusion," *British Journal of Psychology*, XLIX (1958). They did not know that Oscar Reutersvärd discovered the same object in 1934.

[12] The Japanese artist Shigeo Fukuda built an accurate model of Escher's *Belvedere*. As with the tribar, his model works visually when seen from the correct point of view but seen otherwise it falls apart. Also the Swiss artist Sandro del Prete made a drawing based on the same work of M. C. Escher. According to his drawing the columns of the building are curved – they seem to be straight only from one correct viewing angle. At the Escher exhibition in Rotterdam in 1998, a large screen animation based on this idea had viewers fly around the Belvedere to witness it from all viewpoints.

[13] From the Greek, meaning "transform shape".

[14] Manuscript from 1492. Paris, Institut de France.

Tilings and Other Unusual Escher-Related Prints

Peter Raedschelders

Mathematics is beauty. For most people, this is hard to understand. Mathematics is often synonymous with strange symbols and formulas, which are understood only by mathematicians. How can something that is pleasing to look at be the result of these formulas? One can use these formulas to make graphs, and as soon as we use these graphs for making drawings, strange things happen. At first sight, these drawings have little to do with mathematics. However if one looks closer, the mathematics behind the drawings becomes clearer. Many of M.C. Escher's prints can be considered to be "mathematical." For most people, these prints were their first and only acquaintance with this kind of drawing.Escher often claimed that he understood little of mathematics, but nevertheless many of his prints are the result of it. And who is to say that the prints of M.C. Escher aren't beautiful?

Creating Escher-like patterns is a real challenge. The challenge is to make such drawings without copying Escher and of course without trying to be as good as Escher, because that would be quite impossible. For my prints, mathematics is often used as a starting point, but not always. Sometimes simple paper folding gives a new idea for a print. But all my prints are the result of the M.C. Escher-challenge. And there is no need to be a mathematician or an artist to create these kinds of drawings. The prints here are the result of a hobby and a lot of patience by a non-mathematician and non-artist. These prints illustrate a number of techniques for creating Escher-like patterns.

All the drawings are made by hand and afterwards prints are made from them. The computer was only used as an aid to prepare some preliminary sketches and

Fig. 1. Grid of hyperbolas on which Fig. 2 is based

graphs. We will explain in general terms some of the methods used and we hope to stimulate your imagination to create these kinds of drawings on your own. The definitions used are not completely mathematically correct, but, we hope, clear enough for you to understand the ideas.

Hyperbolic Turtles

A *tiling* consists of a set of tiles that covers the plane without gaps or overlaps. To be regular, all tiles have to be of the same size and shape. But it is also possible to create tilings with tiles that have the same general shape, but which are deformed slightly from one tile to the next.

In order to make this kind of tiling, the first thing that is required is a basic tile: a turtle in our first example. The turtle is simply a rectangle that has been deformed. Finding this deformation is part of the game. The turtle was the result of a lot of trial and error, but now there is some good computer software that greatly reduces the time spent finding a basic tile. Having found the turtle we could now make a regular tiling, but Escher had already done that so we tried to make something different. Since a grid of hyperbolas contains deformed rectangles (Fig. 1), and because the turtle is itself a deformed rectangle, a solution was easily found (Fig. 2).

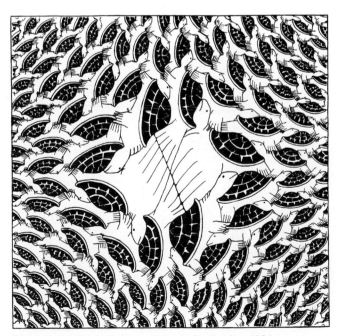

Fig. 2. Peter Raedschelders, *Hyperbolic Turtles*, 1984

Turtles with a Limit

In Fig. 3, the same turtles are now deformed in order to make a tiling with one border as a limit. This was the first step in our search to find a tiling that was completely surrounded by border limits. Escher produced a tiling of reptiles with just

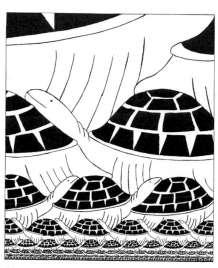

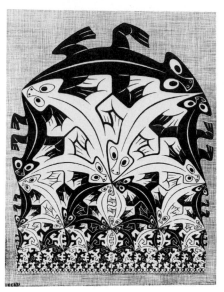

Fig. 3. Peter Raedschelders, *Turtles with Border Limit*, 1984

Fig. 4. M.C. Escher, *Regular Division of the Plane VI*, 1957. Woodcut

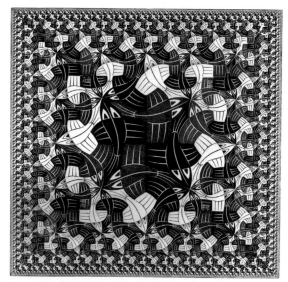

Fig. 5. M.C. Escher, *Square Limit*, 1964. Woodcut

Escher's grid on which Figs. 4 and 5 are based

one border as limit (Fig. 4). In making this, he succeeded in making a repetitive division of the square that also could be used as the underlying division in his print *Square Limit* (Fig. 5), that is completely surrounded by border limits. Escher's studies for these self-similar "division" prints (mis-identified as studies for *Smaller and Smaller*) can be seen in [5, pp. 68–69]; his explanation is in [1, pp. 168–169], and Bruno Ernst's explanation is in [3, pp. 103–105]. Unfortunately we were unable to go further with our *Turtles* border limit tiling.

Seals

The tiling in Fig. 6 solves our problem: it can be completely drawn on one sheet of paper, and the sides have border limits. The basic idea is quite simple: divide the central square into two isosceles right triangles, place on each side of these triangles smaller isosceles right triangles and repeat this procedure. This is similar to Escher's procedure.

It is clear that the triangles can be used as tiles. The second process is to deform each tile into a recognizable object or animal. First, each side of a triangle has to be replaced by the same curve or the same set of lines. Due do the symmetrical aspect of the two largest triangles, the curve itself has to be symmetrical. Secondly, one has to imagine the new form as an object or animal; in this case we recognized a seal. The result is a non-regular octagon filled with seals, similar in concept to that of Escher's *Square Limit*.

Fig. 6. Peter Raedschelders, *Seals*, 1985

Butterflies

The starting point for the print in Fig. 7 was a regular hexagon. Again we tried to make a tiling with border limits but the results turned out differently than that in Fig. 6. Here, the boundary is a fractal. We can never reach the final border of this tiling in a finite number of steps. Instead of a regular border limit, it has several point limits within the tiling. It was impossible for us to use a single tile to fill the pattern completely, so we were forced to invent two kind of tiles. Both tiles were deformed into different types of butterflies.

Due to the form of the butterflies, the tiling has some gaps, so it is certainly not perfect from a mathematical point of view. But again, with the help of some simple mathematical forms, we have created some beauty or at least something pleasing to look at. The center of this print is reminiscent of Escher's symmetry drawing 65 with moths, based on squares rather than hexagons [7, p. 167].

Fig. 7. Peter Raedschelders, *Butterflies*, 1985

Stegosaurs

Sometimes simple paper-folding gives an idea for making a tiling. Take a sheet of square paper. Fold the paper in half diagonally to make an isosceles right triangle. Now take one 45° corner of the triangle and fold it into the other 45° corner, making a smaller isosceles triangle of half the area. Repeat this process to make ever smaller isosceles right triangles. You will obtain a set of triangles, each of them half the size of the previous one. This set of triangles can be used for making a tiling (see below).

The grid on which Fig. 8 is based

Fig. 8. Peter Raedschelders, *Stegosaurs*, 1994

At the time I did this division into triangles for Fig. 8, my daughter Barbara was very interested in dinosaurs, so I decided to deform each triangle into a stegosaurus. The problem was that the complete tiling filled only half a square. As a result, this set of triangles was not very useful for making a good-looking print. In order to solve this problem, the stegosaurs were drawn in their natural environment.

Tropical Fish and Five Snakes

Sometimes a mathematical sketch results into two totally different prints. Until now we have considered the grids used for the tilings as flat. But what happens if one considers the grids as being 3-dimensional? A grid of squares on the walls, floor, and ceiling of a bathroom can be filled with square tiles, and the result is a tiling of a three-dimensional surface. However the same grid can be used to define 3-dimensional cubes. These cubes can then be used to draw houses. Now the grid is considered to be 3-dimensional.

First we take a grid of hyperbolas (Fig. 9a) and fill it with tropical fish, obtaining Fig. 9b, a tiling of the same type as the tiling with turtles of Fig. 1. The only difference between these two prints is that for the turtles we used four "axes," whereas for the tropical fish we used five.

Next, we take exactly the same grid with the same hyperbolas on it, but now use it to build a three-dimensional structure, in the same way as drawing houses using a square grid. The hyperbolic grid also shows "squares" but now they are curved. The result (Fig. 9c) differs totally from a tiling: complex curved surfaces appear. Five snakes live in this world, and if one looks very carefully, one can see that the snakes live on a single surface. Probably the only place where such a world could exist is somewhere far away in the universe.

Fig. 9. (a) Grid of hyperbolas on which prints on next page are based

(**b**) Peter Raedschelders,
Tropical Fishes, 1993

(**c**) Peter Raedschelders,
Five Snakes, 1994

City with Tunnel

There exist other strange worlds. Only a small number of people live there, so the city is rather small in Fig. 10. Not only small but also dangerous. You can safely take a walk around the city but take care that you don't fall into the tunnel (at the top of the square). If you do fall into that hole, don't panic, just follow the tunnel. After some time you will see the end of the tunnel. If you then come out, you will be at exactly the same spot as where you entered the tunnel. You will see the same buildings, the same city, but you are on the opposite side of the square!

Fig. 10. Peter Raedschelders,
City with Tunnel, 1993

Once there was a mathematician who lived in this city. He suggested building a dome at the underside of the square covering the complete "under-city." In that case the whole city would be built according to a mathematical model he once described. The city with dome is a Klein Bottle, named after the German mathematician Felix Klein (1849–1925). Escher also created such imaginary worlds: *Double Planetoid* (page 37) and *Tetrahedral Planetoid* [1, cat. no. 395]; large reproductions of these and studies for them can be seen in [5, pp. 94–97].

a b

(a) If one looks at the city in Fig. 10 from the right side, it looks like this, only the tunnel is enlarged. Deforming the tunnel does not change the topology of the city. (b) After building the dome, the city looks like this; it is a Klein bottle

Space

As soon as the third dimension is involved, the problem of perspective occurs. When we draw a cube, we usually use three vanishing points to draw it in correct perspective. Depending on the position of the cube in relation to our eye, there are different vanishing points. But what happens when we draw a cube with four vanishing points, one to the left, one to the right, one up and one down? To show this, we need several cubes placed next to each other and on top of each other. We repeat this process in order to build a real three-dimensional structure, and in order to give it more depth, we place some "space-animals" in it. The print in Fig. 11 consists of 54 triangles, all with the same pattern of lines. Escher used ordinary perspective in several of his prints, but he used non-standard perspective in *House of Stairs* [1, cat. no. 375], [5, pp. 120–126].

Fig. 11. Peter Raedschelders, *Space*, 1994

Ducks

One of the unsolved problems with tilings is, "Does there exist a single tile which forms an aperiodic set ?" This means that every tiling made with copies of this tile is necessarily nonperiodic. If we take a copy of a tiling and move it in a certain direction over a certain distance, we say that the copy has been *translated* to a new position. It is often possible that the copy coincides with the original tiling. If we can do this in two non-parallel directions, the tiling is periodic. If we can't do this, it is nonperiodic. The print *Turtles with border limit* (Fig. 3) is nonperiodic, because there is only one direction of coincident movement. We used turtles with the same shape but different sizes in that print. What we are searching for is a nonperiodic tiling with identical tiles, all the same size and shape. So the unanswered question is: "Is it possible to find a tile so that using identical copies, it is only possible to make tilings that are nonperiodic?"

During our search for this special tile, we did not find it, but we found a tile (Fig. 12a) that makes nice nonperiodic as well as periodic tilings. This tile is based on a hexagon (Fig. 12b). We deformed the tile into a duck, and made a nonperiodic tiling with the duck tile.

In the center of the print (Fig. 13) there is a infinite row of black ducks all facing left. As soon as this first row of tiles is drawn, all other rows of ducks are forced, that is, the position of all other ducks in the tiling is completely determined; there is no other way possible to complete the tiling. If you try to place the ducks in another way, after a while, you will find places where the ducks don't fit properly. There will be gaps or overlaps, and of course this is not allowed.

The duck has six different orientations because its form is based on a hexagon. We colored three orientations black, and the other three white. Because all rows (except the center one) are forced, the different triangular groups of ducks, which are visible in the print, are also forced. Each of these triangles has $2^n - 1$ ducks.

Let us take a look at the left triangle with size 7 (above the center row). Not counting the ducks at the vertices, the triangle consists of 7 ducks of the center row along the bottom, 7 black ducks facing up on the left side and 7 white ducks facing down on the right side. At the top vertex of this triangle there is again a black duck facing up. It now appears that we have the same pattern if we take the triangle of size 7 on the right side (above the center row). This would

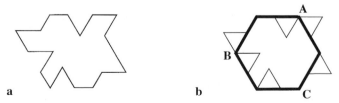

Fig. 12. The duck tile, based on a regular hexagon

Fig. 13. Peter Raedschelders, *Ducks*, 1995

mean that we have found a first direction of translation, and if we could then find a second one, the print would be periodic. But look at the duck at the top vertex of the triangle on the right side – it is a white duck facing down, and since all rows are forced, we had no choice for the orientation of this duck. So the two triangles including their top ducks are not the same. Thus there is no translation to the right or left by 8 duck lengths. So we don't have periodicity for two triangles of size 7. Since we can repeat this procedure for all sizes of triangles, the print is nonperiodic. It can also easily be seen that the triangles grow bigger and bigger and that there will be no second infinite row somewhere that looks

the same as the center row. This second infinite row would also be necessary to have periodicity.

When looking only at the coloring (and not at the orientation of the ducks), one probably thinks that the tiling is very symmetrical (not considering the central row of course) with respect to a change of colors across a center line. It seems that every black duck above the center row has a white counterpart at the same place under the center row. But once again this is not true. It is important to remember that all rows are forced, which means that the orientations of all the ducks in each row are also forced. Since the coloring is orientation-dependent, the coloring of the tiling is forced too. Now look at the top row of the print. Only part of that row is drawn. On the left there are black ducks, on the right white ones. If the coloring of the print were symmetrical with respect to a center line, the bottom row of the print would be white on the left, black on the right. But just the opposite is true. So the coloring of the print is not symmetrical.

Thus we found a single tile which allows a nonperiodic tiling. If this tiling were the only one possible, then the problem of finding one aperiodic tile would be solved. But as we mentioned before, this duck tile also allows periodic tilings. In Fig. 12b, we showed that the duck tile was based in a hexagon. The three corners are labeled A, B and C. For the two sides of the hexagon that meet in corner A, corner A is a rotation center. The same is true for the sides that meet in corner B and corner C. According to the "Escher Hexagon" theorem discussed in [7] and [6], the duck tile is an "Escher Hexagon". Escher used the "Escher Hexagon" to produce several periodic tilings, including his most famous one by lizards, his symmetry drawing 25 (page 427).

The "Escher Hexagon" is based on a convex hexagon tile that Escher read about in a paper by the mathematician F. Haag. Haag showed that a such a hexagon will tile the plane in a periodic way and Doris Schattschneider was so kind to inform me that the duck tile can be considered as of this type [8]. So the duck tile can produce periodic tilings. For the periodic tiling we didn't deform the tile into a duck, but we deformed it into a cuddly animal (on the CD Rom). The cuddly animal looks different from a duck, but the properties of the tiles are the same.

Conclusion

Often simple ideas lead to beautiful tilings (with or without recognizable tiles) and this world, the world of tilings is the domain not only of mathematicians. To enter this world all you need is a piece of paper and a pencil. Escher made masterpieces of tilings and together with them he gave us a challenge to create similarly-inspired patterns. We can admire the masterpieces and we should accept the challenge. With the help of some mathematics, some imagination, and a lot of patience, as an honour to M.C. Escher, we can meet this challenge to show that mathematics is beauty.

References

[1] F.H. Bool, Bruno Ernst, J.R. Kist, J.L. Locher, F. Wierda. *M.C. Escher. His Life and Complete Graphic Work*, London: Thames and Hudson; New York, Harry N. Abrams, 1982.

[2] B. Grünbaum and G.C. Shephard, *Tilings and Patterns,* W.H. Freeman and Co., New York, 1987.

[3] Bruno Ernst, *The Magic Mirror of M.C. Escher*, New York, Random House, 1976. Taschen America 1994.

[4] F. Haag, "Die regelmässigen Planteilungen und Punktsysteme," *Zeitschrift für Kristallographie* 58 (1923): 478–488.

[5] J.L. Locher, intro., *The Magic of M.C. Escher*, New York, Harry N. Abrams, 2000.

[6] John F. Rigby, "Escher, Napoleon, Fermat, and the Nine-point Centre," this book, pp. 420–426.

[7] D. Schattschneider, *Visions of Symmetry: Notebooks, Periodic Drawings and Related Work by M.C. Escher*, W.H. Freeman, 1990.

[8] Personal correspondence with Doris Schattschneider, 1995.

Escher-Like Patterns from Pentagonal Tilings

Marjorie Rice

My first acquaintance with tiling pentagons was from Martin Gardner's "Mathematical Games" columns in *Scientific American* magazine, in July and in December 1975. Although every triangle and every quadrilateral can tile the plane (that is, fill the plane with congruent copies, without gaps or overlaps), only certain types of pentagons can tile the plane. Until Gardner's article, it was believed that all such types were known; there were eight different types.

I became fascinated with the subject and wanted to understand what made each type unique. Lacking a mathematical background, I developed my own notation system and in a few months discovered a new type which I sent to Martin Gardner. He sent it on to Doris Schattschneider to determine if it truly was a new type, and indeed it was.

That was my first contact with Doris and from that time on we corresponded concerning pentagon tilings. It was because of her interest and encouragement and the information which she sent me that I continued on in the search that eventually led to the discovery (over a two-year period) of three other new types that were named types 11, 12 and 13. (Although my first discovery was named type 9 because it was similar to the last three types of those reported by Gardner, a computer scientist from California had actually discovered the first new type, which was named type 10.) A detailed account of these discoveries is given in the chapter "In Praise of Amateurs," in *The Mathematical Gardner* [5], and more mathematical details of the whole pentagon tiling story are given in [6].

I should mention that all the new types of tiling pentagons that were discovered had the property that they can only tile the plane in a manner called non-tile-transitive, or non-isohedral. Essentially, that means that although all the tiles in such a tiling are congruent, it is possible to choose two tiles in the tiling for which every rigid motion that sends one chosen tile onto the other does not send every tile of the tiling onto another tile of the tiling (in other words, the tiling is not invariant under these motions). On the other hand, for each new type, there was a block of two tiles or a block of three tiles for which the tiling by the block was isohedral. Such tilings are called 2-block or 3-block transitive (or 2-isohedral or 3-isohedral). I set out to determine all possible 2-block and all 3-block transitive tilings by congruent pentagons.

During the search I came across many new tilings by pentagons. Usually they were produced by different ways of juxtaposing either types 1 or 2, the most common types. I would send them to Doris and she continued to send me helpful information on the subject, including manuscripts, booklets, and articles from mathematical journals. Through her efforts some of my tilings were printed in articles about pentagonal tilings (see references). In 1993 she sent

Fig. 1. (**a**) A symbolic diagram that shows how angles of copies of a pentagon come together in a tiling, and which sides are equal to each other. (**b**) A portion of the pentagon tiling determined by the conditions shown in (**a**)

computer printouts from a program "Reptiles" by Daniel Huson which could be used to find combinatorial information on all of the possible kinds of 1-, 2- and 3-isohedral edge-to-edge tilings by pentagons; there were 73 tilings in all, with just seven that were isohedral. The "Reptiles" program could not determine when in a 2- or 3-isohedral pattern the pentagons in a block were forced to be noncongruent or if they could possibly all be congruent. That was what I set out to determine, using an exhaustive case-by-case search of all 66 possibilities. When I finished the search I was glad to find that while all of the 1- and 2- block tilings were already in my collection, there was a new 3-block tiling by congruent pentagons to be added.

The diagram that was my key to finding the different tilings is a small five-sided shape like the little houses children draw. Each corner represents an angle of the pentagon; they are labeled A, B, C, D and E, with A at the peak and running counterclockwise. Figure 1(a) is a typical diagram. Symbols connecting certain corners are drawn inside the diagram to indicate which corners meet in the tiling. One symbol is a tent-shape that stretches to three corners that come together in the tiling; those angles sum to 360°. A single line stretched to two corners means that those corners are joined in the tiling; their angles sum to 180°. If those two corners are each 90° angles, they are marked instead with a small v shape at each corner instead of by a line joining the two corners. A 120° angle at which three tiles will join at one point is indicated by two v's stuck together, and a 60° angle at which six tiles will join together at one point is indicated by the same symbol with a bar across the center. When two of one angle and a different angle come together in the pattern and sum to 360°, the two angles are joined by a "Y" symbol, with the fork in the corner of the repeated angle. Another symbol, a small v fastened to the top of the tent shape, indicates four angles coming together in the pattern; here, two same and two different angles sum to 360°.

These symbolic diagrams give a signature for a possible tiling and allow one to quickly see the angle equations that must be satisfied. In a diagram for a 2-block tiling, every corner must be touched exactly twice (every angle in the pentagon is "used" exactly twice in the equations), and similarly, in

a 3-block tiling, each corner of the diagram is touched three times. For example, the diagram in Fig. 1(a) gives the angle equations $3C = 360°$, $B + D + E = 360°$ (twice), $2A + B + D = 360°$. An additional equation (true for every pentagon) is $A + B + C + D + E = 540°$. This, combined with the second equation, implies $A + C = 180°$, indicated by a dashed line. For this particular diagram, the list of all five equations completely determines the angles of the pentagon: $A = 60°$, $B = 150°$, $C = 120°$, $D = 90°$, $E = 120°$.

The possible ways in which the angles come together also determines which edges must have equal length. In Fig. 1(a), for example, the condition that three copies of angle C come together requires that $BC = CD$, and other equations require that $AB = DE = EA$. The equal sides are marked on the symbolic diagram in the usual manner. Figure 1(b) shows a portion of the tiling with this particular pentagon, satisfying all the conditions diagrammed in 1(a). (It turns out that this particular pentagon, which is of type 1, can tile the plane in many other ways as well.) In 1999, the pentagon tiling in Fig. 1(b) was rendered in glazed ceramic tile and installed by the Mathematical Association of America in the entrance foyer of their national headquarters building in Washington, D.C.

A signature for a possible tiling may produce incompatible equations, or equations for which a convex pentagon cannot exist, or require conditions on sides that cannot be satisfied. Thus in considering all the theoretical possibilities, many are discarded as impossible for a tiling pentagon. This is especially true when blocks larger than two are considered. There are only a small number of three-block possibilities that are successful.

From Pentagons to Escher-Like Patterns

Those who are familiar with Escher's quest to understand and formulate rules to make shapes that interlock and fill the plane know that some of his early efforts were based on altering the outlines of polygons that tiled the plane in interesting ways. He would study the geometric relationships between a tile and those that surrounded it and then gradually tinker with the outline of the tile until it became a "recognizable" shape but retained the same geometric relationships to all the tiles that surrounded it [9]. This is a technique that I have applied to some interesting tilings of the plane by convex pentagons.

There are many different shapes of pentagons that will tile the plane, but only certain ones have the qualities necessary to transform them into interlocking designs by recognizable shapes. It usually takes some experimenting to find ones that can be transformed. The pentagon tile is filled with one or more motifs (a flower, shells, fish, for instance) and as this is done, the edges of the tile must be reshaped inward and outward in such a way that the edges of neighboring tiles fit according to exactly the same rules that govern the pentagon grid. The new tiles, which I call "picture tiles," will then fit together and meet at the same

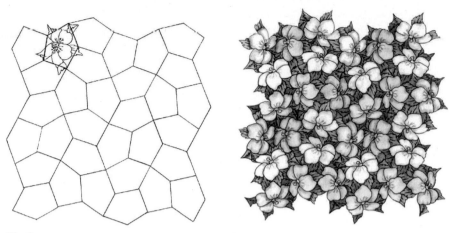

Fig. 2.

corner points as the original pentagons but the straight edges of the pentagons will have vanished. Various ideas are tried out to get the picture as I want it.

Once I've chosen an adaptable pentagon tiling, I first make a version of the chosen pentagon in the size I wish it to be. It is then drawn on a piece of tracing paper as accurately as possible. By putting it on tracing paper it can be turned over to copy if reversed (mirror-image) tiles will also be used. On another sheet of tracing paper, I copy the original pentagon to make a block of four or more tiles in the correct orientations for the tiling. This block can then be used as a pattern to make the whole pentagon grid on good tracing paper; this underlying grid is the basis for the finished design.

The picture tile is now drawn on tracing paper over the original pentagon. The penciled pentagon tiling is turned over and the picture design is traced onto each pentagon, then inked in. The tracing is turned over again and the underlying pentagons are erased. Colored pencils are used first on the back and then on the front to color the tessellations. When the coloring is finished, the pattern on tracing paper is backed by a sheet of white paper. The six patterns shown here were all made this way. All these patterns can be seen in full color on the CD Rom.

The first four patterns were made more than 20 years ago, shortly after my discoveries of the new types of tiling pentagons. The last two were made especially for the Escher Centennial Congress in June 1998.

Hibiscus (Fig. 2 and color plate 8) has an underlying grid of equilateral type 2 pentagons; in each pentagon, the sum of the smallest angle with either of the angles not adjacent to it is 180°. The tiling is 2-block transitive and the pentagons occur in eight different orientations. To highlight this, the hibiscus are colored in eight different colors, each according to its orientation in the pattern.

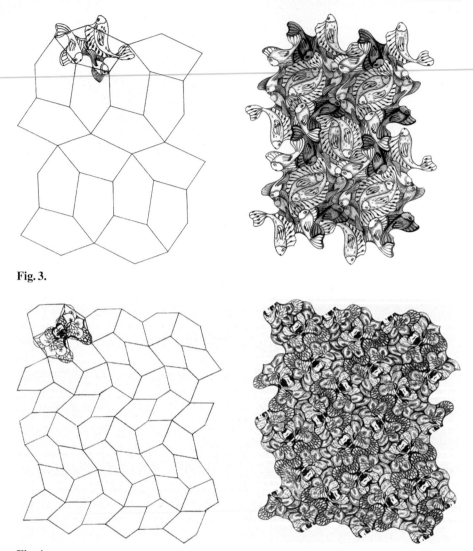

Fig. 3.

Fig. 4.

The pentagons in *Fishes* (Fig. 3) have four equal sides and also are type 2. The tiling is 2-block transitive. Three different fish occupy a single pentagon and the pentagons occur in four different orientations. Six colors are used – each of the three fish occurs in two colors, with each color appearing in two of the four orientations of the fish.

Unlike the previous two tilings, the pentagons in the grid for *Bees in Clover* (Fig. 4) occur in mirror pairs. In the design, a mirrored pair of pentagons is occupied by a symmetric bee flanked by a clover flower on each side, amidst a bed of clover leaves. The pentagon is type 9, the first new type I discovered,

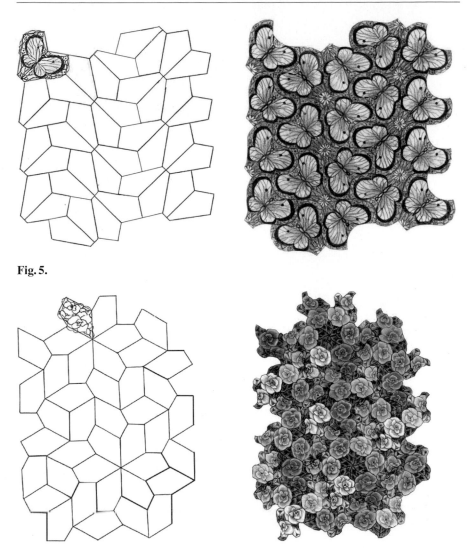

Fig. 5.

Fig. 6.

and the tiling is 2-block transitive with the bees occuring in four different orientations.

Butterflies (Fig. 5) is also based on a 2-block transitive tiling with mirror pairs of tiles that are type 13, the last new type I discovered. In this tiling, however, each pentagon has two right angles and at one of the right angles, four tiles join in a bow-tie block that is symmetrical in two directions. To preserve the geometric relationships among the tiles fused in this block, two of the five sides of each tile must remain as straight edges. To accomplish this, a single butterfly against a field of greens with a half-daisy occupies one mirror pair of tiles in a block, and its mirror image occupies the other half. This tiling also differs from the previous

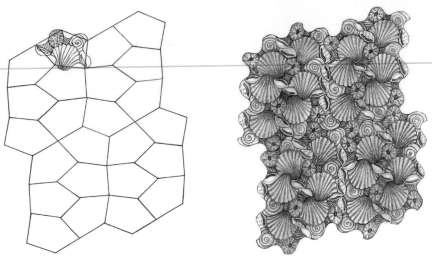

Fig. 7.

ones in that it is not edge-to-edge, that is, a short edge of one pentagon abuts a long edge of a neighboring tile.

Roses (Fig. 6 and color plate 9) is based on the 3-block transitive tiling by a special type 1 pentagon (see Fig. 1(b)) that has six of its 60° corners meet and three of its 120° corners meet in the tiling. Each pentagon is occupied by two roses of the same color, and six colors are used, one for each of the six different orientations of the tile.

My last design, *Sea Shells* (Fig. 7), is another 3-block transitive tiling by a special equilateral type 2 pentagon. Each pentagon is filled with a collection of shells, with the pink scallops most prominent. Each distinct shell appears in six different orientations in the tiling.

I hope in days to come to investigate my collection of pentagon tilings and find others upon which I can build designs.

References

[1] Martin Gardner July 1975. "On tessellating the plane with convex polygon tiles." Mathematical Games, *Scientific American*, pp. 112–117.
[2] Martin Gardner 1988. "Tiling with Convex Polygons." *Time Travel and other Mathematical Bewilderments*. W.H. Freeman & Co. pp. 174–175. [This reproduces the 1975 column of [1] and gives updates on the aftermath of the column.]
[3] Daniel Huson and Olaf Delgado Friedrichs 1992–95. *RepTiles*, computer software to produce k-isohedral tilings.
[4] Ivars Peterson 1990. "Paving the Plane." *Islands of Truth*. W.H. Freeman & Co. pp. 83–86.

[5] Doris Schattschneider 1981. "In Praise of Amateurs." *The Mathematical Gardner*, edited by David A. Klarner. Wadsworth International, pp. 140–166.

[6] Doris Schattschneider. Jan. 1978. "Tiling the Plane with Congruent Pentagons." *Mathematics Magazine*. pp. 29–44.

[7] Doris Schattschneider Nov. 1985. "A New Pentagon Tiler." *Mathematics Magazine*, cover and News and Notes.

[8] Doris Schattschneider and Marjorie Rice. Dec. 1980. "The Incredible Pentagonal Versatile." *Mathematics Teaching* pp. 52–53.

[9] Doris Schattschneider 1990. *Visions of Symmetry: Notebooks, Periodic Drawings, and Related Work of M.C. Escher*. New York: W.H. Freeman & Co.

Not the Tiles, but the Joints: A little Bridge Between M.C. Escher and Leonardo da Vinci

Rinus Roelofs

The regular division drawings of M.C. Escher are considered an important part of his artistic work. He made about 150 basic drawings of regular divisions, some of which were used later in his prints. In almost all of these drawings, it is the tile, the motif, that plays the leading role. However, there are a few exceptions. In his own definition of regular division of the plane, given in *Regelmatige vlakverdeling* [1, p. 94] Escher says that the tiles should fit tightly together on all sides, so that there is no space between them. In other words, the joint, the grout, the layer of mortar used by bricklayers to cement each stone to an adjacent stone, separates them in practice, but can theoretically be reduced to nothing. Mathematicians would call these joints "edges" of the tiling; edges are never considered to have any width.

We can say that this is the mathematical point of view. From an artistic point of view, the separating-lines between tiles will always be there; we can't ignore them. We can give these boundaries more attention and even go so far as to omit the tiles. What we have then is just a grid of joints, connected in some regular way, or a latticework: a plane with a lot of carefully outlined holes. Chinese windows and screens often display such latticework; a nice collection of such designs can be found in reference [3].

In a few of Escher's sketches these lines that separate the tiles indeed seem to take over the leading role. For example, this can be seen in his regular division drawing number 11 (Baarn '42) in his Abstract Motif Notebook [5, p. 87] and in his regular division drawing number 133 (Baarn '67) [5, p. 226], which has been redrawn by computer in Fig. 6. At first glance, this focus on the space between the tiles may seem to be only a slight shift of attention, but it opens up a vast area of artistic possibilities for which Escher might not have had the time to investigate. If we use Escher's own metaphor about wandering in his beautiful garden of regular division, it's like discovering the gate to another garden adjoining it. And like a real garden, no description can substitute for seeing the blooms; these explorations are shared primarily through pictures.

Tiling-Lattices

When we start with a simple tiling consisting of large and small square tiles (Fig. 1), we can construct the latticework of mortar-joints by just removing the tiles. We will call this the *tiling-lattice*. The first step to make the tiling-lattice visible is to thicken the joints (Fig. 2). We then notice that apart from study-

ing the tiling-lattice as a whole, there are a few basic new configurations we can make from it. First, the lattice can be seen as a set of contour lines (Fig. 3). With this set we can, for example, make constructions by extending each contour and even interweave some contours. We can find an example of this in Escher's work: the entwined circular rings in his print *Snakes* (page 76). Another possibility is to dismantle the lattice into equal-length bars, where each bar is a straight segment that is made up of a connected set of joints. The bar grids you then get can be used in 3-dimensional constructions in which bars overlap (Fig. 4). Leonardo da Vinci was evidently interested in such bar constructions. In his work, I found drawings of three different regular bar grids [2, p. 154–155], and Fig. 4 is one of them. We will discuss these and other possibilities of constructions with lattices at greater length in what follows.

First Constructions with Tiling Lattices

Since the tiling-lattice is the net that remains after the tiles are removed, instead of tiles there are now holes. This means that we can overlay and interweave tiling-lattices. For example, in Fig. 5, two copies of the lattice in Fig. 2 have been interwoven. We have already noticed that from the drawing of contours (as in Fig. 3), connected constructions also can be made by extending the contours.

It is interesting to see how we can step from the first kind of construction to the second. In Fig. 6 we can see an interwoven tiling-lattice originally drawn by M.C. Escher. If each thick strand of the mesh of the two differently colored hexagonal tiling-lattices is split in two, and the resulting double strands are re-woven, we get the drawing of connected contours shown in Fig. 7. Extending

these contours and reweaving brings us to Fig. 8 and color plate 27a. (Notice that we need five colors for Fig. 8 to discern the separate connected strands.) In Figs. 9 and 10 we see interwoven lattice constructions in which three layers are used. The same step that took Fig. 6 to Fig. 7 is used to transform the tiling-lattices from Fig. 10 to the connected contours in Fig. 11. Color plate 27b shows a four-layer interweaving.

Three-Dimensional Constructions

Some drawings of tiling-lattices or connected contours can easily be transformed to real three-dimensional constructions. Some tilings that occur frequently in Islamic decoration are a rich source for this exercise. It is not uncommon for these to appear as interwoven tiling-lattices. The hexagonal rings that are interwoven in Fig. 12 can be viewed as projections of cubic elements. Figs. 13, 14, 15, and color plate 27c show different examples of how the structural pattern of Fig. 12 can be worked out as a three-dimensional mesh of congruent linked three-dimensional forms whose edges trace out six edges of a cube.

We can also begin with a two-dimensional tiling-lattice and turn it into an impossible three-dimensional construction. In Fig. 16 a tiling-lattice is shaded so it appears three-dimensional and forms an impossible structure: a scaffold of Penrose tribars. We can even make interwoven impossible structures: two of these are shown in Figs. 17 and 18. Beginning with the same two-dimensional interwoven lattice in Fig. 12, by a different shading we can also produce an impossible interwoven mesh of Penrose tribars, as in Fig. 19 and color plate 27d. Although Fig. 20 looks very different, it begins with the same tiling-lattice

from which Fig. 19 was derived. It is interesting to compare the impossible three-dimensional mesh in Fig. 21 with the Islamic design in [1, p. 155].

More Layers, Different Layers

Interwoven tiling-lattices can be constructed in several ways. The number of layers is one thing we can vary. The tiling-lattice with the large and small square holes (Fig. 2) can be interwoven with different numbers of copies: while Fig. 5

has two layers interwoven, Fig. 22 has four. Figs. 23 and 24 are constructed from the planar tiling-lattice that is the basis for Fig. 16, but there are three layers in Fig. 23 and seven in Fig. 24.

Another technique, of which we will see more examples later on, is to use copies of the same tiling-lattice, with some at a different scale. In Fig. 25, there are four congruent layers of the tiling-lattice for the familiar Archimedean tiling by squares and octagons. In Fig. 26, three layers of the same tiling-lattice are used, but the grey layer is at a smaller scale.

The most interesting interwoven tiling-lattices are made by combining more than one type of tiling-lattice. For example, Fig. 27 is a combination of the right-turning version and the left-turning version of the same lattice (see Fig. 2). In Fig. 28, the tiling-lattice in Fig. 2 is combined with the octagon-square tiling-lattice. In Figs. 29 and 30 you can see the black and white hexagonal tiling-lattices of Escher (Fig. 6) combined with lattices with square and octagonal holes.

Transformation of M.C. Escher's Periodic Drawings

An unexpected consequence of combining different types of tiling-lattices is that we can use some of these methods to transform one of Escher's tilings to a different one in his collection. In our first example (Fig. 31) we start with Escher's tiling of Chinese men (regular division drawing number 4, [5, p. 118]). From this tiling a set of three interlocked tiles is carefully dissected into three equal pieces, following the tiling-lattice of another Escher drawing (Fig. 32). Now, after pulling apart the pieces (Fig. 33) and turning the pieces over (Fig. 34), we can reassemble them, and behold, the three Chinese men have changed into three lizards (Fig. 35), fitting exactly into Escher's regular division drawing number 25 (Fig. 36) (see page 427). An animation of this transformation can be seen on the CD Rom.

When you want to make this kind of transformation, you first have to choose both tilings carefully. The tiling of Chinese men has three different kinds of 3-fold rotation points: where three heads meet, where three left hands meet, and where three right hands meet. The lizard tiling also has three different kinds of 3-fold rotation points. When we want to combine both tilings (in order to turn one into the other), it is important that in superimposing the tilings, these symmetry-points are matched exactly. This can be achieved in six different ways, one of which is shown in Fig. 37.

The next step is to choose a cluster of three Chinese men that meet at a 3-fold rotation point and see whether we can use the outlines of the lizard-tiling as cutting lines from the center 3-fold point to the boundary of the cluster in such a way that the number of pieces after cutting is small. On each of the six possible superimposed tilings, there are three different ways to choose such a cluster of three

The underlying triangular grids for the two symmetry drawings are overlaid so that distinct 3-fold rotation centers match

37

Chinese men, yet only the one in Fig. 32 can be used for a dissection into no more than three pieces using the contour lines of the lizards.

There are many tilings in Escher's collection that can be used for this kind of transformation, and in some cases there is more than one possibility for successful overlay and cutting. From Escher's tiling with fish (regular division drawing number 20 (color plate 2) we can take a cluster of four fish centered at a 4-fold rotation point and divide the cluster into four congruent pieces, in order to transform the fish into four birds from Escher's regular division drawing number 23 [5, p. 133] (see Figs. 38–43). But, as you can see in Figs. 43–50, those four birds can also be cut in four pieces in such a way that we can make

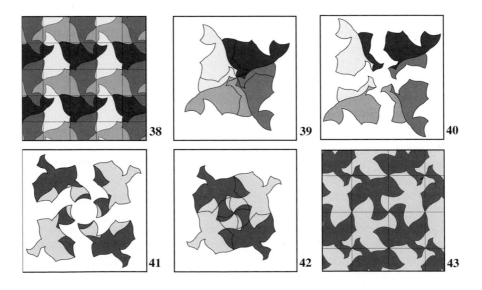

Table 1. The table entries are $a^2 + b^2$

b / a	0	1	2	3	4 ...
0	0	1	4	9	16
1	1	2	5	10	17
2	4	5	8	13	20
3	9	10	13	18	25
4 ⋮	16	17	20	25	32

eight fish (from the same Escher drawing 20) out of them! The trick here is to use combinations of tiling-lattices in different scales. We have seen this before in Fig. 26.

The basic grid here is just a square grid. When we want to combine two square grids of different scales, what scale combinations can be made? To answer this, draw a big square on a square grid, so that the corner points of the big square are on grid points, as shown in Fig. 51. Now measure the area of the big square in small square units. By the Pythagorean Theorem, this area is $a^2 + b^2$. This means that we can divide any such big square into $a^2 + b^2$ small squares where a and b are non-negative integers. And this leads to the series of areas of large squares: 1, 2, 4, 5, 8, 9, 10, ... as you can read from Table 1.

In our example of turning four birds into eight fish, we began by making a square grid on each tessellation by joining the rows of centers of 2-fold and four-fold rotations (see Figs. 38 and 43). Note that each square in these grids has area equal to exactly one motif (one bird or one fish), so each square can represent one motif. Consider the square grid of fish as the small squares in Fig. 51 and then enlarge the scale of the bird tessellation so that a cluster of four birds (four bird-squares) centered at a 4-fold rotation point fits the large square shown in Fig. 51, with $a = b = 2$. Then the large square contains four birds and $2^2 + 2^2 = 8$ fish. Also notice that 4-fold centers of the two tessellations are superimposed.

Four birds can be changed into eight fish because the large square built on the hypotenuse of the 2×2 right triangle has the property that 4-fold centers of the large grid are superimposed on those of the small grid. Any pair of numbers m, n chosen from Table 1 which allow this kind of superposition may be used for tessellations with 4-fold rotations to turn m motifs into n motifs.

So, how about scaling in 3-fold rotational systems, like the Chinese men and the lizards: can we make six lizards out of three Chinese men? First, remember that we need some kind of nice, regular connection between the symmetry points in both layers. The combination of two differently-scaled hexagonal lattices in Fig. 52 seems to give a solution, but exact calculation shows that the areas of the red hexagons and the black hexagons are in the proportion of 4 to 7.

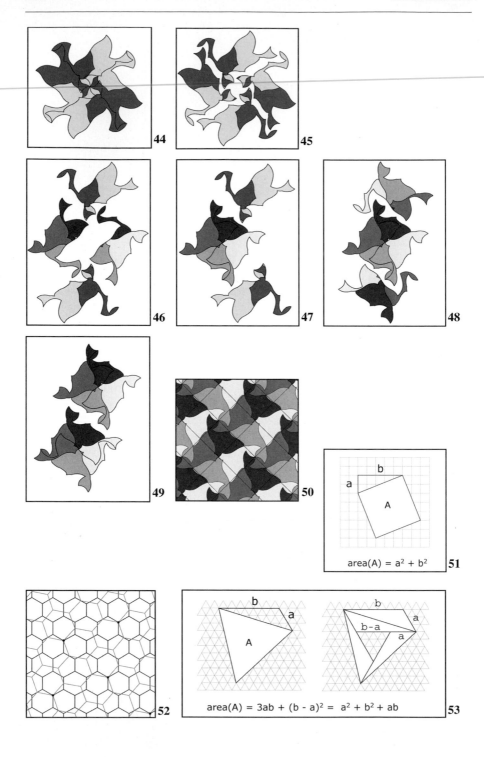

44

45

46

47

48

49

50

$$\text{area}(A) = a^2 + b^2$$

51

52

$$\text{area}(A) = 3ab + (b - a)^2 = a^2 + b^2 + ab$$

53

Table 2. The table entries are $a^2 + b^2 + ab$

b / a	0	1	2	3	4 ...
0	0	1	4	9	16
1	1	3	7	13	21
2	4	7	12	19	28
3	9	13	19	27	37
4	16	21	28	37	48
⋮					

In general, using an isometric grid of equilateral triangles and following the reasoning for the square grids, we see that any equilateral triangle can be divided into $a^2 + b^2 + ab$ small equilateral triangles (see Fig. 53), so we can only use combinations of numbers from the series (of areas) 1, 3, 4, 7, 9, 12, 13, 16, 19, 21, ... that are shown in Table 2.

And so there is no way to just double the number of lizards. (Note: We only allow the use of the separating lines of the tilings as cutting lines in the transformations.)

Bar Grids

There is another nice example in Escher's work where he uses the joints instead of the tiles. And this brings us to the third way of dealing with tiling-lattices: we can split up the tiling-lattice into a set of congruent bars in which each bar is composed of a connected set of joints. For several reasons, I divide this group into two categories: a) grids with crossing bars, and b) grids without crossing bars.

Escher's print *Belvedere* (page 135) provides an example in the first category. If you look closely at the lower windows of the building, you see iron window-lattices that are constructed with bars: horizontal bars are threaded through holes

54

55

56

in vertical bars and vice versa (Fig. 54 shows a close-up of one window). In Rome, where Escher lived for several years, you can find many examples of this kind of barred window. This is nothing special, you might think. But all the barred windows I have seen in Rome could easily be disassembled by just sliding the bars off each other. Several different systems are used; the photo in Fig. 55 shows one. This can be dismantled by working around the center section, loosening the bars in each of the four directions until the mesh falls apart completely. Yet when we look at Escher's design (detail drawn in Fig. 56) it is obvious that this mesh will always stay in one piece. Escher made his own 'impossible' variation on this theme.

Leonardo da Vinci

Now we come to the second category of bar grids: grids without crossing bars. Figure 4 shows an example of this kind of bar grid. Note that in this example all bars can be seen as combinations of three joints (three contiguous edges of the tiling). This seems to be an ideal number. With this extra limitation we can define a construction system as follows: three-bar grids are built up with bars of unit length 3, so we can define four connecting points on a bar: two endpoints and two middle-points. Bars should be connected in only one way: endpoint of one bar connected to middle-point of another bar. And every point on every bar should be connected to another point.

With this definition, many different regular grids can be designed (Figs. 57–60) show just a few examples). After working several months with this system

61

Leonardo's sketches of bar grid systems

(it turned out to be a perfect building system for domes, spheres, columns, etc.), I discovered the drawings of Leonardo da Vinci [2] in which you can see three examples of these bar grids (Fig. 61), probably meant to be used for roof constructions!

With finite bar grid systems (in which the bars are necessarily bent so that they can be connected according to the rules), we can construct some of the regular and semi-regular polyhedra, a favorite subject of both M.C. Escher and Leonardo da Vinci. Polyhedra in which three faces meet at each vertex can be constructed with da Vinci's noncrossing-type bar grid. Figure 62 shows a tetrahedron, Fig. 63 a dodecahedron, and Fig. 64 a truncated octahedron. Polyhedra in which four faces meet at each vertex can be constructed with Escher's crossing-type bar grids. In the figures that show some examples, a single closed loop of one bar is highlighted. Figure 65 shows an octahedron, Fig. 66 a cuboctahedron, Fig. 67 a rhombicuboctahedron, and color plate 27e and f a truncated dodecahedron and a rhombicosidodecahedron.

Although the figures shown here are computer-generated, I have successfully constructed models of figures such as these from wood, from acrylic, and other materials. They require no glue or fasteners – the individual "bars" hold together merely by the structure of the interlaced construction. The CD Rom contains color versions of illustrations in this article as well as other related art work..

References

[1] S.J. Abas and A.S. Salman, *Symmetries of Islamic Geometrical Patterns,* London, World Scientific, 1995.

[2] Leonardo da Vinci, *Codex Atlanticus,* f 328 v-a (1508–1510). Reproduced in *Leonardo Architect,* by Carlo Pedretti, Translated by Sue Brill, New York, Rizzoli International Publications, 1985.

[3] Daniel Sheets Dye, *Chinese Lattice Designs*, New York, Dover Publications, 1974. Reprint of *A Grammar of Chinese Lattices*, Harvard University Pr., 1937 and 1949.

[4] M.C. Escher, *Regelmatige vlakverdeling* (1958), translated into English and reproduced in *M.C. Escher, His Life and Complete Graphic Work*, F.H. Bool et al, eds., New York, Harry Abrams, 1982. Also (a different translation) in *Escher on Escher: Exploring the Infinite*, New York, Harry Abrams, 1989.

[5] B. Grünbaum and G.C. Shephard, *Tilings and Patterns*, New York, W.H. Freeman, 1987

[6] D. Schattschneider, *Visions of Symmetry: Notebooks, Periodic Drawings, and Related Work of M.C. Escher*, New York, W.H. Freeman, 1990.

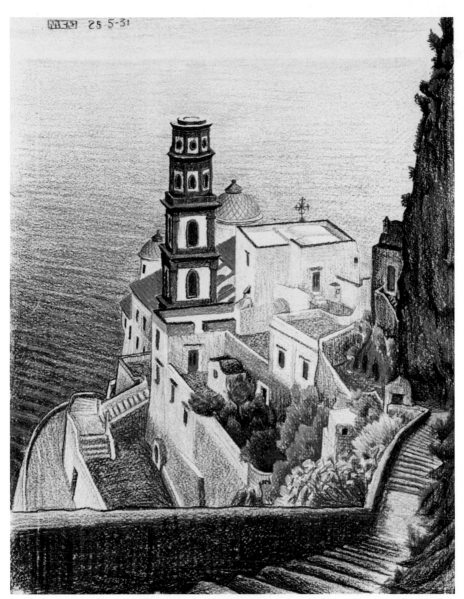

1. M.C. Escher, *View of Atrani*, drawing, 25 May 1931

This drawing greeted those who visited the web site "M.C. Escher, 1898–1998: An international conference 24–28 June 1998, Roma, Ravello." Although recorded by Escher 60 years ago, the site has changed little. Compare with the cover photo by J.A.F. De Rijk, taken in 1973

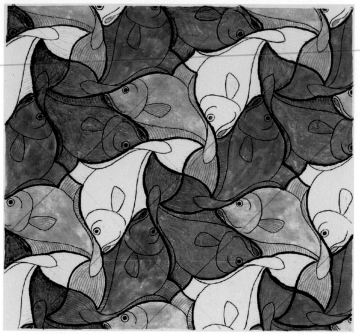

2. M.C. Escher, symmetry drawing 20, March 1938. Pencil, ink, watercolor

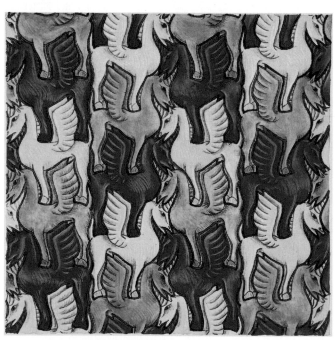

3. M.C. Escher, symmetry drawing 78, October 1950. Pencil, ink, watercolor

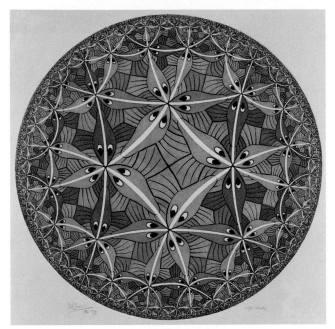

4. M.C. Escher, *Circle Limit III*, 1959. Woodcut

5. M.C. Escher, *Three Intersecting Planes*, 1954. Woodcut

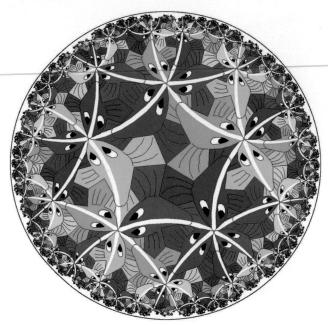

6. Douglas Dunham. A hyperbolic pattern with 6-color symmetry, based on the fish motif of Escher's *Circle Limit III* and the {10,3} tessellation

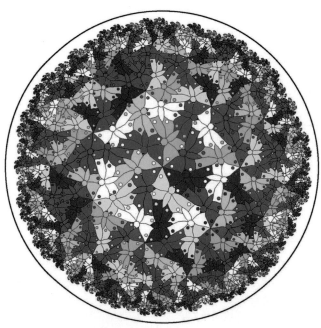

7. Douglas Dunham. A hyperbolic pattern with 8-color symmetry, based on the butterfly motif of Escher's symmetry drawing 70 and the {7,3} tessellation

8. Marjorie Rice, *Hibiscus*, 1978. Color pencil and ink

9. Marjorie Rice, *Roses*, 1998. Color pencil and ink

10. Makoto Nakamura, *Trick in the Grove*, 1991. Gouache

11. Makoto Nakamura, *Wind and Wave*, 1993. Gouache

13. Eva Knoll, *Aquatic S*, 1993. Printed and hand colored

12. Eva Knoll, *Changing Tiles*, 1993. Computer generated

14. Eva Knoll, *Series XIII*, 1992. Acrylic on canvas

15. Robert Fathauer, Non-periodic tiling based on the Penrose set P1

16. Robert Fathauer, *Fractal Serpents*, 1994. Screen print

17. Victor Donnay. **a** Schwarz P-surface. **b** Sphere whose geodesic motion is chaotic.
c Four copies of the Schwarz P-surface. **d** Torus whose geodesic motion is chaotic

18. Two-holed torus made by Douglas Dunham, decorated with Escher's tessellation

19. Dick A. Termes, *Fish Eye View*, 1995. Silk screened on acrylic sphere

20. Dick A. Termes, *Notre Dame of Paris*, 1995. Acrylics on polyethylene sphere

21. Jos De Mey, *A Window with an Outside and Inside View*, for friends of *Ars & Mathesis*, 1993–94. Acrylic on canvas

22. Jos De Mey, *A Windscreen in the Wide Warm Desert*, 1996. Acrylic on canvas

23. Victor Acevedo, *Ectoplasmic Kitchen*, 1987. Computer graphic

24. Victor Acevedo, *The Lacemaker*, 1997. Computer graphic

25. Teja Krašek, *Quasicrystal World*, 1996. Acrylic on canvas

26. Teja Krašek, *Quasicube V*, 1997. Acrylic on canvas

27. Rinus Roelofs. **a** A 5-color weaving of hexagons. **b** Four interwoven layers of the octagon-square tiling. **c** A mesh of rings that are cube edges. **d** A mesh of impossible Penrose tribars. **e** A mesh truncated dodecahedron. **f** A mesh rhombicosidodecahedron

28. Tamás F. Farkas, *Celtic VIII*, 1996. Graphics on paper

29. Tamás F. Farkas, *Pyramid*, 1997. Oil on canvas

30. S.J. Abas, *Tu Kisti? (Who art thou?)*, 1996. Computer image

31. S.J. Abas, *The Islamic Ferric Wheel*, 1995. Computer image

Architecture, Perspective and Scenography in the Graphic Work of M.C. Escher: From Vredeman de Vries to Luca Ronconi

Claudio Seccaroni and Marco Spesso

Some Architectural Implications in Escher's Work

The iconographic sources for Escher's graphic work have not been investigated in depth. In analyses of Escher's works, the links with mathematics and the sciences of perception and communication have been mostly preferred, while an exclusive historic-artistic reading has generally been neglected. This can be in part explained by Escher's eccentric position with respect to mainstream art in the 20th century.

A considerable portion of Escher's large production of graphic work is devoted to architecture, sometimes depicting the structure of an urban scene and sometimes the details of a single autonomous building. The artist carefully studied and most often represented towns and monuments following the usual patterns of perception. However these views are not helpful for understanding Escher's real thoughts on architectonics (we use the technical term *architectonics* to mean a system of design and construction).

In his work, a multiplicity of iconic references reveals Escher's wide-ranging and eclectic attraction to several different periods and types of work in art history. His woodcut *Dream (Mantis religiosa)* (1935) illustrates this very well (see page 66). A different relationship between the artist and architectural

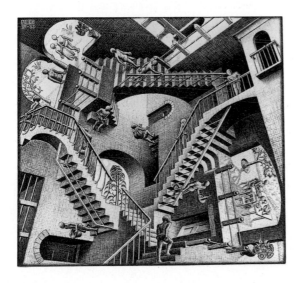

M. C. Escher, *Relativity*, 1953. Lithograph

representation emerged in the 1940s and 1950s, beginning with the first *Metamorphosis* (1937). In this print, the aerial view of *Atrani* (1931) becomes a domain for experimentation, reducing buildings to mere sizes and mass through geometric highlighting of light and shadow and abstraction of layout. His lithographs *Cycle* (1938), *Up and Down* (1947), *House of Stairs* (1951), *Relativity* (1953) and his colored wood engraving *(Two) Doric Columns* (1945) confirm Escher's a-tectonic architectural design, (we use the term *a-tectonic* for the deficiency of structural coherence in buildings [4]).

During his career, Escher had various opportunities to execute commissioned decorative designs for new buildings. These include the wood marquetries in the Leiden Town Hall (1940-41), three pillars in the Neue Mädchenschule in Den Haag (1959), the facade of a school in Den Haag (1960), a pillar in the Ministry of Transport in Haarlem (1962) and the enormous frieze of *Metamorphosis* for the central hall in the Post Office in Den Haag (1968). Pictures of these can be found in [10]. All these works display various flat tessellations and show typical features of the movement "De Stijl," which was very prevalent in Dutch architectural design. This vanguard group was founded in Holland in 1917 by T. van Doesburg and P. Mondrian. These artists exalted Euclidean geometry as mere abstraction, without three-dimensional links to the real world [2].

Links Between Vredeman de Vries' and Escher's Architectural Vision

The complexity and contradictions of architectural representation versus the real structural properties (tectonics) of buildings can be found by analysing the books and graphic works by the Dutch architect and theoretician Jan (or Hans) Vredeman de Vries (Leeuwarden 1527 – Antwerp 1606?). Escher must have known these by virtue of their immense influence in Holland [1, 6, 8, 9, 16].

The prolific de Vries issued during his lifetime 483 engravings, after his drawings, in 27 volumes [11–15]. He developed a leading role by establishing an autonomous and detailed canon for illusionistic architectonic representation. This new concept was freed from building theories and processes, expanding the expressive possibilities of the late-mannerist *quadraturismo* (i.e. architectural *trompe l'oeil* or feigned architecture), which progressively diverged from the traditional projection of a design on a plane. This overcame the unitary and universal vision of drawing and was the conquest of autonomy for many doctrines; among these was scenography (i.e. the design of a scene on the stage; it implies three-dimensional or painted volumes). This application in scenography involves either the refusal of three-dimensional representation or the representation of impossible buildings.

Although Vredeman de Vries was an architect, he built very little. In fact only two buildings in Antwerp are ascribed to him: the roof-terrace of van Straalen house in Korte St. Annastraat (1565–67) and the rebuilding of the "Four

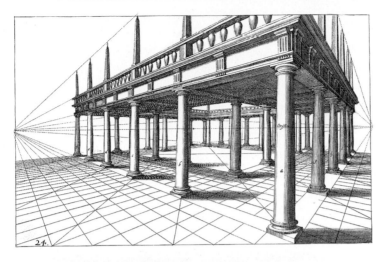

Fig. 1. Vredeman de Vries: *Perspective* (1604), Plates 24, 28, Part I

winds Palace" in Gildenkamerstraat. However, he produced endless architectonic drawings from about 1550 on. His best-selling collections were *Perspective* (1604) and *Architectura* (1606).

In *Perspective*, Plates 7-10, 24 and 26 of Part I and Plates 1, 3, 4, 6 and 7 of Part II display the pure aesthetic worth of de Vries' drawing procedure through his own structural layouts (see Fig. 1, top). Plate 28 Part I shows the intersection between perspective art and scenographic building, and is like a manifesto (see Fig. 1, bottom).

In Part II it is also possible to find other immediate references for Escher's prints, such as *Gallery* (1946) and *Another world* (1947). The features of these works by Escher are directly related to de Vries' spectacular depiction of "worm's eye" views of stacked floors of colonnades (Part II, Plates 20 and 21)

Fig. 2. Vredeman de Vries: *Perspective* (1604), Plates 20, 21, 22, Part II

Fig. 3. Vredeman de Vries: *Perspective* (1604), Plate 39, Part I

and to the up-down perspective aberration of an attic of a palace populated by a thick mass of obclisks like *objectes trouvés* (Part II, Plate 22). (See Fig. 2.) In Part I of *Perspective*, Plates 37, 38 and 39 show analogous situations; Plate 39, seen in Fig. 3, shows a bird's eye view of a many-storied colonnade.

Stairs also became occasions for experimentation by de Vries about architectural incoherence and consequently received an absolute formal autonomy (Part I, Plates 31, 32, 35 and 36); see Fig. 4. *Perspective* shows an unusual inventory of depiction for its time. The book was full of consequences for drawing and was more or less heterodox. Links with Escher's works can be clearly seen.

A further possible connection between these two Dutch artists could be given by Vredeman de Vries' presence, with his son Paul, in Prague at the court of

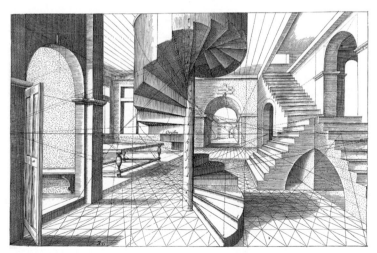

Fig. 4. Vredeman de Vries: *Perspective* (1604), Plate 36, Part I

Rudolph II between 1594–98; platonic solids occur in the work of de Vries and (much later) Escher; this well agrees with the theosophical-mathematical preferences at the court of Rudolph II.

Scenic Use of Vredeman de Vries' and Escher's Architectural Vision in Plays Produced by Luca Ronconi

An unusual confirmation of the association between Vredeman de Vries and Escher is present in scenes for some plays produced by Luca Ronconi, in which excerpts from the prints of both these artists were not only direct, but were sometimes very contextual. Luca Ronconi, born in 1933, is one of the most important European vanguard play directors. He has experimented with a personal language since his first production in 1963. His productions often show peculiar research in scenic space [5]. At the end of this article, we include brief remarks on the works produced by Ronconi that we discuss.

The connections between Escher and Vredeman de Vries – both dependent and independent – and with Luca Ronconi force us to extend our observation from an analysis of the polarity between architecture and perspective to a dialectic comparison in which scenography is inserted as a third pole. It might be considered that scenography is not connected with Escher's works, but we assert that is not true. There are many prints by Escher where the perspective box creates an ideal scene in which space is illusively represented (in a two-dimensional mode) on wings and background. His prints *Serenade* in Sienna (1932), some of the views of *Nocturnal Rome* (1934), but mainly *Gallery* (1946) and *Other World* (1947) are the most important examples.

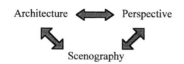

The three poles of architecture, perspective and scenography obviously cannot be considered similar from a hierarchical point of view. Using the formalism of mathematical (Venn) diagrams we can visualise the situation as show below, in which Escher's work is seen as contained in the intersection of the three.

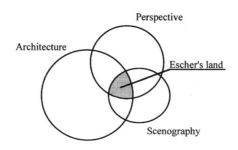

For these three artists we can represent as unions and intersections the fields of interest for each, limiting to architecture, perspective and scenography.

$$\text{Escher} \equiv \text{Perspective} \cap \text{Scenography} \cap \text{Architecture}$$
$$\text{Vredeman de Vries} \equiv \text{Perspective} \cup \text{Architecture}$$
$$\text{Ronconi} \equiv \text{Perspective} \cap \text{Scenography}$$

For all three, the approach to architecture is very partial and strongly conditioned by perspective. This is particularly because they were interested in an interpretation that tends to renounce the expression of volumes. For Ronconi, the polarity between architecture, perspective and scenography is obviously connected with the need to define the scenic space of a theatrical event. Only extremely rarely did this play director totally refuse the absence of an articulation and an organisation. Among these rare cases we note the absence of a visible scene for *Al Pappagallo verde*. Therefore from the point of view of scenography, Ronconi tends to prefer the common field with perspective. In contrast, Vredeman de Vries focused his interest on perspective representation and architecture.

We found the most explicit borrowing by Luca Ronconi from works by Escher and Vredeman de Vries in *Lodoiska* – an opera by Cherubini (see Figures 5, 6). Analogously, the *mise en scène* of another opera by Cherubini,

Fig. 5. Cherubini: *Lodoiska*, Act III, Scene 1 (sketch)

Fig. 6. Cherubini: *Lodoiska*, Act III, Scene 2 (sketch)

Fig. 7. Cherubini: *Demophoon*, Act III (sketch)

Demophoon, showed implicit relations to Escher. The direct iconographic reference for the scenes was the French architect Claude-Nicolas François Ledoux (1736–1806). However the upsetting of perspective that allowed the double view of a monument from Ledoux (front and upward sightlines) is a characteristic of Escher's work (see Fig. 7). In the works of C.-N. F. Ledoux there are other links to Ronconi and Escher. For example Escher's mezzotint *Eye* (1946) is reflective of Ledoux's famous project for the theatre of Besançon where the pit and the loge of this theatre are reflected in an eye [7].

A ninety degrees upsetting of a part of the scenery and/or the simultaneous presence of two or more views from different vantage points for one and the same scenic element suggest rotating and/or translating the scene in the course of the presentation, in order to offer to the spectator manifold views of the same environment. Luca Ronconi employed these practises for a long time and he forced them to the extreme in performances like *La Torre* or, in a more radical way, the *Orlando Furioso* or the *Gli Ultimi giorni dell'umanità*. In these events each spectator can choose his own observation point.

The importance that Luca Ronconi gives to the spectator's vision underlines the assonance in the scenographies, in which strictly perspective views are selected. The role of changing or moving scenes also conditioned the language used by Luca Ronconi in his rare plays carried out expressively for television: *Bettina* and *John Gabriel Borkman*. In these plays the camera, which was

the spectator's viewpoint, moved in a continuous way in the same direction throughout the play without ever coming back, as in an infinite flight of mirrors.

Conclusion

Luca Ronconi forced his stage designers to search for inspiration in works by Escher and Vredeman de Vries. This fact is incontestably attested to by the performance's programs, in which the stage designs are presented along with engravings by the two Dutch artists. An ideal link between Escher and the Dutch mannerist artist resides essentially in focusing on architectural design in order to entice the viewer with unsettling strangeness yet wonderful and imaginative scenes. This aim is pursued through the illusory building of a world where the rules of physics do not rule. The same vision was recovered by the European vanguard theatre between the 1960s and 1980s.

Appendix

We list here some additional information on the plays produced by Luca Ronconi cited in this article.

Operas:
L. Cherubini (music), C.-F. Fillette-Loraux (libretto), *Lodoiska*, Milan, Teatro alla Scala, 1991 [scene design by M. Palli].
L. Cherubini, (music), J.-F. Marmontel (libretto), *Demophoon*, Rome, Teatro dell'Opera, 1985 [scene design by G. Quaranta].

Plays:
A. Schnitzler, *Al Pappagallo Verde* [At the Green Parrot], Genoa, Teatro di Genova, 1979.
H. von Hoffmanstahl, *La torre* [The Tower], Prato, Teatro Fabbricone, 1978.
L. Ariosto (adapted by E. Sanguineti): *Orlando furioso*, Spoleto, Festival dei Due Mondi, 1969.
K. Krauss, *Gli ultimi giorni dell'umanità* [The Last Days of the Humanity], Turin, Teatro Stabile, 1990.

Television plays:
C. Goldoni, *Bettina*, from *La putta onorata* [The Honoured Maid] and *La buona moglie* [The Good Wife], RAI (Radiotelevisione Italiana), 1976.
H. Ibsen, *John Gabriel Borkman*, RAI (Radiotelevisione Italiana), 1982.

References

[1] AA. VV., exhibition catalogue to the exhibition "Hans Vredeman de Vries, 1526 ca – 1606," Den Haag (1979).

[2] C. Blotkamp (editor), *De Beginjaren van de Stijl, 1917–1922*, Reflex, Utrecht, 1982.

[3] F.H. Bool et al., *M.C. Escher, His Life and Complete Graphic Work*, Harry Abrahms, New York, 1982.

[4] C. Brandi, *La prima architettura Barocca: Pietro da Cortona, Bernini, Borromini*, Laterza, Bari, 1970.

[5] A. Carmine, *Modelli spaziali in alcune messe in scena di Luca Ronconi* (Spatial Models in Some Stage Plays Directed by Luca Ronconi), Dissertation, Università di Roma "la Sapienza," 1996.

[6] J. Ehrman, *Hans Vredeman de Vries (Leeuwarden 1527 – Anvers 1606)*, in "Gazette des Beaux-Arts," XCII (1979), pp. 13–26.

[7] C.-N.F. Ledoux: *L'architecture considérée sous le rapport de l'Art, des Mœurs et de la Législation*, Paris, 1824.

[8] H. Mielke, *Hans Vredeman de Vries*, Dissertation, Berlin Freie Universität, 1967.

[9] A.K. Placzek, Introduction to J. Vredeman de Vries, *Perspective*, Dover Books, New York, 1968.

[10] D. Schattschneider, *Visions of Symmetry: Periodic Drawings, Notebooks, and Related Work of M.C. Escher*, W.H. Freeman, New York, 1990.

[11] H. Vredeman de Vries, *Scenographiae, sive perspectivae (ut aedificia, hoc modo ad opticam excitata)*, Jeronymus Cock, Antwerp, 1560 (reprinted in 1563).

[12] H. Vredeman de Vries, *Artis perspectivae plurium generum elegantissimae formulae multigenis fontibus*, Gerard de Jode, Nijmegen, 1568.

[13] H. Vredeman de Vries, *Architectura oder Bauung der Antiquen aus dem Vitruvius*, Gerard de Jode, Antwerp, 1577 (reprinted in 1581, 1597, 1598 and 1615).

[14] H. Vredeman de Vries, *Perspective*, Hendrick Hondius, Den Haag, 1604 (reprinted in 1605).

[15] H. Vredeman de Vries, *Architectura: Die hooghe en vermaende conste bestaende in vijf manieren van edifitien*, Hendrick Hondius, Den Haag, 1606 (reprinted in ten editions from 1607 to 1662).

[16] M. Van de Winckel, entry *Vredeman de Vries, Hans (Jan)*, in "The Dictionary of Art," vol. 32, New York, 1996, pp. 724–727.

Hand with Reflective Sphere to Six-Point Perspective Sphere

Richard A. Termes

M.C. Escher was fascinated with the idea that a mirrored ball almost captures the full sweep of visual space in all directions. Many of Escher's works show his interest in reflected images in a mirrored ball: *St. Bavo's Haarlem* [2, p. 137], *Still Life With Reflecting Sphere* (page 180), *Hand With Reflecting Sphere* (Fig. 1), *Still Life With Spherical Mirror* [2, cat. no. 267], *Three Spheres II* (page 80), and *Dewdrop* (page 131). The mirrored ball probably also helped Escher to be aware of curved line perspective, seen in his prints *Up and Down* (page 29), and *House of Stairs* [2, cat. no. 375]. In this article, I will explain how my total environment "six point perspective" paintings on spheres (and polyhedra) are connected to Escher's interests.

The Mirrored Ball

The mirrored ball, I believe, gave Escher insight into the concept of infinity. One of the most important reasons he made studies with a mirrored ball was to figure

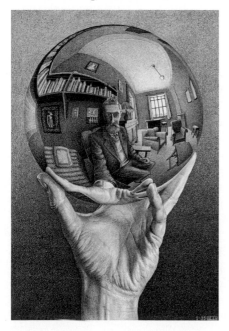

Fig. 1. M.C. Escher, *Hand With Reflecting Sphere*, 1935. Lithograph

out a method to capture the total visual space around him. He desired to see the visual world as a whole.

To experience what was possible for Escher to learn from *Hand With Reflecting Sphere* (Fig. 1), take a mirrored ball in your hand (a shiny Christmas ball will do) and look into it while you slowly revolve in a circle. What happens to the reflection of the surrounding room in the ball's surface? Now tie the mirrored ball onto the handle of a broom. Take a video camera in your other hand and focus on the mirrored ball. As you turn in a circle, move the ball up and down and study the changing image on the surface of the ball. Zoom in. This makes your own image much smaller and the environment more noticeable. Of course, Escher's mirrored-sphere studies came before the video camera but this is a great way to see what the mirrored ball can do (without a large human in the center of the image). When you get over the excitement of this effect, take time to carefully study what happens to the lines that frame the room around you. I think you will notice that an incredibly large area of the visual world outside the ball is found in the reflection. You will also notice the lines of a cubical room curve and converge in six directions towards their vanishing points.

After Escher studied the mirrored ball, which is a spherical surface, he interpreted this information on a flat surface. Rather than take the information back to the plane, I observed that if you could freeze the reflected image Escher viewed on the mirrored ball it would be similar to my six-point perspective "Termesphere" paintings. When I conveyed this thought to George Escher (when he visited my studio), he suggested that the structure of the mirrored ball and the structure of six-point perspective on the sphere were not the same. He said his father was interested in the mirrored ball because it gave him the total picture surrounding it – all on one side of the mirrored ball. The reflection on the mirrored ball included everything that you could see all around the ball except for a narrow circle that was hidden right behind the ball. To prove his point, George Escher had me hold a reflective ball while he moved around with a flashlight in my dark studio. Even when the flashlight was behind the mirrored ball its beam showed up as a long stretched and distorted light along the outside edge. All of the image was there, right to mirrored ball's edge where the ball would eclipse the rest of the visual information. Very little visual information was missing, but yes, lots of it was very distorted.

Are there other ways than the mirrored ball to gather all of this visual information around us into one picture, with no distortion? Would Renaissance perspective lead us to an answer? How about a crystal ball or the reflection on the inside of a spoon? Would spherical geometry have the answer? Can we learn from the map-makers and the Earth-globe makers with their various transfers from sphere to flat?

David Greenhood wrote in his book *Mapping* [6], "Only a globe can give a valid picture of the earth as a whole. No other kind of map can represent the true forms of continents in the full. A globe does not need to simulate the spherical relations of the earth we live on: it has them. If a plane could be globular it wouldn't be a plane." [p. 113] ... "We must accept the inevitable: that there is

no way of flattening out a global surface and keeping intact all the useful features we wish maps to have." [p. 114] The various map projections that try to show what our spherical earth looks like on a flat surface, such as the Mercator projection, the polyconic projection, the Werner equal-area projection, the sinusoidal equal-area projection, the bipolar oblique conic conformal projection, and even Bucky Fuller's icosahedron dymaxion map, all have one thing in common: distortion. The unmistakable fact is, the best way to show the earth is to show it on a globe. Spherical ideas are best expressed on the sphere.

The total visual space around us is also a spherical concept. What do your hands do when you try to explain the totality of what surrounds you? They naturally sculpt a sphere in the air. Try to imagine a painting that can capture all of the visual information that is around you. What kind of surface would that painting have to be on? I have found that you can draw or paint these total visual worlds on any convex polyhedron but the sphere is the best surface because it has no edges or corners. The sphere is the perfectly smooth canvas – this is why I paint my "Termespheres."

As a painter or printmaker, it is a major step to give yourself permission to paint on the sphere. We have learned to paint or print on the flat plane from great artists who have all painted and printed on the flat for thousands of years. Even when we realize we could capture it all with the sphere we still think the real question is: how do we get it back to the plane? Escher came close to accepting the sphere as a canvas with his tessellating patterns on wooden spheres, but as a printmaker, he worked in the flat plane. (In fact, some of his spherical carvings were derived from tessellations that he first produced in the plane – for these, he went from a flat to a spherical canvas.) Albert Flocon [1] and Fernando Casas [4] each used the sphere for their perspective but took that knowledge back to the flat plane for their finished work because they found exciting ideas that could still be presented on the flat surface.

Earth-globe techniques could have been used to reproduce spherical images, but until recently globes were not of very high quality. In the late 1960s my early spheres were kids' rubber balls, old Earth globes and fiberglass spheres which I made on my own. Later I found a supply of globes made for light fixtures that were lexan plastic – tough and light so they could be hung from the ceiling. The problem of finding a sphere of good quality is probably the major reason artists did not play with spherical ideas on spheres. When I hit upon the idea in 1969 and painted a compete 360° view of a room onto a sphere, I also took the information back to the plane for a couple of paintings but soon realized the most exciting thing was to see the image on the sphere. It was a spherical idea and it should be expressed on that surface.

The Termesphere and Six-Point Perspective

What is a "Termesphere" and how does it relate to the mirrored ball and to capturing total visual space? How can we understand the geometry of visual space around us? One of the easiest ways to explain what a Termesphere does is to imagine you are inside a transparent sphere. You transport the sphere (and yourself inside it) inside a wonderful building such as St. Peter's Basilica in Rome and find the perfect spot to stand where you can observe the grandeur of the basilica surrounding you (Fig. 2). Fixing the sphere to that spot, with your viewpoint exactly in the center of the transparent sphere, you copy what you see outside the sphere onto the inside surface. When you have painted everything you see above, below, and all around you, you can then move outside of the sphere to view the painting that covers the sphere. You are now outside, looking in at the scene you observed from inside (Fig. 3). All my spherical paintings are easier to understand if you imagine you are inside the sphere when you view them.

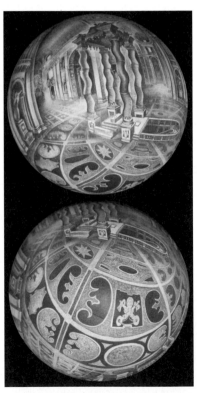

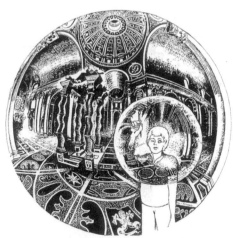

Fig. 2. Dick A. Termes, *Inside St. Peter's Basilica in Rome*, 1998. Sketch

Fig. 3. Dick A. Termes, *St. Peter's Sphere*, 1996. Silk screened sphere

As George Escher observed, an image created this way will be different from the reflected image found on the mirrored ball. The spherical painting will spread the image of St. Peter's equally around the ball. From one side of the painted sphere only one half of what you see around you will show. The mirrored ball would show almost all of the Basilica on just one side of the ball, but much of its image would be foreshortened. When you look at the mirrored ball *you* are always shown on the ball in the center of the mirror (Fig. 1). The painted Terme-sphere gives you a choice: you can be in the picture, or only partly in the picture, or totally absent from the painted sphere. When you look at a Termesphere painting you should be mentally inside the ball. Thus the mirrored ball and the Termesphere put the observer into the center of their respective universes.

There is very little distortion with the Termesphere but what distortion does exist is found at the furthest edges of the scene, as on the mirrored ball. Compare the distortion in Escher's *Hand With Reflecting Sphere* (Fig. 1) with my *Escher to The Third Power* (Fig. 4).

You can understand that capturing the total visual space around you is a spherical idea. You can see from studying map-making that the globe is the only way to comprehend a spherical Earth. You can understand how you must imagine painting what you see from inside the transparent sphere and then move to the outside to see your result. But how do you organize this total space onto the outside of the sphere? My six-point perspective organization begins with six equidistant points (vanishing points) placed on the sphere; these points are the vertices of a regular octahedron. My spherical paintings hang from ceiling motors, so the top point is usually the hole where the suspending chain comes out. This point I think of as Up, and its polar opposite Down, with the other four on the equator as North, East, South, and West. This helps people to understand that the points are at equal distances from each other. Even though I paint the sphere on the outside, I still think of myself as being inside it. The convex surface on which I paint becomes concave in my mind.

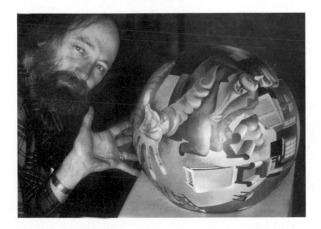

Fig. 4. Dick A. Termes, *Escher to the Third Power*, 1983. Acrylics on polyethylene sphere

Fig. 5. Cube in six-point perspective

The rule in Renaissance perspective (for drawing on a flat plane) is that each family of parallel lines projects to a point on the horizon line or eye-level line. The rule in spherical six-point perspective is that each family of parallel lines projects to two opposite points on the sphere. On the sphere, if a line projects to the North point, it also projects to the South. If another projects to the East point it also projects to the West and one that projects to the Up point also projects to the Down. If you think about it, that is how things really are. The edges of a cube drawn on the sphere would project to six points on the sphere since a cube is composed of three sets of parallel lines (Fig. 5). And in this perspective system, all lines drawn on the sphere are greater circles.

When I paint a real building or landscape, I don't want the image on the sphere surface to be reversed like the one in Escher's mirrored ball. It would be reversed if I really painted it on the inside of a transparent sphere and it was then viewed from the outside. So I reverse the image from what I would see from the inside of the sphere to read true from the outside. *St. Peter's Basilica* (Fig. 6) gives an example of this. This flattened silk-screened sphere shows everything

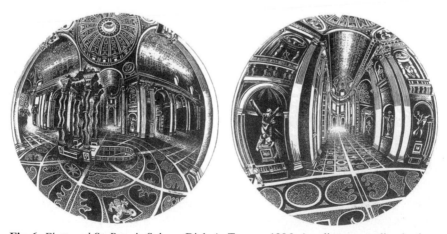

Fig. 6. *Flattened St. Peter's Sphere*, Dick A. Termes, 1996. Acrylics on acrylic plastic

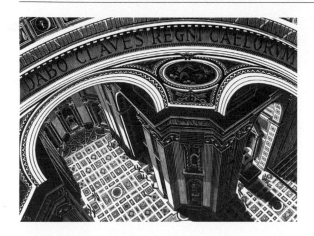

Fig. 7. M.C. Escher, *St. Peter's Rome*, 1935. Wood-engraving

around you as if you were floating about twenty feet above the floor, to the side of the High Altar. Escher also drew the inside of *St. Peter's Rome* (Fig. 7) from a very high vantage point, using a three-point perspective system that allowed him to capture a large portion of that interior.

My sphere of St. Peter's "in the round" was mass-produced, so I was able to print a few spheres with just the dark-colored part of the pattern on a transparent globe. As this version of the sphere hangs and rotates from its ceiling motor, the viewer can look through the front of the sphere to the back side. This causes a strange visual perception. Usually images that are closest to us are what we see first, and these grab our attention. But being able to look at the image on the concave side of the sphere seems more natural – we are more at home inside the sphere than viewing images around us painted on the outside of the sphere.

Another illusion related to this concave/convex phenomenon occurs when the normal opaque Termespheres are viewed: most people who see the convex sphere seem to read it as concave. Indeed, when a close-up video of one of my rotating painted spheres is viewed, it is very difficult to imagine that what is being shown is actually on a convex surface. Also, as the sphere turns, the direction of its perceived concavity seems to reverse. Studies have shown this illusion works best with more realistically-painted spheres [3]. I would guess this is true because realism would make the observer more relaxed and at home with the subject and therefore want to see the scene in the most normal way, that is, concave. You can observe these effects in a video on the CD Rom.

Other Spherical Ideas

In the total visual environment of Termespheres, new concepts can be explored that are not able to be expressed on a flat surface. Some of these ideas are explored on several different Termespheres. Like Escher, many of these ideas reflect my interest in ideas of perception.

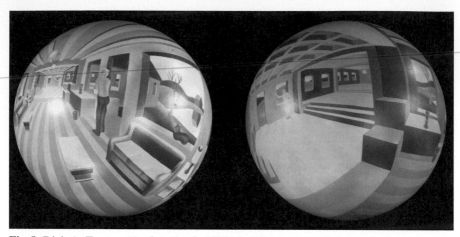

Fig. 8. Dick A. Termes, *North is South*, 1979. Acrylics on polyethylene sphere

Reminiscent of Escher's *Up and Down* (page 29), the 24-inch sphere *North is South* (Fig. 8) repeats what you see in a room. What you see to the south is repeated to the north and everything that is on the room's east side is repeated on its west side. Observers of the painting find they must move to different locations within the room to make sense of what they see.

Another Escher-like work on a similar theme is the 16-inch sphere *Up is Down* (Fig. 9). What if, when you looked above the horizon, instead of seeing the sky you expect, you saw land again that seems just like the land below the horizon? Now add some skyscrapers extending from the land on one side of the horizon to the land on the other side. Which side is up? I found that at both ends of a skyscraper it appeared as though you were looking down. So this city is without sky and without an "up."

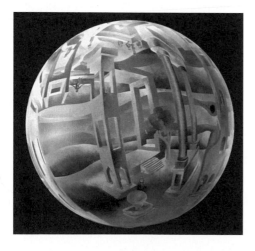

Fig. 9. Dick A. Termes, *Up is Down*, 1982. Acrylics on polyethylene sphere

Fig. 10. Dick A. Termes, *Finishing an Escher*, 1977.
Acrylics on polyethylene sphere

The sphere *Finishing an Escher* (Fig. 10) grows from Escher's *Cubic Space Filling With Curved Lines*, a pencil and ink study for *House of Stairs* [5, p. 54], [8, pp. 120–121]. I call the grid system he used for this a continuous four-point perspective system. The transformation of this idea to six-point perspective on the sphere worked extremely well.

In *The Six Senses* the six vanishing points are the focus of the painting (Fig. 11). This 16-inch-diameter sphere shows plants that sinuously transform to outline human parts, each one appearing at one of the six vanishing points on the sphere. Each human part represents one of the senses: the eye of a face is on one vanishing point, an ear at a second, a nose on another, a mouth with tongue on the forth point, a finger of a hand on another, and at the last a spiral into the top of the head indicating intuition, the sixth sense.

The sphere *Fish Eye View* (color plate 19) is a play on the fish-eye lens which also gives an effect similar to the mirrored ball. Here the sphere represents

Fig. 11. Dick A. Termes, *The Six Senses*, 1993. Silk screened on acrylic sphere

Fig. 12. Dick A. Termes, *The Pantheon in Rome*, 1998. Acrylics on polyethylene sphere

a spherical bowl but you don't know if you are inside or outside. Once you study the piece you realize you are inside the bowl and are looking out, seeing what the fish would see around them, both inside and outside the bowl. With a little more study however, you realize that some of the fish you see have to be outside the bowl to be doing what they are doing!

The 24-inch sphere *Notre Dame of Paris* (color plate 20) is an example of a very exciting total visual environment that is only possible to capture on a spherical canvas. It shows the complete inside scene of the cathedral from its center. All three rose windows can be seen from this spot, in which the viewer is floating and revolving some twenty feet above the floor.

The geometry of the dome building that is *The Pantheon in Rome* (Fig. 12) is also captured on a sphere. It depicts the best view of this wonderful architecture from the very center of the building. I have also painted other interior architectural environments: the Sainte Chapelle and the Paris Opera in Paris, the Loretto Chapel in Santa Fe, New Mexico, the Adams House and Saloon Number Ten in Deadwood, South Dakota, the Capital Building in Pierre, South Dakota, and the Blue Mosque of Istanbul.

An Endless Source of Inspiration

Many important ideas arise from studying the mirrored ball. Escher likely found insight into curved line perspective and visual expression of the concept of infinity from such studies. His challenge was to observe the information on the mirrored sphere and translate it back to a flat surface. The mirrored sphere and the complete sphere each hold some wonderful possibilities. My challenge is to interpret, with the use of my six-point perspective, what the mirrored ball shows, but spread over the total sphere. On the spherical surface "infinite" lines can actually close, and many paradoxes of perception can be explored.

References

[1] Andre Barre, Albert Flocon, and Robert Hansen, *Curvilinear Perspective*, Berkeley and Los Angeles, Univ. of California Press, 1987.
[2] F.H. Bool, Bruno Ernst, J.R. Kist, J.L. Locher, F. Wierda. *M.C. Escher. His Life and Complete Graphic Work*, London: Thames and Hudson; New York, Harry N. Abrams, 1982.
[3] A.R. Branum and K.C. Thornton, "Illusion of Rotary Motion Reversal in a Sphere Is Facilitated by Increased Rotational Speed," *Perceptual and Motor Skills* 73 (1991) 627–634.
[4] Fernando R. Casas, "Flat Sphere Perspective," *Leonardo* 16, No. 1 (1988) 1–9 and "Polar Perspective," *Leonardo* 17, No. 3 (1984) 188–194.
[5] B. Ernst, *The Magic Mirror of M.C. Escher*, New York, Random House, 1976.
[6] David Greenhood, *Mapping*, The University of Chicago Press, 1981.
[7] J.L. Locher, ed., *The Infinite World of M.C. Escher*, New York, Abradale Press/Harry N. Abrams, Inc., 1984.
[8] J.L. Locher, intro., *The Magic of M.C. Escher*, New York, Harry N. Abrams, 2000.
[9] D. Termes, *New Perspective Systems, Seeing the Total Picture*, 1920 Christensen Drive, Spearfish SD 57783, 1998.

Families of Escher Patterns

Douglas Dunham

Although M.C. Escher is best known for his repeating Euclidean patterns of interlocking motifs, he also designed patterns for the sphere and hyperbolic plane. In some cases it is evident that he modified the motif of one pattern to obtain a new pattern with different parameters, different color symmetry, or even a different geometry. For example, Escher transformed his planar "angels and devils" pattern (Fig. 1) onto the sphere and the hyperbolic plane (Fig. 2), thus making use of each of the three classical geometries. H.S.M. Coxeter gives an interesting discussion of these three patterns and their symmetry groups [3, pp. 197–209]; a picture of the sphere is in [8, p. 92]. Figs. 1 and 2 are two examples from a doubly infinite family of angels and devils patterns parameterized by p, the number of figures whose feet meet at a point, and q, the number of devil wing tips meeting at a rotation center. The values of p and q are 4 and 4 for Fig. 1, and 6 and 4 for Fig. 2.

Escher is also known for his use of color symmetry. This adds another dimension to each family of patterns, since there are infinitely many ways to color a repeating pattern in a regular way.

We start with a brief review of hyperbolic geometry and of regular tessellations, which form the basis for many of Escher's patterns. Then we discuss symmetries of patterns and color symmetry. Finally we show new examples from

Fig. 1. M.C. Escher, symmetry drawing number 45, 1941

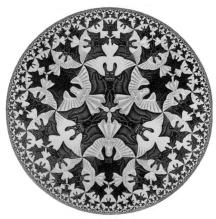

Fig. 2. M.C. Escher, *Circle Limit IV*, 1960 Woodcut

families of Escher patterns, and indicate future challenges to create more patterns and their colorings.

Hyperbolic Geometry

Among the classical geometries, the hyperbolic plane presents unique challenges to an artist working "by hand." Escher surmounted these difficulties in creating four hyperbolic patterns: *Circle Limit I* (Fig. 3), *Circle Limit II* (Fig. 4), *Circle Limit III* (color plate 4 and Fig. 5), and *Circle Limit IV* (Fig. 2); also see [8, p. 180]). Also, the pattern of interlocking rings near the edge of his last woodcut, *Snakes* (see page 76), exhibits hyperbolic symmetry [9].

For these prints, Escher used the *Poincaré circle model* of hyperbolic geometry, which has two useful properties: (1) it is conformal (that is, angles are measured as in Euclidean geometry), consequently a transformed object has roughly the same shape as the original object, and (2) it lies entirely within a circle in the Euclidean plane, so the viewer can see the whole hyperbolic pattern (unlike Euclidean patterns which are artificially cut off by the edges of the page). In this model, "points" are the interior points of the *bounding circle* and "lines" are interior circular arcs perpendicular to the bounding circle, including diameters. The backbones of the fish in *Circle Limit I* (Fig. 3) are hyperbolic lines. However, the backbone lines in Escher's *Circle Limit III* (Fig. 5) are *not* hyperbolic lines – they are not perpendicular to the bounding circle (see [2], [4], and Coxeter's article, p. 297). All the devils of *Circle Limit IV* (Fig. 2) are the same hyperbolic size, which shows that equal hyperbolic distances are represented by ever smaller Euclidean distances as one approaches the bounding circle.

Fig. 3. M.C. Escher, *Circle Limit I*, 1958 Woodcut

Fig. 4. M.C. Escher, *Circle Limit II*, 1959 Woodcut

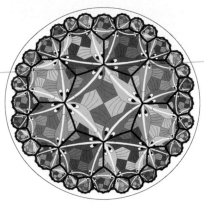 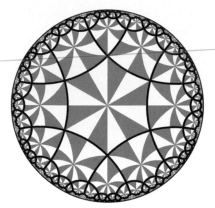

Fig. 5. Computer rendition of Escher's *Circle Limit III* with the hyperbolic tessellation {8, 3} superimposed

Fig. 6. A hyperbolic pattern of triangles based on the {6, 4} tessellation with that tessellation superimposed

Regular Tessellations

Many of Escher's Euclidean patterns and all of his spherical and hyperbolic patterns are based on regular tessellations. The *regular tessellation {p,q}* is a repeating pattern whose basic subpattern is a regular *p*-sided polygon, or *p-gon*, *q* of which meet at a vertex. Figure 6 shows the {6, 4} tessellation superimposed on a pattern of hyperbolic triangles, and Fig. 5 shows the {8, 3} tessellation superimposed on *Circle Limit III*. We discuss this more fully later as well as how the angels and devils patterns are based on {p, q} tessellations where q must be even.

Euclidean geometry, spherical geometry, and hyperbolic geometry are sometimes called the *classical geometries* because they have constant zero, positive, and negative curvature respectively. The values of p and q determine the geometry in which the tessellation lies. The tessellation {p, q} is spherical, Euclidean, or hyperbolic according as $(p - 2)(q - 2)$ is less than, equal to, or greater than 4. Table 1 summarizes the geometry of the tessellation {p, q}. Notice that most of the tessellations are hyperbolic; only three are Euclidean.

In the spherical case, the tessellations {3, 3}, {3, 4}, {3, 5}, {4, 3}, and {5, 3} correspond to versions of the Platonic solids (the regular tetrahedron, octahedron, icosahedron, cube, and dodecahedron respectively) that are "blown up" onto the surface of their circumscribing spheres. The tessellations {3, 6}, {4, 4}, and {6, 3} are familiar Euclidean tessellations by equilateral triangles, squares, and regular hexagons, all of which Escher used extensively. Escher used the tessellations {4, 4} and {6, 4} as a basis for the "angels and devils" patterns of Figs. 1 and 2 respectively; he used {4, 3} for his related spherical pattern.

Table 1. The geometry of the tessellation $\{p, q\}$ There are three Euclidean tessellations, an infinite family of spherical tessellations in which $p = 2$ or $q = 2$, five spherical tessellations for $p > 2$ and $q > 2$; all other tessellations are hyperbolic.

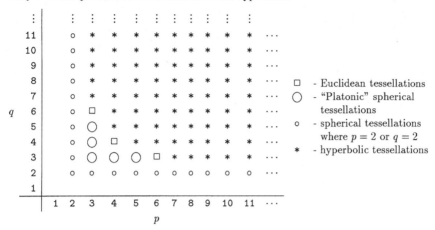

	1	2	3	4	5	6	7	8	9	10	11	
11	o	*	*	*	*	*	*	*	*	*		...
10	o	*	*	*	*	*	*	*	*	*		...
9	o	*	*	*	*	*	*	*	*	*		...
8	o	*	*	*	*	*	*	*	*	*	...	
7	o	*	*	*	*	*	*	*	*	*	...	
6	o	□	*	*	*	*	*	*	*	*	...	
5	o	○	*	*	*	*	*	*	*	*	...	
4	o	○	□	*	*	*	*	*	*	*	...	
3	o	○	○	○	□	*	*	*	*	*	...	
2	o	o	o	o	o	o	o	o	o	o	...	
1												

q (vertical axis), p (horizontal axis)

□ - Euclidean tessellations
○ - "Platonic" spherical tessellations
o - spherical tessellations where $p = 2$ or $q = 2$
* - hyperbolic tessellations

Symmetry and Color Symmetry

A repeating pattern is made up of congruent copies of a basic subpattern or *motif*. A *symmetry operation* or simply a *symmetry* of a repeating pattern is a distance-preserving transformation that maps the pattern onto itself, superimposing each motif exactly onto another motif. For example, hyperbolic reflections across the fish backbones in *Circle Limit I* (Fig. 3) are symmetries. Other symmetries of that pattern include rotations by 180° about the points where the trailing edges of fin tips meet, and translations by four fish lengths along backbone lines.

One very striking feature of Escher's patterns is their color symmetry – a coloring of the motifs in a regular way. If we want to be precise, we say that a pattern has *n-color symmetry* if each of its motifs is drawn with one of n colors, and each symmetry of the uncolored pattern maps all motifs of one color onto motifs of a single color. Escher also adhered to the *map-coloring principle*: copies of the motif that share part of a boundary must be different colors.

Most patterns in this chapter exhibit color symmetry. Notice that *Circle Limit I* does not have 2-color symmetry since the black and white fish are not equivalent (the black fish have 60° noses and the white fish have 90° noses). However, the pattern of triangles in Fig. 6 is an example of 2-color symmetry. *Circle Limit II* (Fig. 4) has 3-color symmetry, and *Circle Limit III* (color plate 4) has 4-color symmetry. In fact, Escher did pioneering work in *n*-color symmetry (for n larger than 2) before the theory was developed by mathematicians and crystallographers. For more on color symmetry, see [7] and [12].

Families of Patterns

Escher was almost certainly aware that his patterns came in families, each based on a common motif; this is evident in his three "angels and devils" patterns mentioned above. Most of his spherical patterns seem to be derived from his Euclidean patterns. Why didn't he create more patterns in each family? The reason is almost certainly that it was too time-consuming – and he was probably more interested in creating new motifs rather than refashioning old ones into new configurations. Also, it is impossible to construct hyperbolic tessellations $\{p, q\}$ by ruler and compass except for certain values of p and q.

My students and I have written computer programs to solve the problems of tedious hand work in modifying patterns and of producing patterns that are impossible to construct with ruler and compass. One of the programs converts a hyperbolic motif from one tessellation $\{p, q\}$ to another $\{p', q'\}$. This program is used in conjunction with a program that replicates the whole hyperbolic pattern from a motif (see [5] and [6]). Such programs can theoretically generate a limitless number of patterns based on a single motif. But the results are not very satisfactory for large values of p or q with a "natural" motif such as a fish or lizard, since the motif will be highly distorted. Figure 7 shows a distorted fish pattern based on $\{12, 4\}$ and Escher's symmetry drawing number 20 (color plate 2). Escher would never have drawn anything like this; he specifically ruled out designs where animal motifs must be very angular to have a great number of them meet at a point. Later we show a much less distorted fish pattern in this family (Fig. 14). However, one can sometimes obtain pleasing results by distorting abstract motifs such as the crosses of *Circle Limit II*.

In the following sections, we first consider families of Escher patterns based on his hyperbolic patterns. Then we will look at some families based

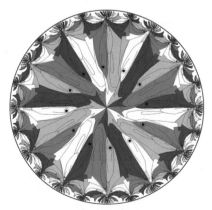

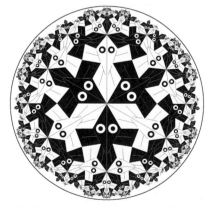

Fig. 7. A distorted hyperbolic pattern based on $\{12, 4\}$ and Escher's symmetry drawing 20

Fig. 8. A pattern of black and white angular fish based on the $\{6, 6\}$ tessellation

on Euclidean Escher patterns for which Escher or others provided spherical examples.

Patterns Based on *Circle Limits*

In 1958 the mathematician H.S.M. Coxeter sent Escher a reprint of an article that Coxeter had written [1]. In that article, there was a figure that showed a pattern of hyperbolic triangles based on the {6, 4} tessellation. When Escher saw this triangle pattern it gave him "quite a shock" (Escher's words), since it solved his problem of showing a pattern "going to infinity" in a finite space. This was the inspiration for his *Circle Limit* patterns. Coxeter's triangle pattern is shown in Fig. 6 in gray, with its underlying {6, 4} tessellation superimposed.

It is easy to see how the triangle pattern of Fig. 6 could be modified to obtain the angular fish of Escher's first hyperbolic pattern, *Circle Limit I* (Fig. 3). Escher was unsatisfied with *Circle Limit I* for at least two reasons: there is no "traffic flow" along the backbone lines – the fish alternate directions every two fish lengths, and there are fish of both colors along each backbone line. He resolved these problems in his *Circle Limit III* pattern. A different solution to the "traffic flow" problem, shown in Fig. 8, is to convert the *Circle Limit I* pattern to one based on the {6, 6} tessellation. The resulting pattern does have 2-color symmetry, unlike *Circle Limit I*.

By using three colors for the pattern of Fig. 8, we can make the fish all the same color along a backbone line, thus solving Escher's second problem as well (Fig. 9). We can also re-center the pattern of Fig. 9 so that the 4-fold rotation point of trailing fin tips is at the center of the bounding circle (Fig. 10). The resulting patterns have 3-color symmetry. Figure 10 bears some resemblance to Escher's *Circle Limit III*. However, the fish are symmetric in Fig. 10,

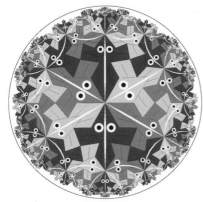

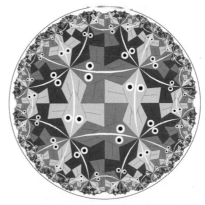

Fig. 9. The fish pattern of Fig. 8 with 3-color symmetry

Fig. 10. The fish pattern of Fig. 9 with fins in the center

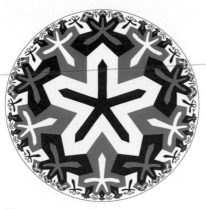

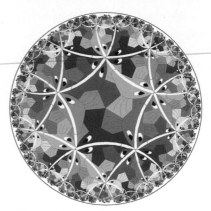

Fig. 11. A 5-armed cross pattern based on the motif of *Circle Limit II*

Fig. 12. A pattern based on the fish motif of *Circle Limit III* and the {10, 3} tessellation

so that the backbone lines are true hyperbolic lines, unlike the asymmetric fish of *Circle Limit III* whose backbone lines are circular arcs making an angle of approximately 80 degrees with the bounding circle [2].

A gray-scale copy of *Circle Limit II*, based on {8, 3}, is shown in Fig. 4; Escher's original print was in black, white, and red (see [8, p. 180] for a color image). This pattern does not seem to be related to any other Escher work. In Fig. 11, we show a related pattern of 5-armed crosses based on the tessellation {10, 3}.

Figure 5 shows a gray-scale version of Escher's most beautiful and successful hyperbolic pattern, *Circle Limit III* (see color plate 4) and demonstrates how it is based on the {8, 3} tessellation. The octagon centers are the 4-fold

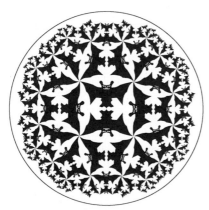

Fig. 13. An "angels and devils" pattern based on the {5, 4} tessellation

Fig. 14. A hyperbolic pattern with the fish motif of Escher's symmetry drawing 20

rotation points where right fins meet, and the octagon vertices are alternately left fin and nose 3-fold rotation points. Thus, the family of *Circle Limit III* patterns is more complicated than the other families considered in this paper. *Circle Limit III* is related to Escher's symmetry drawings 122 and 123 which are based on {4, 4} and {3, 6} respectively, and seem to be the only case in which Escher used the same motif for two different Euclidean patterns. It is also curious that those drawings are dated after *Circle Limit III*. Figure 12 shows a new pattern with 6-color symmetry, using the fish motif of *Circle Limit III* and based on the tessellation {10, 3} (see also color plate 6).

We have already discussed the "angels and devils" family of which *Circle Limit VI* (Fig. 2) is a member. Any member of this family is based on the tessellation {p, q} where there is a q-fold "wing tip" rotation center at each vertex of a p-gon. The lines of bilateral symmetry of the angels and devils pass through the centers of the p-gons and bisect the p-gon sides, so p must be even. Figure 13 shows another member of this family based on the {4, 5} tessellation.

This concludes our discussion of patterns based on the *Circle Limits*. Some distorted cross patterns related to *Circle Limit II* and color versions of other grayscale figures in this section can be seen on the CD Rom.

Patterns Based on Symmetry Drawings

Escher collected and numbered his polished "Regular Division of the Plane" drawings in five folio notebooks [10]. For some of these, Escher or others produced related spherical patterns. Schattschneider and Walker wrapped his patterns around polyhedra in [11]. Such a polyhedral pattern can be "blown up" onto a surrounding sphere to obtain a spherical pattern. Escher carved a beechwood sphere with the fish motif of symmetry drawing 20 (color plate 2). Figure 14 shows a hyperbolic pattern based on this drawing. The patterns of the beechwood sphere, symmetry drawing 20, and Fig. 14 are based on the tessellations {3, 3}, {4, 4}, and {5, 5} respectively.

Although Escher did not create a spherical pattern with exactly the motif of his drawing number 42 shown in Fig. 15, he did design a pattern of starfish and shells on an icosahedral tin box. Also, Schattschneider and Walker covered a dodecahedron with the pattern of drawing 42. Figure 16 shows a related hyperbolic pattern based on the {4, 5} tessellation, while drawing 42 is based on {4, 4}. There is a subtlety in these patterns: the place where four orange and white scallop shells meet is only a 2-fold rotation point, since the openings of the brown snails touching those scallop shells point alternately toward and away from the scallops.

Escher did not create a spherical pattern based on drawing number 56, shown in Fig. 17, but Schattschneider and Walker wrapped that pattern around a tetrahedron. Figure 18 shows a related hyperbolic pattern. The tetrahedron

Fig. 15. M.C. Escher, symmetry drawing number 42, 1941

Fig. 16. A hyperbolic pattern based on Escher's drawing 42

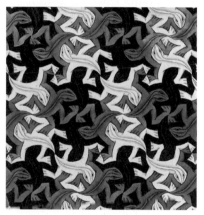

Fig. 17. M.C. Escher, symmetry drawing number 56, 1942

Fig. 18. A hyperbolic pattern with the lizard motif of Escher's drawing 56

pattern, Fig. 17, and Fig. 18 are based on the tessellations $\{3, 3\}$, $\{6, 3\}$, and $\{9, 3\}$, respectively.

Again, Escher did not create a spherical pattern based on his drawing number 70 of butterflies [8, p. 60], but Schattschneider and Walker used this pattern to cover an icosahedron. Figs. 19 and 20 show related hyperbolic patterns with seven and eight butterflies, respectively, meeting at a left front wing tip. (See color plate 7 for a color version of Fig. 19.) In general, a pattern of butterflies meeting p at a left front wing tip and 3 at a right rear wing tip can be given color symmetry by using $p + 1$ colors. However, if p is even, three colors are enough.

Color versions of the hyperbolic patterns in this section and related patterns can be found on the CD Rom.

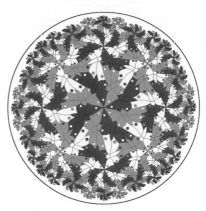

Fig. 19. A hyperbolic pattern with the butterfly motif of Escher's symmetry drawing 70, based on the {7, 3} tessellation

Fig. 20. A hyperbolic pattern with the butterfly motif of Escher's symmetry drawing 70, based on the {8, 3} tessellation

Conclusions and Future Work

We have looked at Escher's four hyperbolic *Circle Limit* patterns, and some of his patterns on spheres. This leads to the question: have we missed any interesting families of patterns? The answer is almost certainly "yes," considering Escher's many Euclidean symmetry drawings and other periodic designs [10]. We usually picked families for which there were at least two sample patterns. Escher himself chose particularly striking Euclidean patterns to convert to spherical or hyperbolic geometry. But there are other such patterns that he probably would have converted to other geometries if he had been able to do so easily – with computer programs, for instance. Escher was pleased with his spherical and hyperbolic works since the viewer could see an entire pattern without having it stop at the artificial edges of (theoretically infinite) Euclidean patterns.

A second question is: why didn't we show more patterns from each family? One answer is aesthetics. Escher's motifs only remain pleasing to look at with small amounts of distortion, which means small values of p and q. There are just a few such combinations of p and q that satisfy the hyperbolic condition $(p-2)(q-2) > 4$. Figure 7 shows an extreme example of distortion, but even the moderately deformed devils of Fig. 13 seem too wide when compared to Escher's angels and devils patterns. Escher carefully chose motifs and values of p and q that were compatible.

One remaining challenge is to automatically generate colorings of patterns. We have followed Escher's example and only used the minimum number of colors for a symmetric coloring while adhering to the map-coloring principle. But these colorings were determined "by hand" – it seems difficult to automate this process.

Another challenge is to handle Escher families that are more complicated than those based on the regular tessellations $\{p, q\}$. For example, one can certainly imagine a 3-parameter family of *Circle Limit III* patterns in which the right fins of the fish meet at a p-fold point, the left fins meet at a q-fold point, and r noses meet at a point.

We have made progress in being able to easily view many hyperbolic members of Escher pattern families. However, there are certainly more unexplored ways to create patterns from Escher families. Transforming and coloring Escher patterns via computer has become almost as much of an obsession with me as creating them was for Escher in the first place. I thank him for his extensive, inspiring legacy of beautiful patterns.

References

[1] Coxeter, H.S.M., "Crystal Symmetry and its generalizations." *Transactions of the Royal Society of Canada* (3) **51** (1957) 1–13.
[2] Coxeter, H.S.M., "The non-Euclidean symmetry of Escher's picture *Circle Limit III*." *Leonardo*, **12** (1979) 19–25.
[3] Coxeter, H.S.M., "Angels and Devils." In *The Mathematical Gardner*, David A. Klarner ed., Prindle, Weber and Schmidt, Boston (1981) 197–209.
[4] Coxeter, H.S. M., "The Trigonometry of Escher's Woodcut 'Circle Limit III.' " *The Mathematical Intelligencer*, v. 18, no. 4 (1996) 53–57.
[5] Dunham, D., "Hyperbolic symmetry." *Computers & Mathematics with Applications* (1,2), 12B (1986) 139–153.
[6] Dunham, D., "Creating hyperbolic Escher patterns." In *M.C. Escher: Art and Science*, H.S.M. Coxeter, et al., eds, North-Holland, Amsterdam, (1986).
[7] Grünbaum, Branko and G.C. Shephard, *Tilings and Patterns*. W.H. Freeman and Co., New York (1987).
[8] Locher, J.L., *The Magic of M.C. Escher*. Harry N. Abrams, Inc., New York (2000).
[9] Rigby, John, "Butterflies and Snakes." In *M.C. Escher: Art and Science*, H.S.M. Coxeter, et al., eds, North-Holland, Amsterdam, (1986).
[10] Schattschneider, Doris, *Visions of Symmetry: Notebooks, Periodic Drawings, and Related Work of M.C. Escher*. W.H. Freeman, New York (1990).
[11] Schattschneider, Doris and Wallace Walker, *M.C. Escher Kaleidocycles*. Ballantine, New York (1977). New Edition: Pomegranate Artbooks, Corte Madiera, California, (1987).
[12] Senechal, Marjorie, "Color Symmetry and colored polyhedra." *Acta Cryst.* A39, 505–511 (1983).

The Trigonometry of Escher's Woodcut
Circle Limit III

H.S.M. Coxeter

Preface. During the 1954 International Congress of Mathematicians in Amsterdam, my wife Hendrina introduced me to M. C. Escher, with whom we became close friends. On one of the occasions when he was visiting his son George in Nova Scotia, he gave an illustrated lecture in the Art Gallery of Ontario and spent a few nights with us in our Toronto house. He gave us four original prints; including one of *Circle Limit III*, which inspired this article, as well as an earlier one. In contrast to the other three *Circle Limits* (*I*, *II* and *IV*), this employs four colours in addition to black and white, and features arcs which are not orthogonal to the peripheral circle. In an earlier article [1], I used hyperbolic trigonometry for my analysis, but several years later I took up the challenge of using Euclidean trigonometry instead. My former student J. Chris Fisher kindly helped by reducing my expressions for the measurements to calculated numbers that could be compared with the actual print on my staircases wall. At first one of the six measurements seemed to be wrong by a few millimetres. (The diameter of the peripheral circle is 41 cm.) Rather than blame Escher, I asked Chris to check his computation again. When he admitted that the mistake was his, I realized that Escher's intuition was completely justified. I still find it almost incredible that he, with no knowledge of algebra or trigonometry obtained accurately the centres and radii (r_1, r_2, r_3) of the three different circles to which the three different axes belong.

The Euclidean material was accepted by Chandler Davis for *The Mathematical Intelligencer* [2]. But neither he nor I was intelligent enough to notice the simplifying relation $r_1 r_2 = 2$. When this and its neat consequences were pointed out to me by Jan van de Craats of Breda, I rearranged the material into a "streamlined" version which was accepted by Koji Miyazaki for publication in his mainly Japanese journal *Hyper-Space* [3]. It is that streamlined version that is republished here.

In M. C. Escher's circular woodcuts, replicas of a fish (or cross, or angel, or devil), diminishing in size as they recede from the centre, fit together so as to fill and cover a disc. *Circle Limits I, II*, and *IV* (pages 286, 287) are based on Poincaré's circular model of the hyperbolic plane, whose lines appear as arcs of circles orthogonal to the circular boundary (representing the points at infinity). Suitable sets of such arcs decompose the disc into a theoretically infinite number of similar "triangles," representing congruent triangles filling the hyperbolic plane. Escher replaced these triangles by recognizable shapes. *Circle Limit III* (Fig. 1 and color plate 4) is likewise based on circular arcs, but in this case, instead of being orthogonal to the boundary circle, they meet it at equal angles of almost precisely 80°. (Instead of a straight line of the hyperbolic plane, each arc represents one of the two branches of an "equidistant curve.") Consequently, his

construction required an even more impressive display of his intuitive feeling for geometric perfection. The present article analyzes the structure, using the elements of trigonometry and the arithmetic of the biquadratic field $\mathbb{Q}(\sqrt{2}+\sqrt{3})$: subjects of which he steadfastly claimed to be entirely ignorant.

Concerning his four Circle Limit woodcuts, M. C. Escher wrote:

> *Circle Limit I, being a first attempt, displays all sorts of shortcomings ... and leaves much to be desired. ... There is no continuity, no "traffic flow" nor unity of colour in each row.... In the coloured woodcut Circle Limit III, the shortcomings of Circle Limit I are largely eliminated. We now have none but "through traffic" series, and all the fish belonging to one series have the same colour and swim after each other head to tail along a circular route from edge to edge. ... Four colours are needed so that each row can be in complete contrast to its surroundings. As all these strings of fish shoot up like rockets ... from the boundary and fall back again whence they came, not a single component reaches the edge. For beyond that there is "absolute nothingness." And yet this round world cannot exist without the emptiness around it ... because it is out there in the "nothingness" that the centre points of the arcs that go to build up the framework are fixed with such geometric exactitude. [4], p. 109*

The purpose of the present article is to demonstrate this "geometric exactitude" (see Fig. 2) by finding the radii and centres of the first three sets of four congruent circles that trace the backs of the "strings of fish." I naturally assume that the relevant arcs of these circles cross one another at equal angles of 60°, decompose the interior of the "boundary" into alternate triangular and quad-

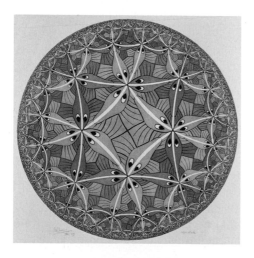

Fig. 1. M. C. Escher, *Circle Limit III*, 1959. Woodcut

Fig. 2. Escher's "framework"

rangular regions, and all cut the boundary at the same pair of supplementary angles

$$\omega, \quad \pi - \omega.$$

The acute angle ω appears on the side of each arc where the regions are quadrangular.

An earlier article ([1], p. 24) used hyperbolic trigonometry to prove that

$$\cos \omega = \sinh(\frac{1}{4} \log 2)$$
$$\approx \sinh 0.1732868 \approx 0.1741553.$$

Since $\cos(79°58') \approx 0.17424$, ω scarcely differs from the value $80°$ which can easily be measured in Escher's woodcut. Here I obtain this expression for ω by a more elementary procedure.

The Angle ω at the Boundary

Figure 2 is a sketch of the middle part of Escher's "framework," showing the centres O_ν, at distances

$$d_\nu = AO_\nu$$

from the centre A of the bounding circle, of radius 1, and showing the radii

$$r_\nu = O_\nu X_\nu.$$

Fig. 3. Triangles with angles ω at X_1 and X_3, $\pi - \omega$ at X_2

Fig. 4. The similar triangles $O_1 AC$ and $O_2 AB$

From the triangle $X_1 A O_1$, whose angle ω at X_1 is opposite to the side $A O_1 = d_1$, as in Fig. 3, we have

$$d_1^2 = 1 + r_1^2 - x r_1 \, , \tag{1}$$

where

$$x = 2 \cos \omega \, . \tag{2}$$

Similarly, the triangle $X_2 A O_2$, whose angle $\pi - \omega$ at X_2 is opposite to d_2, yields

$$d_2^2 = 1 + r_2^2 + x r_2 \, . \tag{3}$$

Because the angle between two intersecting circles equals the angle between their radii to a common point, the triangle $O_1 A C$ has angles $2\pi/3, \pi/4$, and $\pi/12$ opposite to sides

$$A O_1 = d_1 \, , \quad C O_1 = r_1 \, , \quad C A = d_2 - r_2 \, ,$$

respectively, as in Fig. 4. Hence we have

$$\frac{d_1}{\sin(2\pi/3)} = \frac{r_1}{\sin(\pi/4)} = \frac{d_2 - r_2}{\sin(\pi/12)} \, ,$$

that is,

$$\frac{d_1}{\sqrt{3}} = \frac{r_1}{\sqrt{2}} = \frac{d_2 - r_2}{(\sqrt{3} - 1)/\sqrt{2}} \, . \tag{4}$$

The similar triangle $O_2 A B$, with angles $2\pi/3$ and $\pi/4$ opposite to sides

$$A O_2 = d_2 \, , \quad \text{and} \quad B O_2 = r_2 \, ,$$

respectively, yields

$$\frac{d_2}{\sqrt{3}} = \frac{r_2}{\sqrt{2}} = \frac{A B}{(\sqrt{3} - 1)/\sqrt{2}} \, . \tag{5}$$

Thus,

$$d_\nu^2 = \frac{3}{2}r_\nu^2 \quad (\nu = 1 \text{ or } 2) \tag{6}$$

and expressions (1) and (3) for d_ν^2 yield quadratic equations for r_ν:

$$r_1^2 + 2xr_1 - 2 = 0, \quad r_2^2 - 2xr_2 - 2 = 0.$$

Solving these equations for the positive numbers r_ν, we find

$$r_1 = -x + \sqrt{x^2 + 2}, \quad r_2 = x + \sqrt{x^2 + 2}. \tag{7}$$

From (4) we have

$$(\sqrt{3} - 1)r_1 = 2(d_2 - r_2) = (\sqrt{6} - 2)r_2,$$

and from (7),

$$r_1 r_2 = 2.$$

It follows that

$$r_1^2 = (\sqrt{6} - 2)(\sqrt{3} + 1), \tag{8}$$
$$r_2^2 = (\sqrt{6} + 2)(\sqrt{3} - 1),$$
$$4x^2 = (r_2 - r_1)^2 = r_1^2 + r_2^2 - 2r_1 r_2 = 2\sqrt{2}(\sqrt{2} - 1)^2$$

and

$$x = 2^{-1/4}(2^{1/2} - 1) = 2^{1/4} - 2^{-1/4} = 2\sinh(\tfrac{1}{4}\log 2).$$

The First Two Circles

Since $\sqrt{x^2 + 2} = \sqrt{2^{1/2} + 2^{-1/2}} = 2^{-1/4}\sqrt{3}$, (7) yields

$$r_1 = 2^{-1/4}(1 - \sqrt{2} + \sqrt{3}) \approx 1.1081646, \tag{9}$$
$$r_2 = 2^{-1/4}(\sqrt{2} - 1 + \sqrt{3}) \approx 1.8047860,$$

and, from (6),

$$d_1 = 2^{-3/4}(\sqrt{3} - \sqrt{6} + 3) \approx 1.3572189,$$
$$d_2 = 2^{-3/4}(\sqrt{6} - \sqrt{3} + 3) \approx 2.2104024.$$

From (5) we have

$$AB = \tfrac{1}{2}(\sqrt{3} - 1)r_2$$
$$= 2^{-3/4}(-1 + 2\sqrt{2} + \sqrt{3} - \sqrt{6}) \approx 0.6605975.$$

The Biquadratic field $\mathbb{Q}(\sqrt{2}+\sqrt{3})$

The numbers $(a+b\sqrt{2}+c\sqrt{3}+d\sqrt{6})/q$, where a, b, c and d are integers and q is a positive integer, are easily seen to constitute a *field* ([5], p. 230). This field is called $\mathbb{Q}(\sqrt{2}+\sqrt{3})$ because it can be expressed as the set of all rational functions of the special number $\theta = \sqrt{2}+\sqrt{3}$ in terms of which

$$\sqrt{2} = \tfrac{1}{2}(\theta - \theta^{-1}), \quad \sqrt{3} = \tfrac{1}{2}(\theta + \theta^{-1}), \quad \sqrt{6} = \tfrac{1}{2}(\theta^2 - 5).$$

In this field, θ is called an *integer* because it satisfies a monic equation, namely

$$\theta^4 - 10\theta^2 + 1 = 0.$$

When we assert that "factorization is unique," we disregard, as factors, the *units*, which are divisors of 1; for if $st = 1$, any number

$$n = nst$$

has the trivial factorization $ns \times t$.

Comparing (8) and (9), we obtain the apparently surprising identity

$$(1 - \sqrt{2} + \sqrt{3})^2 = 2(\sqrt{3} - \sqrt{2})(\sqrt{3} + 1).$$

This "factorization" loses its element of surprise when we face the obvious fact that $\sqrt{3} - \sqrt{2}$ is a unit:

$$(\sqrt{3} + \sqrt{2})(\sqrt{3} - \sqrt{2}) = 1.$$

The Third Circle

Looking again at Fig. 3, we see that

$$d_3^2 = 1 + r_3^2 - xr_3$$

and, since the third circle passes through B,

$$d_3 - r_3 = AB.$$

Thus

$$d_3 + r_3 = \frac{1 - xr_3}{AB}, \quad 2r_3 = \frac{1 - xr_3}{AB} - AB,$$

$$r_3 = \frac{(1/AB) - AB}{2 + x/AB} = \frac{1 - AB^2}{2AB + x}$$

$$= \frac{1 - 2^{-3/2}(18 - 10\sqrt{2} - 10\sqrt{3} + 6\sqrt{6})}{2^{1/4}(-1 + 2\sqrt{2} + \sqrt{3} - \sqrt{6}) + 2^{-1/4}(\sqrt{2} - 1)}$$

$$= \frac{-9 + 6\sqrt{2} + 5\sqrt{3} - 3\sqrt{6}}{2^{1/4}(3 - 2\sqrt{3} + \sqrt{6})}$$

$$= 2^{-1/4}\frac{5 - 3\sqrt{2} - 3\sqrt{3} + 2\sqrt{6}}{-2 + \sqrt{2} + \sqrt{3}}$$

$$= 2^{-1/4}\left(\frac{-1 + 2\sqrt{6}}{-2 + \sqrt{2} + \sqrt{3}} - 3\right)$$

$$= 2^{-1/4}\left(\frac{(-1 + 2\sqrt{6})(-2 + 5\sqrt{2} + 3\sqrt{3} + 4\sqrt{6})}{(-2 + \sqrt{2} + \sqrt{3})(-2 + 5\sqrt{2} + 3\sqrt{3} + 4\sqrt{6})} - 3\right)$$

$$= 2^{-1/4}\left(\frac{50 + 13\sqrt{2} + 17\sqrt{3} - 8\sqrt{6}}{23} - 3\right)$$

$$= 2^{-1/4}\left(\frac{-19 + 13\sqrt{2} + 17\sqrt{3} - 8\sqrt{6}}{23}\right)$$

$$\approx 0.3375915$$

and

$$d_3 = r_3 + AB = 2^{-3/4}\frac{3 + 27\sqrt{2} + 7\sqrt{3} - 6\sqrt{6}}{23} \approx 0.998189.$$

Since Escher's bounding circle has diameter 41 cm, our results

$$r_1 \approx 1.10816, \qquad d_1 \approx 1.3572,$$
$$r_2 \approx 1.8048, \qquad d_2 \approx 2.2104,$$
$$r_3 \approx 0.3376, \qquad d_3 \approx 0.9982,$$

should be multiplied by 20.5 to obtain the distances in centimetres:

$$22.7, \quad 27.8,$$
$$37.0, \quad 45.3,$$
$$6.92, \quad 20.46.$$

These distances agree perfectly with actual measurements in the woodcut itself.

Acknowledgements

I am grateful to J. Chris Fisher for the numerical computations and to Jan van de Craats for two clever ideas.

References

[1] H.S.M. Coxeter: The non-Euclidean symmetry of Escher's picture 'Circle Limit III,' *Leonardo* **12** (1979), 19–25, 32.
[2] H.S.M. Coxeter: The Trigonometry of Escher's Woodcut 'Circle Limit III,' *The Mathematical Intelligencer* **18**, no. 4, (1996), 42–46.
[3] H.S.M. Coxeter: The Trigonometry of Escher's Woodcut 'Circle Limit III,' *HyperSpace* **6**, no. 2, (1997), 53–57.
[4] B. Ernst: *The Magic Mirror of M.C. Escher,* New York: Random House, 1976.
[5] G.H. Hardy and E.M. Wright: *An Introduction to the Theory of Numbers,* 4th ed., Oxford: Clarendon Press, 1960.

Escher in the Classroom

Jill Britton

What is mathematics? Most school children equate mathematics with its computational tools (*"Things you can do with numbers."*) and have little, if any, understanding of the true nature of the subject.

To the ancient Greeks, mathematics was the *study of patterns* and embraced both music and astronomy. The computational tools of these early mathematicians were few, yet they used mathematics to explore the world in which they lived. In the ensuing centuries, as more and more analytical tools were developed, mathematics education focused on drill-and-practice exercises to the eventual virtual exclusion of any exploration of real-world phenomena. Math aversion and anxiety was the predicable result. Few would argue that the response would have been any different to a music curriculum that explored only scales, or a reading curriculum with spelling drills but no stories.

Today we are in the midst of a mathematical renaissance. The introduction of calculators and computers into the curriculum has allowed mathematics teachers to adjust the emphasis placed on their computational drills. Mathematics educators are endeavoring to rediscover their subject and its connections to the real world. They are attempting to use their classic tools in a context, rather than as an end unto themselves. And what better material to use than the art of M.C. Escher, particularly his tessellations, to excite students about the power of geometry? In this article, I would like to share with you several Escher-based activities that I use with school children (ages 10 to 14) to promote mathematics as the study of patterns.

Fig. 1. *Top Left*: Reflectional symmetry. *Top right*: Rotational symmetry.
Bottom left: Translational symmetry. *Bottom right*: Glide-reflectional symmetry

Symmetry

A methodical analysis of Escher's tessellations requires a familiarity with the various kinds of symmetry they exhibit. To begin, students are exposed to reflectional and rotational symmetry through a set of exercises involving animals and insects, especially butterflies, letters of the alphabet, national flags, First Nations art, Pennsylvania Dutch hex signs, representative emblems such as the familiar recycling symbol, and commercial trademarks or logos (see Fig. 1 top).

Translational and glide-reflectional symmetry will be far less familiar to most students than reflectional or rotational. An investigation of animal tracks is a good exploratory activity. The trail left by a biped hopping on one foot has translational symmetry while the one made by a biped with a human gait has glide-reflectional symmetry (Fig. 1, bottom). Exercises involving symmetrical strip patterns and classical friezes can be used to reinforce these ideas.

Polygons and Tessellations

A simple connect-the-dots exercise is used to introduce the concept of a polygon. The 50-sided polygon in Fig. 2 resembles a reptile similar to the one that appears in Escher's lithograph *Reptiles* (Fig. 4). This is but one of several identical lizards that interlock in a jigsaw puzzle configuration or *tessellation* in the drawing Escher depicts of his own notebook. A set of 15 soft foam lizards is available from the Imagination Project; a tessellating foam trio is shown in Fig. 3.

Next, students are introduced to regular polygons. Each student is provided with a pair of identical plastic mirrors hinged together with cloth tape. When the assembly (referred to as a hinged-mirror kaleidoscope) is opened like a book, the mirrors will stand alone. The students are instructed to stand their kaleidoscope on the broken lines as shown in Fig. 5. Instantly they can view the equilateral triangle formed by the kaleidoscope.

Fig. 2.

Fig. 3. Lizards from *M.C. Escher SoftPuzzles*

Fig. 4. M.C. Escher, *Reptiles*, 1943. Lithograph

Fig. 5. Hinged mirrors placed on the dashed lines produce an equilateral triangle

Fig. 6. The regular tessellations

If the students move their mirrors towards one another so they always form an isosceles triangle with the base line, a square will eventually be formed by the kaleidoscope. If they continue to move their mirrors towards one another, they will see, in turn, a regular pentagon, a regular hexagon, a regular heptagon, a regular octagon, and so forth. Each time a regular polygon is formed by the kaleidoscope, the students are asked to determine the angle between the mirrors (and they discover it is $360°/n$, where n is the number of sides of the regular polygon).

After determining the measure of the interior angle of the first few regular polygons, the students discover that only three of these polygons will tessellate the plane – the equilateral triangle, the square, and the regular hexagon. The corresponding patterns, the regular tesselations, are shown in Fig. 6.

Fig. 7. M.C. Escher, symmetry drawing no. 85, 1952, with an equilateral triangle that generates it

Fig. 8. Jill Britton, *Clowns*. Tessellation, with an equilateral triangle that generates it

Fig. 9. *Left*: M.C. Escher, symmetry drawing no. 105, 1959, with parent square outlined. *Right*: A single Pegasus translates to adjacent copies in the tessellation

If a third mirror is added to the hinged-mirror kaleidoscope, the resulting 60°-60°-60° prism kaleidoscope can be used to generate tessellating art with re-flectional symmetry. (The equilateral triangle configuration of three mirrors can be maintained with an elastic band.) Figure 7 shows a generating triangle for Escher's *Lizard/Fish/Bat* tessellation. A similar generating triangle created by the author and the associated tessellation of clowns is in Fig. 8.

Tessellating Templates, Stamps, and Sponges

If you look closely at the drawing depicted in the lithograph *Reptiles* (Fig. 4), you can see a superimposed grid of hexagons. Escher's creatures are modifica-tions of simple tessellating polygons. Consider his tessellation of winged horses (Fig. 9), a pattern with translational symmetry alone. To find the *parent poly-gon*, the students are asked to go around a single complete tessellating shape (one Pegasus), looking for points at which **more than two** shapes meet. When all such points have been located, they are instructed to join them in cyclic order. In this case, a square will be outlined.

If the students study a shaded Pegasus in its parent square, they will discover how Escher modified the square to obtain his imaginative creature. A "bump" on the upper side is compensated for by a congruent "hole" on the lower side, and vice-versa. The same is true of the left/right sides. (George Escher, the artist's eldest son, refers to the modifications as "pimples" and "dimples.") Since what is added to one side of the square is removed from the other side, the area of the par-ent square is maintained. Corresponding modifications are related by translation.

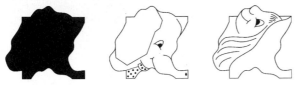

Fig. 10. Making a tessellation template

Fig. 11. Interpretations of a single shape

This can be verified by sliding translucent copies of the assembly to adjacent squares that surround one Pegasus (Fig. 9, right).

To apply this modifying rule, each student is provided with a 2-inch cardboard square imprinted with a grid of nine smaller squares. If distinct cutouts are removed with scissors from each of two adjacent sides (without interrupting the corners of the square), each modification can be translated to the side directly opposite by matching appropriate grid lines, and then taped in position. The result is a tessellating template (Fig. 10). Each student is asked to study the contour of his/her template and to try to give it an original interpretation. The student who designed this shape saw both an elephant and an elf (Fig. 11).

Finally the students use their template to draw their tessellations. They align the residual square corners of the template with the dots on 2-inch dot paper and trace around the boundary of their template with a pencil. Since the template design was created by means of translation, they slide it to new locations repeating the same translations. Interpreting features can be added by hand (Fig. 12).

Fig. 12. Producing the tessellation

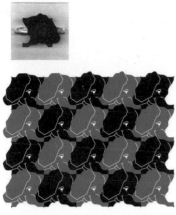

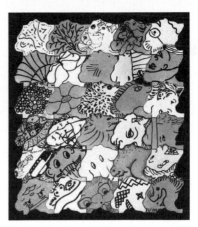

Fig. 13. *Left*: A printed tessellation. *Right*: A group tessellation of sponge tiles

Escher was a graphic artist, producing lithographs and woodcuts. If students don't try printing their tessellation, then they aren't mirroring Escher's craft. To create a tessellating rubber stamp, each student will need a transparent stamp mount and a piece of self-adhesive foam rubber. They trace around their template on the backing of the rubber, then cut out the shape. Once the adhesive surface is exposed by peeling away the backing, they can attach the rubber securely to the mount.

Interpreting features can be added to the stamp by scoring its rubber surface with a ballpoint pen. Students then print their tessellations on large sheets of 2-inch dot paper. They use stamp-pad ink to print in one color in a checkerboard pattern, aligning the residual square corners of the rubber shape with the dots on the paper. When done, they clean the stamp with water, dry it, then print in the uncolored spaces using a contrasting color (Fig. 13, left).

A tessellating shape can form the basis of a jigsaw puzzle with only one shape in which the pieces will fit together in numerous ways. A medium that is fun to use is compressed or "pop-up" sponge. The material has the appearance and thickness of felt. Students can draw on it and cut it like cardboard. The border of the cut shapes can be outlined and interpreting features can be added with a waterproof marker. When immersed in water, the material expands to a 1/2-inch thickness. Students squeeze out the excess moisture, then assemble their jigsaw puzzles. In a cooperative approach to the sponge activity, the teacher can furnish each student with the same tessellating shape. Choose a shape with lots of possibilities (like the elephant/elf used in this article). Each student adds his/her interpretation, "pops" his/her sponge, and the class gets to assemble the various pieces. In Rome, congress participants were invited to give their own interpretation to the elephant/elf shape. Selected submissions appear in the tessellating jigsaw puzzle in Fig. 13, right.

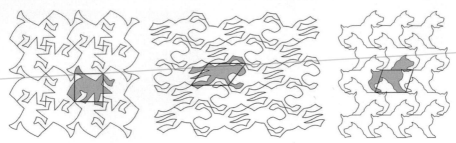

Fig. 14. Three worksheets based on Escher tessellations

Investigating Escher's Tessellations

Once students have some experience with creating tessellating art, they are ready to learn other ways to create these symmetrical patterns. To begin, they review the regular tessellations and discover other tessellating polygons such as rectangles, parallelograms, and quadrilateral kites.

Next, the teacher presents several of Escher's tessellations, each generated by its own unique modifying rule or rules. Each student is provided with a set of corresponding worksheets, and instructed to outline the parent polygon as demonstrated earlier with the Pegasus tessellation. Three completed worksheets are shown in Fig. 14.

Finally, students are provided with a translucent sheet imprinted with single shaded tessellating shapes and their parent polygons. Those that correspond to the tessellations in Fig. 14 are given in Fig. 15. The students study each assembly on the translucent sheet, looking for corresponding "bumps" and "holes," and for the transformations used to modify the parent polygon. (Although the actual and relative sizes of the graphics have not been preserved in this article, in actual practice, each assembly on the translucent sheet is congruent to the shaded tessellating shape and parent polygon on the corresponding worksheet.)

In order to make the lizard in Fig. 15a, the top and bottom edges of the parent square were modified and then each was rotated 90° to an adjacent side. Each rotation was about a vertex of the square between the related sides. The parallelogram in Fig. 15b was transformed into a different lizard by translating the

a **b** **c**

Fig. 15. The tessellating shapes for the tessellations in Fig. 14

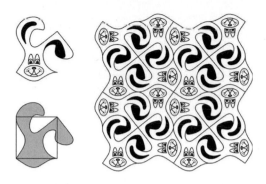

Fig. 16. An original tessellation of rabbits from a modified square

modified top edge to the bottom edge and by rotating a curve about the midpoint of each of the other sides. To be more specific, curves modifying one half-side of each side were rotated 180° about the midpoint of that side to the adjacent half-side. The parallelogram in Fig. 15c was changed into a dog by translating a modified left side to the right side and by performing a glide reflection between the other pair of modified sides. Specifically, a modification to one side was flipped (L/R) and then translated (vertically) to the equal and opposite side.

The students verify each rule or set of rules by moving the translucent sheet on the appropriate worksheet until they obtain coincidence of congruent shapes. Then they are shown a similar example of original artwork. The tessellating shape in Fig. 16 was made in a manner similar to Escher's silhouetted lizard in Fig. 15a, although the 90° rotations are about the other pair of alternate vertices of the parent square.

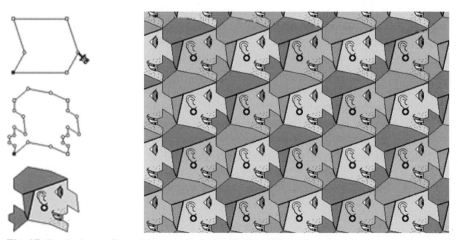

Fig. 17. Producing a tile and its tessellation with *TesselMania!*

Fig. 18. Polyhedra covered with tessellations made with *TesselMania! Deluxe*, and (for the dodecahedron) other software

Explorations with *TesselMania!* and *TesselMania! Deluxe*

Once they have used Escher's tessellations to investigate the transformations that can be used to create tessellating art, students are given the opportunity to create their own artwork on a computer with *TesselMania!* software. Within the program, they select a polygon and a modifying rule or rules (translation, rotation, and/or glide reflection). Whenever a "bump" or "hole" is added to a side, *TesselMania!* automatically removes or adds the corresponding "hole" or "bump" from/to the appropriate side according to the rule or rules selected. Classic paint tools, including stamps, are available for adding interior interpreting features. When their tessellating shape is complete, students simply press a button, and the corresponding tessellation fills the drawing screen automatically (Fig. 17). Each student's original artwork can be printed on transfer material suitable for color bubblejet printers, and then ironed onto a T-shirt. The results are truly outstanding!

Using reverse-engineering, teachers can reconstruct many of Escher's tessellations with the software. (Reverse-engineering is the process of analyzing an object to discover the details of its design in order to reconstruct it. For more on this, see Kevin Lee's article, page 393.) Students can use these files with *TesselMania!*'s magic options to animate the generation of the tessellating shape from its parent polygon, to animate the creation of the tessellation through the repeated application of transformations to the tile, or to watch the artwork morph to/from the parent tessellation.

With *TesselMania! Deluxe*, students can print their tessellations on the nets of four of the regular polyhedra (tetrahedron, octahedron, icosahedron, or cube) or on the net of a hexagonal box. The dodecahedron is missing from the set of regular polyhedra in *TesselMania! Deluxe*, but can be added to the classic set of 3D models, as we have done, with other software (Fig. 18).

Fig. 19. Jill Britton, *Clowning Around* kaleidocycle

Kaleidocycles

Inspired by the kaleidoscopically-designed geometric forms covered with adaptations of Escher's patterns in the collection *M.C. Escher Kaleidocycles*, I have created my own "Clowning Around" version (Fig. 19). (A kaleidocycle is a three-dimensional ring made from a chain of tetrahedra.) A color version of the pattern is printed on legal or even larger white card stock, then lightly scored with a blunt darning needle. (This pattern may be found on the CD Rom.) Each student cuts out his/her own copy, folds it on the scored lines in the usual way, then assembles the model with glue or transparent tape. As with the Escher versions, the kaleidocycle rotates to reveal its three distinct tessellating clown faces.

Summary

The symmetry activities described here introduce students to the motions of transformational geometry and teach them how to recognize and identify symmetrical characteristics of real world objects. The activities with polygonal

tessellations introduce the concepts of angle measure, polygons, angle relations in polygons, congruence, and space filling. The extensions to Escher-based activities demonstrate the potential connections between mathematics and art, while developing and testing students' imagination and precision skills. In particular, the printing activities mirror Escher's craft. Further extensions to *TesselMania!* activities add a technological component to the math/art connection. Finally, the introduction of polyhedra and kaleidocycles adds a three-dimensional component and develops spatial visualization.

In all activities, the inclusion of an artistic Escher connection makes the exercise interesting to the students. They can be further introduced to Escher's artwork and its far-reaching themes through the film/video *Adventures in Perception* which features a brief interview with the artist and shows him printing his last work, *Snakes*. This film can lead to investigations with Möbius bands, impossible figures, and other topological phenomena. The fact that the students literally "ask" to learn more is the most telling and desirable result.

The content of this article is discussed in much more detail in my books *Investigating Patterns: Symmetry and Tessellations and Investigating Patterns: Polyhedra Pastimes*. Associated internet links to the activities in these publications can be found in my web page. The materials referred to in this article (plastic mirrors, stamp mounts, foam rubber, and pop-up sponge) are available from Dale Seymour Publications.

Acknowledgments

Mark Veldhuysen of Cordon Art, Baarn, The Netherlands, for his continuing support.

Dale Seymour Publications, White Plains, NY, for permission to reproduce my illustrations from *Explorations with TesselMania!*, *Investigating Patterns: Symmetry and Tessellations, and Investigating Patterns: Polyhedra Pastimes*.

Imagination Project, Hamilton, OH, for permission to scan three lizards from *M.C. Escher SoftPuzzles*.

The Learning Company, Cambridge, MA, for permission to use screen dumps from *TesselMania!* and to reproduce 3-D models created by *TesselMania! Deluxe*, both programs by Kevin Lee.

References

[1] Britton, J., and W. Britton, *Teaching Tessellating Art*. Palo Alto, CA: Dale Seymour Publications, 1992.
[2] Britton, J., *Explorations with TesselMania!* Palo Alto, CA: Dale Seymour Publications, 1997.

[3] Britton, J., *Investigating Patterns: Symmetry and Tessellations*. White Plains, NY: Dale Seymour Publications, 2000.

[4] Britton, J., web page: *http://www.camosun.bc.ca/~ jbritton/jbsymteslk.htm*

[5] Schattschneider, D., and W. Walker, *M.C. Escher Kaleidocycles*. Rohnert Park, CA: Pomegranate Artbooks, Inc, 1987.

[6] Schattschneider, D., *Visions of Symmetry: Notebooks, Periodic Drawings, and Related Work of M.C. Escher*. New York: W.H. Freeman, 1990.

[7] Seymour, D., and J. Britton, *Introduction to Tessellations*. Palo Alto, CA: Dale Seymour Publications, 1989.

Chaotic Geodesic Motion: An Extension of M.C. Escher's Circle Limit Designs

Victor J. Donnay

My parents, Gabrielle (Gai) and Joseph D.H. Donnay, were crystallographers. In June of 1959, while on sabbatical leave in France, they met and visited with M.C. Escher at his home in Holland. They were fascinated with his beautiful designs and the lovely way in which his work illustrated ideas of symmetry. Gai was then organizing a symposium on symmetry for the 1960 International Union of Crystallography meeting to be held in Cambridge, England and invited Escher to present his work at this meeting [1, p. 94]. His talk at the meeting was a great success and was the start of a wonderful collaboration between Escher and crystallographers. The family story was that Gai "discovered" Escher and made him famous (to the scientific community). I grew up in an Escher-rich environment which no doubt contributed to my development as a visual and geometric mathematician. It was a great pleasure for me to participate in the centennial celebration of the birth of M.C. Escher. In honor of the role they played in the Escher story, I dedicate this article to the memory of Gai and J.D.H. Donnay (Fig. 1).

In his *Circle Limit* (see pp. 286–287 and color plate 4) series of designs, M.C. Escher uses hyperbolic geometry to tessellate the hyperbolic plane. By taking a fundamental domain for this tessellation, one can produce an abstract mathematical surface. The hyperbolic geometry from the hyperbolic plane can be carried over to this surface, thereby producing a hyperbolic surface. If one walks along this surface following paths of shortest distance, one gets a chaotic motion in that the paths wind all over the surface. These paths of shortest distance are called geodesics. Thus Escher's *Circle Limit* designs can be interpreted as

Fig. 1. Gabrielle and J.D.H. Donnay with sons Albert and Victor, Paris, France, September 1959

Fig. 2. *Left*: Schwarz P-surface. *Right*: Sphere whose geodesic motion is chaotic

giving rise to chaotic geodesic motion. Unfortunately, the surfaces on which this chaotic motion occurs are abstract surfaces: they can be mathematically defined but they do not really exist in normal, three-dimensional space.

Here we present the first examples of actual surfaces sitting in three-dimensional Euclidean space for which the geodesic motion is chaotic. These surfaces are made by attaching special "focusing caps" to the Schwarz P-surface (Fig. 2 and color plate 17). Along the way, we will discuss such notions as geodesic motion on surfaces, what it means for such motions to be chaotic, fundamental regions for tessellations on the Euclidean and hyperbolic plane, how tessellations give rise to abstract surfaces, the difference between abstract and physical surfaces, and the different types of geometry a surface can have.

Geodesics and Chaotic Motion

Given two points on a plane, the path of shortest distance between the points is a straight line. This well known result is one of the basic tenets of Euclidean geometry. Now suppose we take two points not on the plane, but on the surface of a sphere. What would be the path of shortest distance connecting these two points? We make the provision that this path must lie on the surface of the sphere; it is not allowed to pass through the inside of the sphere.

On a sphere, the path of shortest distance between two points is an arc of the so-called great circle (i. e., a circle whose radius equals that of the sphere) that goes through these points (Fig. 3). Given more complicated surfaces which might, for example, contain hills and valleys, there will still be paths of shortest distance, but these paths will no longer be as simple as straight lines or circular arcs. The term for such a path of shortest distance is a *geodesic*.

These geodesic paths give rise to a deterministic rule of motion on a surface. Place yourself at some point on the surface and point yourself in a direction.

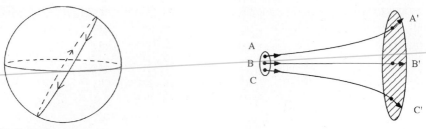

Fig. 3. Geodesics on the sphere are great circles

Fig. 4. Sensitive dependence on initial conditions

Then start walking in what you think is a "straight line." The path you follow by going in this fashion will be a geodesic; it will be a path of shortest distance. To you, living on the surface, it appears to be straight.

Note that to an outside observer looking down on the surface from above, the geodesic path may appear to curve due to the fact that the surface is curved. For example, on the sphere, what appears to the walker to be a straight path is seen by the outside observer as a circle.

For the sphere, the geodesic motion is very simple. No matter at which point you start and no matter in which direction you aim yourself, the "straight line" path you follow will be a great circle. If you walk far enough, you will go all the way around the sphere and come back to your starting point. If you continue walking along the geodesic forever, you will continue to trace out the same circular path over and over again.

We might wonder: Are there surfaces, perhaps ones that are not so perfectly round as the sphere, for which the geodesic motion is more complicated? For example, perhaps when you start walking along a geodesic path, you never return exactly to where you started. Instead, you wind "all over" the surface. In addition, as you wind all over the surface, you do so by moving through all possible directions. Such a geodesic path would be "chaotic." Thus we are led to ask,

Question 1 *Are there surfaces for which the geodesic motion is chaotic?*

The theory of chaotic motions arising from deterministic rules, part of the field of mathematics called dynamical systems, has been a very popular scientific and mathematical topic during the past twenty years. The notion that a deterministic dynamical system can generate very complex motions can be traced back to the work of the famous French mathematician Henri Poincaré in the latter part of the 19th century. Shortly after Poincaré's ground-breaking work in this field, another French mathematician, J. Hadamard [10], applied these new ideas to geodesic motion. Hadamard found examples of surfaces for which the geodesic motion had a certain type of chaotic motion: sensitive dependence on initial conditions. Over the past century, examples of geodesic motion have served as motivation for the development of general theories of dynamical systems and as a testing ground for techniques that have been developed to analyze deterministic motions.

Mathematicians have developed a whole lexicon of terms with very precise meanings to describe exactly what is meant by chaotic motion. For our purposes, it will suffice to use the following slightly vague definition of chaos.

Definition of Chaos. *Geodesic motion is chaotic if it has sensitive dependence on initial conditions and if most geodesic paths wind all over the surface and move with all possible directions.*

A deterministic system has sensitive dependence on initial conditions if a small change in the starting point of the system leads very quickly to a large change in the future behavior of the system. We illustrate this notion in Fig. 4. Particles starting at points A, B and C will move to points A', B' and C', respectively, under the motion of the system. We see that a small change in the initial location of the point will lead to a very large change in the position of the point later on. There is always some uncertainty in measuring the initial position of a system. With sensitive dependence, this uncertainty will grow, making predictions of future positions increasingly uncertain.

A slightly tongue-in-cheek application of sensitive dependence on initial conditions is the Butterfly Effect in weather prediction. We wish to study the weather and predict what the weather will be like two weeks from now. We have some uncertainty in the present weather conditions; for example we do not know if a butterfly on the coast of South America is sitting still or is flapping its wings. This small uncertainty in the initial situation of the weather could lead to a large change in the weather after two weeks. For example, no flapping could lead to a sunny day while flapping could lead to a hurricane.

Mathematicians are interested in studying various systems and in determining whether the systems are chaotic or not. A computer simulation may show that a system appears to behave chaotically. Such a simulation provides experimental evidence of chaos but is not the same as a rigorous mathematical proof that a system is chaotic. We are looking for surfaces for which we can rigorously prove that the geodesic motion is chaotic.

Surfaces and Their Geometry

We will be interested in surfaces that are finite and have no edges; they completely close up on themselves. (Technically, such surfaces are compact, complete orientable Riemannian surfaces.) It turns out that one can completely list all such surfaces. There is the sphere, the torus, the two-holed torus, the three-holed torus, and so forth (Fig. 5). We call the number of holes through the surface the *genus*. Thus a sphere has genus zero while a torus has genus one. We call a surface with g holes a g-holed torus.

In the mathematical field of topology, one imagines that surfaces are made out of rubber and says that two surfaces are (topologically) the same if one can deform the first surface, by bending and stretching it, until it attains the same

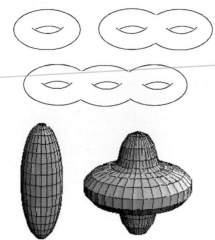

Fig. 5. One-holed, two-holed, and three-holed tori

Fig. 6. Non-standard spheres **Fig. 7.** Saddle-shaped surface

shape as the second surface. Thus for example, an egg-shaped surface (Fig. 6) is the same, from the point of view of topology, as the sphere since we can imagine stretching out the egg shape until it becomes perfectly round. Henceforth, when we use the term "sphere," we are referring to any surface which is topologically the same as the round sphere. When we want to refer specifically to the round sphere, we will use the term the "standard sphere."

Even though two surfaces may be the same from the point of view of topology, they can be different from the point of view of geometry. There are three main classes of geometry: flat, spherical and hyperbolic. The plane has flat geometry, the standard sphere has spherical geometry and saddle-shaped surfaces have hyperbolic geometry (Fig. 7). We can also categorize the geometry of a surface by its (Gaussian) curvature. A flat surface has zero curvature, a standard sphere has positive curvature and a saddle-shaped surface has negative curvature. A flat surface (zero curvature) does not bend at all. Positive curvature, as on the standard sphere, means that the surface bends the same way in all directions. Negative curvature, as on a saddle, means that in some directions the surface bends up and in other directions it bends down. Brushing aside certain technicalities, we will pretend that spherical geometry and positive curvature are equivalent, as are hyperbolic geometry and negative curvature.

Circle Limit III and Hyperbolic Geometry

M.C. Escher's print *Circle Limit III* (color plate 4) shows a representation of the hyperbolic plane, using the so-called Poincaré disk model of hyperbolic geometry (the same Poincaré who pioneered the study of dynamical systems). Escher

learned about the hyperbolic plane from an illustration in a paper by the noted geometer H.S.M. Coxeter [1, p. 91]:

> *I'm engrossed again in the study of an illustration which I came across in a publication of the Canadian professor H.S.M. Coxeter ... I am trying to glean from it a method for reducing a plane-filling motif which goes from the center of a circle out to the edge, where the motifs will be infinitely close together. His hocus-pocus text is no use to me at all, but the picture can probably help me to produce a division of the plane which promises to become an entirely new variation of my series of divisions of the plane. A circular regular division of the plane, logically bordered on all sides by the infinitesimal, is something truly beautiful ... At the same time I get the feeling that I am moving farther and farther away from work that would be a "success" with the 'public,' but what can I do when this sort of problem fascinates me so much that I cannot leave it alone?*

In order to make regular divisions of the hyperbolic plane, Escher first had to come to grips with some surprising properties of hyperbolic geometry. One is the behavior of parallel lines. In Euclidean geometry, given a line and a point not on the line, there is one and only one line through the point that never meets the line. We say that there is one line through the point that is parallel to the given line. In hyperbolic geometry, there can be infinitely many lines through the point that never meet the initial line.

What are the "lines" of hyperbolic geometry? Here "line" should be thought of as the path of shortest distance between two points. So we come again to the notion of geodesics. In the Poincaré disk model of hyperbolic geometry, we can determine precisely the geodesics. They come in two types: (1) straight lines that pass through the center of the disk, and (2) arcs of circles that meet the edge of the disk at right angles.

In Fig. 8, we draw one geodesic of type (1) and several geodesics of type (2). This figure shows several geodesics that all pass through the same point and yet never meet the geodesic through the center of the disk. Thus we see how in

Fig. 8. Geodesics in the hyperbolic plane

hyperbolic geometry, there can be more than one line through a single point parallel to another line.

The reason that we end up with circular arcs as paths of shortest distance is that the distance in the hyperbolic disk is measured in a strange way. Given a short line segment, its hyperbolic length is obtained by taking its Euclidean (or ordinary length) and then dividing by $(1 - r^2)$, where r is the Euclidean distance from the origin to the segment. The Poincaré disk consists of all points in the plane whose Euclidean distance from the origin is less than one. When the segment is close to the center of the disk, then its distance r from the origin is close to zero, so $(1 - r^2)$ is close to 1, and the hyperbolic and Euclidean distances agree. However, if the segment is close to the edge of the disk, then r is close to 1 and $(1 - r^2)$ is close to zero. Dividing by this factor which has value close to zero will cause a segment that has a short Euclidean length to have a very long hyperbolic length.

In Escher's *Circle Limit III*, the fish are all moving in what they think are straight lines. Since the fish are living in a hyperbolic world, these straight paths are actually arcs of circles. (It turns out that the paths Escher drew are not exactly hyperbolic geodesics. They meet the sides of the disk with an angle closer to eighty degrees than to the required ninety degrees. The reasons for this are discussed in [5]; also see Coxeter's article here (p. 297). Although it does not look like it to our Euclidean eyes, the fish are all the same size when measured hyperbolically.

Tessellations and Abstract Surfaces

In the plane-filling designs that so engrossed Escher, one starts with a pattern on a single tile, takes (infinitely many) identical copies of the tile, places them next to one another (as if one were tiling a bathroom floor) and ends up with a design that completely fills up the Euclidean plane. The end result is a *tessellation* of the Euclidean plane. The individual tile is the basic building block; it is called a fundamental region of the tessellation. Escher made a comprehensive study of the various ways to tile the Euclidean plane. I illustrate these ideas with a very simple tessellation (Fig. 9). The fundamental region for this design is one rectangle that contains the letters A, B, C in the horizontal direction and A, D, E in the vertical direction.

Inspired by Coxeter's paper, Escher began to make tessellations of the hyperbolic plane. Again, one starts with a design on an individual tile and then tries to fill up the plane (but now the hyperbolic plane) with infinitely many identical copies of the tile. Making tessellations of the hyperbolic plane is much more difficult than for the Euclidean plane because of the way in which hyperbolic geometry distorts distances. Specifically, two tiles that are identical from the point of view of hyperbolic geometry will look very different from the point of view of Euclidean geometry.

Fig. 9. A tessellation of the Euclidean plane and a geodesic

Fig. 10. A geodesic on the fundamental region with opposite sides identified

We will see that the fundamental region of a tessellation gives rise to a mathematical surface. For example, Escher's tessellation of the hyperbolic plane in *Circle Limit III* will produce a surface of genus two (two-holed torus) with hyperbolic geometry (negative curvature). There will be a close relationship between the geodesics (i.e. paths of shortest distance) on surfaces coming from fundamental regions and the geodesics on the Euclidean or hyperbolic plane that the fundamental region tessellates.

Our goal is to understand the surfaces produced by tessellations of the hyperbolic plane and their geodesics. As a warm-up to this challenging problem, we first look at the simpler case of tessellations of the Euclidean plane. In my simple tessellation (Fig. 9), I have drawn a geodesic on the Euclidean plane. Since the Euclidean plane is flat, the geodesic is just a straight line. Now imagine walking along this geodesic; you will see a succession of letters pass by.

We could produce the same effect by taking one rectangular tile (i.e., one fundamental region of the tessellation), walking in a straight line on this rectangle, and connecting the opposite sides of the rectangle. Thus when the path goes off the right side of the region, it reappears on the left side. And when it goes off the top of the region, it reappears on the bottom (Fig. 10). These are the same rules that creatures living inside a video game often obey. We say that opposite sides of the region are "identified."

When we walk in a straight line along the rectangle and use these rules of identifying edges, we see the same sequence of letters pass by as if we were moving on the plane. Thus by looking at the letters, we would not be able to distinguish if we were walking on the plane or on the fundamental region with opposite sides identified.

If our rectangle were made out of rubber sheeting, we could physically connect the appropriate edges. When we bend the surface around and connect the top side with the bottom side, we produce a cylinder. If we now bend the cylinder around and connect the right side with the left side, we produce a torus (Fig. 11; see also the video on the CD Rom). Thus the rectangle with opposite sides

Fig. 11. Connecting opposite edges of a rectangle to produce a torus

identified is a (topological) torus. So the creatures in a video game live in a torus world!

We call the rectangle with opposite sides identified the *flat torus*. It is flat because it has the same geometry as the plane. As a result, the geodesics on the flat torus are straight lines.

Note that the flat torus cannot physically exist as a closed surface in three-dimensional space. When we bend the surface to connect opposite sides and thereby physically realize the torus, we change the geometry and produce a torus that is not flat. We call the flat torus an abstract mathematical surface. The rules of identifying opposite edges permit us to understand that this surface is connected in the same way as a torus. And we can completely understand how the geodesic motion behaves. Having fixed a starting point and direction of motion, we move in a straight line along that direction and when we go off an edge, we reappear on a different edge. Thus the flat torus is a meaningful, well-defined object – it just cannot be physically realized in three-dimensional space.

Henceforth, we will divide surfaces into two types:

I. *Physically realizable surfaces*. These are surfaces that can actually exist in three-dimensional space. We will sometimes call them "physical surfaces."

II. *Abstract mathematical surfaces*. These are surfaces that are defined by precise rules and for which the geodesic paths can be determined. But they are not presented as physically existing in three-dimensional space.

The standard sphere is an example of type I and the flat torus is an example of type II.

We now return to Escher's tiling of the hyperbolic plane with fish (color plate 4). One fundamental region for this tessellation is an eight-sided polygon [6, p. 29] (Fig. 12a). In the hyperbolic plane, we can follow a geodesic and see a pattern of fish passing by. Remember, in the disk model of hyperbolic geometry, the geodesics are either straight lines through the center of the disk or arcs of circles that meet the boundary of the disk perpendicularly.

We can see the same pattern by taking the fundamental region and identifying edges. Here the identification rules are a bit more complicated than for the rectangle. We identify sides 1 and 1', 2 and 2', 3 and 3', and 4 and 4'. When the geodesic reaches one of the edges, it gets re-attached at the appropriate edge and continues (Fig. 12b). It can be a bit tricky to determine visually how to make the

Fig. 12. (a) An 8-sided fundamental region. **(b)** Geodesic gotten via identification of edges

continuation since we typically need to find an arc of a circle going through the point on the new edge. But such a continuation of geodesics can be done.

With these rules of identification, the eight-sided polygon turns out to be the same (topologically) as a two-holed torus. Unfortunately, this equivalence is harder to visualize than the one between the rectangle and the one-holed torus. A beautiful sculpture made by Douglas Dunham (color plate 18) can give us an idea what this fundamental region would look like when the sides are identified.

Our eight-sided polygon lies inside the hyperbolic plane and hence has hyperbolic geometry (negative curvature). When we identify sides as described above, we produce another abstract mathematical surface, this time a two-holed torus with hyperbolic geometry. If we were to physically connect the edges to produce the two-holed torus, rather than abstractly identify them, we would have to bend the surface in ways that would destroy the hyperbolic geometry. We would end up with a surface of mixed geometry; parts of it would be hyperbolic with negative curvature but other parts (the outermost parts of the surface in color plate 17d) would have spherical geometry with positive curvature. Thus this hyperbolic two-holed torus is not physically realizable.

Geodesic Motion on Abstract Surfaces

Is the geodesic motion on our abstract surfaces, the flat torus and the hyperbolic two-holed torus, chaotic or regular?

On the flat torus, for a typical choice of initial position and direction, the associated geodesic will start to fill up the whole rectangle (torus). However, as we move along this geodesic, we will always move in exactly the same direction: parallel to the direction we started in. Since our definition of chaos requires that in addition to moving all over the surface, we also move with all possible directions, this motion is not chaotic; rather it is regular.

On the hyperbolic two-holed torus, the geodesic flow is chaotic. Indeed, it was shown in the 1930s and 40s by G. Hedlund [11], E. Hopf [12], and M. Morse that

Theorem *The geodesic flow on any compact, complete, orientable surface with hyperbolic geometry is chaotic: such a system has sensitive dependence on*

Fig. 13. Geodesics on saddle-shaped surfaces diverge

initial conditions and a typical geodesic will go all over the surface and in all possible directions.

To see why the geodesic flow has sensitive dependence, remember that hyperbolic geometry on an abstract surface corresponds to a saddle-shaped surface sitting in three-dimensional space. Let us look at two geodesics on a saddle-shaped surface. Choose one geodesic so that it runs along the ridge of the saddle. Choose the second geodesic so that it starts near the ridge but points slightly downhill. This second geodesic will quickly veer away from the ridge and go down the hill. The geodesics are said to diverge from one another (Fig. 13). Thus we see that two nearby geodesics move quickly away from one another thereby producing sensitive dependence on initial conditions. It is harder to see why a typical trajectory goes all over the surface. Very roughly, the idea is that because nearby trajectories keep pushing away from one another (sensitive dependence), a typical geodesic will get pushed all over the surface. In Fig. 12b, we see that the direction of the geodesic on the hyperbolic two-holed torus continually changes and thus behaves quite differently than for the flat torus (Fig. 10).

Thus the answer to our Question 1 is

Answer 1 *There exist abstract mathematical surfaces whose geodesic motion is chaotic. Specifically, any surface with hyperbolic geometry or, more generally, with everywhere negative curvature will have a chaotic geodesic flow.*

Now that we have an initial answer to our question, we refine the question and ask

Question 2 *Do there exist surfaces that are physically realizable in three-dimensional space whose geodesic motion is chaotic?*

In other words, can chaotic geodesic motion happen in the real world in which we live or does it only happen in abstract mathematical worlds?

The first candidates to consider are the hyperbolic surfaces. Is there any way to physically realize these surfaces? We saw that for the hyperbolic two-holed torus, when we tried to physically construct it by identifying appropriate sides, the resulting surface had a mixture of positive and negative curvature. Hence it could not be physically realized as a surface with everywhere negative curvature. Perhaps there are other hyperbolic surfaces that can be physically realized, keeping negative curvature.

It turns out to be impossible to have a physical surface that has everywhere negative curvature. To see why, take a physical surface sitting in three-

Fig. 14. A surface must have positive rather than negative curvature at the point farthest from the origin

dimensional space and consider the distance from the origin to different points on the surface. There will be some point or points on the surface that are farthest away from the origin. At any of these points, the surface must have positive curvature (spherical geometry). For if the surface had negative curvature (hyperbolic geometry) there, then the saddle shape of the surface would imply that there were other points yet farther away from the origin. But we are already at the points that are farthest away (Fig. 14). So the surface can not have negative curvature at the points farthest from the origin.

Thus none of the first candidates known to have chaotic geodesic flow, the hyperbolic surfaces, are physically realizable. So the question remains, can one have a physical surface whose geodesic flow is chaotic?

As the above argument shows, any physical surface must have places at which the curvature is positive. The presence of positive curvature presents a very serious barrier to producing a chaotic geodesic flow; in particular, it would seem to impede sensitive dependence on initial conditions.

Consider the simplest example of a surface with positive curvature; the standard sphere. Take two geodesics that start at the north pole but are pointing in slightly different directions (Fig. 15). These geodesics trace out great circles which, when they start at the north pole, correspond to lines of longitude. Initially, these geodesics move apart. They reach a maximum separation at the equator and then start coming back together again. When they reach the south pole, they meet again. Thus rather than diverging from one another, as would be the case with sensitive dependence, these geodesics come back together. This phenomenon of moving apart and then coming back together again is called

Fig. 15. Positive curvature causes geodesics to focus

Fig. 16. Flat torus with focusing cap

focusing. Thus at first glance, by producing focusing, positive curvature seems to prevent sensitive dependence and hence to prevent chaotic behavior.

Over the past twenty years, mathematicians have learned how to overcome the problem of focusing and can now actually harness focusing to generate chaotic dynamics. The techniques for exploiting focusing were initiated by the Russian mathematician L.A. Bunimovich in his study of billiard systems [2] and then extended to geodesic flows.

For geodesic flow, the key ingredient is the "focusing cap" [8]. We have seen that positive curvature (spherical geometry) causes nearby geodesics to first move apart but then to come back together again. A focusing cap has the special property that not only will a family of geodesics that is diverging when it enters the cap be made to come together (focus) but it will then continue past this focusing point and become diverging.

In Fig. 16, we start with a flat torus, attach a volcano-shaped cone of negative curvature and then top off the cone with a focusing cap. Geodesics will initially diverge as they move on the saddle-shaped cone (curvature $K < 0$). When they go through the cap (curvature $K > 0$), they will come together, focus, and then start to diverge. They then return to negative curvature and continue to diverge. The net effect is that by going through the focusing cap, the geodesics end up diverging (Fig. 17). Hence this abstract surface, called "Flat torus with focusing cap" will have sensitive dependence on initial conditions and be chaotic [8], [9].

Using focusing caps and building on earlier works [4], [8], [9], [14] involving focusing caps on abstract surfaces, Keith Burns and the author [3] were able to answer Question 2.

Answer 2 *There exist physically realizable surfaces for which the geodesic motion is chaotic.*

Furthermore, we can make such surfaces with arbitrary topology so that there are physical spheres, tori, two-holed tori, three-holed tori and so on, for which the geodesic motion is chaotic.

We describe the construction in the case of a sphere. Start with a surface that is everywhere saddle-shaped, having negative curvature (Fig. 2, left). The surface has circular ends. To these ends attach focusing caps, thereby closing up the surface and making a non-standard sphere (Fig. 2, right). Its geodesic flow will be chaotic.

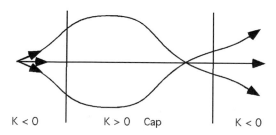

K < 0 K > 0 Cap K < 0

Fig. 17. Focusing followed by defocusing

The negatively-curved surface we started with is called the Schwarz P-surface, after the French mathematician H.A. Schwarz [15] who discovered it in the 1880s in the context of minimal surfaces. Take a cube and on each face of the cube draw a (nearly) circular curve. Consider all surfaces whose boundary (or edges) consist of these six curves. The Schwarz surface is one such surface (color plate 17a). Roughly speaking, out of all surfaces with these fixed boundary curves, the Schwarz surface is the one that has the least area. Hence it is called a minimal surface.

The Schwarz surface has many beautiful properties. It divides the cube into a part that is "inside" the surface and a part that is "outside" the surface. These two parts have equal volume. It also has a continuation property. Take several cubes, each of which contains a Schwarz surface. Stack these cubes together. The Schwarz surfaces will join together smoothly at the faces of the cubes to form a larger surface (color plate 17c). We can repeat this stacking infinitely often along all three coordinate directions. The resulting infinite minimal surface is triply periodic because it is made by taking a fundamental region consisting of a single Schwarz surface and repeating it under translations in three independent directions. This infinite surface divides three-dimensional space into two equivalent parts – a part that is "inside" the surface and a part that is "outside."

Digressing from the topic of geodesics for a moment, we mention that triply-periodic minimal surfaces have been found in nature. The first such example was found by Gai Donnay and D. Pawson [7] who showed that the skeletal element of echinoderms had such a structure. Curiously, the interambulacral plates of the echinoderm, when viewed with an electron microscope, resemble our higher genus surfaces with caps [13]. In his lovely book *The Self-Made Tapestry: Pattern Formation in Nature*, Philip Ball discusses this and other examples of minimal surface shapes that appear in nature.

We utilize the continuation property of the Schwarz surface to make higher genus surfaces. To make a non-standard torus, we join four Schwarz surfaces together (color plate 17c) and attach focusing caps to the ends (color plate 17d). The geodesic flow on this torus will be chaotic. We can make a surface of arbitrary genus by taking enough copies of the Schwarz surface, stacking them together and putting caps on the ends.

In this way, we show that there do indeed exist physically realizable surfaces with chaotic geodesic flow. The construction we describe of starting with the Schwarz surface and attaching focusing caps to the ends, works equally well when we replace the Schwarz surface by other surfaces of negative curvature with ends. More details can be found in [3].

Future Work

We now know that there do exist some physical surfaces with chaotic geodesic motion. However, in mathematics, the answer to one question usually leads to

several new questions. That is the case here, too. The physical surfaces we have found are all of a special type: they have negative curvature (hyperbolic geometry) in the middle and focusing caps on the end. Suppose we were to take some physical surface that was not of this special type. Would its geodesic flow be chaotic? More generally, if we were to look at the collection of all physical surfaces, what percentage of them would have chaotic geodesic flow? At present, mathematicians are not able to answer these questions. More work and fun remains!

As a parting Escherism, we wonder what interesting designs could one draw on the Schwarz surface? The Schwarz surface is highly symmetric, made up of eight identical curved hexagons, each of which is itself made up of six copies of a smaller, four-sided fundamental region. Let us try to make a design that incorporates these symmetries. Once we have chosen a design for our Schwarz surface, we can take multiple copies of the decorated surface and link them together to build up a triply-periodic surface. We would want a design that matches up smoothly at the edges where two adjacent Schwarz surfaces meet. The end result would be a periodic, three-dimensional Escher-like design.

Acknowledgments

Louisa Winer Tran helped make the pictures involving the Schwarz surface. This paper was written while I was a Visiting Scholar at the University of California, Berkeley. My thanks to the department and Charles Pugh for their hospitality, to Bryn Mawr College's Enhanced Sabbatical Program for making the visit possible and, most importantly, to my wife Michelle Francl for her support and encouragement.

Related Reading

Here are some recommendations for further reading about the geometry and topology of space.
E.A. Abbott, *Flatland: A Romance of Many Dimensions*, Dover, New York, 1952.
D. Burger, *Sphereland*, Barnes and Noble, New York, 1983.
W. Thurston and J. Weeks, "The Mathematics of Three-dimensional Manifolds," *Scientific American*, July 1984.
J.R. Weeks, *The Shape of Space*, Marcel Dekker, 1985.
M. Field and M. Golubitsky, *Symmetry in Chaos : A Search for Pattern in Mathematics, Art, and Nature*, Oxford Univ. Pr., 1996.
J.-P. Luminet, G.D. Starkman and J.R. Weeks, "Is Space Finite?," *Scientific American*, April 1999.

Philip Ball, *The Self-Made Tapestry: Pattern Formation in Nature*, Oxford University Press, 1999.

References

[1] F.H. Bool, J.R. Kist, J.L. Locher, F. Wierda, *M.C. Escher, His Life and Complete Graphic Work*, Harry Abrams, 1982.

[2] L.A. Bunimovich, "On the ergodic properties of nowhere dispersing billiards," *Commun. Math. Phys.* 65 (1979), 295–312.

[3] K. Burns and V.J. Donnay, "Embedded surface with ergodic geodesic flows," *Inter. J. Bifurcation and Chaos*, Vol. 7 (1997), 1509–1527.

[4] K. Burns and M. Gerber, "Real analytic Bernoulli geodesic flows on S^2," *Ergod. Th. and Dynam. Sys.* 9 (1989), 27–45.

[5] H.S.M. Coxeter, "The non-Euclidean symmetry of Escher's picture Circle Limit III," *Leonardo* 12 (1979), 19–25.

[6] H.S.M. Coxeter, "Coloured symmetry," *M.C. Escher: Art and Science*, H.S.M. Coxeter et al., eds., North-Holland, 1986.

[7] G. Donnay and D.L. Pawson, "X-ray diffraction studies of Echinoderm plates," *Science* 166 (1969), 1147–50.

[8] V.J. Donnay, "Geodesic flow on the two-sphere, Part I: Positive measure entropy," *Ergod. Th. & Dynam. Sys.* (1988), 8, 531–553.

[9] V.J. Donnay, "Geodesic flow on the two-sphere, Part II: Ergodicity, Dynamical Systems," *Springer Lecture Notes in Math.*, Vol. 1342 (1988), 112–153.

[10] J. Hadamard, "Les surfaces à coubures opposées et leur lignes géodésiques," *Journal de Pures et Appliquées* (5), vol. 4 (1898), 27–74.

[11] G.A. Hedlund, "The dynamics of geodesic flows," *Bull. A.M.S.* 45 (1939), 241–260.

[12] E. Hopf, "Statistik der Lösungen geodätischer Probleme vom unstabilen Typus. II," *Math. Ann.* 117 (1940), 590–608.

[13] H.-U. Nissen, Crystal orientation and plate structure in Echinoid skeletal units, *Science* 166 (1969), 1150–52.

[14] R. Osserman, Lecture at geodesic flow workshop, Cal Tech, January 1985.

[15] H.A. Schwarz, *Gesammelte Mathematische Abhandlungen*, Springer Verlag: Berlin, 1890.

Rotations and Notations

Jane Eisenstein and Arthur L. Loeb

M.C. Escher and A.L. Loeb first met just prior to the International Congress of Crystallography held in Cambridge, U.K. in 1960, at which Escher had been invited to give an address. [13], [14]. Escher's account of that meeting, in which his lecture was standing-room only, can be found in [1, p. 101]. At that congress, Loeb presented a paper which evoked from Elizabeth Wood, who headed the U.S. delegation, the following comment, "I had always wanted to give a paper called 'To Hell with the Unit Cell,' and now you have done it!"

The paper presented at the Cambridge crystallography congress dealt not with the *symmetry,* but with the *systematics* of crystal structures. The great metallurgist and humanist Cyril S. Smith once expressed the opinion that symmetry is a snare and an illusion in developing an understanding of crystal structure [21]. Indeed, *connectivities* are a better parameter for classifying and understanding crystals, because a slight change in temperature or pressure may move a crystal into an entirely different symmetry class without substantially altering the connections between ions or atoms. However, as Niccoló Machiavelli observed 500 years ago [18], "There is nothing more perilous to take in hand, more perilous to conduct, or more uncertain in its success, than to take the lead in the introduction of a new order of things." With this warning in mind, Loeb and colleague LeCorbeiller decided rather than to reject symmetry out of hand, to re-examine the theory of planar symmetries, in particular, to determine whether rotational or reflection symmetries are more fundamental. They presented their view at the congress of the International Union of Crystallographers in Rome in 1963 (see [12, 16]).

An Alternate Notation for Symmetry Groups

Since coexisting lines of reflection symmetries together imply translational or rotational symmetries, but rotational symmetry can exist without reflection symmetry, their conclusion was that rotational symmetry is the more fundamental. Furthermore, their approach does not give as much significance to translation symmetry as does the unit-cell approach of the crystallographers, since translational symmetry may be considered a special case of rotational symmetry.

At the 1963 Rome congress, Carolina MacGillavry was commissioned by the Teaching Commission of the International Union of Crystallography to write a book on color symmetry, using M.C. Escher's symmetry drawings as examples for analysis [17]. Loeb and MacGillavry had been friends for several decades, and following the 1960 Cambridge congress Escher and Loeb

developed a friendship which lasted the rest of the artist's life. In 1964, Loeb visited MacGillavry, then working on the commissioned book, and he noted that his approach to planar symmetry lent itself particularly well to analysis of Escher's work.

Crystallographers have based their description of crystals on the unit cell because of its link to translational symmetry: a primitive unit cell is the smallest region, typically a parallelogram, which when *translated*, can generate the entire pattern. A beam of X-rays has itself translational symmetry, with the result that X-ray analysis will disclose translational symmetry easily. However, for an understanding of the reasons why certain crystal structures are stable, or what the electrical and magnetic fields around ions or atoms in a crystal are, translational symmetry is not as important.

The concept of a unit cell is related to that of a lattice: a *lattice* is a collection of all points in a repeating pattern that are images of a single point acted on by two independent translations that can generate the whole pattern. A unit cell contains at least one lattice point; if it contains more than a single lattice point, a unit cell is called *multiple*, or in special cases *centered*, whereas a unit cell that contains not more than a single lattice point is called *primitive*. Figure 1a shows a repeating pattern having centers of 3-fold rotational symmetry. The parallelogram highlighted in Fig. 1b is a primitive unit cell, whereas the highlighted rectangle is a centered double unit cell.

In Fig. 1c a smaller parallelogram (a rhombus) is highlighted. Its vertices are centers of 3-fold rotational symmetry; these points are also known as *rotocenters*. When the pattern is rotated 120° around any of these, it will look exactly

Fig. 1a. A periodic pattern

Fig. 1b. A parallelogram unit cell and a centered double unit cell for the pattern

Fig. 1c. A rhombic fundamental region and (outlined) hexagonal unit cell for the pattern

the same, and appear to be in its original position. This rhombus, like the unit cell in Fig. 1b, will generate the entire pattern, but whereas the unit cell need only be translated, the rhombus in Fig. 1c, known as a *fundamental region*, requires rotations as well. It may be rotated twice through 120° around one of its obtuse vertices to generate a hexagon (outlined) which is a *unit cell* that can tile the plane by translations. In this example, the fundamental region has an area one-third that of the primitive unit cell, but still contains all the information needed to generate the entire pattern by repetition.

The different approaches to the symmetry of planar periodic patterns require different notations by which the patterns can be easily enumerated and classified, and which give the essential information about their symmetries in as transparent a fashion as possible. We shall refer to the two approaches to symmetry theory as the *unit-cell* (or IUCr, for International Union of Crystallography) notation and the *rotocenter* notation. In the rotocenter notation, it is essential to distinguish between rotocenters having distinct contexts even though their symmetry *value* (3 in the example in Fig. 1c) is the same. To make this distinction, primes are used. The rotocenters in our example are denoted 3, 3' and 3'' respectively. This distinction is not explicit in the unit-cell notation [20].

For artists and designers, the fundamental region has the attraction that all the information necessary to generate a repeating pattern needs to be presented only once, whereas a unit cell, if not primitive, contains that information more than once. It is not easy to represent that information several times identically;

to rotate the fundamental region instead of translating a unit cell does not present a problem to the artist or designer,

The rotocenter approach is based on the following theorem [12, 16]:

Theorem. *The coexistence of an f-fold and a g-fold rotocenter in a planar pattern implies the existence of an h-fold rotocenter in the same planar pattern. The values of f, g and h must satisfy the diophantine equation*

$$\frac{1}{f} + \frac{1}{g} + \frac{1}{h} = 1 .$$

The only solutions are the following triples fgh:

$$1^{\infty\infty}, \ 22^{\infty}, \ 236, \ 244 \ and \ 333.$$

Furthermore, more than three distinct rotocenters may coexist in a planar pattern only if they are all 2-fold rotocenters, in which case there are four distinct rotocenters.

Accordingly, the following combinations of rotational symmetry values may coexist in a plane:

$$1^{\infty\infty\prime}, \ 22^{\prime\infty}, \ 236, \ 244^{\prime}, \ 33^{\prime}3^{\prime\prime}, \ and \ 22^{\prime}2^{\prime\prime}2^{\prime\prime\prime} .$$

Figure 2a shows a repeating pattern of little airplanes, some flying to the right, others to the left. In Fig. 2b we show one plane in black; its white nearest neighbors all fly in the opposite direction. The horizontal and vertical white lines superimposed are mirror lines for the infinitely extended pattern, each dividing it into two halves that are each others' mirror image. (We note that the mirror

Fig. 2. (a) A periodic pattern. (b) Mirror lines (white) intersect and glidelines (black) intersect in 2-fold rotocenters

symmetry is not perfectly exact, as is the case in most hand-made patterns.) At the intersections of these mirror lines are 2-fold rotocenters. These rotocenters are distinct since one is where the planes' noses meet, and the other is between their respective tails. Rotocenters located on mirrors are identified by underlining their symmetry values (order of rotation), so these are denoted 2 and 2'. The black lines superimposed on the pattern are *glide lines*; they divide the pattern into two halves which are displaced mirror images of each other with respect to these lines. The white arrow on the horizontal glide line is the *glide vector*; this indicates the distance the pattern below the line is displaced (translated) before it is reflected to its mirror image above the line. At the intersections of the glide lines there are also 2-fold rotocenters. Since these are where tips of plane wings almost touch, they are distinct from those labeled 2 and 2', but they are related to each other by a reflection, so both are labeled 2''. Thus there are in the airplane pattern four different types of rotocenters, all of them 2-fold. The two rotocenters that have contexts which are each others' reflection are called *enantiomorphically paired*, which is denoted by the symbol \wedge. Thus the symmetry of the airplane pattern recorded in rotocenter notation is $\underline{2}'2''2''^{\wedge}$.

A collection of mutually equivalent rotocenters is called a *rotocomplex*. Where necessary, lines of reflection symmetry are explicitly indicated: **m** indicates a mirror line, **g** a glide line. A slash, / indicates that the lines are mutually perpendicular (m/m, m/g, g/g); without a slash the lines are parallel (mm, mg, gg). The unit-cell and rotocenter approaches to notation are to an extent mutually complementary. The principal differences are these:

- *The unit-cell approach is analytic, the rotocenter approach synthetic.* The unit-cell approach finds a preferably rectangular or square unit cell which contains all the information regarding a repeating pattern. The rotocenter approach is synthetic in the sense that two symmetry elements are allowed to interact, and the repeating pattern is generated by logical implication.
- *The unit-cell approach aims for rectangular or even square unit-cells even if this means resorting to multiple cells. The rotocenter approach does not show preference for the right angle.*
- *Unit-cell notation only refers to symmetry values of rotocenters, but does not distinguish between mutually distinct, enantiomorphic, or equivalent rotocomplexes.*
- *In the rotocenter approach, all the planar symmetry groups are generated: one having no symmetry at all and one having a single mirror line only; infinitely many having a single n-fold rotocenter for n > 1, where these may or may not have a mirror line passing through the rotocenter; the seven monoperiodic (ribbon or frieze) groups which repeat in one direction only; and the seventeen diperiodic (wallpaper) groups.*

Recently mathematician John H. Conway introduced a notation for the classification of symmetry groups in the Euclidean and hyperbolic planes as well as on the surface of a sphere [2]. This notation is based on the concept of orbifold by Bill Thurston. It, too recognizes the importance of rotocenters and distinguishes between those that lie on mirrors (which he called called *cone points*

Table 1.

Notation for Monoperiodic (Ribbon or Frieze) Groups

Rotocenter	Unit Cell (IUCr)	Short	Orbifold	Reflections, Glide reflections
∞	p111	11	∞ ∞	none
∞m	p1m1	1m	∞ *	mirror parallel to translation
∞mm'	pm11	m1	* ∞ ∞	alternating mirrors perpendicular to translation
22'∞	p112	m2	22∞	none
22'∞	pmm2	mm	*22∞	all rotocenters at intersections of perpendicular mirrors
22^∞	pma2	mg	2*∞	paired 2-fold rotocomplexes
∞g	p1a1	1g	∞⁰	single glideline

Notation for Diperiodic (Wallpaper) Groups

Rotocenter	Unit Cell (IUCr)	Short IUCr	Orbifold	Reflections, Glide reflections
1∞∞'	p111	p1	o	none
1∞∞'mm'	p1m1	pm	* *	parallel mirrors
1∞∞'gg'	p1g1	pg	× ×	parallel glidelines
1∞∞'mg	c1m1	cm	* ×	parallel mirror and glidelines, alternating
22'2"2'''	p211	p2	2222	none
22'2"2'''	p2mm	pmm	*2222	mutually perpendicular mirrors
22^2'2"	c2mm	cmm	2*22	alternating mutually perpendicuar mirrors and glide lines
22^22'^m/g	p2mg	pmg	22*	mirrors perpendicular to glidelines
22^2'2'^g/g	p2gg	pgg	22×	mutually perpendicular glidelines
33'3"	p311	p3	333	none
33'3"	p3m1	p3m1	*333	all rotocenters on mirrors
33'3'^	p31m	p31m	3*3	one rotocomplex on mirrors; two others enantiomorphically paired
244'	p411	p4	442	none
244'	p4mm	p4m	*442	all rotocenters on mirrors
244^	p4gm	p4g	4*2	2-fold rotocenters on mirrors; two paired 4-fold rotocomplexes
236	p611	p6	632	none
236	p6mm	p6m	*632	all rotocenters on mirrors

and those that do not (called *gyration centers*). For comparison we have tabulated in Table 1 the frieze and wallpaper groups according to the rotocenter notation, their unit-cell (IUCr) notation together with the common shortened notation, as well as John Conway's orbifold notation. The shortened notation for the frieze groups is due to Marjorie Senechal. Here, the first symbol notes if there is a mirror perpendicular to the translation direction: (**m** = yes, 1 = no). The second symbol asks if there is a mirror parallel to the translation direction:

m = yes; if no, then the second symbol is a **g** if there is a glide line, **2** if there is no glide-line but there is a 2-fold rotocenter, and **1** if there is no glide line or 2-fold rotocenter.

A Preferred Notation for a Textile Artist

Jane Eisenstein, a textile artist, was introduced to the study of symmetry and the rotocenter notation in the fall of 1995, when she took Loeb's courses in the Harvard Extension School [3]. Most textile patterns contain repeats, and except at the lowest level of weave technology where individual threads are manipulated by hand, a weaver's loom limits the types of patterns that can be woven on it. With conventional hand looms it is easy to create textile patterns having certain symmetries, while it is difficult or impossible to incorporate other symmetries. Consequently, traditional handwoven textiles are generally limited to patterns having two-fold and fourfold rotational symmetry and reflection lines at angles of 45° or 90° to each other.

Recently, more sophisticated hand looms and computer-aided design tools have made greater patterning capabilities available to hand weavers. With these new tools, many are looking for richer pattern possibilities. Symmetry has given Eisenstein a language for understanding existing patterns as well as for creating new ones. Since art and design are primarily synthetic rather than analytic activities, the rotocenter approach seems appropriate.

Eisenstein's introduction to the unit-cell notation was through Verda Elliot's articles [4]. This notation did not seem very useful until she consulted Washburn and Crowe's *Symmetries of Culture* [22], which uses the unit-cell notation as described in [20]. With this help, she began the process of learning how the unit cell works and how it corresponds with the rotocenter notation. She generally prefers the rotocenter notation, because it usually carries more information about qualities inherent in the pattern, explicitly noting all the distinct symmetry elements and their relationships to each other. Nevertheless, both notations are useful in distinguishing particular pattern types: *cmm* is easier to remember than $22^{\wedge}2'2''$. On the other hand, the essential differences between $\underline{3}3'3''$ and $\underline{3}3'3'^{\wedge}$ are captured in the rotocenter notation in a way that the IUCr's p3m1 and p31m do not accomplish. (Schattschneider's article [20] points out how, for years, even the most distinguished mathematicians have confused the IUCr notation for these two groups.) Both LeCorbeiller and Loeb were particularly puzzled by this pair of unit-cell notations, and became convinced that an alternative notation was needed.

In contrast with the unit-cell notation, the rotocenter notation does not require a "flow chart" of questions as in [22], or rote memorization for identification. Once a pattern's distinguishing symmetry elements are noted, the symmetry is named. The diophantine equation in the theorem guides and confirms this analysis.

A Parade of Patterns

The Crystallography Congress in 1963, and the Escher Centennial Congress exactly thirty-five years later, both held in Rome, represent significant recognitions of the interaction between art and science. At both, Loeb was afforded the opportunity to exhibit original patterns. In 1963, congress organizers requested an impromptu exhibition of Loeb's slides illustrating the LeCorbeiller–Loeb theory. These slides were made available for teaching purposes, and were reportedly still in use as late as 1990. In 1966 Loeb designed collages to illustrate the planar symmetry groups for a joint exhibition with Duncan Stuart entitled *Symmetry and Transformations* in the newly established Carpenter Center for the Visual Arts at Harvard. This exhibition in turn led to his courses on Visual Mathematics and Design Science in the Department of Visual and Environmental Studies at Harvard.

The collages eventually wore out, and in 1998 Loeb returned to Rome to present at the Escher Centennial Congress a symmetry sampler, originally designed for these courses, purporting to be the archive of an (as yet) fictional design firm named THURBER/*Lalo* (THUR B E R L A LO being a permutation of A R THUR L LO E B), each print illustrating one of the planar symmetry groups. Like Escher's creations which included many fictional animals, such as the *wentelteefjes* in his print *Curl-up* [1, cat. no. 374], THURBER/*Lalo*'s clients *Cornélia Dermaete Cosmetics,* the *Belletterie Department Store,* the *Quellinck* couple, the quaint town of *Witches' Cove,* of which everyone appears to have heard but which no one seems to be able to locate, and the *Enzovoort* dynasty are purely fictional, and any resemblance to living or even deceased persons is somewhat if not entirely unintentional. There are antiqued floor and wall tilings, textile designs, cosmetic firm logo and furniture designs, stained-glass windows, screens for hotels and yacht clubs, antiqued wall stencils, department store arcades and chapel windows, all accompanied by a brief text. This 'archive' is intended to illustrate the diversity of applicability of symmetry theory – whimsically, and like any work of fiction, somewhat autobiographical. This symmetry sampler was shown as slides at the Escher Centennial Congress in Rome in 1998, and can be viewed on the CD Rom that accompanies this book.

Acknowledgement

It is a pleasure to acknowledge Doris Schattschneider's helpful editorial contributions and those of the anonymous referee to this paper.

References

[1] F.H. Bool, Bruno Ernst, J.R. Kist, J.L. Locher, F. Wierda, *M.C. Escher: His Life and Complete Graphic Work*, London: Thames and Hudson; New York, Harry N. Abrams, 1982.

[2] John H. Conway, "The Orbifold Notation for Surface Groups," *Groups, Combinatorics, and Geometry*, ed. Liebeck, Cambridge University Press, 1992.

[3] Jane Eisenstein, "A Pattern by any other Name," *Complex Weavers Newsletter* # 54, 1997, 53–62.

[4] Verda Elliot, "Pattern," in four parts, *Shuttle Spindle & Dyepot*. Part one: "The Seventeen Pattern Types," v. XXVI, # 4, no. 104 (1995), 42–45. Part two: "The First Twelve Symmetries," v. XXVII, # 1, no. 105 (1995/96) 36–39. Part three: "The Five Hexagonal Symmetries," v. XXVII, # 2, 106 (1996) 30–32. Part four: "Analysis of Patterns, Point and Border Pattern Types, and Other Ways of Covering a Plane with Pattern," v. XXVII, # 3, 107 (1996) 55–59.

[5] A.L. Loeb, "A Binary Algebra Describing Crystal Structures with Closely Packed Ions," *Acta Crystallographica*, 11 (1958) 496–476.

[6] A.L. Loeb, "A Modular Algebra for the Description of Crystal Structures," *Acta Crystallographica*, 15 (1962) 219–226.

[7] A.L. Loeb and G.W. Pearsall, "Moduledra Crystal Models," *Amer. J. Physics*, 31 (1963) 190–196.

[8] A.L. Loeb and R. Casale, "The Crystograph: a Teaching Aid in Crystal Physics," *Proc. Annual Winter Meeting Amer. Assoc. Physics Teachers*, January 1963.

[9] A.L. Loeb, "The Subdivision of the Hexagonal Net and the Systematic Generation of Crystal Sructures," *Acta Crystallographica*, 17 (1964) 179–182.

[10] A.L. Loeb, "The architecture of crystals," in Gyorgy Kepes, ed., *Module, Proportion, Symmetry, Rhythm,* Braziller, New York, 1966.

[11] A.L. Loeb, "A Systematic Survey of Cubic Crystal Structures," *J. Solid State Chemistry*, 1 (1970) 237–267.

[12] A.L. Loeb, *Color and Symmetry,* John Wiley & Sons, New York, 1971.

[13] A.L. Loeb, "Some Personal Recollections of M.C. Escher," *Leonardo*, 14 (1981) 318–319.

[14] A.L. Loeb, "On my Meetings and Correspondence between 1960 and 1971 with the Graphic Artist M.C. Escher," *Leonardo*, 15 (1982) 23–27.

[15] A.L. Loeb, "Hierarchical Structure and Pattern Recognition in Minerals and Alloys," *Per. Mineralogia*, 59 (1990) 197–217.

[16] Arthur L. Loeb, *Concepts and Images*, *Visual Mathematics*, Birkhäuser, Boston, 1992.

[17] Carolina MacGillavry, *Fantasy and Symmetry*, Harry N. Abrams, New York, 1976.

[18] Nicoló Machiavelli, *The Prince*.

[19] I.L. Morris and A.L. Loeb, "A Binary Algebra Describing Crystal Structures with Closely Packed Ions, Part II," *Acta Crystallographica*, 13 (1960) 434–443.

[20] Doris Schattschneider, "The Plane Symmetry Groups: Their Recognition and Notation," *Amer. Math. Monthly*, 85 no. 6 (1978) 439–450.

[21] C.S. Smith, private communication, 1969.

[22] Dorothy K. Washburn and Donald W. Crowe, *Symmetries of Culture: Theory and Practice of Plane Pattern Analysis*, University of Washington Press, Seattle, 1988.

Folding Rings of Eight Cubes

George Escher

My story begins in Japan, in 1981, where I received from the mathematician Naoki Yoshimoto a small puzzle consisting of eight cubes having white and black faces, stacked in the form of a larger cube, all white-colored faces on the outside. The cubes are attached by hinges to each other in such a way that they can be unfolded, then re-folded into a new configuration, which is now black on the outside.

Next, in 1996, I saw the mathematician John Conway demonstrating another puzzle, also consisting of eight cubes connected by hinges. Like Yoshimoto's cube, it began with eight cubes stacked in $2 \times 2 \times 2$ fashion, with eight hinges connecting two cubes each, so that it could be unfolded into a ring and then re-folded differently, to make new arrangements of $2 \times 2 \times 2$ cubes (see Fig. 1).

The significant difference between the constructions of Yoshimoto's and Conway's cubes was the location of the hinges. As illustrated in Fig. 1, which shows identical initial relative positions of the eight cubes, the difference in locations of hinges leads to different re-folded positions of the cubes.

Musing aloud while showing his puzzle, John Conway said something like this: Are there any more objects of this kind, which begin as a ring of eight cubes joined by eight hinges and which can be manipulated into at least two different cubic packs of $2 \times 2 \times 2$ cubes? I remember being taken aback by the thought that of all people, John Conway had not answered that question for himself. Why didn't he?

At home I made eight cardboard cubes and tried to find hinge arrangements which would work as required. It did not take long to conclude that the problem was far from simple. I also realized that if John Conway had not found an elegant, reasoned way to answer his own question, I certainly need not attempt to find

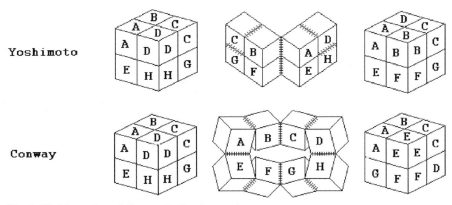

Fig. 1. Yoshimoto's and Conway's 8-cube puzzles

one. But it struck me that there were only eight cubes and eight hinges, which did not seem a lot. I was retired and could dispose of a fair amount of free time. What if I tried answering John Conway's question the dumb, laborious way, by exploring every possibility?

I visualized beginning with two cubes, recording their possible relative positions, then adding a third one, then a fourth, and so on until all combinations with eight cubes had been examined. I tried, and very soon was hooked. I went on and on for about a year, until I had the answer, which is given in the form of diagrams of hinge locations (at the end of this article).

In the sections that follow, I give an outline of the method used in completing the task which is restated here as:

> Given eight cubes and eight hinges, the hinges to be placed along the cubes' edges. Find all possible ways to join the cubes into rings of eight cubes by using the eight hinges so that each ring can be freely folded into at least two different cubic stacks of $2 \times 2 \times 2$ cubes. By "free folding" is meant that it is not permissible to subject the hinges to twisting, pushing, pulling or shearing.

If you are wondering what all this has to do with M. C. Escher, take a peek at the last paragraph at the end of the article.

The main tools used to perform the job were:
• Pencil and paper for diagrams.
• Eight sturdy cardboard cubes, with 4 cm edges. The surface was treated with lacquer to permit repeated application and peeling of masking tape hinges.
• Masking tape for the hinges, applied on both sides of each pair of edges being joined.
• A computer spreadsheet, for recording cube and hinge positions.

The investigation took place in five main steps:
1. Establish conventions for identification of cubes, hinge location and cube location.
2. Describe all possible ring patterns.
3. Find for each ring pattern which hinge positions allows the existence of two different $2 \times 2 \times 2$ cubic stacks, regardless of whether one stack may be folded into the other.
4. Among the ring patterns found above, determine in which ones the hinge positions allow free folding from one $2 \times 2 \times 2$ stack into the other.
5. Describe the results.

An outline of the above steps is given in the following sections. A complete discussion is available in a 180-page report, as noted at the end of this paper.

Conventions

Standard starting position and cube lettering is shown in Fig. 2. The position and orientation of cube A are fixed at the center of a cubic space formed by three sets

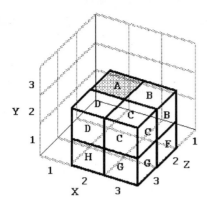

Fig. 2. Reference coordinates and cube lettering

of mutually perpendicular coordinates which are used to define cube positions. In order to end up with $2 \times 2 \times 2$ stacks all other cubes must be located somewhere inside that $3 \times 3 \times 3$ cubic space.

Rings

While stacked in $2 \times 2 \times 2$ form as in Fig. 2, cubes can be connected to each other in two distinct ways. For example, A can be connected to C only by using one hinge, along the two touching edges. I call this a "diagonal" connection, because the cubes being joined lie along one of the 12 face diagonals of the $2 \times 2 \times 2$ stack. Similar diagonal connections can be made between D and G, A and F and so on.

On the other hand, A may be connected to B by placing a hinge along any one of the four pairs of adjacent edges of the two cubes. I call these "edgewise" connections, because the cubes being joined lie along the same edge of the $2 \times 2 \times 2$ stack. Similar edgewise connections can be made between G and F, D and C and so on. Note that the "diagonal" and "edgewise" descriptions only apply to the $2 \times 2 \times 2$ stacked condition. Once the cubes are separated by unfolding, these terms lose their significance.

A ring of eight cubes is formed by connecting pairs of cubes to each other by a single hinge. Each cube must have two and only two hinges, located on different edges. For the first stage of the study of rings it is sufficient to deal with connections only, disregarding which specific hinges make the connections.

Fig. 3. Typical diagram of a ring of 8 cubes with two diagonal connections

Fig. 4. The only ring with 0 diagonal connections

Fig. 5. The five rings with 2 diagonal connections. Rings B, C, D and F have opposite-hand forms as well

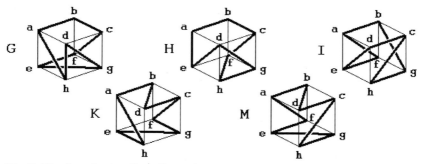

Fig. 6. The five rings with 4 diagonal connections. They all have opposite-hand forms as well

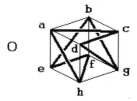

Fig. 7. The only ring with 6 diagonal connections. It also has an opposite-hand form

Only after the ring has been completely folded into a $2 \times 2 \times 2$ stack can it be determined whether a particular hinge forms a diagonal or edgewise connection.

The structure of a $2 \times 2 \times 2$ stack may now be simplified by replacing each cube by a point in its center, and showing connections by straight lines between the points. An example of this is shown in the diagram of Fig. 3. The cube has six edgewise and two diagonal connections. The centers of cubes are identified by lower-case letters.

The next step was to determine the number and the geometry of all possible 8-cube ring configurations which may be folded into $2 \times 2 \times 2$ stacks. A total of twelve was found, not counting mirror images. They could be classed in four categories: those having zero, two, four and six diagonal connections. The results are shown in Figures 4, 5, 6 and 7.

Hinges

Once the ring geometries were established, the next step was to find where hinges may be placed to make the connections between cubes for each ring. This was done by systematic trial, using cardboard cubes and hinges of masking tape. For each ring the investigation proceeded as follows:

- Select the ring to be investigated.
- Consider cube A fixed in its standard position in the center of the coordinate space of Fig. 2.
- Attach, in standard position, cube B to cube A by one hinge, record hinge position and the positions to which cube B may be rotated. Because I defined all rings to have an edgewise connection between A and B, there are four possible hinge locations and nine possible positions for B.
- Attach, in standard position, the next cube in the ring to B, choose and record hinge position, then for each possible position of B record the possible positions of this following cube.
- Continue in this way with the remaining cubes along the ring. At the end of this cycle a few sets of eight hinges will have been found which connect the eight cubes both in standard position and in new positions inside a $2 \times 2 \times 2$ stack.

It should be understood that during this stage of the investigation I was only concerned with the static case of $2 \times 2 \times 2$ stacks. Apart from manipulations of individual cubes as they were being added, I ignored any combined movements of the eight connected cubes which may be needed to transform the standard stack into the new-found $2 \times 2 \times 2$ stack. That would become the concern in next stage, after all non-standard stacks for a ring had been discovered.

Free Folding

The last stage of the investigation consisted of assembling models of those rings which had been found to have a $2 \times 2 \times 2$ stack configuration different from the standard configuration. Each would be tested carefully by hand and eye to discover whether any unfolding was possible, and next whether a complete free transformation from standard to alternative $2 \times 2 \times 2$ stack was possible. The hinge locations (or at least the ones I found) which allow such a complete transformation were then recorded, using the conventions shown in Fig. 8. Figure 9 shows these 17 different configurations; here are brief comments on each.

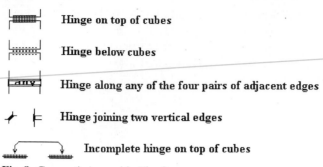

Hinge on top of cubes

Hinge below cubes

Hinge along any of the four pairs of adjacent edges

Hinge joining two vertical edges

Incomplete hinge on top of cubes

Fig. 8. Conventions used in Fig. 9

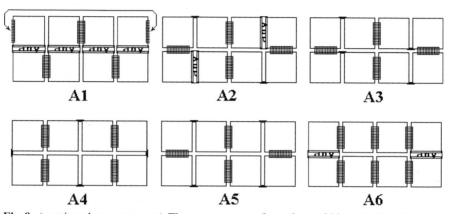

A1 **A2** **A3**

A4 **A5** **A6**

Fig. 9. (continued on next page) The seventeen configurations of hinged cubes that allow a complete "free" folding and unfolding from the standard $2 \times 2 \times 2$ configuration to an alternative $2 \times 2 \times 2$ stack

A1. A family in which four pairs of cubes may be joined face to face by any one of the four available hinges, without affecting the two end configurations. One combination of the hinges marked "any" provides one more configuration: A3.

A2. Has a mirror image. A family in which two pairs of cubes may be joined face to face by any one of the four available hinges, without affecting the two end configurations. One combination of the hinges marked "any" provides one more configuration (A3), another combination provides two more configurations (A5).

A3. Has a mirror image. Three configurations, one belonging to the A1 family, one to the A2 family, and one to both.

A4. An interesting case of A1, showing misleading looseness. Notwithstanding an appearance of freedom, any folding leads to one of the two usual configurations.

A5. Special case of A2, with four configurations. This is the hinge arrangement of John Conway, discussed at the beginning of this article.

Fig. 9. (continued)

A6. A family in which two pairs of cubes may may be joined face to face by any one of the four available hinges, without affecting the two end configurations.

A7. A family in which four pairs of cubes may may be joined face to face by any one of the four available hinges, without affecting the two end configurations.

A8. Two configurations. This is the hinge arrangement of Naoki Yoshimoto, discussed at the beginning of this article.

A9. Two configurations.

A10. Four configurations.

A11. Has a mirror image. Two configurations.

A12. Has a mirror image. Two configurations.

A13. Has a mirror image. Two configurations.

A14. Has a mirror image. Two configurations.

A15. Has a mirror image. Two configurations.

F1. Four configurations.

F2. Has a mirror image. Two configurations.

Results

The investigation had the following results (refer to Figures 4, 5, 6, 7):
- Ring O, with six diagonal connections, is totally immobile.
- Rings G, H, I, K and M, i.e. all those with four diagonal connections, have some alternative $2 \times 2 \times 2$ configurations, none of which can be freely manipulated from standard to alternative.
- Rings B, C, D, and E, with two diagonal connections, have many more alternative $2 \times 2 \times 2$ configurations than the previous group. They are also more mobile, but not a single one could be freely manipulated from standard to alternative configuration.
- Ring F, also with two diagonal connections, was the first one to yield two transformations from standard to alternative $2 \times 2 \times 2$ (F1 and F2, Fig. 9a). It had taken six months, and recording of approximately 5000 cube positions to reach this stage.
- Ring A, with only edgewise connections, has the largest number of alternative configurations of all. The ones that can be freely transformed from standard to alternative $2 \times 2 \times 2$ stacks are shown as A1 through A15 in Fig. 9. It took an additional five months and recording of about 6000 cube positions to complete the investigation of this last ring.

Diagrams in Figures 8 and 9 give the information necessary for building models of the rings of eight cubes. I find it convenient to use hardwood 3/4 inch cubes, available at many craft stores, and join them with 3/4 inch masking tape. The rings are shown unfolded, flat on a table, with hinge positions explained in Fig. 8. In the four cases A1, A15, F1 and F2 it is not possible to completely

unfold the eight cubes on a flat plane, therefore one hinge is shown disconnected, with arrows indicating which edges to join last, after raising and turning some of the cubes.

Comments

Theoretical foundation. At the very beginning of this project I decided to proceed by experimental, essentially non-mathematical methods, because I had no idea how to attack the problem in a more reasoned, mathematically elegant way. While working with models and masking tape, I would ponder every now and then whether I could see a less brainless way to find the answer I was seeking. I couldn't, and I still have no inkling of a usable theory that may provide a more direct way to an answer.

Completeness. Although in principle the approach taken in this project should provide the complete set of possible answers to John Conway's initial question, some possible hinge configurations may have been missed, for two reasons:
1. The search involved roughly 11, 000 steps, each of which required a visual, spatial judgement and the typing of an entry in the record. Errors must have occurred now and then. But because there were far more blind alleys than paths leading to a properly folding set of cubes, it is likely that few, if any, correct steps were missed.
2. In the final stage, when it was a matter of manipulating $2 \times 2 \times 2$ cubes to find out whether they would open up, everything depended on having a mechanically clean model and applying the right amount of force in the right direction. This kind of eye-and-hand mathematics is unreliable: I discovered accidentally one more folding hinge pattern (F2) after believing that I had found them all.

Stress-free folding. It is clear that unfolding of most $2 \times 2 \times 2$ stacks (A1, A4, A6, A7, A8, A9, A10, A11, A12) can occur in stress-free fashion. In this group every move may be executed by rotating blocks of cubes simultaneously about two hinges located on one line, thereby providing the specified stress-free movement. But for the remaining stacks (A2, A3, A5, A13, A14, A15, F1, F2) the unfolding pattern requires complex rotations and translations of cubes in space, with several hinges operating simultaneously in different directions. Although the folding seems stress-free, are we certain that we are not cheating?

For F1, a convincing demonstration of stress-free folding was devised by Brian Calvert of the mathematics department of Brock University in St. Catharines, Ontario. It requires the flat, square cardboard model shown in Fig. 10 (left). If creased along the interior lines, it can be folded to emulate the movements of the cubes of F1. Except perhaps for A2, and therefore also for A3 and A5, I have been unable to devise any demonstration of stress-free folding for the

Fig. 10. *Left*: Brian Calvert's model for F1. *Right*: My model for A2

remaining stacks. For A2 I designed the flat cardboard model of Fig. 10 (right). It consists of two pairs of identical pieces: two rectangles with sides of one and two units; and two pieces shaped by two squares which are turned an arbitrary but equal angle in relation to each other. The four pieces are joined by three hinges as shown. On some days handling this model convinces me that A2 folds in stress-free fashion, on other days I am not so sure. I leave it to the reader to decide for him/herself.

An odd pair. In one respect A8 an F2 are opposites of each other. A8 is the only pattern which everts, i.e. all faces which are hidden in one configuration become the outside faces in the other configuration. F2 does the opposite. It is the only pattern where every face on the outside in one configuration remains on the outside in the other configuration. Only the relative positions change, somewhat like on a Rubik's cube.

Connections with M.C. Escher

One may ask: what has all this to do with M.C. Escher and his work? Apart from the family connection – he was my father – I can see several features. Stacking eight cubes in accordance with a simple rule has much in common with working with a tessellation, but in space rather than on the flat plane. The methods used by my father and myself were very similar: a systematic, patient approach by successive trials, without help of formal mathematics, using the eye and hands to manipulate pencil, paper and models. What drove us both to such lengthy and often monotonous tasks was very similar: first curiosity about a geometric puzzle, growing into interest, finally becoming an addiction.

Whenever I asked myself why I was engaged in such a silly activity, I could hear my father's genes speaking loud and clear: You do it because it's fun, because you are too interested in the problem to abandon it.

Note. A 180-page report of this project is available. To receive one, send name, address and a money order for US $30.00 to the author (address at the back of this volume).

Dethronement of the Symmetry Plane [1]

István Hargittai

In memoriam Caroline H. MacGillavry [2]

C.H. MacGillavry (1904–1993)

There is a whole variety of Escher's works that I like looking at, thinking about, or discussing with friends. They include his drawings of wild flowers, Italian scenery, "impossible figures," and periodic drawings. My favorite is his wild flowers. They are as forceful as they are subtle. They stress the essential and ignore the rest, which is also the characteristic of good scientific models of nature. I anticipate, however, that Escher's periodic drawings will have the longest lasting impact of all his works. The present contribution probes into their appeal for scientists.

When the notion of dethronement of the symmetry plane is introduced, it is implied that the symmetry plane had been enthroned. This is so, to the extent that reflection is the most common of symmetries. When we think of symmetry the first example that comes to mind is the bilateral symmetry of the human body, however approximate this symmetry is. The symmetry plane in this case bisects the human body. The symmetry plane is ubiquitous in nature as well as in human creations. However, it has extremely restricted utility wherever good space utilization is concerned. The message of the present communication is that whether it is Escher's periodic drawings, or crystal structures, or the interaction of biological molecules, the symmetry plane is not a common symmetry element.

Densest Packing and Complementarity

Escher's periodic drawings provide a model of densest packing. They have been used extensively to demonstrate symmetry properties of patterns in two dimensions. Densest packing is achieved, in most cases, through complementarity in

the arrangement of the building elements. The symmetry operations generating these patterns seldom include the symmetry plane. The symmetry plane can be involved only in extreme cases when the building elements themselves are of high symmetry. For an arbitrary shape, however, application of the symmetry plane would exclude densest packing by leaving considerable chunks of the surface uncovered. Densest packing means the maximal utilization of the available space, be it a surface or a three-dimensional volume. Of course, in Escher's works as in most educational material of crystallography, the focus is the two-dimensional plane.

The best utilization of the available space is the goal of densest packing. The empirical observation that nature abhors a vacuum has been stated repeatedly since Galileo, but has been seldom scrutinized. My assertion is that the ultimate goal in finding the best arrangements of building elements in nature is not governed by such a principle. Rather, there is an underlying principle at a deeper level, namely, that the arrangements sought should provide the greatest stability, that is, the lowest overall energy. This happens when the amount of possible interactions is maximized between the building elements, provided that they are of attractive nature. If this is the case, the amount of interactions is maximized when the interacting surface areas are maximized. This condition is provided by a complementary arrangement of two pieces of the same arbitrary shape. This would be far from maximized, in the general case, if the two were related by a symmetry plane. The utility of the complementarity concept will be illustrated here by invoking selected examples, from Lucretius to the latest discoveries in molecular biology.

Saying It with Lucretius

Escher's drawings are the most beautiful examples of densest packing in the plane. Cavities of one object are filled with the protrusions of the other.

Lucretius (ca 96 – ca 55 B.C.E.) proclaimed the fundamental principle of best packing arrangements two thousand years ago. He came, in fact, to the principle of complementarity. Lucretius stated in his *De rerum natura*: [3]

Things whose fabrics show opposites that match,
one concave where the other is convex,
and vice versa, will form the closest union.

Valued Predictions

Molecular crystals provide numerous examples of densest packing in nature. The great Russian crystallographer, Aleksandr I. Kitaigorodskii made a unique contribution to this area of science. [4] He predicted that among crystal

structures, three-dimensional space groups of lower symmetry are much more frequent than those of higher symmetry. This was a prediction at a time when few crystal structures had been determined experimentally.

Kitaigorodskii used to say, "a first rate theory predicts, a second rate theory forbids, and a third rate theory explains after the facts." Even a third rate theory is important because even if we did not anticipate our findings, at least we would like to understand them afterwards. It is a whole different thing, however, when our findings can be predicted by a suitable theory or model. This happens only if we really understand the phenomenon under study. Thus Kitaigorodskii's successful prediction of the distribution of three-dimensional space groups implied the understanding of the underlying principles of molecular packing.

Kitaigorodskii found that the packing of molecules is spatially complementary. In order to achieve densest packing, the molecules of arbitrary shape complement each other in the best arrangement. Thus molecules having a shape with cavity and protrusion will not use the available space most efficiently if they turn to each other in such a way that the cavity of one molecule matches the cavity of the other. This would be the case if they would be related by reflection. On the contrary, the best arrangement is when the protrusion of one molecule fits the cavity of the other, and so on. This is yet another expression of the principle of complementarity appearing in so many ways in science because it does so in nature.

Enter Molecular Biology

The principle of spatial complementarity itself was, of course, not Kitaigorodskii's invention. He "only" carried it to its extreme utility in finally arriving at the prediction of frequency distribution of the 230 three-dimensional space groups among crystal structures.

An important contribution appeared in 1940 jointly by two future Nobel laureates, the structural chemist Linus Pauling and the physicist turned biologist Max Delbrück. They titled their note in *Science* "The Nature of the Intermolecular Forces Operative in Biological Processes." [5] It was prepared in response to a series of papers by Pascal Jordan who had suggested that a quantum mechanical stabilizing interaction operates preferentially between identical or nearly identical molecules or parts of molecules. The suggestion came up in connection with the process of biological molecular synthesis, leading to replicas of molecules present in the cell. Pauling and Delbrück suggested precedence for interaction between complementary parts, instead of the importance of interaction between identical parts. They argued that the intermolecular interactions of van der Waals attraction and repulsion, electrostatic interactions, hydrogen-bond formation, etc., give stability to a system of two molecules with complementary structures in juxtaposition, rather than two molecules with identical structures.

Accordingly, they argued that complementariness should be given primary consideration in discussing intermolecular interactions.

The eventual discovery of the mechanism of the function of deoxyribonucleic acid (DNA) through the double helix is the best known illustration of complementarity in molecular biology. The immediate key to the discovery was the base complementarity discovered by Erwin Chargaff.

Lower Symmetry Packs Better

The description of the nature of intermolecular forces by Pauling and Delbrück seems directly applicable to the packing of molecular crystals. For Kitaigorodskii it took many years of painstaking measurements in addition to his brilliant conjecture before he could arrive at his findings whose validity have withstood the test of time.

Early on in his scientific research program Kitaigorodskii decided to use identical but arbitrary shapes in his probing into the best possible arrangements in the plane. He established the symmetry of two-dimensional layers that allow a coordination number of six at an arbitrary tilt angle of the molecules with respect to the tilt axes of the layer unit cell. He found that such an arrangement would always be among those that have the densest packing. We quote here an example of the general case for molecules of *arbitrary* shape. Kitaigorodskii addressed himself to the task of selecting the two-dimensional space groups for which efficient packing for molecules of arbitrary shape is possible. This is an approach of great interest since the result will answer the question as to why there is a high occurrence of a few space groups among the crystals while many of the 230 groups hardly ever occur.

Kitaigorodskii first examined the problem of dense packing. For the plane group with the least amount of symmetry (translational symmetry only, $p1$) it is possible to achieve densest packing with any molecular form if the translation periods (t_1 and t_2) and the angle between them are chosen appropriately. The same is true for the plane group generated by twofold rotations ($p2$) (Fig. 1). On the other hand, the plane groups with symmetry planes (pm and pmm) are not suitable for densest packing. Due to the symmetry planes in these arrangements the molecules are oriented in such a way that their convex parts face the convex parts of other molecules. This arrangement counteracts dense packing (Fig. 2). The plane groups with glide reflection (pg and pgg) may be suitable for 6-coordination. This layer is not of maximum density and in a different orientation of the molecules only 4-coordination is achieved (Fig. 3). For plane groups of higher symmetry, efficient space utilization is increasingly difficult. If the molecule itself has reflection symmetry, i.e., retains a symmetry plane, then it may have a better chance for denser packing even in symmetry groups with a high number of symmetry elements, with symmetry planes included.

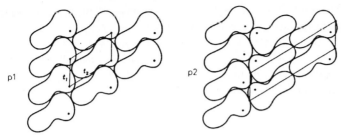

Fig. 1. Densest packing with space groups *p1 and p2*, from Kitaigorodskii [4]

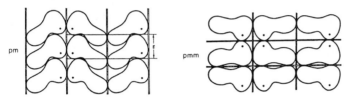

Fig. 2. The symmetry planes in space groups *pm* and *pmm* prevent dense packing, from Kitaigorodskii [4]

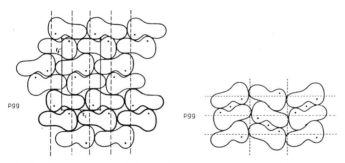

Fig. 3. Two forms of packing with *pgg* space groups: one is densest packing and the other is using a different orientation of the molecules that reduces the coordination number from six to four; from Kitaigorodskii [4]

After considering plane groups for dense packing, the next step is to apply the geometrical model to the examination of the suitability of three-dimensional space groups for such packing. The task in this case is to select those space groups in which layers can be packed allowing the greatest possible coordination number. Obviously, mirror planes would not be applicable for repeating the layers.

Low-symmetry crystal classes are typical for organic compounds. Densest packing of the layers may be achieved either by translation at an arbitrary angle formed with the layer plane, or by inversion, glide plane, or by screw-axis rotation. In rare cases closest packing may also be achieved by two-fold rotation.

Kitaigorodskii has analyzed all 230 three-dimensional space groups from the point of view of densest packing, and found only six space groups to be available for the densest packing of molecules of arbitrary form ($P\bar{1}$, $P2_1$, $P2_1/c$, Pca, Pna, $P2_12_12_1$). For molecules with symmetry centers, there are even fewer suitable three-dimensional space groups ($P\bar{1}$, $P2_1/c$, $C2/c$, $Pbca$). In these cases all mutual orientations of the molecules are possible without losing the six coordination.

One of the low-symmetry space groups ($P2_1/c$) occupies a strikingly special position among organic crystals. It is the unique feature of this space group that it allows the formation of layers of densest packing in all three coordinate planes of the unit cell. There are two other space groups ($P2_1$ and $P2_12_12_1$) among those providing densest packing. According to statistical examinations, these three groups are the first three in frequency of occurrence. For chiral molecules, these possibilities are valid only for either the left-handed or right-handed forms.

Kitaigorodskii's pioneering work on the distribution of molecular organic compounds over the space groups stands out not only as an important source of scientific information but also as a model of scientific research.

Copying DNA

The mechanism of action of DNA molecules is characterized by complementarity, although on a different scale of complexity. Kary Mullis, the discoverer of the Polymerase Chain Reaction, describes it in the following way: [6]

> DNA has the remarkable property that there are two forms of any particular sequence of the purine and pyrimidine bases that you can string together. You can make one chain and you can make another chain that goes backwards in sequence; it is the complement, and they are held very tightly. It's a beautiful helix but it also has kinks causing a lot of excitements. However, the two helices are clamped so tightly that you have to boil DNA to get them apart. This can also be done by an enzyme, burning a lot of ATP [adenosine 5'-triphosphate]. This DNA can reproduce itself. Clay also does this, if you consider its layered structure, each layer binding the complementary layer to the previous one. DNA has this ability.
>
> If you make a short piece of one string of a DNA, like 20 bases, this piece will have a tremendous affinity for the complementary sequence. You put this 20 base long sequence in a mixture which has one out of a billion, or even trillion (10^{12}) different pieces, and it will find the sequence exactly complementary to it in about 30 seconds.

Lord Kelvin's Geometry

Kitaigorodskii's principal contributions focused on the geometrical properties of crystal structures rather than their physical properties. One of his predecessors in this quest was Lord Kelvin. In 1904, Lord Kelvin published his celebrated *Baltimore Lectures on Molecular Dynamics and the Wave Theory of Light*, originally delivered in 1884. [7] The twenty Baltimore lectures are appended by twelve more lectures on allied subjects in this volume. Appendix H is "On the Molecular Tactics of a Crystal," which discusses the geometry of the arrangement of the molecules in the constitution of a crystal. This was *The Robert Boyle Lecture* by Lord Kelvin, delivered before the Oxford University Junior Scientific Club, on May 16, 1893.

This lecture shows a tremendous prescience by Lord Kelvin. He makes this suggestion, for example, to future crystallographers, "I advise any of you who wish to study crystallography to contract with a wood-turner, or a maker of beads for furniture tassels or for rosaries, for a thousand wooden balls of about half an inch diameter each. Holes through them will do no harm, and may even be useful; but make sure that the balls are as nearly equal to one another, and each as nearly spherical as possible."

The two patterns by Kelvin differ in that in one the molecules are all oriented in the same way, while in the other the rows of molecules are alternately oriented in two different ways (Fig. 4). The boundary of each molecule presented a great puzzle to Kelvin, and he considered it a purely geometrical problem. This is the point where his successors introduced considerations for intermolecular interactions, and for Kitaigorodskii this culminated in what he expressed metaphorically that he "dressed the molecules in the fur-coat of van der Waals domains." Kelvin's plane tessellation was ahead of Pólya and Escher, but then the Islamic and Moorish decorators had been doing this for hundreds of years before him.

As Lord Kelvin was looking for a more efficient, that is, closer packing in the plane, he moved around the planar motifs that represented identical molecules

Fig. 4. Two arrangements of molecular shapes by Lord Kelvin [7]

of arbitrary shape and arrived at a much more efficient packing indeed. He was trying to use shapes as nearly rectilinear as possible for partitioning the plane and he did not let his molecules quite touch one another. Otherwise, he created a modern representation of molecular packing in the plane.

Although Lord Kelvin did recognize the importance of complementarity in molecular packing, this property has not become associated with his name. One reason may have been that he was so well known for other works. Another reason may have been that this was described in an Appendix only. Yet another reason may have been that the world of science was not ready for this discovery at the time of his Oxford lecture, in 1893, or at the time of the publication of these lectures, in 1904.

Escher Patterns

The best known presentation of the 17 two-dimensional space groups is by George Pólya [8] because he illustrated the 17 groups with patterns that completely fill the surface without gaps or overlaps. Today we would call them Escher-like patterns. In fact, there was an important connection between Pólya and Escher that has been described by Doris Schattschneider. [9]

Planar patterns that fill the plane without gaps or overlaps are popular among crystallographers because crystal structures have no gaps or overlaps either. Thus the planar patterns are excellent tools for teaching crystal symmetries. The Azerbaijani crystallographer Khudu Mamedov's drawings are intriguing examples relating their geometries with motifs of the past. Mamedov and his colleagues had made a conscious effort to collect and record their findings in the interest of the preservation of their culture. In this they felt that crystallography greatly aided their anthropological explorations. The close relationship between Mamedov and Escher can be symbolized by two simple yet powerful patterns of antisymmetry. Antisymmetry is the symmetry of opposites and occurs

Fig. 5. Six "Ali" in kufic script. The Palace of Shirvanshahs, Baku, Azerbaijan, 15th century; after Mamedov, 1986

Fig. 6. M.C. Escher, *Plane-filling motif with Reptiles*, 1941. Woodcut

when a symmetry operation is accompanied by a property reversal. Mamedov discovered [10] an architectural medallion in the Shirvanshahs Palace of the 15th century in Baku, Azerbaijan. The medallion, carved in relief in stone, repeats the word "Ali" six times (Fig. 5). Three of the six are written in the shape of hollows in the stone and the other three on the juts between the hollows. Escher's *Plane-filling motif with Reptiles* of 1941 (Fig. 6) shows a close relationship to this architectural medallion. Khudu Mamedov had great respect for M.C. Escher's art.

Escher's periodic drawings are, of course, the most famous. Let me quote Doris Schattschneider's comments about their significance: [11]

> *When I taught the course "Mathematics and Decorative Art," I came across Carolina MacGillavry's book that had the Escher designs. It had 40 plates in it, most of them black and white but a few in color and we analyzed a lot of them. Her introductory essay had the tantalizing information that Escher had made notebooks. She was the person who introduced Escher to the crystallographic world. She visited him in his studio after she had seen an exhibit of his in the late '50's and found out a little about his symmetry drawings. She saw in his studio what a huge amount he had already done. By the mid-fifties he had already done well over a hundred symmetry drawings. He also showed her his personal notebooks that have his theory he had developed between 1938 and 1941 on his own. That is what Carolina referred to in her Preface. So I was aware that he had produced notebooks and that he had developed what he called a layman's theory. From that point on I wanted to know: What did Escher do? And how did he do it?*
>
> *Carolina was interested in using Escher's periodic designs as a teaching device – to teach beginning students of crystallography about crystallographic analysis of two-color and multicolor patterns. In the late fifties when she visited him in his studio that's when she got the idea to have him make an exhibit at the 1960 Cambridge (England) meeting of the International Union of Crystallography. He gave a lecture and got a standing ovation at the end of his presentation. After that meeting she got the idea to produce the book using his drawings and got the International Union to sponsor it. She actually worked with Escher. She went through all his periodic drawings and chose those that would illustrate the particular color symmetry groups that she wanted to illustrate. That's when she discovered that one of the simplest groups was missing and she requested him to prepare a drawing to illustrate that one, which he did. It was the p2 group with just two colors. [See Fig. 7.] He also redrew or fixed up some of the other drawings. Incidentally, the p2 group is not very common in Islamic decorations either, if not totally*

Fig. 7. M.C. Escher, symmetry drawing no. 115. This drawing was made by Escher at the request of Caroline MacGillavry for her 1965 book [2]

missing. It is nowhere in the Alhambra unless you take into account the under-and-over weaving of some designs. If you look for just point symmetry designs in the Alhambra, you don't see the all-over p2 designs.

I. Hargittai: "Escher seems not to have liked reflection symmetry either."

I think it's because of his wanting to have recognizable shapes, completely recognizable in silhouette. He also wanted the creatures to be not symmetrical. If you have birds flying and reptiles squirming, they are not symmetrical. If you line them up and pin them down, like you do with a butterfly to display it, there is symmetry, but in nature and in action that symmetry is gone. He has a few patterns where he has reflection symmetry and they seem quite static; he really liked the idea of movement. In his own classification system he doesn't talk about reflection, he only talks about glide reflection. Reflection symmetry in an overall pattern is only introduced when the motif is symmetric – that's how he was looking at it. Thus his own classification system only uses rotations, translations, and glide-reflections. When he happened to have a symmetric motif, he would add a little asterisk to the classification symbol to say this one has reflection as well. In that sense it was only induced reflection symmetry. He never thought of global reflection symmetry at all, only local reflection which sometimes, of course, induces global reflection. An example is the pattern of a bird, bat, butterfly, and bee which was designed for a ceiling for an exhibit room of the Phillips Company at the time. The silhouette of these shapes was cut out of wood panels about one square meter and a thin film

was placed over the hole and the motif was painted on. The ceiling was back-lit and there were the shapes of these flying things. Quite a fantastic sight. Some parts of this ceiling were just recently rescued from a storage room.

Less Symmetry Is Better

Is dethronement of the symmetry plane the equivalent of advocating the merits of asymmetry? Not at all. Repetition is also symmetry and Nature operates with a rather limited number of recurring patterns, giving us the hope to learn more and more about it. As it happens with the most frequent crystal structures, Escher's periodic drawings are full of rotational symmetry, inversion, and glide-reflection, along with translation. However, reflection scarcely appears in them. Asymmetry would be the complete absence of symmetry. As it turns out, Escher's periodic drawings, just as crystal structures, are characterized with "less symmetry," i.e., with less than the maximum possible amount of symmetry.

I would like to mention two instructive examples to illustrate the "less symmetry is better" thesis. When Linus Pauling was looking for a model of the alpha-keratin protein structure, he broke through by realizing that the key is in making a helical arrangement of non-symmetrical motifs, that is, the amino acids. [12] He even disregarded part of the experimental observations when he found it not compatible with his model. He could be that bold, of course, only because he had accumulated a tremendous amount of observed data on chemical structures and their regularities.

My other example is the importance of less perfect structures versus more perfect ones in the quest for understanding the chemical basis of life. J. Desmond Bernal, one of the founders of molecular biology wrote: [13]

I should say here that the distinction between the fully and the partially crystalline structures was fully recognized in practice between Astbury and myself. I took the crystalline substances and he the amorphous or messy ones. At first it seemed that I must have the best of it but it was to prove otherwise. My name does not appear, and rightly, in the double helix story. Actually the distinction is a vital one. The picture of a helical structure contains far fewer spots than does that of a regular three-dimensional crystalline structure and thus far less detailed information on atomic positions, but it is easier to interpret roughly and therefore gives a good clue to the whole. No nucleic acid structure has been worked out to atomic scale though the general structure is well known. It may be paradoxical that the more information-carrying methods should be deemed the less useful to examine a really complex molecule but this is so as a matter of analytical strategy rather than accuracy.

> *A strategic mistake may be as bad as a factual error. So it*
> *turned out to be with me. Faithful to my gentleman's agreement*
> *with Astbury, I turned from the study of the amorphous nucleic*
> *acids to their crystalline components, the nucleosides.*

This is an extraordinary insight into the thinking of one of the most original scientists of the twentieth century.

With some oversimplification, the message of this contribution is the following: getting innoculated with Escher's periodic drawings may assist us in avoiding strategic mistakes in research and help us in understanding the complexity of the world around us.

Notes and References

[1] Much of the message of the present contribution and details, background informa-
 tion, and numerous references can be found in I. Hargittai, M. Hargittai, *In Our*
 Own Image: Personal Symmetry in Discovery, Kluwer Academic/Plenum Press,
 New York and London, 2000.

[2] To dedicate such a contribution to the memory of Caroline MacGillavry does
 not need much justification. She, more than anyone else, built the bridge
 between M.C. Escher and the scientific community. See C.H. MacGillavry,
 Symmetry Aspects of M.C. Escher's Periodic Drawings, A. Oosthoek's Uitgevers-
 maatschappij, Utrecht, 1965 (republished as *Fantasy and Symmetry*, Harry
 Abrams, New York, 1976). See also C.H. MacGillavry, "The Symmetry of M.C.
 Escher's 'Impossible' Images," in I. Hargittai, ed., *Symmetry: Unifying Human Un-*
 derstanding. Pergamon Press, New York, 1986, pp. 123–138. She was, however,
 first of all an outstanding crystallographer, a scientist of structure. My personal
 encounters with Caroline MacGillavry were very enriching and memorable.
 I thank Henk Schenk, president of the International Union of Crystallography, for
 providing the photo of her, taken on the occasion of her farewell lecture at the
 University of Amsterdam.

[3] Lucretius, *The Nature of Things, De rerum natura*, translated by F.O. Copley.
 W.W. Norton & Co., New York, first edition, 1977. This quoted passage is from
 Book VI, lines 1084–1086. I am grateful to Jack D. Dunitz for calling my attention
 to this quotation.

[4] A.I. Kitaigorodskii, *Molekulyarnie Kristalli*. Nauka, Moscow, 1971. English trans-
 lation *Molecular Crystals and Molecules*. Academic Press, New York, 1973.

[5] L. Pauling, M. Delbrück, "The Nature of the Intermolecular Forces Operative in
 Biological Processes." *Science* vol. 92 (1940), pp. 77–79.

[6] I. Hargittai, *Candid Science II: Conversations with Famous Biomedical Scientists*,
 Imperial College Press, London, 2002. Dr. Mullis shared the 1993 Nobel Prize in
 chemistry, "for contributions to the development of methods within DNA-based
 chemistry, for his invention of the polymerase chain reaction (PCR) method."

[7] Kelvin, Lord, *Baltimore Lectures on Molecular Dynamics and the Wave Theory of*
 Light, Appendix H, pp. 618–619. London: C.J. Clay & Sons, 1904.

[8] G. Pólya, "Über die Analogie der Kristallsymmetrie in der Ebene." *Z. Kristall.*
 vol. 60 (1924), pp. 278–282.

[9] D. Schattschneider, "The Pólya–Escher Connection," *Mathematics Magazine*, vol. 60 (1987), pp. 293–298.

[10] Kh.S. Mamedov, "Crystallographic patterns." In I. Hargittai, ed., *Symmetry: Unifying Human Understanding*. Pergamon Press, New York, 1986, pp. 511–529.

[11] I. Hargittai, "Transmitting M.C. Escher's Symmetries: A Conversation with Doris Schattschneider." *HyperSpace* (Kyoto), vol. 6, no. 3 (1997), pp. 16–28.

[12] L. Pauling, "Discovery of the Alpha Helix." *The Chemical Intelligencer*, vol. 2, no. 1 (1996), pp. 32–38. This was a posthumous publication of Linus Pauling, communicated by his associates.

[13] J.D. Bernal, "The Material Theory of Life." *Labour Monthly*, (1968), pp. 323–326.

Computer Games Based on Escher's Spatial Illusions

Scott Kim

I have always loved the way Escher invites me to participate in his worlds. In *Ascending and Descending*, Escher invites me to join a procession of monks as they walk around an endless staircase. In *Convex and Concave* he asks me to compare objects on the left with their inverted counterparts on the right. His tessellations challenge me to trace the dual logic of the curves that outline the tiles.

Escher once said that if he had a second lifetime he might have become an animator. Perhaps in a third lifetime he might have designed games.

Many artists have found that games let viewers experience their work in a deeper way. The Italian sculptor Miguel Berrocal makes intricate metal sculptures that come apart into many pieces. The Japanese artist Toshio Iwai made a computer game called SimTunes that invites players to experiment with patterns of color and sound. When I play with a Berrocal sculpture or an Iwai game, I gain an active understanding of how pieces relate to one another that is very different than if I merely viewed them passively. "I hear and I forget, I see and I remember, I do and I understand."

Fig. 1. Screen shot from *Escher Interactive*

Escher Interactive

I got my chance to design an Escher game in 1994, when author Joost Elfers invited me to contribute to a CD-ROM called *Escher Interactive*. Over the next year I worked with programmer David Oster in California, and Mike Chanowski and Henk Alles at Eyeware Interactive in the Netherlands where the disk was being produced, to create a collection of sixteen "Impossible Puzzles". They are called impossible not because they are impossible to solve, but because they are based on impossible figures and other spatial illusions from Escher's work.

Escher Interactive is the first major software project based on Escher's work. Published in 1996, the disk includes an art gallery, timeline, interviews with experts, animations of Escher works, three games, and a drawing program for creating tessellations (see Fig. 1).

Impossible Puzzles

The player's goal in each Impossible Puzzle is to assemble a collection of pieces into a given shape. Often the final shape is a visual illusion. Each piece is made of cubes seen in flat isometric projection. Pieces may be overlapped, but not rotated.

The Letter M	The Letter C	The Letter E	The Letter S
The Letter C	The Letter H	The Letter E	The Letter R
Impossible Triangle	Relativity	Dragon	Columns
Convex Concave	Ascending	Waterfall	Belvedere

Fig. 2. The sixteen puzzles in *Escher Interactive*, based on Escher's work

The first eight puzzles are the eight letters of the name M.C. ESCHER. The last eight are based on specific Escher prints. Each puzzle has a unique solution, in order to make the puzzles harder, as well as to make the answers easier for the computer to verify. The sixteen puzzles are illustrated in Fig. 2.

The idea for the Impossible Puzzles first appeared in my earlier game *Heaven & Earth* [10]. I designed over six hundred puzzles on the theme of Illusions for *Heaven & Earth*, working with lead game designer Michael Feinberg, producer Brad Fregger, programmers Ian Gilman and Michael Sandige, artist Mark Ferrari and musician Richard Marriott.

M.C.

The first two puzzles, **M**, **C**, are shown in Fig. 3. The goal is to overlap the small pieces to make a copy of the big shape. Pieces cannot be rotated; they must stay in their original orientation. Of course you could play this game with cut-out paper pieces, but on the computer, pieces are easier to manipulate. Pieces automatically snap into place, and pop to the front layer when you click on them. The computer also automatically enforces the rule that pieces cannot be rotated.

As in most computer games, the first few puzzles are easy and then the puzzles gradually get harder. The main purpose of the first two puzzles is to teach the rules of the game. Fig. 4 shows their solutions; notice how pieces overlap.

Fig. 3. The puzzles **M** and **C**

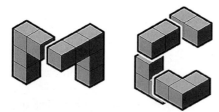

Fig. 4. Solutions to the puzzles **M** and **C**

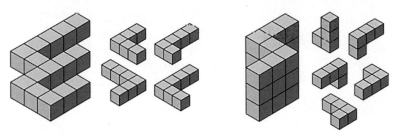

Fig. 5. The puzzles **E** and **S**

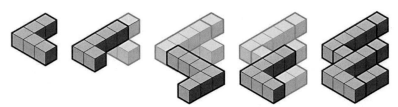

Fig. 6. The solution to the puzzle **E**

E S

The puzzles **E**, **S** are shown in Fig. 5. Although pieces appear to be solid, the player must think of them as flat shapes cut out of paper – pieces sometimes overlap in ways that make no sense in three-dimensional space. For instance, the solution sequence for **E** is shown in Fig. 6.

C H

The puzzles **C**, **H** are shown in Fig. 7. Notice that the way you perceive the shapes in three dimensions shifts while you are putting the pieces together. For instance, in the solution sequence for **C**, cubes that appear to be in the same plane at one stage shift into different planes at a later stage because other pieces have been added.

I have seen other illusions in which your perception of a situation changes when you add or remove a piece, but I do not know whether anyone has given this type of illusion a name. I like to call them "interactive illusions." Because interactive illusions are under your control, the effect is particularly startling. (I have included interactive illusions in several of my computer games. For example, *Heaven & Earth* includes interactive illusions based on figure/ground ambiguity.)

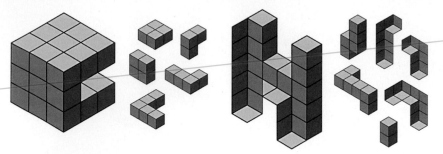

Fig. 7. The puzzles **C** and **H**

H introduces concave/convex ambiguity, which appears in Escher's print *Convex and Concave* (see page 132). Assembling this puzzle is a disorienting experience: pieces often overlap along faces with contradictory interpretations. It was particularly difficult for me to find a way to break this shape into pieces so the solution was unique.

E R

The last two puzzles, which complete Escher's name, are in Fig. 8. The second **E** is an "improbable figure" – it appears to be an **E** only when seen from certain angles. Notice that the shape is composed entirely of L tetrominoes in various orientations. To keep the solution unique, no two pieces are identical.

R is an impossible figure, similar to the impossible triangle that appears in Escher's print *Waterfall* (see page 65). To make it more challenging for the player I made the initial arrangement of pieces appear to be close to the solution. In fact most pieces are not where they should be in the solution.

Fig. 8. The puzzles **E** and **R**

Fig. 9. M.C. Escher, vignette 4 *Graphic Artists*, 1952. Woodcut

Escher himself occasionally played visual tricks with letterforms. Fig. 9 shows a print he made to announce a four-person art exhibition. Notice how the same letters can be perceived differently depending on their orientation: the **E** also serves as an **M**, the **H** as an **I**, the **U** as a **C**, and so on. A similar crossword design appears at the beginning and end of his epic scroll *Metamorphose* (see page 147).

A similar design on the name "M.C. Escher" appears in my book of illusionary lettering designs *Inversions*. An animation of this design appears in *Escher Interactive*; you can also find it on the CD-ROM accompanying this book.

Triangles

The Impossible Triangle, also called the Penrose tribar, was invented by British psychologist L. S. Penrose and physicist son Roger Penrose in 1958. (Dutch artist Oskar Reutersvärd discovered the shape much earlier, but did not publish his work until later.) Their original article [9], which they sent to Escher, included drawings of both the impossible triangle and an endlessly rising staircase.

The puzzles "Impossible Triangle" and "Relativity" are shown in Fig. 10. Try playing the demo version of the impossible triangle puzzle on the CD-ROM that accompanies this book. As you join one bar to the next you will find that the loop always closes with one bar in front of another where it should really be behind. Use the two extra parallelograms to patch up this defect.

Fig. 10. The puzzles "Impossible Triangle" and "Relativity"

Escher's print *Relativity* also involves a triangle, but not an impossible one (see page 265). Instead, it plays on the ambiguity of which way is up. The corresponding puzzle simplifies the triangle of stairs in Escher's print, and adds a new twist: pieces that reverse the sense of convex and concave, similar to Escher's *Convex and Concave* (see page 132).

Flat and Solid

In his prints *Dragon* (Fig. 11) and *Two Doric Columns* (see page 9), Escher questions whether the image you are seeing is flat or solid. To turn these works into puzzles I had to figure out a way to simplify the images into parallelograms. For each, I made different compromises (see Fig. 12).

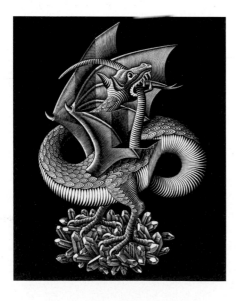

Fig. 11. M.C. Escher, *Dragon*, 1952. Wood engraving

Fig. 12. The puzzles "Dragon" and "Columns"

The puzzle "Dragon" retains the pattern of folded slits in a flat surface, but discards the dragon itself. The puzzle "Columns" uses a different illusion from the one in the original work. Instead of exploiting flat versus solid, the puzzle exploits concave versus convex. Nonetheless it retains the form of two colums, each resting on the opposite side of the other's tail. This illusion is strikingly captured in drawings by Sandro Del Prete and paintings by Jos de Mey (see pp. 125–141).

Notice that Escher's depiction of the columns, as well as mine, is completely symmetrical. One of the pairs of pieces in the "Columns" puzzle, however, is not symmetrical.

Staircases

Escher's *Convex and Concave* (see page 132) contains the classic ambiguous staircase illusion, broken into a symmetrical arrangement of pieces. The corresponding puzzle also has pairs of matching pieces (Fig. 13). Escher's *Ascending and Descending* (see page 6) contains the impossible endlessly rising staircase. The corresponding puzzle reduces the staircase to just one step on each leg. If we reduce the staircase even further, we get the impossible staircase with the fewest number of steps that can be composed of cubes (Fig. 14).

Fig. 13. The puzzles "Convex and Concave" and "Ascending and Descending"

Fig. 14. The smallest staircase

Of course the endlessly rising staircase is impossible only if we assume that what seem to be straight lines, right angles, and connected cubes actually are as they appear. If we allow the cubes to be slightly distorted into wavy surfaces, then we can make a three-dimensional model that looks just like this figure when viewed from a particular angle.

Note that in both the original Escher work and my puzzle the left two legs of the stairs' circuit are shorter than the right two legs. The asymmetry is aesthetically unappealing, but unavoidable. In my study of four-dimensional impossible figures – three-dimensional "drawings" that appear impossible to a four-dimensional person – I found that the four-dimensional analog of the impossible staircase has no such asymmetry.

Impossible Figures

The final two puzzles involve impossible figures. The mill race in Escher's *Waterfall* (see page 65) is constructed from three impossible triangles. The corresponding puzzle abstracts this impossible geometry (Fig. 15). Notice that the ends of the puzzle pieces are all shaved slightly differently.

Fig. 15. The puzzles "Waterfall" and "Belvedere"

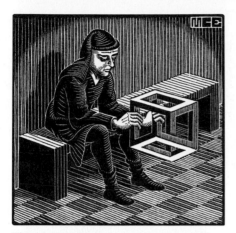

Fig. 16. M.C. Escher, vignette *Man with Cuboid*, 1958. Wood engraving

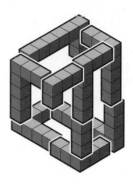

Fig. 17. Solution to "Belvedere" puzzle

The man seated in Escher's vignette *Man with Cuboid* (Fig. 16) is similar to the one sitting at the base of the stairs in the print *Belvedere* (see page 135). He holds a small model similar to the one in my puzzle "Belvedere" (Fig. 15). Since the exact model that he is holding had already appeared in *Heaven & Earth*, I twisted it differently for this *Escher Interactive* puzzle.

Notice that in the "cube" there are two points where one bar crosses in front of another. Because the seams of the cubes are visible, the back bar can be seen as merging into the front bar at these points. I exploit this ambiguity in the solution (Fig. 17).

Try It Yourself

Here is a version of the Impossible Puzzles you can play without a computer. It originally appeared in Games Magazine. Photocopy Fig. 18 onto heavy paper and cut out the pieces. Assemble the pieces to make the various configurations in Fig. 19. You can rotate or overlap pieces, but you can't fold or cut them. Each puzzle tells you how many pieces you may use. Answers appear on page 448.

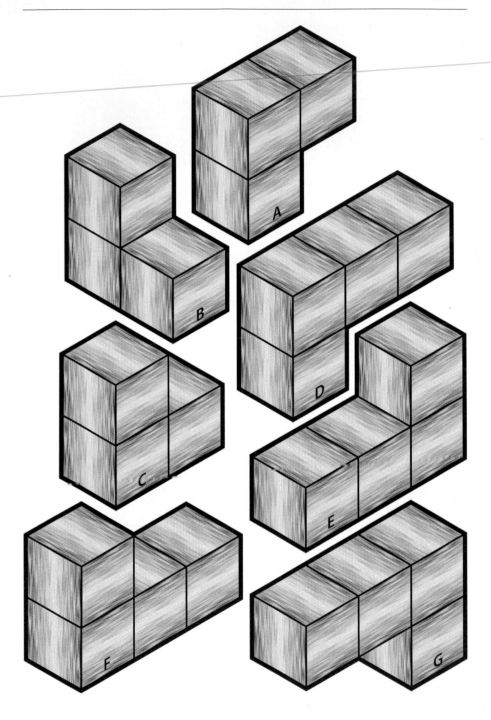

Fig. 18. A puzzle for you to cut out and play with

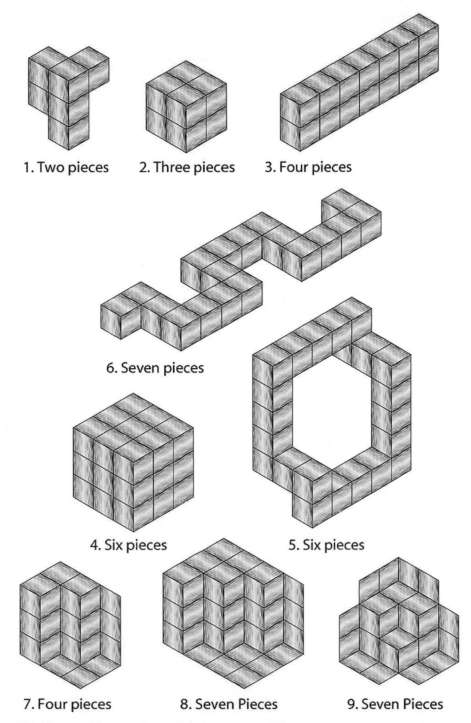

1. Two pieces 2. Three pieces 3. Four pieces

6. Seven pieces

4. Six pieces 5. Six pieces

7. Four pieces 8. Seven Pieces 9. Seven Pieces

Fig. 19. Assemble these shapes. Solutions on page 448

References

[1] Ernst, Bruno, *Adventures with Impossible Figures*. Berlin: Taschen 1985.

[2] Eyeware Interactive BV, *Escher Interactive: Exploring the Art of the Infinite* (CD-ROM for Windows). New York: Harry N. Abrams, London: Thames & Hudson, Paris: Hachette Multimedia, Cologne: Dumont Verlag, Utrecht: A. W. Bruna, 1996.

[3] Gardner, Martin, "From Burrs to Berrocal," *Scientific American*, January 1978. Reprinted in *Penrose Tiles to Trapdoor Ciphers*, W. H. Freeman and Company, 1989.

[4] Iwai, Toshio, *SimTunes* (CD-ROM for Windows). Electronic Arts / Maxis, 1996.

[5] Kim, Scott, "An Impossible Four-Dimensional Illusion." In Brisson, David. *Hypergraphics: Visualizing Complex Relationships in Art, Science and Technology*. Westview Press, 1978.

[6] Kim, Scott, "Convex Concave," *Games Magazine*, October 1993, p. 20.

[7] Kim, Scott, *Inversions: A Catalog of Calligraphic Cartwheels*. Key Curriculum Press, 1996.

[8] Kim, Scott, *www.scottkim.com*

[9] Penrose, L. S., and Penrose, R., "Impossible Objects: A special type of illusion," *British Journal of Psychology* [49] (1958), 31.

[10] Publishing International, *Heaven & Earth* (floppy disks for Mac or Windows). Buena Vista Software, 1992. (out of print)

Escher's World: Structure, Symmetry, Sense

Vladimir A. Koptsik

In 1959 I heard for the first time about the interesting and original artist Maurits Cornelis Escher. My scientific supervisor A.V. Shubnikov showed me Escher's book *Grafiek en Tekeningen*, which was sent to him from Sweden by the well known crystallographer P. Terpstra. Shubnikov also told me about the letter which he sent to Sweden; the letter gave high praise for the artist's drawing skill. Only recently did I have the chance to read Terpstra's account of Shubnikov's letter and Escher's reaction to it. Here is this letter [1, p. 99]:

> *Groningen, 1 February 1960:*
>
> *Dear Mr. Escher, I sent a copy of your* <u>Graphiek en Tekeningen</u> *to the Academician A.V. Shubnikov in Moscow (one of the top authorities in the field of crystallography). Today I received a letter from him in which he says, "I find Escher's prints extremely interesting, because they are an excellent illustration of the theory of antisymmtery. The picture on the cover of the book, for example, shows that antisymmetry rotation points of the second order exist in the given two-dimensional symmetry group."*
>
> *The print* <u>Day and Night</u> *made a great impression on me. It can be considered as the imaginary antisymmetrical operation of transformation of our light, left world in[to] the right, dark counter – world of Dirac.*
>
> *I presume you will be pleased to hear this.*
>
> *Yours sincerely, P. Terpstra.*

Many other commentators had opinions similar to Shubnikov's about this woodcut. M.C. Escher agreed with the possibility of other interpretations of the woodcut different from the his. But he remarked that in the course of creation of the picture he didn't have in mind anything similar to that concept. His plan was to create the "dynamical equilibrium" of the parts in the composition of *Day and Night* (Fig. 1) that is, to provide the characters of his "story in pictures" (he called them "speaking figures" [1, p. 162]) with dynamical equivalence. In the remarkable 1958 essay which reveals his creative method, he wrote the following [1, p. 169–170]:

> *The dynamic equilibrium between the motifs*
> *This most fascinating aspect of the division of the plane, already described above, has led to the creation of numerous prints. It is here that the representation of opposites of all kinds arises. For is not one led naturally to a subject such as* <u>Day and Night</u> *by the double function of the black and white motifs? It is night when the white, as an object, shows up against the black as the background,*

and day when the black figures show up against the white. Like-
wise, the idea of a duality such as air and water can be expressed
in a picture by starting from a plane-filling design of birds and fish;
the birds are "water" for the fish, and the fish are "air" for the
birds. Heaven and Hell can be symbolized by an interplay of angels
and devils. There are many other possible pairs of dynamic sub-
jects – at least in theory, for in most cases their realization meets
insuperable difficulties.

We shall discuss below in detail the means used by M.C. Escher to embody his creative ideas. We first note the fact that the variety of interpretations of an artistic text is connected in general with the polysemantics of the works of art, with its conventional nature, and with the mixed personal-social character of interaction between the artistic text and the reader, spectators or listeners, the essence of which is co-creation. The other central problem of art is the very process of artistic creation that transforms the author's ideas into an artistic text.

In the broad sense of the term, an *artistic text* is a semiotic system that is the organic unity of the plan of expression and the plan of content (sense), the conventional sign and its meaning, the material and the ideal. In the narrow sense of the word, we consider the text as its material component only, that is, the coded materialization of the flow of ideas connected with the author's plan, its embodiment and the artistic work itself. At the same time there is no strict equality between the sense of an artistic work and what the artist wished to express. In general, an artist succeeds in embodying his creative plan in material only partly and the text created by him proves to be loaded with other meanings (senses) not expected by him.

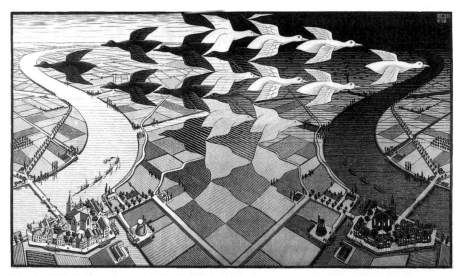

Fig. 1. M.C. Escher, *Day and Night,* 1938. Woodcut

Let us denote the author's understanding of his own work (artistic text) by the symbol A or I_0. Let I_1, I_2, I_3, \ldots be the interpretations of different readers, spectators or listeners, arising as a result of their contacts with the text. Then what we are talking about can be drawn in a set-theoretical diagram (Fig. 2), which we called in [2] and [3] the "*Lotman flower*" in honor of Yu.M. Lotman, the Russian researcher of artistic literary texts, who is a semiotician, structurologist, and historian of verbal art and culture.

We select *Day and Night* to illustrate our analysis, and denote by I_1, I_2, I_3, I_4, I_5, ..., I_n the interpretations belonging to H.S.M. Coxeter–I_1 (1972) [23], R. Penrose–I_2 (1986) [5], A.V. Shubnikov–I_3 (letter, 1959–60), C. MacGillavry–I_4 (1965,1976) [6], D. Hofstadter–I_5 (1979) [7], ..., and the author of the present paper–I_n (1974, 1997) [3, 10]. The interpretations I_0 and I_3 were quoted earlier. We shall speak below about I_5 which is close to our point of view. In every case, the interpreter I_k contacting the text (the shaded circle in Fig. 2) and trying to reveal its sense in the course of decoding the text can reveal the author's plan (idea) only partly. At the same time he can add to it his own understanding of the work of art connected with his own experience with art, the richness of his own life (private world), his own preferences, artistic traditions and outlook (philosophy). The spectator's interpretations I_k (except I_n) are shown by dotted lines in Fig. 2. These ellipsoidal petals of the flower intersect with I_0 only partially.

The question arises: Which I_k manages to get maximally close to I_0? Or a yet more general question: Is it possible to establish the theme (or the main idea) of the work of art according to its text without knowing the author's interpretation I_0? The answer is affirmative: It is possible with some degree of approximation, because the author strives to be understandable if he creates not only for himself. For instance, knowing about possible different interpretations of black and white, Escher must have used these to serve as prompts to the spectator and must have tried to remove motifs that might lead the spectator in another direction. Even so it is impossible to get rid of conventionality, polysemanticity,

Fig. 2. The informational–semiotic structure of the work of art: the "Yu. M. Lotman's flower"

ambivalence and fuzziness in the interpretation of representation, idea and plot of the picture.

The first prompt to the spectator is the title which governs the representative plan of the picture and determines the setting of perception. Indeed, a first glance at the picture shows that it depicts some concrete manifestations of day and night simultaneously in static and dynamic aspects. At the same time, the semantic neutrality of the title does not allow us to fix a single interpretation of a frozen instant or a transition between the states. A more detailed analysis is necessary.

The main striking structural peculiarity of the composition *Day and Night* is its vertical mirror (anti)symmetry; it is not strict in geometrical details, but has an ideal balance in color and composition for each separate figure – town, river, part of the field, road – there corresponds a mirror-equivalent figure. The mirror reflection of the composition was more often connected by the spectators according to their own experience with the stability of reality. In the picture plane which represents the earth there is no sign of struggle. The idea of a peaceful life of the city-dwellers is supported by the geometrical equivalence of the sailing convoys of ships, the early passers-by going to their fields on the bridge, and by their absence on the other bridge (the workers have returned to the black city, but the windows are still lit: people are preparing for the night). Everything witnesses that both towns are inhabited by peaceful people and the only difference is that in one town it is daytime while in the other it is night. But as time goes by, night will fall in the white town, and day will come in the black one. After the natural change of states both towns will preserve their quality of being peaceful and quiet. The idea of dynamical equivalence, I_0, wins!

At first glance this peace is disturbed only by slight disharmony. The layout of fields between the two towns is such that parallel lines of roads and boundaries going from the black town converge (in perspective) in the southeast while those going from the white town converge in the southwest. But this difference of perspectives is canceled by the layout of fields situated on the other sides of the rivers according to the same chessboard plan as between the towns. Here the infinitely far points of both perspectives coincide for both towns and in no way may serve as evidence of the different outlooks of city dwellers. The very principle of the chessboard planning of fields which gives to both towns plots of equal fertility, area and topographic characteristics speaks in favor of their friendliness. It is unlikely that the chessboard field coloring was defined by the regularity of sowing two different crops. White and black serve there as a conventional sign of the white fields belonging to the white town and the black ones to the black town. The bends of the rivers at the horizon allow us to suppose that they flow into the same sea. Therefore the two rivers are equal and differ only by illumination.

The elements of confrontation are seen only in the upper part of the picture – in the sky. It is necessary for the two flocks of white and black geese to literally force their way through each other because of the dense packing and the absence of free space in the sky. But one may see the situation also in a different way: the separation in color of white birds against the black background may be understood as the flocks of birds flying at different levels without disturbing

each other. But what do they represent in the picture? What semantic part do they play? It cannot be excluded that the unlikely event of two flocks of birds meeting at the same time and place at the break of day or night is just a symbol of rays of dawn going to the black town and night going to the white town.

This structural analysis reveals a greater number of arguments in favor of Escher's interpretation I_0 of peaceful coexistence of towns as compared with Shubnikov's interpretation I_3 of their confrontation. But let's not be in a hurry. Escher's picture is not a real situation but a fairy tale. The artistic space and time by no means coincide with the real ones, and utterly improbable events may happen there. The confrontation of the good and dark forces which ends in a victory for the forces of good is a typical theme of fairy tales. The same semantic roles of black and white occur in Western mythology and Christian religion. If one adds to this that the woodcut *Day and Night* was created in 1938 at the end of the Spanish Civil War and on the eve of the Second World War it may not be denied that Escher's troubled mood was unconsciously reflected in his composition. Shubnikov's interpretation of Escher's picture becomes quite natural and legitimate for people who experienced all the horror and deprivation of World War II.

Is it possible under such conditions to speak about some general sense of Escher's picture shared by a wide category of either experts or ordinary spectators? One can attempt to reveal it, though the polysemantic field of a true work of art can hardly be squeezed into the bed of Procrustes of "general sense" without losing some of its artistic merit. Art as the self-consciousness of culture [8] is a social institution, the form of social artistic knowledge (cognition), and sometimes fantastic (imaginary) modeling of reality (the "second reality"). At the same time it is a process and a result of creation and co-creation (a dialogue between the semantic field connected with the work of art and the mentality of the observer). The highest sense of art (as the sense of life itself) is in its rich conceptual being. The abstract concept of "opposition of antipodes" will be the metasense, the invariant of the transformation $I_1 \rightarrow I_3$, $I_3 \rightarrow I_1$.

To sum up our results on Escher's woodcut *Day and Night*, it is certain that reduction to the artist's understanding I_0 or to individual interpretations I_k, or to the union of their conceivable intersections (the common subset of both sets I_i and I_k) is impossible. Cognitive-aesthetic information in art studies is not reduced either to the sum of concrete investigations or to the sum of their commonplaces (intersections), but includes in itself some system effect. Then the best approximation to the artistic sense of the work will be striving for an extension of the quality of understanding the union of all individual senses (petals I_k of the "Lotman's flower") multiplied by some factor which extends the informational system and takes into account the system effect. At the same time it will be a shared understanding of works of art by a large category of interpreters which will increase together with the number of individual senses that constitute a semantic field of the woodcut.

All these considerations are reflected in our diagram (Fig. 2), where I_4 represents the "crystallographic" reading of some of Escher's texts, I_1 and I_2 are readings of well-known mathematicians who presented to M.C. Escher the idea

of self-similarity tending into infinity and the idea of "strange loops" and who admired their artistic realization. D. Hofstadter's interpretation I_5 [7] established a structural correspondence ("translation") of a number of Bach's canons and inventions with some of Escher's compositions. Hofstadter's interpretation of Gödel's theorem and its application to works of art is of special importance as it demands from art studies the informational completeness found in the variety of their languages of description. The same claim was repeatedly declared by Yu.M. Lotman [9] who defined the very sense of a work of art as a mental invariant (verbal and/or visual) preserved under the translation $T_1 \rightarrow T_2$ from one language to another language, and mapped into itself by the inverse translation $T_2 \rightarrow T_1$.

Finally, we should mention the interpretation I_n. Instead of an ellipsoidal dotted petal in the "Lotman flower" there is a dotted circle enveloping I_0 and interacting in the form of a dialogue not only with the author's sense I_0, but also with all significant (for the author of this report) interpretations I_k in the intersection. It goes without saying that upon the increase in the number of I_k (along with self-education of the interpreter), the sense I_n will grow to I_0 when n goes to infinity.

It is known that from prehistoric times ornament has performed ethnic and heraldic functions to distinguish between tribes, their chiefs, and estates. Later on the aesthetic function of decoration of clothes, habitats, tools and weapons emerged. Ornamental semantics became richer in content in connection with the function of performing religious ceremonies and the development of folk art: plays, songs and dances. The principles of ornamental composition gradually found applications in ornamental music, poetry, and in decorated rhetorical prose. It has long been held that the function of repetition of artistic motifs is one of the most important components of beauty in music, poetry and architecture. The principle of varying repetition of topics, of their interweaving, comparison, opposition, and dialogue has become the leading method of composition in temporal forms of art. It is interesting to note that in the Moorish ornaments of the 12th–14th centuries (and much earlier in Egypt) all two-dimensional groups of symmetry were discovered empirically [16], and the principle of varying (color) repetition in music appeared before the modern theory of antisymmetry and color symmetry with their positional Wp- and Wq variants that take into account local violation of symmetry [10, 17, 18].

Escher has enriched ornamental semantics and poetics in the framework of the principle of varying repetition of figures as well as produced a new genre of ornamental cognitive drawing. Escher's world is exceptionally rich: it is a multidimensional, polyfunctional and polysemantic world full of hidden metaphors and allegories. It is a world of fairy tales, full of paradoxes, where the impossible turns out to be possible, where infinite movement and improbable transformations are realized, and where new possibilities of artistic geometrical modeling open up.

In the theory of art it is useful to define the concept of symmetry as a set of artistic transformations of the plan of expression and content, which preserves the sense of a work of art (or of the set of works of art); this is equivalent to sym-

metry in the generalized sense [2, 3, 10, 12]. Depending on the definition of what substructure or a set of substructures of a work (or works) of art will be invariant, one will get a hierarchy of different symmetries distinguished by the concrete expressive sense and/or structure of art transformations. From this point we can go to a symmetry analysis of Escher's compositions.

Let us denote by $1'$ the operator of color inversion: white into black and vice versa. It is obvious that this transformation of antisymmetry does not belong to the complete symmetry of the original composition which preserves both the plan of expression and sense of the picture *Day and Night*. The action of this transformation on the initial composition gives another composition *Night and Day,* that is, the left white town becomes the left black one and also the right black town changes into white while preserving its position and chirality. At the same time this new composition continues to express Escher's idea of dynamical equivalence of the two states. The same result, *Night and Day,* is obtained under the action of mirror-reflection in a vertical plane in the middle of the print: this operator m (for mirror) transforms the position and chirality of the figures (interchanging left and right), but preserves the colors.

Now let us introduce the combined operator, the plane of antisymmetry m' which consists of two operators, $1'$ and m acting simultaneously: $1'$ on color and m on the position of the figures (that is, on the coordinates of its material points). Then such an operator m' expresses the complete sign-sense symmetry of the original picture *Day and Night* because under the action m' the right black town goes into the left white town and vice versa. We may thus conclude that in performing a symmetry analysis of the art composition, one must distinguish between complete sign-sense symmetry and partial sense symmetry because one and the same sense may be expressed in different languages.[1] And because an art composition is always polysemantic, its generalized symmetry reveals itself more completely in the set of generalized transformations that preserve the "Lotman's flower" (Fig. 2) corresponding to this composition. The invariants of symmetry transformations in the plan of expression will be the artist's style in the given period of his creative work.

Naturally, the inner world of the artist is indirectly influenced by the historical epoch in which he lives, and the cultural and artistic tradition which may define directly or indirectly appropriate subjects and impose limits on his artistic language. It may force him to create by "laws of beauty," by laws of genre and style, by laws of "reflection" or correspondence to the "truth of life" and/or correspondence to the internal world of the artist. The artist is also limited by the laws of the language of art at his disposal, by the material specific for the given form of art, and the "alphabet," the "vocabulary," the "grammar," the logic,

[1] Let us note a correlation of our terms with the terms of connotative and denotative "semiotics" used in the semiology. They have relation to separated and formalized systems of signals that have only a plan of content (sense) of the primary level or a united and indivisible expression - content of the second (higher) level correspondingly (see [26], p. 387 of the Russian edition or the items 1.2 and 1.3 of the section D "Borders of Semiology" in the original Italian edition).

Fig. 3. The philosophical hierarchy of substructures of reality – the external and internal worlds of the artist.
0–the semiosphere [9].
1,2,3 the steps (stages) of the external worlds: **1**–nature, **2**–society (community), **3**–man,who is the product and the creator of his own culture [8] (material components of the culture are shown by the solid circle, mental components belong to the semiosphere **0** are not shown.
4–art as the totality of all its texts.
5–the creative works of a given artist.
6–the internal world of the artist as the mental field of all his texts.
7–the text of a given work of art.
8–the mental (substantial) field (content) of the given work of art

and the ways of combination of an artistic sign with its senses which may be developed by the artist himself [2, 3, 10–12, 16, 20, 26]. Let us embrace all those factors by the term "external world" and draw on the oversimplified diagram (Fig. 3) the multi-level structure of the creative work of the given artist, which must be taken into account by a modern researcher who seeks to penetrate into the mystery of the personality of the artist and his art by all the texts bearing a relation to the text under investigation (its "dialogues" and "verbal exchanges").

Let us give a more concrete expression to the diagram in Fig. 3 in conformity with Escher's work during his second (crystallographic) period (1937–1969). The semioticians still argue on the question, "is art a semiotic system?" [20, 26] Taking a sufficiently developed natural language for the standard of the semiotic system, many of them deny art this quality, while others consider the semiotics of art as an incomplete (imperfect) system, We disagree: the semiotics of fine arts (graphic art being among them) cannot be considered as an underdeveloped system. The system is qualitatively different. Although it lacks the cognitive-analytical (verbal) qualities of the natural linguistic systems, it exceeds (or rather supplements) them in its specific and concrete imagery, its emotionally saturated and integral language.

Let us consider specific characteristics of black-white graphic art as a semiotic system characterized by increased fuzziness.

Its *alphabet* consists of material points, distinguishable by the eye – segments of straight and curved lines and spots, colored homogeneously – in black against a gray or white background or in white against a black background. These generalized geometrical images serve as analogs of letters: if allowable transformations of the letters preserve their "meaning" (sound), then the allowable scaling transformations, transformations of curvature and color, as well as changes in saturation of lines leave the visual images invariant. The very being of the thing in the real world, corresponding to the sign, then becomes its only sense. The typology of visual images then corresponds to the combinations of the finite number of letters in the alphabet.

The *vocabulary* of the black-white tone drawings consists of the "words" created by the artist; that is, of the signs consisting of the intersections, associations and intertwinings of the lines, points and spots. As in the case of words in a natural language, the only sense of a geometrical configuration may turn out to be its own existence, sometimes combined with functions of the background and the context of the drawing. But creation of understandable images ("speaking figures" according to M.C. Escher) is the aim of the artist. Recognizable images that occur in the real world (or in the inner world of the artist) can be recognized by the contour (outline), silhouette or the surrounding context. The sense of these "words" has been established in the course of centuries-old art tradition, in dialogues and exchanges of the texts in the repeatedly renewed process of creation by artists and co-creation by interpreters who vary and enlarge the word supply of "drawing vocabulary" of mankind. Its difference from verbal (explanatory) and etymological dictionaries lies in the fact that the thousand-year experience of analytical cognition of humanity is reflected in the dictionaries of natural languages. At the same time, modern graphic artists create the language and style of their own work, as well as the form of writing at a given moment, but in correspondence to and opposition with cultural and artistic traditions limiting their freedom. There are also limitations on the part of material: the drawing's "words" and "idioms" must be separated from the background; it reminds one of prosody (vowel interchange, alternation of the strong and weak syllables) in natural spoken language.

The *grammar* of drawing, that is, the rules of composition for phrases and idioms of drawing and composition rules is very arbitrary. It is reduced in principle to the single demand of emotional response and comprehensibility of images in the drawing, as well as senses associated with them in the context of the nearest surrounding of the drawing, the individual blocks of the picture as a whole.

Although it is possible in many cases to retell with words the content of a work of fine art (with the loss or impoverishment of the visual layer of information), it is impossible to replace such work of art by the verbal retelling. With all its specific language, art is competent and developed in its own semiotic system! See [2, 3, 8–15, 19, 20, 26] for details.

The senses of M.C. Escher's work, revealed by himself and others in [1, 4–7, 21–25], gradually shifted from typical works of landscape-architectural and portrait-still life genres toward the artistic exploration of some problems on the border between science and art, which became systematic in the second period of his creative work (1937–1969). The list of these problems is known [1]: the problem of regular division of the plane by relatively equal (symmetrical, antisymmetrical, and color-symmetrical) figures; providing these figures with the art semantics traditional for painting (and specific for M.C. Escher's semantics of a fairy tale); investigation of paradoxes of visual thinking – the existence in the picture plane of compositions impossible for ordinary perception ("improbable figures"), where figures escape from the plane into the space of a higher dimensionality; the problem of fractal filling of the plane with self-

Fig. 4. *Left*: M.C. Escher, *The Scapegoat*, 1921. Woodcut. The group of functional (transformational) antisymmetry of the playing card consists of the two-fold axis of positional antisymmetry supplemented by appropriate metaphoric transformations of the horizontal metamorphic symmetry plane and of the vertical metamorphic antisymmetry plane. The antisymmetry transformation $1'$ of re-coloring gives a formally equivalent expression of the card, but with a different content provided by the Christian religious tradition.
Right: The yin-yang symbol is presented here in two forms connected by the antisymmetry recoloring operator $1'$. It also expresses (in abstract philosophical form) the principle of dynamical equivalence of the two antisymmetrical states as in the woodcuts *Day and Night* and *The Scapegoat*

similar figures; and the problems of continuity and discreteness, the finite and infinite, order and chaos, "strange" movement repeated in cycles, metaphoric transformations from mythology and fairy tale.

The artistic manifestation of opposition (coexistence or struggle) of antipodes; antisymmetry (or color symmetry) of the phenomena of life understood as a generalized symmetry is a common topic (strange attractor) where all lines of narrative come together. As early as the beginning of his creative work, in the period of search for an individual style in the series of drawings created in 1921, young Escher discovered for himself the idea of black-white antisymmetry[2] and positional metaphoric equivalence of the "speaking figures" in the woodcut *The Scapegoat*, correlating with the well-known Eastern yingyang symbol (Fig. 4). In the rosette *Beautiful* [1, cat. no 82] Escher admires the kaleidoscopic beauty of the dazzling bright diamond pattern on the black background, beautiful in the geometrical regularity without ordinary "speaking" semantics of figures, but having geometrical (symmetry) metasemantics. And in two related woodcuts [1, cat. nos. 85, 86] he varied the degree of recognizabil-

[2] It is curious that the idea of black-white antisymmetry was introduced at the same time (1929–1930) in publications of German geometricians Alexander, Heesch and Weber. It was then developed and generalized by A.V. Shubnikov and other researchers.

ity of the female nude model as if to solve the question of the choice of style (realistic or abstract-symbolic).

Let us consider briefly through some examples what concrete artistic and scientific tools were used by the mature master to express the idea of opposition of antipodes. As we can see, the idea of dynamical equivalence of black and white in the print *Day and Night* was realized in the four-dimensional world of states, split into the three-dimensional geometrical world R^3 and the one-dimensional world of time R^1. The illusion of three-dimensionality was created by ordinary drawing tools (chiaroscuro), and the idea of movement is stressed by the "speaking figures," by the contrast of black and white, and by the title of the picture.

The illusory equivalence of *Ascending and Descending* (page 6) was created by splitting the three-dimensional space into two mutually orthogonal independent subspaces R^1 and R^2. Movement of the two columns of people in two opposite directions was actually carried out in the ordinary way in the two-dimensional plane R^2, and the illusion of ascending and descending was realized by the stepped outer walls and people's steps characteristic of ascending and descending the staircase in three-dimensional space R^3 (see the diagram of the woodcut in Fig. 5). The same idea is realized in the woodcut *Waterfall* (page 65). As a matter of fact, water flows in the picture plane R^2 through the plane gutters, driven by the wheel of the mill, and the illusion of slope is created by the architecture, angled turns of the gutters, and by the same wheel in R^3.

A cyclic movement with the periodical departure of drawing hands from two-dimensional into three-dimensional space was realized in Escher's woodcut *Drawing Hands* [1, cat. no. 355] by transition from the contour outline of the cuffs into the ciaroscuro representation of the hands. A representation of a closed loop may also be seen by the spectator in the woodcut *Print Gallery* (page 80). There the apparent reality (the series of drawings in the gallery and a young man

(a)

(b)

Fig. 5. A schematic explanation of the illusion of ascending and descending in M.C. Escher's print of the same name (see page 6). (**a**) The plan of the roof of the building (the top view) consists of the internal plane square path (road) and the external step-like walls. (**b**) The profile of the front external wall shows the sawtooth steps on the wall with the saw lengthening in the horizontal direction

viewing one of them) turns into the imagined (but also expressed) town where the young man lived. This method of co-existence of two planes of reality (a picture in picture, a novel in novel) is often used in art.

The existence of three worlds can be mentally reconstructed for the appropriate woodcut [1, cat. no. 405] by the projections of the three-dimensional over- and underwater worlds onto the two- dimensional plane. This effect is created by the recognizability of "speaking figures" existing on both sides of the dividing surface (the mirror surface of the water). Finally, it is possible to consider the imperfections of the architectural composition of *Belvedere* (page 135) as a projection of a summer house which is regularly constructed in imaginary multidimensional space, into the three-dimensional world, quite analogous to the case of projections of multidimensional regular crystal patterns into three-dimensional space. The properties of regular periodicity and crystallographic symmetry are lost in such projections, corresponding to the "improbable" yet existing patterns in so-called quasicrystals [17, 18].

To conclude this essay, I would like to return to its beginning. I often show Escher's drawings to students to illustrate the ideas of antisymmetry, color symmetry, and metaphoric positional transformations. But on August 18, 1960 my distant acquaintance with M.C. Escher became a personal one. At the International Crystallographic Congress at Cambridge, England I was introduced to M.C. Escher. After his brilliant lecture on regular divisions of the plane by the "speaking figures" he stood in the corner of the lecture room surrounded by admiring people and smiled confusedly in the zenith of his crystallographic and artistic glory. Such an image of him has remained in my memory in the haze of years passing by.

Acknowledgement

I wish to express my gratitude to Michele Emmer and Doris Schattschneider, the organizers of the Congress [24, 25], for their assistance and the corrections to my text, and to Oleg Belyaev for technical help. Unfortunately, I could not take part in the Congress. But my work on the text of this paper gave me once again a unique possibility to have a mental dialogue with the great artist and apply my theory of generalized symmetry in art to Escher's world of prints.
This work was done under the support of RFFI, grants #96-06-80156a and 99-06-80300.

References

[1] F.H. Bool, Bruno Ernst, J.R. Kist, J.L. Locher, F. Wierda. *M.C. Escher. His Life and Complete Graphic Work*, London: Thames and Hudson; New York, Harry N. Abrams, 1982.

[2] V.A. Koptsik. "Creative power of dissymmetry in science and art and the principle of restoration of broken symmetry." In: *Katachi and Symmetry*. Ed. by T. Ogawa, K. Miiura et. al. Tokyo: Springer, 1996, pp. 363–371.

[3] V.A. Koptsik. "On the threshold of XXI century: The Dialogue of the Natural Sciences and Humanities (the problems of symmetry of the artistic text)." In *Mathematics and Art*, Moscow: "Tradition" foundation, 1997, pp. 77–87 (in Russian).

[4] H.S.M. Coxeter et al., eds. *M.C. Escher. Art and Science*. Amsterdam: North Holland, 1987.

[5] R. Penrose. "Escher and the visual representation of mathematical ideas." In [4], p. 143–157.

[6] Caroline H. Macgillavry. *Fantasy and Symmetry. The Periodic Drawings of M.C. Escher*. Utrecht, Oosthock, 1965; reprinted as *Symmetry Aspects of M.C. Escher's Periodic Drawings*, New York: Harry N. Abrams, 1976.

[7] D.R. Hofstadter. *Gödel, Escher, Bach: An Eternal Golden Braid*. New York: Basic Books, 1979.

[8] M.S. Kagan. *The Philosophy of Culture*. St. Petersburg: "Petropolis'," 1996 (in Russian).

[9] Yuri M. Lotman. *Universe of the Mind. A semiotic study of culture* (Translated from Russian). London & New York, Tauris & Co Ltd., 1990.

[10] A.V. Shubnikov and V.A. Koptsik. *Symmetry in Science and Art*. New York: Plenum, 1974. (Russian edition: Moscow, Nauka, 1972).

[11] Giuseppe Caglioti. *Symmetriebrechung und Wahrnehmung*. Translated from Italian. Braunschweig: Vieweg and Sohn, 1990.

[12] V.A. Koptsik. The translator's afterword to the Russian edition of the book [11], p. 201–218 (in Russian).

[13] R. Arnheim *Visual Thinking*. Univ. of California Press, 1969.

[14] D.S. Lichachev. *Notes on the Philosophy of Artistic Creativity*. St. Petersburg: the Russian-Baltic Information Center, 1996 (in Russian).

[15] I.V. Melic-Gaikazian. *Informational Processes and Reality*. Moscow, Nauka, 1997. (in Russian).

[16] Slavik V. Jablan. *Theory of Symmetry and Ornament*. Beograd: Matematiki institut, 1995.

[17] V. A. Koptsik. "Generalized symmetry in crystal physics." *Comput. Math. Appl.*, 1988, vol. 16, pp. 407–424.

[18] V.A. Koptsik. "Crystallography of Quasicrystals: The Problem of Restoration of Broken Symmetry." In: *Lecture Notes in Physics* v. 382. Berlin: Springer-Verlag, 1991, pp. 588–600.

[19] V.V. Nalimov. "The theory of meanings. The constructivistic aspects of the mathematical theory of consciousness." In *Mathematics and Art*, Moscow, "Tradition" foundation, 1997, pp. 19–31 (in Russian)

[20] Yu.S. Stepanov. *Language and Method. To the modern philosophy of language*. Moscow: Languages of Russian Culture, 1998 (in Russian).

[21] M.C. Escher. *Escher on Escher. Exploring the infinite.* New York: Harry N. Abrams, 1986, 1989.
[22] M.C. Escher. and J.L. Locher. *The infinite world of M.C. Escher.* New York: Abradale Press/Harry N. Abrams, 1984.
[23] J.L. Locher, C.H.A. Broos, M.C. Escher, G.W. Locher, H.S.M. Coxeter. *The World of M.C. Escher.* New York: Harry Abarams, 1972.
[24] Michele Emmer (ed.). *The Visual Mind.* Cambridge: MIT Press, 1993. See the paper "Reflections on Symmetry – Dissymmetry in Art and Art Studies," V.A. Koptsik, pp. 193–197.
[25] Doris Schattschneider. *Visions of Symmetry. Notebooks, Periodic Drawings, and Related Work of M.C. Escher.* New York: W.H. Freeman and Co., 1990.
[26] Umberto Eco. *Opera Aperta.* Milano: Casa, Valentino Bompiani & Co, 2a edizione, 1967 (Russian edition - Moscow: TOO TK "Petropolis," 1998).

Adapting Escher's Rules for "Regular Division of the Plane" to Create *TesselMania!®*

Kevin Lee

M.C. Escher's fascination with "regular division of the plane" is well documented both by his artistic works and numerous texts and articles. In his own words,

> *A plane, which should be considered limitless on all sides, can be filled with or divided into similar geometric figures that border on each other on all sides with leaving any "empty spaces." This can be carried on to infinity according to a limited number of systems.* ([1, p. 156]; also see [3, p. 15])

Mathematicians now call a "regular division of the plane" a tessellation (or tiling) and making such tessellations has become a wonderful activity for school children and teachers connecting mathematics and art. Jill Britton and Dale Seymour in their book *Introductions to Tessellations* [2] have introduced thousands of students and teachers to Escher's work and the joy of creating a tessellation. Unfortunately, due to time limitations in the classroom and the difficulty of creating tessellations by hand, students are able to experiment with just a few rudimentary tile *types*. A tile type is described by the specific geometric rules of how it is constructed and repeated to cover the plane without any gaps or overlaps.

The computer program, *TesselMania!*, was designed to let students easily create tessellations, therefore enabling them to explore many different tile types. The program was inspired by Escher's pioneering work on "regular division." In describing his study, he wrote:

> *At first I had no idea at all of the possibility of systematically building up my figures. I did now know any of the 'ground rules' and tried, almost without knowing what I was doing, to fit together congruent shapes that I attempted to give the form of animals. Gradually, designing new motifs became easier as a result of my study of the literature on the subject, as far as this was possible for some untrained in mathematics, and especially as a result of my putting forward my own layman's theory . . . It remains an extremely absorbing activity, a real mania to which I have become addicted. . .* [1, p. 164]

In creating the computer programs *TesselMania!* and *TesselMania! Deluxe* I experienced much of this same mania.

Escher's investigations of the geometry behind regular division is well documented by Doris Schattschneider in her excellent book: *M.C. Escher Visions of Symmetry* [7]. She chronicles Escher's initial introduction to the problem of regular division through his many years of investigations and discoveries.

He recorded his "layman's theory" in a notebook that was completed in 1942. This notebook was not published and relatively unknown until the first Escher Congress in 1986 when Schattschneider made it the subject of her talk and then wrote an article for the proceedings [3, pp. 82–96]. She expanded on it further in her book.

Escher's Initial Discoveries

Escher realized that when he started with a single tile (motif) there were only certain types of geometric moves, or motions, to apply that would not change the size or shape of the tile. These moves are known as isometries and math students learn that there are exactly four types: translation, rotation, reflection, and glide-reflection. In his lectures on regular division Escher would explain:

> Anyone who wishes to achieve symmetry on a flat surface must take account of three fundamental principles of crystallography: repeated shifting (translation); turning about axes (rotation) and gliding mirror image (reflexion). [4, p. 8]

Note that Escher states three fundamental principles, not four! He is clearly talking about translation, rotation, and glide reflection. But what about reflection? Escher certainly knew about reflection, but for creating tiles it is not a useful operation. If a side of a tile was used as a reflection line then that side is forced to be a straight line – not very helpful if you dream of creating tiles in the shape of lizards, fishes, or other creatures! For a further explanation, see [7, p. 33]. Interestingly, he did create some tiles with bilateral reflection symmetry (see [7, p. 118] for an example).

Escher initially did what every good mathematician does (although he claimed he was not a mathematician!) – he placed restrictions on his problem. When he set about to classify his tiles and tilings he initially limited himself to asymmetric tiles whose congruent copies produced tilings in which each tile was surrounded in the same way (hence the name "regular division of the plane"). An asymmetric tile is one that by itself has no symmetry. Moreover, he also required that in his tilings, no two tiles that shared a common border were the same color, and in achieving this, a minimum number of colors should be used. In Escher's view, tiling and coloring were inseparable problems. He actually did research in a field, eventually called color symmetry, that would not be fully explored by crystallographers until years later [7, p. 39]. He didn't really set out to classify tiles and tilings, but rather he set out to explore all the ways he could generate tiles.

The Idea for a Computer Program

The idea for a educational computer program to create Escher-like tessellations originated with Craig Solomonson and Shari Zehm at MECC (Minnesota

Educational Computing Corporation). They had noticed the popularity of sessions on tessellations at math teacher conferences. They attended several sessions on creating "Escher-like" tessellations in the classroom, including one by Jill Britton, and they were hooked. These workshops were teaching some of the geometric rules that Escher had discovered.

Craig and Shari quickly realized the advantage a computer program could bring to the process of creating tessellations. Craig then suggested the idea to me and used a computer paint program to illustrate how to create a few simple tiles. It didn't take long to figure out why Escher had found creating tessellations such an interesting problem and I, too, was caught up in the mania of trying figure out the geometric rules with the additional task of writing a computer program that applied the rules. Fortunately, Escher had already figured out the theory; I just had to be able to understand it and apply it in designing a computer program.

A Simple Quadrilateral System

The prototype for *TesselMania!* started with simple tile systems from Britton and Seymour's *Introduction to Tessellations*. By analyzing Escher's symmetry drawings, they managed to rediscover the 'ground rules' behind some of Escher's drawings. They describe geometric systems for creating Escher-like tessellations using their own graphic notation. As Escher discovered, the key to creating a tessellation is to start with a polygon that tessellates, and then alter the edges in such a way that the tessellating property is preserved. An **edge** of a tile connects two vertices. A **vertex** of a tile is defined as any point on the tile where more than two tiles in the tessellation meet. In Fig. 1 each tile has four vertices and four edges.

The first tile type implemented in *TesselMania!* was based on a parallelogram and used only translations. The initial parallelogram tiles the plane, forming the underlying grid of the tessellation. To transform the tessellation at the left in Fig. 1 to that on the right, two adjacent edges are altered and translated to opposite edges: the top edge is altered then translated to the bottom edge and the left edge is changed and translated to the right. The original vertex points do not change position and, in fact, form an underlying grid of parallelograms.

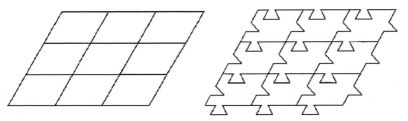

Fig. 1. Tessellation based on Translation

This strict application of the geometric rules guarantees that as a tile is copied and moved to the spot below it, the top edge of the copy will match exactly with the bottom edge of the original, or conversely, if the tile is moved to the position above it the bottom edge of the copy will match the top edge of the original. The same is true for moving the tile to the left or right.

Creating Escher-Like Tessellations

The tile-making process taught in many tessellation workshops for teachers uses an index card to create a tessellating polygon, usually starting with a square or a rectangle. A piece is carefully cut off one edge and taped to a corresponding edge according to the geometric rules for the tile type. This technique is discussed in more detail in the article by Jill Britton (page 305).

TesselMania! set out to mimic this process of transforming a polygon into an interesting tessellating shape, but adapted it to take advantage of the power of the computer. Students start by selecting a tile type (the geometric rules for the tile). Instead of cutting and taping a cardboard tile, they shape a virtual tile on the computer screen by using a tack tool that allows them to bump the sides of the initial polygon. As they introduce bumps on one side of the tile, corresponding bumps are automatically introduced on the related side. Unlike the index card method, students can re-shape their tile's edges at any time. As a further advantage, students see corresponding sides of the tile being formed simultaneously. Once they have completed the outline of their tile, computer paint tools can be used to add features to the interior of the tile. By clicking the "tessellate" button they see their tile repeated to cover the screen, complete with all the interior details.

The following illustration gives more details of this procedure. Here the tile type selected is a parallelogram with parallel sides related by translation (the same type of tile used in Fig. 1). Three tools are provided to manipulate the border of the tile: an arrow, a tack, and a scissors. The arrow is used to drag existing points on the tile, the tack is used to introduce and drag points on the border of the tile, and the scissors is used delete existing points. The tile outline is kept track of by the computer as a series of points that can be manipulated at any time. Figure 2 illustrates how the tile border tools are used to produce a tessellating tile. At every step in the construction the tile retains the ability to tessellate.

The last two stages show features added to the interior of the tile using the paint tools. The tools include a stamp tool with many pre-designed features like eyes, ears, noses, mouths, and hats to allow students to quickly add new features to their designs and to help the unfortunate student, who like me, cannot draw very well.

Figure 3 illustrates part of the plane (the computer screen) tessellated with the fish. Coloring is a key part of Escher's tessellations; he used color to make it easier to recognize individual tiles. In a tiling such as in Fig. 3, *TesselMania!*

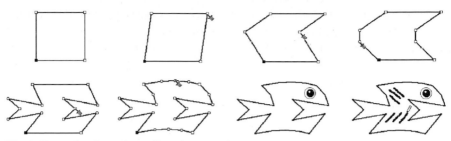

Fig. 2. Example of creating a tile using *TesselMania!*

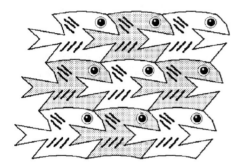

Fig. 3. A portion of the tessellated computer screen

places colors in contrasting pairs. Thus if a student paints inside the master tile, the surrounding tiles are automatically painted a contrasting color. This scheme is extended to triples of colors for tessellations that require a minimum of three colors for recognizability of tiles.

Tile Types and TesselMania!

The prototype for *TesselMania!* was created using the information about tile types from [2]. When I discovered *Visions of Symmetry*, I started to adopt Escher's numbering for his quadrilateral systems (Part I of his 1941–42 notebook) for some of the tile types. The remaining tile types were contained in his transition systems (Part II of the notebook) and his triangle systems (Part IV of the notebook). These two additional systems were harder to understand and I did not relish trying to explain the systems to school children. Eventually I switched to a system invented by the mathematician Heinrich Heesch. Heesch's classification system is very similar to Escher's system but mathematically more elegant and complete. Heesch proved there are 28 different ways (using combinations of translations, rotations or glide-reflections) to tile the plane in a regular way with an asymmetric tile. Each of the 28 ways determines a tile "type," since

the geometric motions that fit copies snugly next to each other naturally determine certain relationships among the edges of a tile. Escher's work shows that he, working independently of Heesch, discovered 27 of the 28 tile types.

Escher's Quadrilateral Systems (Part I of his notebook)

Part I of Escher's notebook describes his two-colored quadrilateral systems. These are systems that begin with an underlying grid of some type of parallelogram. He identified ten systems using a Roman numeral to indicate the system and further specified the type of quadrilateral by using a letter (A, B, C, D, or E). Each tile system is classified by the motions needed to move the original tile to the tiles adjacent to it. In a quadrilateral system, for each tile, there are eight surrounding tiles, four that share an edge with the center tile and four that share just a vertex. This property assures that the tiling can be colored using a minimum of two colors with no two tiles that share an edge having the same color. In fact, the coloring is just that of a checkerboard (see [7], p. 59).

Escher identified the relationships of tiles that surrounded a given tile by using transversal and diagonal directions. In the fish tessellation of Fig. 3, the central tile translates in both transversal directions (up-down and left-right) and translates in both diagonal directions; this is the signature of his quadrilateral system I. In some quadrilateral systems, it is possible for a tile to be related to an adjacent tile by a glide-reflection or by a rotation of 180° (2-fold rotation) or 90° (4-fold rotation). The centers (axes) about which a tile rotates to an adjacent tile must be located at midpoints of the sides of the parallelogram or at its vertices. In his notebook, Escher published a summary table for his quadrilateral systems; it is reproduced in [7, p. 61].

Escher's classification scheme is a *local* classification system in which he specified the moves needed to generate a tiling from a single tile. (This is in contrast to the "global" view of crystallographers, who classify using symmetry groups. They look at the *entire* pattern rather than only a patch surrounding one tile, and collect (in the symmetry group) all symmetries of the entire pattern.) An advantage of Escher's local system is that it also tells how to construct the tile. Essentially, he determined the geometric relationships among the edges of a tile and therefore determined how edges could be modified yet keep the tile's ability to fill the plane.

Heesch's System

Before exploring more of Escher's systems it will be useful to know how Heesch's system works. In fact I will use Heesch's notation to explain Escher's transition and triangle systems. I had implemented about eleven of Escher's tile

types in the software when Doris Schattschneider suggested I look at Heesch's system. She had mentioned Heesch in her book and included his table of 28 types of asymmetric tiles that can fill the plane in a regular manner without using reflections [7, p. 326 Table 2].

Heinrich Heesch was a German mathematician who in 1932 investigated and classified the possible asymmetric shapes that could tile the plane in a regular manner, not allowing reflections[1]. Unfortunately for Escher, this work was not published until 1963. Apparently, in 1963 they briefly corresponded [7, p. 44].

Heesch's table proved to be a computer scientist's dream, at least for a computer scientist who dreamed of creating a tessellations program. Not only does it classify all possible ways to create the tiles, but the notation system contains the algorithm that describes how each tile is made! Heesch's system is very similar to Escher's in that it uses local information about how the tile is constructed to classify the tile. He used a letter code, with subscripts when needed, to denote the geometric properties of the tile construction. For each edge of the tile there is a letter (and possibly a subscript) that indicates how it is constructed in relation to another edge in the tile. The number of letters equals the number of edges. He used the letter **T** to denote translation, **G** to denote glide-reflection, and **C** for rotation. For the letter **T** a subscript is never needed since it is clear that a translated side is matched with the opposite, parallel side of the tile. In the case of **G**, subscripts were used, if necessary, to denote corresponding sides. For rotation a subscript was used to indicate the amount of rotation: the letter **C** without a subscript represents 180° rotation (2-fold), C_3 represents 120° rotation (3-fold), C_4 represents 90° (4-fold) rotation, and C_6 represents 60° rotation (6-fold). Since the tilings produced with these tiles are periodic two-dimensional patterns, no other angle possibilities exist.

Figure 4 gives a stepwise explanation of the Heesch type for the tile in Fig. 2. In Fig. 4a the top and bottom edges are related by translation so they are each labeled with **T**. Similarly, the right and left edges are related by translation (Fig. 4b). All the labels are shown in Fig. 4c and the Heesch type is found by proceeding (counterclockwise) around the tile, recording the letters: **TTTT**.

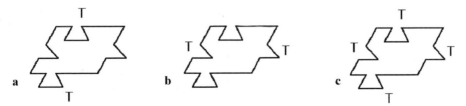

Fig. 4. Explanation of Heesch Type TTTT

The next example illustrates the use of subscripts to identify a tile type that uses a glide-reflection. It also involves reverse-engineering a tessellation, which

[1] A complete classification of isohedral tiles without the asymmetric restriction was done by Branko Grübaum and G. C. Shephard in their book *Tilings and Patterns* [6].

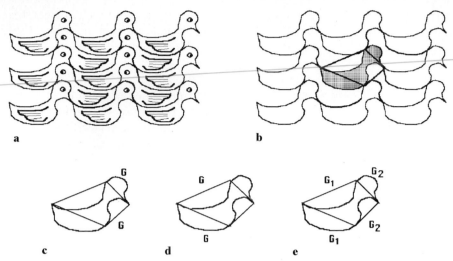

Fig. 5. Finding the Heesch type of a tile

is an activity students seem to enjoy, especially if the tessellation was created by Escher. Figure 5a shows a tessellation of ducks. The first step is to pick one duck and find its vertices by going around the boundary of the duck and finding points where more than two tiles meet. In this case there are four vertices of the tile, which also means there are also four edges. In Fig. 5b a single duck is high-lighted and the four vertices have been connected by line segments to show the initial polygon for this tile.

The next task is to figure out the relationships between the four edges of a single tile. In Fig. 5c the top right edge is related to the bottom right edge by a glide-reflection along a vertical axis. The two edges each are labeled with the letter G, The top left edge and bottom left edge are also related by a glide-reflection along a different vertical axis of the tiling so in Fig. 5d these two edges are also labeled with the letter G. But now there is a dilemma: it is possible to have glide reflections relate adjacent sides (as is the case here) or opposite sides. Heesch used subscripts (as shown in Fig. 5e) to resolve the possible ambiguity. The Heesch type for this particular tile is $G_1G_1G_2G_2$. *TesselMania!* has a feature to animate the creation of any tile to make it easier for the student to visualize the geometric relationships between pairs of edges.

For each of the 28 tile types, Heesch's notation system generates a descriptive label that contains the geometric information necessary to understand the tile type. If I were to use Escher's labeling system, I would need to include a separate explanation for each tile type. There is a fair amount of work involved in understanding Escher's three separate systems for the types of tiles I wished to implement. So I decided to drop Escher's numbering system in the software and replace it with Heesch's labels.

The relationship between Escher's ten quadrilateral systems and Heesch's system is shown in Table 1. Even though the *TesselMania!* software uses

Table 1. Comparison of Escher's ten quadrilateral systems and Heesch's system.

Escher's Quadrilateral System	Heesch System
I	**TTTT**
II	**TCTC**
III	**CCCC (IIIA)** **CCC (IIIC)**
IV	**G$_1$G$_1$G$_2$G$_2$**
V	**TGTG**
VI	**CCGG** **CGG**
VII	**CGCG**
VIII	**G$_1$G$_2$G$_1$G$_2$**
IX	**C$_4$C$_4$C$_4$C$_4$**
X	**CC$_4$C$_4$**

Heesch's system it will be useful to examine Escher's transition and triangle systems and correlate them to Heesch types in order to count the total number of Heesch tile types Escher discovered. Table 1 accounts for 12 Heesch types.

Escher's Transition Systems (Part II of his notebook)

In the second part of his notebook, Escher explained how his quadrilateral systems that require only two colors can be modified to require three colors for

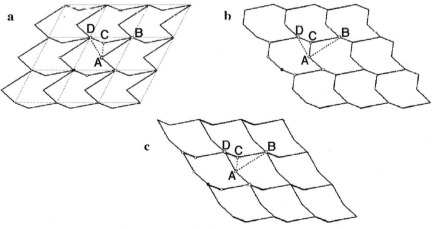

Fig. 6. Escher's Transition system IA–IA

Table 2. Comparison of Escher's Transition systems and Heesch's system.

Escher's Transition System	Heesch System
I^A–I^A	$TTTTT$
II^A–III^A	$TCCTCC$ $TCTCC$
V^C–IV^B	$TG_1G_2TG_2G_1$
VII^C–VI^B	$TCCTGG$
$VIII^C$–VI^C	$CG_1CG_2G_2G_1$
$VIII^C$–VII^C	$CG_1G_2G_2G_1$
IX^D–X^E	$CC_4C_4C_4C_4$

recognizability of tiles; this formed the basis of his "transitional" systems. I will illustrate one transitional system here, Escher's label for it is I^A–I^A. Later I will use a similar procedure to investigate a Heesch tile type Escher missed. (See Escher's notebook along with Schattschneider's comments in [7] for a complete description of all his transitional systems).

Step 1. (Figure 6a) Start with quadrilateral system I^A. Mark vertices **B** and **D** of one edge; mark any point **C** on edge **BD** and mark any point **A** on the adjacent edge with endpoint **B** as shown. (Heesch System **TTTT**.)

Step 2. (Figure 6b) Remove the portion of the edge from **A** to **B** and connect **A** to **C**. Do this to every tile in the tessellation. This new tessellation, in which each tile has 6 edges, requires a minimum of 3 colors. Escher denoted this as transition system I^A–I^A. (Heesch System **TTTTTT**.)

Step 3. (Figure 6c) The transition process can be continued. Now remove the portion of the edge from **A** to **C** and connect **A** to **D**. Do this to every tile in the tessellation. This returns us to a (different) two-color quadrilateral system I^A. (Heesch System **TTTT**)

Table 2 shows that Escher's transition systems account for nine more Heesch types.

Escher's Triangle Systems (Part IV of his notebook)[2]

Tilings that had 3-fold and 6-fold rotations were classified by Escher as triangle systems since they were based on an underlying grid of equilateral triangles. Heesch's tablei [7] shows there are only six tile types that include a C_3 or C_6

[2] The astute reader will notice that I skipped from part II of Escher's notebook to part IV. Part III is about a technique of splitting a single tile into two motifs so as to produce tessellations with two distinct interlocked shapes.

Table 3. Escher's Triangle systems and Heesch's systems.

Escher System	Heesch System
Tr I A₃ type 1	$C_3C_3C_3C_3C_3C_3$
Tr I A₃ type 2	$C_3C_3C_3C_3$
Tr I B₂ type 1	CC_6C_6
Tr I B₃ type 1	$C_3C_3C_6C_6$
Tr I B₃ type 2	$CC_3C_3C_6C_6$

symbol. Escher's triangle systems account for five of these six (see Table 3). (For further explanation of Escher's triangle systems see [7] or [3, p. 92]).

Escher's notes indicate he knew about the sixth Heesch type, CC_3C_3, since he specifically mentioned that he was not considering systems where more than 6 motifs meet at one vertex [7, p. 79]. Heesch type CC_3C_3 is the only tile type that produces such tilings, and in fact, these tilings have vertices where 12 motifs meet.

Counting Escher Tile Types: A Surprise and Mystery

Tables 1, 2, and 3 show that 25 of the 28 Heesch types have associated Escher systems. Heesch type CC_3C_3 was explicitly omitted by Escher. That leaves only two types to account for: $TG_1G_1TG_2G_2$ and TCTGG. Escher's symmetry drawing 78 of unicorns (color plate 3) contains the marginal note: "New System?" He could not find this system among those he enumerated in his notebook. Surprise! This is Heesch type $TG_1G_1TG_2G_2$. So, working independently, Escher had discovered 27 of the possible 28 Heesch types! Amazing for a man who claimed to have been poor at mathematics.

So here is the mystery: What about the remaining Heesch Type, TCTGG? Was there something special about this type that it was not included in Escher's classification system? It requires a minimum of three colors and it has no 3-fold or 6-fold rotation centers so if it could arise using his techniques, it would have to be a transition system. I set out to see if I could discover such a transition system. Since *TesselMania!* had been written to create Escher-like tessellations, perhaps I could use it to create an Escher-like transition system! I did manage to find a transition system to generate TCTGG, but it took one little trick. Figure 7 illustrates the steps.

Step 1. (Figure 7a) Start with a tile of Heesch type **CCGG** (Escher system VI). Mark **B**, the common vertex of the edges with 2-fold rotation centers, marked as **C** and **E**. Mark **D** the other vertex on the edge with points **B** and **C**. Mark any point **A** on the edge between **B** and **E**. Then mark **A'**, **B'**, **C'**, and **D'**, the images of **A**, **B**, **C**, and **D**, under a 180° rotation about **E**.

Fig. 7. An Escher-like transition system for Heesch Type TCTGG. Using Escher's notation, this transition system would be called VI-VI

Step 2. (Figure 7b) Remove the portion of the edge from **A** to **B** and connect **A** to **C**. To preserve the 2-fold rotation center **E**, remove the edge segment **A'B'** and connect **A'** to **C'**. Do this to every tile in the tessellation. Beginning with edge **B'C'**, travel counterclockwise around the new tile: **B'C'** gets Heesch label **T**, edge **C'C** is labeled **C**, edge **CD** is labeled **T**, and the two remaining (unaltered) edges are labeled **GG**, so the tile is Heesch type **TCTGG**. Vertex **B** of the original tile has been moved to point **C**, a center of 2-fold rotation.

Step 3. (Figure 7c) The process can be continued to return to a quadrilateral system. Remove the portion of the edge from **A** to **C** and connect **A** to **D**. Correspondingly, replace **A'C'** by **A'D'**. Do this to every tile. The resulting tiling is Escher's quadrilateral system VI (Heesch type **CCGG**).

It seems that Escher just missed this type. The little trick of moving a vertex along to a center of rotation would not have been much of a trick to Escher, who created many more amazing feats with regular division.

In some sense I feel it is unfair (uncharitable) to even point out the missing transition system. *I* know it is missing since I have Heesch's table and further-

more I know exactly the tile type to look for. Escher wandered "... through the garden of the regular division of the plane all alone..." [1, p. 162] discovering different systems of regular division with no prior knowledge of the exact number of possibilities. To have found 27 of the 28 possible types through his explorations and investigations was an amazing accomplishment.

A Colorful Confession

I will conclude by giving an example of how I am continually surprised and always learning from Escher's pioneering work. The original *TesselMania!* implemented 15 Heesch types. In the later *TesselMania! Deluxe* the remaining 13 were added, which included Heesch type $CC_4C_4C_4C_4$. Each type is automatically colored with a minimum number of colors, which is either two or three. This meets Escher's criterion that tiles sharing a common edge must be of different colors. But there was a further coloring criterion that Escher implemented: the coloring of the tiles should be compatible with all the symmetries of the uncolored tiling. This condition is now called "perfect coloring" (see [7] for a further explanation of perfect coloring). Figure 8 shows the coloring scheme implemented in TesselMania! Deluxe for Heesch type $CC_4C_4C_4C_4$. Here letters indicate colors: **R** stands for red, **G** for green, and **B** for blue.

If a tiling is perfectly colored, every symmetry of the uncolored tiling either must preserve all colors or permute the colors in the colored tiling. The coloring in Fig. 8 is not perfect. To see this, note that a 90° rotation of the tiling about the marked center is a symmetry of the uncolored tiling, that is, it moves every

Fig. 8. Three-Colored $CC_4C_4C_4C_4$

tile exactly onto another tile. But look at the four tiles that surround this rotation center. The rotation moves one green tile to a blue tile and the other green tile to a red tile. If this tiling were perfectly colored, then this rotation would have to move every green tile to the same color. It is a nice exercise to try to perfectly color this tessellation using four colors (it can't be done using three colors – see Shephard's article [3, pp. 111–122].

Early on in his studies, Escher became aware of perfect coloring. His symmetry drawing 14 with 4-fold rotations uses the minimum three colors and has the same problem as that of Fig. 8. Made a short time afterward, his symmetry drawing number 20 of fish (color plate 2) could also have been done in three colors but he choose to use four colors and then perfectly colored it. I would like to think he would forgive me for having implemented this tile type in three colors!

Addendum

Following in footsteps of Escher and Heesch, my fascination with tessellations has continued. Since writing this article I have developed a completely new tiling program called *Tessellation Exploration* [Tom Snyder Productions, Cambridge, MA 2001]. This new program takes advantage of what I learned since creating *TesselMania!* (e.g. all tiles are perfectly colored!) It also takes advantage of the increased speed and power of the new microprocessors. A demonstration version has been included on the accompanying CD with a special set of slide show tiles that illustrates all 28 Heesch types.

In 1998 Bigalke and Wippermann [8] have extended Heesch's classification to 43 tile types by including edges with reflections. In *Tessellation Exploration* I implemented five of the new types in a modified way, the reflected edge is used to generate a larger tile with bilateral symmetry. Escher quickly discovered that an edge based on reflection can not be re-shaped!

Acknowledgment

I would like to thank Professor Doris Schattschneider for her initial suggestion in 1993 that I explore Heesch's classification system and her more recent suggestions and comments on drafts of this article.

References

[1] F.H. Bool, J.R. Kist, J.L. Locher and F. Wierda, *M.C. Escher, His Life and Complete Graphic Work*, Harry N. Abrams, New York, 1982.

[2] Jill Britton and Dale Seymour, *Introduction to Tessellations*, Dale Seymour Publications, Palo Alto, CA, 1989.

[3] H.S.M. Coxeter, M. Emmer, R. Penrose and M. Teuber, eds., *M.C. Escher: Art and Science*, Amsterdam, North Holland, 1986.

[4] M.C. Escher, *The Graphic Work of M.C. Escher*, New York, Merideth, 1967.

[5] Heinrich Heesch and Otto Keinzle, *Flächenschuss. System de Formen lüchkenlos aneinanderschliessender Flachteile*, Berlin, Springer, 1963.

[6] Branko Grünbaum and G.C. Shephard, *Tilings and Patterns*, New York, W. H. Freeman and Company, 1987.

[7] Doris Schattschneider, *Visions of Symmetry: Notebooks, Periodic Drawings, and Related Work of M.C. Escher*, W.H. Freeman, New York, 1990.

[8] Hans-Gunther Bigalke and Heirich Wippermann, *Regulare Parkettierungen*, Leipzig, Wissenschaftsverlag, 1994.

M.C. Escher at the Museum:
An Educator's Perspective

Jean-François Léger

> *Escher on calendars, T-shirts, posters and more: this we*
> *are familiar with. But Escher in a museum is a pleasure*
> *that goes far beyond an amusement for the eye.*
> – Jennifer Couëlle, *Le Devoir,* 29 February 1996

It is rare for a major museum to organize a large-scale exhibition on M.C. Escher. Frequently, museums confine their representation of this artist to the book-store shelves. When the National Gallery of Canada organized an exhibition of Escher's work, it prepared a comprehensive educational program to mark the occasion, as was only fitting. I believe that from this experience emerges a model that might guide others who are similarly interested in the reception of the artist's work.

First, a few words about the exhibition M.C. Escher: *Landscapes to Mind-scapes* (Fig. 1). Shown at the National Gallery of Canada from December 1995 to mid-March 1996, this retrospective celebrated the gift to the Gallery by the artist's eldest son, George Escher, of over 160 engravings and related works. In

Fig. 1. The exhibition banner

M.C. Escher, *Selinunte, Sicily*, 1935. Woodcut

Fig. 2. M.C. Escher, *Curl-up*, 1951. Lithograph

addition to the 90 prints selected from the donation, the exhibition contained other works belonging to George Escher and his family, as well as prints on loan from the Gemeentemuseum in The Hague and from the National Gallery of Art in Washington, D.C. A travelling version of the exhibition was circulated to various galleries across Canada.

The organizer of the exhibition, Brydon Smith, Curator of 20th Century Art at the National Gallery, titled it *Landscapes to Mindscapes* to call attention to the way Escher incorporated landscapes from his youthful sojourn in Italy into the imagined "mindscapes" he produced later in the Netherlands. A multidisciplinary approach to the selection of the prints to be included in the show was an underlying consideration, as is clearly reflected by the makeup of the selection committee, which included Brydon Smith, Claude Lamontagne (psychologist), David Peat (mathematician), and myself, an educator. The composition of the committee, in fact, echoed the diverse interests of the artist.

Escher's works were placed in context according to certain recurring visual themes, to give a holistic view of the artist's career by making connections between his landscape period and the period when he was inspired more by the mathematical and the imaginary. The exhibition provided an opportunity

Fig. 3. View of the third of five galleries

for personal discovery; it was intended as a place to look at and explore works that transparently integrate mathematical concepts and theories of perception. Figure 2 gives one illustration of these visual links.

Since an appreciation of the works' aesthetic qualities was an essential first step, the context in which they were presented was of crucial importance. Careful attention was paid to the way the prints were hung; care was also taken so that the installation would appeal to the young audience that was likely to be attracted by the exhibition. Works, for instance, were hung at a lower height, as were the labels, to allow younger visitors to get closer to the works (Fig. 3).

It's important to understand that educational initiatives are not intended to turn amateurs into experts, but to enrich visitors' view of an artist by suggesting avenues to explore. The intervention of the museum educator focuses on making the underlying thesis of the exhibition more accessible to the general public. The educational program that accompanied the Escher exhibition focused both on the artist's works and on their reception. We'll be looking briefly at a few aspects of the programming, presented according to their intended audience: two didactic rooms, a series of lectures, and a traditional guided tour intended for the general public; a workshop for schoolchildren; two activities for teachers; as well as programs designed for audiences participating in ongoing museum programming, such as families, teenagers, and seniors. Rarely does an education program offer so many varied activities to so many publics.

The Didactic Rooms

To facilitate a better understanding of the originality of Escher's work, a small room was devoted to illustrating a few sources of the artist's inspiration. Visitors could see some prints by Dürer, Piranesi, Vredeman de Vries, Hogarth, along

with a Japanese print. The didactic room was situated after a first gallery giving an overview of Escher's work.

Immediately following the didactic room was exhibited a selection of prints on themes such as the self-portrait, tessellation, works of a nature similar to *Smaller and Smaller*, and ambiguous spatial arrangements, to name only a few. A third gallery presented the prints relating to regular solids, metamorphosis, and impossible worlds. Between these two galleries, at the heart of the exhibition, the second didactic room allowed visitors to explore the artist's work methods.

The first section of the second didactic room concentrated on tessellation. In order to fill the plane with recognizable and interlocking geometric shapes, Escher's figures undergo changes of shape. The method of producing such a metamorphosis is detailed in his book *Regelmatige Vlakverdeling* (*The Regular Division of the Plane*), published in 1958 by the De Roos Foundation, Utrecht. His text is illustrated with diagrams and punctuated by practical tips and philosophical reflections. (The book *M.C. Escher, His Life and Complete Graphic Work* contains the complete text in English translation, together with the illustrative plates.)

A display of prints from Escher's own book introduced visitors to the various types of symmetrical transformation required to divide a plane into recognizable interlocking shapes. Symmetrical movements were also presented, with the aid of an illustrated abridged version of the text from Escher's book.

It is difficult to appreciate fully the complexity and refinement of the artist's technique. Escher's fans are often so distracted by the subject matter of the works that they fail to notice his technical virtuosity. This was the topic of the second section of the didactic room (Fig. 4). Although M.C. Escher produced drawings and watercolours as preliminary sketches for prints, he was first and foremost a graphic artist. The printmaking methods he used most often, and with consummate mastery, were two relief techniques – wood engraving and woodcut – and one planographic technique – lithography.

Viewers were invited to discover the work involved in simplifying and transposing a landscape in order to make a print. Three stages in the making of a print

Fig. 4. Second section of the didactic room

were illustrated by a photograph of an alleyway in Atrani by Mark Veldhuysen, Escher's drawing of the same subject, and his final woodcut, *Covered Alley in Atrani* (see page 94). This allowed the visitor to compare the actual scene with the artist's rendition of it.

To complete the section on printmaking techniques, a showcase displayed the end-grain woodblock (probably pearwood) used for the print *(Church at) Corte, Corsica*, as well as several tools. The preparatory sketch, the printing block, and the print were displayed side by side. Of particular interest to the visitors was the woodblock made of several pieces of wood glued together. Various tools used for cutting the grooves that form the design sketched on the block provided an additional context for the creation of the work. A roller similar to the one used by the artist to ink the surface offered more information on the printing technique. To complete the presentation, a small spoon was included as an example of the type of *frotton* used by the artist. A *frotton* is used for rubbing (burnishing) the back of the sheet of paper placed on the inked block, in order to transfer the created design onto the paper.

The video extract from Han Van Gelder's 1969 film *Adventures in Perception*, showing Escher in his workshop, was especially popular with visitors. It was complemented by a nearby display of the print titled *Snakes* (see page 76) and some of the preparatory drawings. In its way, the juxtaposition of this initial stage in the engraver's work with the finished product offered an eloquent illustration of the technique of creating "mindscapes." It allowed, as well, a better understanding of the fact that Escher's multicoloured prints are produced from several blocks, one for each colour including black.

In a room separate from the exhibition (so as not to distract from the prints) the video *The Fantastic World of M.C. Escher* by Michele Emmer was presented. The video could be seen in a continuous screening of alternating French and English versions.

The Lecture Series

A series of public lectures was intended to examine in greater depth a diversity of viewpoints on the artist. The various personal, anecdotal, cognitive, and mathematical aspects discussed in the lectures put the works more fully in context. The invited speakers were indicative of the scope of the program: Douglas Hofstadter (Professor of Cognitive Science and Computer Science, Indiana University), Claude Lamontagne (Professor, School of Psychology, University of Ottawa), Mark Veldhuysen (Dutch photographer), and, to close, Roger Penrose (Professor of Mathematics, Oxford University). The lectures attracted a number of people not usually likely to attend this type of event.

George Escher spoke at the exhibition's opening ceremonies, introducing his father's works to an enthralled audience. The lecture was broadcast simultaneously in the museum auditorium, which seats 400, in the lecture hall, which

holds 100, and on monitors outside the auditorium doors. Exceptionally, a video recording of the lectures was made and retained in the National Gallery Library for consultation during the exhibition and afterwards. In this way, those who, for whatever reason could not attend the actual event, could benefit from the lectures on tape. The lecture drew a record attendance, and George Escher was invited back to the National Gallery two months later to give another talk.

The lecture was followed by a piano recital of Bach's *Goldberg Variations*. Escher's affinity for Bach is well documented:

> *Bach played with repetition, superposition, inversion, mirror-ing, acceleration, and slowing down of his themes in a way which is, in many regards, comparable with my translation and glide-mirroring of my themes of recognizable figures. And that's perhaps why I love his music particularly.* [6, p. 254]

Through this choice of musical program, we wanted to broaden the possibil-ities for the interpretation of Escher's work and enable people to hear one of his sources of inspiration. The concert was co-produced with the local radio station of the Canadian Broadcasting Corporation. The taped concert was later broadcast.

For Teachers

Interestingly enough, Escher's name is mentioned more often in introductory mathematics and psychology texts than in introductions to art history. Mathemat-ics and geometry teachers often use his prints to demonstrate to their students how science can be a source of poetry and beauty. Psychology textbooks offer them as proof of the claim that our perceptions of reality are, in fact, constructions. Thus, three traditionally unrelated disciplines intersect in Escher's work.

Given Escher's enormous popularity, combined with the fascination that paradoxes seem to exert, it is not too difficult for teachers to interest their students in this artist. Perhaps his appeal also owes something to the fact that his work often evokes the sort of smile brought on when we get a joke or have been playfully taken in by one.

Having heard of the exhibition in advance and knowing that Escher would attract their members, some teachers' associations met in Ottawa. One such meeting was that of the Association francophone des enseignants en arts de l'Ontario (AFEAO), which created an opportunity to explore various ways in which the work of M.C. Escher could be brought into the classroom. The courses and workshops focused on integrating fields of study. Teachers shared lesson plans for the integration of visual arts, music, and drama, as well as mathemat-ics and language. Interested teachers can find some of these shared ideas in the appendix to this article.

The School Program

Teachers were invited to book a guided tour of the exhibition. Workshops were also offered (Fig. 5). The workshop for pupils 9 to 12 years of age included a short visit to the exhibition and a studio activity in which they could explore the familiar mosaics: the children selected one of three grids and created their own tilings to be printed with sponges of different shapes. This simple method of engaging children in tessellating art was based on the work of Jill Britton, who has successfully designed for school children a simple workshop inspired by Escher. The activity was a great success.

For older students, from 13 to 17 years of age, the workshop was based on mirrors. Three types of reflecting surfaces were used: an ordinary mirror, which was used to draw the student's own hand, for example; mylar sheets, for the transformation of a reflected image; and full spherical mirrors or reflecting hemispheres (Fig. 6). The objectives of the activity were to present in a simple form Escher's complex work of visual exploration, and to emphasize its artistic aspect. About 1000 students were introduced to Escher's work in this way.

To allow for some preparation prior to class visits to the Gallery, an introductory booklet for teachers was provided. In an easy-to-photocopy format similar to that of the exhibition catalogue, the booklet gave a quick introduction to Escher's world and offered suggestions on the works' potential to provide

Fig. 5. Introducing the Escher Workshop

Fig. 6. A workshop revelation: À la Escher, students examine themselves in a spherical mirror

stimulating activities for students. It was divided into sections that could be used separately. An idea of the topics covered in *Escher: An Introduction for Teachers* can be obtained by glancing at its table of contents: Chronology, Escher in His Own Words, Printmaking Techniques, Landscapes, Landscapes to Mindscapes, Mindscapes, Classroom Activities, and Annotated Bibliography.

As a supplement, a kit containing ten slides of Escher's prints could be borrowed by interested teachers. The kit also included an introduction to each print, usually by Escher himself, and suggestions for discussion topics. The textual material in the kit was distributed on the Internet in order to reach more teachers.

Taking further advantage of the Internet's capabilities, we also offered teachers a discussion site modelled on a forum. This second Web site included an introduction to the artist and four of his works, a section on printmaking techniques, a bibliography, classroom activities, and extracts from texts. The goal of this Teacher's Forum was to stimulate conversation and to exchange ideas. Key contributions to this page were shared as yet another means of encouraging dialogue between teachers and the Gallery.

Fig. 6. (continued)

Teenagers, Families, and Seniors

Other audiences were also introduced to the artist's work. Two series of three-day workshops were offered to teenagers, who were invited to discover the work of Escher by exploring his techniques and preferred subjects. The fact is that Escher did not consider aesthetic value as an end in itself, but rather as the outcome of the meticulous cutting or engraving of wood and of a rigorous application of his far-reaching studies in geometry and perception. These concepts can be success-fully introduced to participants, especially by privileging a hands-on approach. The above-mentioned school workshops were transformed and extended for this somewhat older audience.

The ongoing *Family and Friends* program of the National Gallery allows for learning to be achieved in an informal setting. For the participants, comprised of a somewhat loosely defined family, the session began with creative exercises, then moved to a first-hand experience of the artist's work by a gallery visit, returning to the workshop for a more in-depth exploration.

> *The children occupied centre stage, and set the tone in this context . Their presence promoted a relaxed atmosphere and encouraged a playful approach. This approach, in turn, benefit-ted the adults.* [3, p. 124]

These sessions, offered in English and French, attracted 150 participants and attest to the idea that museums are informal learning environments quite different from the school setting.

A few words about the Seniors' Program that caters to a growing segment of museum visitors. This ongoing program is structured around a short video intro-duction, a guided tour, followed by a discussion with complementary coffee/tea and biscuits. The last component is an important one, as it offers a relaxed atmosphere and an occasion for socialization. A total of 200 seniors participated in this program.

Conclusion

To sum things up, I'd like to mention that the Escher exhibition attracted a record number of visitors for a print exhibition at the National Gallery of Canada. All the visitors were exposed to some part of the educational program. I should also mention that about 30 percent of them were schoolchildren who took part in either a visit or a workshop. Young people, with their natural curiosity and penchant for irony, enjoy mind-challenging games and respond to a similar attitude in Escher. As the artist has said:

> *... such a game can be played and understood only by those who are prepared to penetrate the surface, those who agree to use their brain, just as in the solving of a riddle. It is thus not*

a matter for the senses, but rather a cerebral matter. Profundity is not at all necessary, but a kind of humour and self-mockery is a must. [5, p. 8]

Educators can provide certain vital keys to interaction with works of art, certain avenues of exploration which visitors can pursue. And once viewers have made this journey, they develop an autonomy that can never be lost. In the case of M.C. Escher, his modesty, his many and varied interests, and the richness and breadth of interpretation of the visible world he offers are all invitations to a direct and intimate appreciation of original works of art.

Appendix: Classroom Activities

Mathematics
Escher was not a mathematician himself, but his work has often inspired and opened avenues for mathematicians in relation to certain concepts and theories. The following activities (beginning with simpler ones) offer ways of exploring spatial representation and geometric transformations: translation, rotation, reflection, and similarity.
1. Ask the students to observe their environment and discover examples of repeated motifs, whether natural or man-made (beehive, pine cone, scales on a fish, mosaic tiles on a kitchen or bathroom floor).
2. Have the students determine which of these are *tilings* (planes covered with a set of polygons arranged so that there is no space between them and no overlapping).
3. Using dot paper (square lattice paper and triangular lattice paper), have the students create a tiling that contains regular polygons of just one shape. The students will discover that regular tilings can be constructed only with equilateral triangles, squares, and regular hexagons.
4. Follow 3 by having the students look at semi-regular tilings, constructed from different regular polygons; lead them to explore the eight semi-regular Archimedean tilings.
5. Once 4 is completed, have the students examine Escher's works, in which they will find similar concepts and inspiration for creations of their own.
6. Using a squared graph paper, students can design interesting motifs to cover a given surface.

The Visual Arts
Escher's work can be the basis for any number of art activities, particularly in the areas of drawing and printmaking. Some are presented here:
1. After familiarizing yourself with Escher's tessellations (mentioned above), draw a repeating motif completely filling a sheet of paper. Use a drawing pencil or felt pen to add a final touch.

2. Cover a piece of cardboard with aluminum paper to create a mirror. Holding it in your hand, curve it slightly to get a concave or convex shape. With a pencil, draw the distorted image seen in the mirror.
3. Observe very carefully the print *Day and Night*. Choose a photo of a landscape and glue it on the left side of a sheet of paper. Then draw the same landscape inverting the shapes and colours (for mirror effect and light-dark contrast).
4. Using plasticine, create a stamp with a motif that will be printed repeatedly on a sheet, thus creating another tessellation.
5. Using *Metamorphosis III* as inspiration, make a drawing that could serve as a sketch for a school mural.

Language
1. Certain of Escher's works – *Castle in the Air, Covered Alley in Atrani, Stairwell, Print Gallery, Still Life with Mirror*, and *Relativity* – can be used as the basis for an exercise in creative writing. Have the students write a poem or a piece of poetic prose inspired by one of these prints.
2. As well, these same prints could inspire the students to compose the first sentence or paragraph of a novel.
3. Have the students write a variety of compositions:
 a) a short essay praising or criticizing Escher's work.
 b) a short text to go with the auctioning of one of Escher's works.
4. The students might also enjoy comparing their creative writing efforts.

Music, Dance, Drama
Escher was known to have a great love of music. Many of his works use repeated motifs and transformations; in the realm of music, composers such as Bach were profoundly interested in these same ideas. Rotation, translation, and symmetry are characteristics of composition found in dance and physical expression. Have the students create dances inspired by Escher's themes and the transformation concepts presented above. For example:
1. Using *Still Life and Street*, students can stage a performance expressing the passage from one world to another.
2. Using *Sky and Water I*, students can explore the transformation of a fish to a bird, and of a seed to a flower.

Escher's works are well-suited to such activities as mime, the mirror game, and an exploration of the theatre of the absurd. Here are some drama activities to try:
1. Use *Relativity* to set the tone for a scene of two friends encountering one another on the street.
2. Create a mime based on a transformation.
3. Stage a sketch based on Belvedere.

References

[1] Bool, F.H., Kist, J.R., Locher, J.L. , Wierda, F. (1982). *M.C. Escher: His Life and Complete Graphic Work*. (T. Langham and P. Peter, trans.). New York: Harry N. Abrams.

[2] Britton, J., and W. Britton (1992). *Teaching Tessellating Art: Activities and Transparency Masters*. Palo Alto, CA: Dale Seymour Publications.

[3] Brûlé–Currie, M. (1996). "When Three- to Five-year-olds and Adults Look at Modern and Abstract Art Together," in Lefebvre, B., and M. Allard, eds. *Le Musée, un projet éducatif* (pp. 109 26), Montréal: Les éditions logiques.

[4] Escher, M.C. (1971). *The Graphic Work of M.C. Escher*. (J.E. Brigham, trans.; revised). New York: Hawthorn Books. (Currently available from Taschen, 1992.)

[5] Escher, M.C. (1989). *Escher on Escher: Exploring the Infinite*. (K. Ford, trans.). New York: Harry N. Abrams.

[6] Schattschneider, D. (1990). *Visions of Symmetry: Notebooks, Periodic Drawings, and Related Work of M.C. Escher*. New York: W.H. Freeman & Co.

Videos

Emmer, M., producer (1994). *The Fantastic World of M.C. Escher*. Acorn Media; Springer-Verlag, Berlin.

Van Gelder, H., producer, director (1969). *Adventures in Perception*. Netherlands Ministry of Foreign Affairs, The Hague.

Escher, Napoleon, Fermat and the Nine-point Centre

John F. Rigby

In his "abstract motif" notebook, Escher investigated a tiling of the plane by congruent non-regular hexagons, as shown in Fig. 1. He found this tiling in an article by F. Haag [1]; more details can be found in [2] and [3, p. 90]. This tiling can be used to give very simple and elegant proofs of some well known theorems in triangle geometry.

Here are the results stated by Escher in his notebook.

(i) Let ABC be an equilateral triangle and E any point (Fig. 2). Let F be the point such that $AF = AE$ and $\angle FAE = 120°$. Let D be the point such that $BD = BF$ and $\angle DBF = 120°$. Then $CE = CD$ and $\angle ECD = 120°$.

(ii) Congruent copies of the hexagon AFBDCE can be used to tile the plane,

(iii) The diagonals AD, BE and CF of the hexagon are concurrent.

I have rephrased Escher's version of (i) in the form of a theorem: he himself simply stated facts about the hexagon *AFBDCE* that are mentioned by Haag and are observable from Haag's tiling (a version of Fig. 3, without lettering, appears in Haag's paper). In [2] I showed how to use a famous geometrical result known as Napoleon's theorem to prove the existence of the hexagon and of the tiling. But I have recently realised that the reverse procedure can be used: there is a simple way to prove (i) and (ii), and we can then use the existence of the hexagon and the tiling to give a very simple proof of Napoleon's theorem and also of Fermat's triangle theorem.

Fig. 1.

Fig. 2.

The Existence of the Hexagon

In Fig. 2, let P be the reflection of E in AC. Then $CE = CP$; also $AP = AE = AF$ and the two angles marked α are equal. Now $\angle\,\mathrm{BAC} = 60° = \alpha + \beta$; hence $\angle\,\mathrm{FAE} = 120° = 2\alpha + 2\beta$. Hence $\angle\,\mathrm{FAB} = \beta$. It follows that P is the reflection of F in AB. A similar argument at the vertex B shows that P is the reflection of D in BC. Hence $CE = CP = CD$, and an investigation of the pairs of equal angles at C shows that $\angle ECD = 120°$.

What we have now obtained is a particular *type* of hexagon; its exact shape depends on the position of E (or of P) relative to ABC. Note that Fig. 2 can be built up starting from any triangle DEF: we construct an isosceles triangle AFE with base FE and an angle of $120°$ at A, also an isosceles triangle BDF with base DF and an angle of $120°$ at B; then we construct the equilateral triangle ABC, and the figure is complete.

For convenience we shall regard P as lying *inside* the triangle ABC, but it may also lie outside. If P lies just outside ABC, the hexagon $AFBDCE$ will no longer be convex; this will not affect the subsequent tiling. But if P lies far outside ABC, the hexagon will become re-entrant; we then have to extend our ideas of what constitutes a tiling, but the mathematics remains valid.

The Construction of the Tiling

To construct the tiling of hexagons, we start with a basic grid of equilateral triangles covering the plane, one of which is the triangle ABC of Fig. 2 with the point P inside it (Fig. 3). We reflect the triangle ABC and its contents (namely the point P and the lines PA, PB and PC) in the sides of the triangle as shown, to produce three heavy lines in each of the reflected triangles. (The lines PA, PB, PC do not form part of the tiling; having used them to link up this figure

Fig. 3.

Fig. 4. **Fig. 5.**

with Fig. 2 we can now remove them.) We can now think of Fig. 3 as being built up initially from equilateral triangular tiles: plain tiles alternating with copies of the triangle *BNC* each containing a pattern of three lines. The patterned copies of *BNC* are oriented in such a way that the patterns in the triangles at any vertex of the grid can be obtained from each other by rotation through 120° and 240° about that vertex. To put this another way, we can regard the vertices of the grid as being of three types: *B*-type, *N*-type, and *C*-type; each triangle of the grid has one vertex of each type. The entire hexagon tiling has a centre of threefold rotational symmetry at each vertex of the grid.

The method of constructing Fig. 3 can be understood without reference to the investigation of Fig. 2 in the previous section; the grid of equilateral triangles is shown in Haag's article and is faintly visible in the page from Escher's notebook. But the proofs given earlier are not superfluous: it will be important in our subsequent geometrical investigations to know that *Fig. 2 (as mentioned earlier), and hence Fig. 3, can be built up starting with any triangle DEF.*

Haag's tiling of hexagons must have assisted Escher's appreciation of repeating patterns with centres of 3-fold rotational symmetry of three different types – patterns whose symmetry type is *p3* in the crystallographic notation. If we replace the straight lines *DB*, *DN*, *DC* in the construction of Fig. 3 by the angular lines shown in Fig. 4, we obtain one of Escher's patterns of lizards (see page 427). In Escher's drawing of this lizard pattern there is a grid of regular hexagons, but he may have introduced this at a later stage in connection with the lithograph *Reptiles* (see page 307) or the woodcut *Metamorphosis II* (see page 147).

Escher's pattern of running men [3, p. 132] has the same symmetry type *p3*. A grid of diamonds (double equilateral triangles) appears in this drawing, but again we can wonder whether this was used in his construction of the pattern or introduced later in connection with the lithograph *Cycle* (see page 77) in which the running men are transformed into diamonds.

Napoleon's Theorem

Figure 5 shows a part of the entire tiling in Fig. 3, with some additional labelling. We have observed previously that the contents of the equilateral triangles with vertex A can be obtained from each other by rotation through 120° and 240°. It follows that XFE is an equilateral triangle with centre A. Similarly YDF and ZED are equilateral triangles with centres B and C. Thus the figure, which can be built up starting with any triangle DEF, demonstrates Napoleon's theorem:

> If equilateral triangles XFE, YDF, ZED are erected on the sides of any triangle DEF, then the centres of these equilateral triangles form an equilateral triangle ABC.

Fermat's Triangle Theorem

In Fig. 5, if we reflect the points L, M, A and X in the horizontal line through Λ, we obtain the points B, C, A and P; hence XP is a vertical line. If we reflect A, B, C and P in the horizontal line BC, we obtain N, B, C and D; hence PD is vertical. Hence X, P and D are collinear on a vertical line. Suppose that equilateral triangles in the basic grid have sides of length 2 units. Then the points L, M, A and X are transformed into B, C, N and D by a downward vertical translation through a distance $2\sqrt{3}$. Hence we have shown that XD has length $2\sqrt{3}$, that X, P, D are collinear, and that XD is perpendicular to BC. Similarly, YE has length $2\sqrt{3}$, Y, P, E are collinear, and YE is perpendicular to CA; and also ZF has length $2\sqrt{3}$, Z, P, F are collinear, and ZF is perpendicular to AB. Thus we have Fermat's triangle theorem:

> If equilateral triangles XFE, YDF, ZED are erected on the sides of any triangle DEF, then the lines XD, YE, and ZF are concurrent (at P), are of equal length, and are inclined to each other at angles of 60°.

The point P is called the Fermat point of triangle DEF. Napoleon's theorem and Fermat's theorem can be found in many books on triangle geometry, but it is not always pointed out that the "Fermat Lines" XD, YE and ZF are perpendicular to the sides of the Napoleon triangle ABC.

Escher's Theorem

We refer to the hexagon $AFBDCE$ and its hexagonal tiling as a Haag hexagon and a Haag tiling. But Escher's observation (iii) in his notebook was not mentioned by Haag, so we shall call it Escher's theorem, even though Escher was apparently not able to prove it or to find a reference to a proof. It is in fact a known result in triangle geometry, in the following more usual form:

If equilateral triangles with centres A, B, C are erected on the
sides of any triangle DEF as in Fig. 5, then the lines AD, BE,
CF are concurrent.

The point of concurrence is called the *Napoleon point* of DEF. The concurrence of XD, YE and ZF at the Fermat point, and of AD, BE and CF at the Napoleon point, are both special cases of a general theorem that is stated and proved in [2]. Also in [2] I give a proof of Escher's theorem using the Haag tiling. The main theorem in the next section suggests yet one more proof of Escher's theorem.

On p. 90 of [3], a confusion between the theorems of Napoleon and Fermat seems to have occurred. Doris Schattschneider agrees that the fourth sentence of text on that page should read "It can be proved that the diagonals of the hexagon $ADBECF$ are concurrent for any chosen angle at A, B, C; when that angle is 60°, the point of concurrence is known as the Fermat point of triangle DEF." But it is the concurrence at the Napoleon point, which occurs when the chosen angle at A, B, C is 120°, which proves Escher's theorem.

A Theorem About the Nine-Point Centre

In Escher's "abstract motif" notebook, his drawing 11 shows four Haag tilings with edges in four colours [3, p. 87]. Doris Schattschneider remarks that Escher "overlays four copies of the hexagon tiling" [3, p. 90].

The situation is shown in Fig. 6, and the manner in which the four tilings are overlaid can be described in the following way. The tiling of Fig. 3 is transformed into itself by three basic translations through a distance $2\sqrt{3}$ vertically and in the two directions making angles of 60° with the vertical (using the same scale of measurement as before). If we translate the tiling in these same directions but through a distance $\sqrt{3}$ only, we obtain the other three tilings in Fig. 6. (The hexagons in Fig. 6 are of a different shape from those in Fig. 3, but they are

Fig. 6.

still Haag hexagons.) The interesting fact about this compound tiling, which is apparent from Fig. 6 as well as from Escher's drawing, is that inside any hexagon of any one of the tilings there are three *concurrent* edges of the other three tilings. I proved this fact in [2] by showing that *inside the particular hexagon AFBDCE, the three edges of the other three tilings all pass through the nine-point centre of the triangle DEF*. (The nine-point centre of a triangle lies midway between its circumcentre and its orthocentre.)

In his notebook, Escher emphasized the concurrence of AD, BE and CF and wrote to his son George to ask if he could prove it; so why did Escher not comment on the equally interesting concurrences in Fig. 6? It occurred to me only recently that Doris Schattschneider's explanation of how Escher derived Fig. 6 may be unintentionally misleading, even though it had the happy outcome of leading me to the interesting result about the nine-point centre: perhaps Escher did not overlay four copies of the original hexagon tiling. In his drawing of the original tiling [3, p. 90], Escher drew the diagonals of several of the hexagons, and indicated clearly that they are concurrent. *Suppose we now remove the edges of the hexagons from this figure, leaving only the diagonals. We shall show in the next paragraph that the diagonals now form the edges of four separate larger Haag tilings, and we already know that these edges are concurrent by Escher's theorem.*

One of the larger tilings is shown by heavy lines in Fig. 7, and a comparison with the method of construction of Fig. 3 shows that this larger tiling is a Haag tiling based on a grid of equilateral triangles twice the size of the original grid. Consider the translations through a distance $2\sqrt{3}$ vertically and in the directions making angles of 60° with the vertical (using the same scale of measurement as before); these translations transform the original tiling and the small grid to themselves, and they transform the large tiling into three other large tilings. The four large tilings taken together use up all the diagonals of the original hexagons. Note that the hexagons in the large tilings have a different shape from the original hexagons.

This I think is what Escher did to obtain Fig. 6, and the actual sizes of the angles in Escher's hexagons seem to bear this out.

Fig. 7.

Suppose that we do not yet have a proof of Escher's theorem. We can still draw the diagonals of the hexagons in the original tiling, then remove the edges, and we shall have four larger tilings related to each other by translations in the manner described earlier. According to my "nine-point centre theorem," whose proof does not depend on Escher's theorem, the edges of the four larger tilings are concurrent by threes. But these edges are the diagonals of the original hexagons, so we have used the "nine-point centre theorem" to give another proof of Escher's theorem.

Escher as Inspiration

Many "serious" artists are said to be unimpressed by the work of Escher. A referee once, among his comments on a paper of mine, wrote "we only get the ubiquitous Escher, the phillistine mathsman's favourite artist." But I hope that mathsmen and women will continue to discover, and to study, the surprising mathematical results and problems implicit in Escher's work. He often referred to his own inability to understand some of the formal mathematics used by others to "explain" his work, but his intuitive grasp of geometrical ideas should be an inspiration to us all.

References

[1] F. Haag, Die regelmässigen Planteilungen und Punktsysteme, *Zeitschrift für Kristal-lographie* 58 (1923) 478 – 488.
[2] J.F. Rigby, "Napoloon, Escher and tessellations," *Structural Topology* 17 (1991) 17 – 23. The same article also appeared in *Mathematics Magazine* 64 (1991) 242 – 246.
[3] Doris Schattschneider, *Visions of Symmetry: Notebooks, Periodic Drawings, and Related Work of M.C. Escher*, W.H. Freernan & Co., New York, 1990.

The Symmetry Mystique

Marjorie Senechal

Ornamental Patterns

M.C. Escher's art presents many worlds which startle and attract in many ways and for many reasons. One source of attraction is the universal appeal of repeating patterns. Every human culture, since neolithic times at least, has decorated walls, floors, ceilings, and textiles with ornamental patterns. Escher's patterns derive from this rich heritage, but his interlocking motifs are uniquely ingenious. The public never seems to tire of Escher posters, T-shirts, and other paraphernalia, which have been reproduced ad *infinitum* (some would say *ad nauseam*) in countless monographs, articles, and textbooks, especially in mathematics and the other sciences. Thanks to Escher, symmetry is not just *cool*, it is *hot*.

I would like to throw some cold water on this enthusiasm, to cool symmetry off again, as it were. We – at least we mathematicians – have taken it too far. It is true that Escher can help us sugarcoat mathematics, especially the mathematics of symmetry. Here's how it goes: first we show our students an Escher print, say *Reptiles* (see page 307). Once they are intrigued, we focus only on the repeating pattern and ignore the rest (Fig. 1). The next step is to assume that the pattern is "really" intended to continue forever, though Escher has given us only a small piece of it. That is, we must assume that the part of the pattern that we see is a swatch, like a swatch of wallpaper, that is to be repeated over and over to fill

Fig. 1. The repeating pattern in *Reptiles*, Escher's symmetry drawing 25

the entire space. The mathematical term for "swatch" is "fundamental region," and the pattern as a whole is the "orbit" of that region. Given the region and the way that copies of the region are fitted together to build the orbit, students can easily discover the pattern's translational and other symmetries. Soon they are happily investigating higher mathematics [14].

There's nothing wrong with that, of course, but why are we – their teachers – so fixated on symmetry? Our fixation blinds us to *dissymmetry* which, I hope to show, is every bit as mathematically rich, and presents new and exciting challenges.

The mathematician and physicist Hermann Weyl was very interested in symmetry, and thought that the patterns of antiquity provide a link with our mathematical past. Weyl seems to have assumed that the ancients understood, in some sense, the concept of a symmetry group and the fact that the number of such groups, for two-dimensional repeating patterns, is limited (the exact number is seventeen): "Examples for all 17 groups of symmetry are found among the decorative patterns of antiquity, in particular among the Egyptian ornaments. One can hardly overestimate the depth of geometric imagination and inventiveness reflected in these patterns. Their construction is far from being mathematically trivial. The art of ornament contains in implicit form the oldest piece of higher mathematics known to us." [18, p. 103]

I found this statement fascinating when I first read it years ago, and it has stimulated my thinking about, and practice of, the role of mathematics in a liberal arts college. But with the passing of years, I've grown increasingly skeptical of both the statement and the importance of symmetry. Symmetry is a dialogue between the parts and the whole. In nature, at least, the parts seem to be as important as the whole; neither is just an approximation to the other. If we are serious about understanding symmetry, and if we really want to understand the role of mathematics in the sciences, and also in the arts, then instead of just jumping on symmetry as a springboard to abstraction, we have to try to understand how the parts came to be there, and why and in what sense they generate the whole that we think we see.

It is all too tempting to identify a fundamental region and its orbit under some group of motions and think we understand the pattern. Of course, in some cases that's the best way for a mathematician to proceed. For example, the enumeration by Federov and Schoenflies, over a century ago, of the 230 three-dimensional groups took place in the context of the scientific battles that were raging over the structure of crystals at that time. One can't help but sympathize with Schoenflies, a mathematician, when he declared that, "Within the fundamental domain the crystallographer may do as he likes."

On the other hand, to this day no one has been able to prove, by statistical mechanics or other methods, that left to their own devices the molecules of crystals *"want"* to arrange themselves in a periodic way. In some cases they do not do so: this has been understood since the 1970's, and especially since the discovery of quasicrystals in 1984. For these crystals, there isn't any fundamental domain at all.

And in fact, Weyl's admiration for the ancients may have been far off the mark. Like nations, professions refashion their pasts to suit their present needs. We must be careful not to play the role of the French historian Jules Michelet who, as Benedict Anderson explains in *Imagined Communities* [1, p. 198], "not only claimed to speak on behalf of large numbers of anonymous dead people, but insisted, with poignant authority, that he could say what they 'really' meant and 'really"wanted, because they themselves 'did not understand'."

We must be careful even with Escher! It is true, as Doris Schattschneider has shown so beautifully in *Visions of Symmetry* [13], that Escher carefully and throughly developed his own classification system for infinite repeating patterns. But in fact, except when asked to do so by scientist friends, he embedded swatches of these patterns in other worlds. He used them as means to other ends.

Egyptian Ornamental Patterns

We may find mathematics in ancient ornamental patterns, but that doesn't mean that their creators put it there. Let's take a closer look at those Egyptian tombs (Fig. 2). They weren't very restful places: every inch of the walls and ceilings is decorated. The paintings on the walls depict daily life; this is what is

Fig. 2. Interior of Egyptian tomb

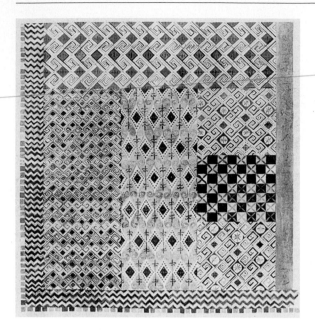

Fig. 3. Multipatterned tomb ceiling, from *Prehistoric Textiles*

usually meant by "Egyptian art." The patterns that interest us were never painted on walls, only the ceilings. Why did the Egyptians put them up there?

Not only were they on the ceilings, but very different patterns were often juxtaposed (Fig. 3). Why? Why didn't they decorate the ceilings with a single pattern? Did artists intend the ceiling to be a sampler of geometric invention?

About a year ago, I came across a fascinating discussion of those ceiling patterns in a surprising place, an authoritative tome called *Prehistoric Textiles* [2]. Its author, Elizabeth Barber, is not a mathematician and when she wrote the book she did not realize that mathematics can be read into these designs. Barber is a professor of linguistics and archaeology at Pomona College in California, and uses both of those tools to study textile production and diffusion in prehistoric times. She is particularly interested in the Egyptian ceilings because they tell us a lot about ancient trade patterns. Barber says, "Let us begin by investigating the nature of Egyptian treatment of ceilings in general. They show sky, with or without stars . . . ; or birds in flight, as if startled up from a swamp thicket . . . ; or a grape arbor, viewed as if from directly underneath . . . ; or a repetitive polychrome design framed by architectural strips painted yellow to imitate wood." [2, p. 340] She then notes that many of these repetitive patterns are common Egyptian *mat* patterns, and asks,

> *Why mat patterns on the ceiling, then? One reason is that mats were often laid on poles across the rafters in the houses, in order to prevent the mud of the roof from crumbling down onto the occupants. In these cases, when one looked up one would indeed*

Fig. 4. Pattern with border, from *Prehistoric Textiles*

see mats. . . . Another common source of mats overhead was the outdoor pavilion erected to provide shade from the hot tropical sun. We see such pavilions, with checkered mat coverings over a flat or gently sloping grid-like framework of yellow wooden beams, both on land and on boats . . . [2, p. 341]

Can it really be that "the oldest piece of higher mathematics that has come down to us" is just a collection of carefully copied mats? Barber argues for this conclusion by examining the borders that surround some of the two-dimensional designs (Fig. 4). Border patterns, she points out, were used as headers for the two-dimensional patterns that Minoans wove on warp-weighted looms. And here we see something quite remarkable: the border pattern *changes* although the design it surrounds does not! Why ever would an artist do that? If she were a textile artist, such a shift would be " . . . the happy result of boredom interacting with the particular weaving technique; but in paint one is not restricted by what the warp will do, nor does the work progress so slowly. So why that particular change?" [2, p. 348] If economy of thought is the surest guide to the truth, then we must agree that it is possible that the painters merely copied mat and weaving patterns onto the ceiling!

Can we rescue Weyl by arguing that the mats themselves illustrate mathematical experimentation? No, not really. Mats cover small areas, and the designs on them are intended for those areas, not for unbounded ones. And, as Washburn and Crowe have argued in their fascinating book *Symmetries of Culture* [17], traditional cultures tend to be very conservative with regard to the symmetry of their artifacts. They may experiment a little with motifs, but with symmetry, they perpetuate tradition.

If Barber is correct, then we must consider the possibility that the ancient Egyptians had a very different aesthetic from ours, a different conception of covering a ceiling: not a pattern of symmetry, but one obtained by juxtaposing various bounded designs.

Weyl's remark doesn't tell us anything about mathematics, but it does tell us something about ourselves. It reminds us how fascinated with symmetry we all are (even the mat designers). In fact, we have what seems to be an inborn sense of order that helps us navigate this confusing world. The art historian E.H. Gombrich has written a richly detailed book, *The Sense of Order* [9], about

Fig. 5. Imperfect honeycomb, from *Animal Architecture*

the ways in which this propensity expresses itself in art. It expresses itself in mathematics too, and has since ancient times, as the eternal fascination with the regular solids attests. It is probably not accidental that we find symmetry aesthetically satisfying and asymmetry disturbing. In medieval times monstrosity was sometimes envisaged as gross asymmetry. But precisely because we have a sense of order, we are prone to seek regularity, and sometimes to find it where none exists. How many people, not only mathematicians but also the author of the books from which Fig. 5 was taken [7], have waxed enthusiastic over the perfect hexagonal honeycombs of the bees!

Disorder: The New Frontier

Our search for symmetry also has the unfortunate side effect of perpetuating the old dichotomy between order and disorder, where those states are distinguished by the presence or absence of translational symmetry and are labeled, respectively, *periodic* and *nonperiodic*. This dichotomy is outdated; almost-periodic functions, statistical mechanics, chaos, fractals, dynamical systems, and many other fields of mathematics teach us that the world of "disorder" is in fact wonderfully diverse.

Let's follow one very old line of mathematical thought to discover the rich variety that emerges if we are willing to cross the periodicity/nonperiodicity frontier. We start with geometric dissection problems, which are as old as the mosaic. There are many dissection problems, of course, but in general they take the form: *whether and in what ways can a given shape be subdivided into a finite number of other shapes of a given form or forms?* For example, *the* classical question, the answer to which is affirmative in two dimensions and negative in three, is *whether given any polygonal (polyhedral) shape can be cut up into a finite number of polygons (polyhedra) and rearranged to form any other given polygonal (polyhedral) shape of the same area (volume)*. Was it really only first in the 1960's that anyone thought to require that the shapes be dissected into

Fig. 6. The "chair" and the "sphinx" rep-tiles

a finite number of smaller copies of themselves? Golomb [8] dubbed polygons with this property "rep-tiles." (Fig. 6)

Rep-tiles can generate infinite nonperiodic patterns. We begin with one tile, and then divide it up into smaller copies of itself. Then we blow up the small tiles to the size of the originals, and subdivide them into copies of themselves, in exactly the same way as before. Repeating these two steps *ad infinitum* we get, in the limit, an infinite tiling of the plane. This tiling contains within itself tilings on a countable infinity of scales (Fig. 7). It is easy to prove that if these steps can be retraced unambiguously, that is, if at each level there is only one way to regroup the tiles at that level into the tiles of the next higher one, then the tiling is nonperiodic.

The various Penrose tilings can all be generated in such a way, though in this case there is more than one tile shape. Figure 8a shows the transformation of the two Penrose rhombs, in which first dissection and then "gluing" takes place. That is, in the iterative process of generating a Penrose tiling (Fig. 8b), parts of the dissected interiors of adjacent rhombs are glued together to complete the smaller rhombs.

A similar process will generate the so-called "binary tiling" (Fig. 9), whose prototiles are the two Penrose rhombs but whose decomposition rule is very different. The properties of this tiling are still not well understood. The deceptively simple pinwheel tiling (Fig. 10), whose tiles occur in infinitely many orientations, is also generated by iterative dissections. All of these tilings – chair, Penrose, binary, and pinwheel – are nonperiodic, but at the same time they are not "disorderly," and certainly are not random. Above all, they are very different from one another [15].

Fig. 7. First steps in generating the chair tiling

Fig. 8. (**a**) The dissection of the Penrose rhombs; (**b**) first steps in generating a Penrose tiling. In the iterative process of generating a Penrose tiling, parts of the disected interiors of adjacent rhombs are glued together to complete the smaller rhombs

Fig. 9. Part of a "binary" tiling

Fig. 10. Part of a "pinwheel" tiling

The mathematician's knee-jerk response to the phenomenon of nonperiodic tilings is to try to broaden our concept of symmetry. We've been doing this for a long time; it is the very history of mathematical crystallography. As Barlow and Miers pointed out in 1900 [3], "The history of its development . . . is the history of an attempt to express geometrically the physical properties of crystals, and at each stage of the process an appeal to their known morphological properties has driven the geometrician to widen the scope of his [sic] inquiry and to enlarge his definition of homogeneity." Broader concepts of symmetry that have been proposed for nonperiodic tilings include, but are not limited to:

- self-similarity (which all of the tilings I've shown here possess, but which many interesting tilings do not),
- the symmetry of the diffraction spectrum (which we will consider briefly),
- the symmetry of the so-called translation modules of the tilings (which we will not discuss), and
- various combinations of the above.

But why insist on symmetry at all? "We're all *a*morphologists now," a physicist said to me about a decade ago. He meant that the interesting problem is to characterize the states that used to be lumped together in the single "amorphous" category. But how can we do it?

There are many approaches to that question; I will indicate one general direction that I find especially interesting. Instead of tilings and patterns, let's consider discrete point sets: we can associate many such sets with any tiling or pattern, for example the set of vertices of a tiling will do (Fig. 11).

The basic concept we need is that of Delaunay sets, called (r, R)-systems by B.N. Delaunay and his colleagues in Moscow, who introduced them in the 1930's.

Fig. 11. Part of a Penrose tiling and its vertex set. The vertex set is a Delaunay set

Definition. *A Delaunay set in n-dimensional Euclidean space is a set of points Λ with two properties: (i) discreteness: there is an $r > 0$ such that any open ball of radius r contains at most one point of Λ, and (ii) homogeneity: there is an $R > 0$ such that any closed ball of radius R contains at least one point of Λ.*

Note that the vertex set of a tiling (with tiles of uniformly bounded size) is a Delaunay set. In Fig. 11, the parameter r is the short diagonal of a thin rhomb, while the parameter R is the center of a circle defined by three vertices of a thick rhomb.

The broad research program that engaged Delaunay and his colleagues for over half a century included finding the minimal conditions, in addition to (i) and (ii) above, that would ensure that a Delaunay set is an orbit of a symmetry group. The high point of this research was their proof, in 1976, of the "local theorem," which states that global regularity is a consequence of local regularity [4].

Let $[x - y]$ be the line segment joining x and y. We define the *global star* of $x \in \Lambda$ to be the set of line segments joining x to all the other points of Λ.

$$ST_\Lambda(x) = \{[x - y], \ \forall y \in \Lambda\} .$$

The bounded or *local star* (Fig. 12), or ρ-star, of $x \in \Lambda$ is constructed like a global star, except that we only draw line segments to those points of Λ that lie within a ball $B(x, \rho)$ about x of radius ρ:

$$ST_\Lambda(x, \rho) = \{[x - y], \ \forall y \in ST_\Lambda(x) \cap B(x, \rho)\} .$$

Fig. 12. A local star in a Penrose vertex set

Fig. 13. Periodic and nonperiodic tilings with more than one class of vertex stars

The vertex sets of both periodic and nonperiodic tilings (and other point sets) can have more than one congruence class of local stars for some given ρ. (Fig. 13) Let $N_\Lambda(\rho) = |ST_\Lambda(x, \rho)|$ be the function that counts the number of congruence classes of ρ-stars.

One can prove [4] that

Theorem. *A Delaunay set Λ is nonperiodic if and only if $N_\Lambda(\rho)$ is unbounded as ρ tends to infinity.*

But as we have seen, there are various kinds of nonperiodicity. One way to study them may be to consider the behavior of $N_\Lambda(\rho)$ (which we assume to be finite for every finite value of ρ). We don't know yet for which types of point sets the function increases linearly, or has polynomial growth, or exponential; it is a difficult problem, but this line of investigation appears to be promising.

Let us call the point set obtained by superposing all the global stars of a Delone set Λ its *difference set*; we will denote it by $\Lambda - \Lambda$. That is,

$$\Lambda - \Lambda = \{[x - y], x, y \in \Lambda\}.$$

In Fig. 14 we see that the difference set for a Penrose tiling is discrete. That is not the case for the vertex set of a binary tiling, which (eventually) becomes dense. On the other hand, the difference set of a chair tiling's vertices is a lattice. This suggests that the degree of overlap of the stars of a Delone set may be a useful characterization of disorder.

Following Lagarias [10], [11] and Moody [12], we might consider a hierarchy of increasingly stringent requirements:

(a) $\Lambda - \Lambda$ is neither finitely generated nor discrete.
(b) $\Lambda - \Lambda$ is finitely generated, but is not discrete.
(c) $\Lambda - \Lambda$ is Delaunay; equivalently, $\Lambda - F \supseteq \Lambda - \Lambda$, where F is a finite set.
(d) $\Lambda - \Lambda = \Lambda + F$
(e) $\Lambda - \Lambda = \Lambda$.

The set of vertices of the pinwheel tiling is a Delaunay set of type (a); the set of vertices of the binary tiling seems to be of type (b), the vertices of the Penrose tilings are either type (c) or (d); the vertex set of the chair tiling is type (d), and some periodic sets are of type (d), while others are type (e).

Fig. 14. Λ and $\Lambda - \Lambda$ for three tilings. *Top*: (Part of) a Penrose tiling. *Middle*: The binary tiling. *Bottom*: A chair tiling. The line segments have been omitted

$\Lambda - \Lambda$ is surely the key to understanding the diffraction spectrum of Λ, which is another important approach to characterizing order. The spectrum is, essentially, the Fourier transform of $\Lambda - \Lambda$, but the fact that some points are weighted (i.e., overlap) is taken into account. This transform is a measure, and there are well-known ways to classify measures. We cannot go into details here, but these diffraction patterns clearly show increasing degrees of order [15].

One of the most interesting, and difficult, open problems of mathematical amorphology is the precise relation among $N_\Lambda(\rho)$, $\Lambda - \Lambda$, and the diffraction

spectrum of Λ. More generally, understanding the relation between the local and the global, the parts and the whole, is every bit as profound, and every bit as important, as the efforts of physicists to unify quantum mechanics and gravitational theory. Symmetry is only our easiest case, group theory only our simplest tool.

Modern, Post-modern, and Post-post-modern Mathematics

What we are engaged in here is nothing less than the eternal dialogue between the continuous and the discrete, a conversation that we can trace back to the ancient Greek philosophers. The 16th century poet, Sir John Davies, asked,

> *Or if this all, which round about we see,*
> *As idle Morpheus some sick brains hath taught,*
> *Of individual motes compacted be,*
> *How was this goodly architecture wrought?*
> *Or by what means were they together brought?*
> *They err that say they did concur by chance:*
> *Love made them meet in a well-ordered dance!*
> *– from Orchestra, or a poem on dancing,* Sir John Davies,
> 1569–1626

The conversation continues today. On the eve of 1998, the *New York Times* published a list of some of the cosmic questions that scientist/statesmen say they are asking themselves. The list included:

Will the "theory of everything" be a theory of principles, not particles? Will it invoke order from above, not below? – Kenneth Ford, Retired Director, American Institute of Physics

Fundamentally, is the flow of time something real; or might our sense of time passing be just an illusion that hides the fact that what is real is only a vast collection of moments? – Lee Smolin, Physicist, Penn State University.

I have said nothing here about the symmetry of natural laws. A good starting place would be Smolin's recent book, *The Life of the Cosmos* [16], which argues that those natural laws may well be contingent. I also recommend another new book, *The First Moderns* [6], which is an effort by its author, William Everdell, to understand what "modernism" was, before we move on beyond "postmodernism."

Everdell argues that "modernism" was, in essence, a shift away from the 19th century view that the world is fundamentally continuous to the view that the world is fundamentally discrete. He finds it intriguing that the mathematicians, scientists, artists, musicians, and writers whose work he discusses – Picasso, Strindberg, Schoenberg, Cantor, Dedekind, Russell, Boltzmann, Einstein, Joyce, de Vries, and many others – had all come to the conclusion, at approximately the same time, that the discrete approximates the continuous, just as the forest is

made up of trees. It was the *Zeitgeist*, the spirit of the times. Symmetry fits into the modernist paradigm very well. But the times are "postmodern" now.

Of course, many believe, as the philosopher Richard Rorty recently declared, that postmodernism is just a word masquerading for an idea: that Emperor has no clothes at all. I'm not sure I agree. The cultural postmodernists seem not to have realized it, but we *can* discern an idea there. If modernism was the notion that wholes are in fact comprised of parts, then post-modernism took things one step further and denied the reality of any wholes. The wholes were artifacts of our own making, they said, figments of our collective imagination, and they tried to deconstruct those artifacts. The pendulum has swung back to Democritus, the atoms, and the void.

But just as history did not end with the cold war, the dialogue between the continuous and the discrete does not end with postmodernism. In mathematics as in art, in physics as in language, in music as in biology, we are finding yet again that the discrete and the continuous are mysteriously intertwined. If we can move beyond the symmetry mystique, we may begin – to use a textile metaphor – to unravel them.

References

[1] Benedict Anderson, *Imagined Communities: reflections on the origins and spread of nationalism*, London, Verso, 1983.

[2] Elizabeth J.W. Barber, *Prehistoric Textiles*, Princeton University Press, 1991.

[3] W. Barlow and H. Miers, "The Structure of Crystals, I" in *Report of the Meeting of the British Association for the Advancement of Science*, 71st meeting, London, 1901, pp. 297–337.

[4] B.N. Delone (Delaunay), N.P. Dolbilin, M.I. Shtogrin, and R.V. Galiulin, "A local criterion for regularity of a system of points," *Soviet Math. Dokl.* 17, No. 2 (1976), 319–322.

[5] N. Dolbilin, J. Lagarias, and M. Senechal, "Multiregular point set," *Discrete and Computational Geometry*, Vol. 20, 1998, pp. 477–498.

[6] William Everdell, *The First Moderns*, University of Chicago Press, 1997.

[7] Karl von Frisch, *Animal architecture*, translated by Lisbeth Gombrich, London, Hutchinson, 1975.

[8] Solomon W. Golomb, *Polyominoes*, New York, Scribners, 1965 (2nd ed., Princeton University Press, 1994).

[9] E.H. Gombrich, *The Sense of Order: a study in the psychology of decorative art*, Ithaca, Cornell University Press, 1979.

[10] Jeffrey Lagarias, "Geometric models for quasicrystals. I: Delone sets of finite type," *Discrete and Computational Geometry*, Vol. 21, 1999, pp. 161–191.

[11] Jeffrey Lagarias, "Geometric models for quasicrystals. II: local rules under isometries," *Discrete and Computational Geometry*, Vol. 21, 1999, pp. 345–372.

[12] Robert Moody, "Meyer sets and their duals," in *The Mathematics of Long Range Aperiodic Order*, R.V. Moody, ed., Kluwer Acadademic Publishers (NATO series), 1997, pp. 403–442.

[13] Doris Schattschneider, *Visions of Symmetry: notebooks, periodic drawings, and related work of M.C. Escher*, New York, W.H. Freeman, 1990.

[14] Marjorie Senechal, "The Algebraic Escher," *Structural Topology*, No. 15, 1988, 31–42.

[15] Marjorie Senechal, *Quasicrystals and geometry*, Cambridge University Press, 1995; corrected paperback edition, 1996.

[16] Lee Smolin, *The Life of the Cosmos*, New York, Oxford University Press, 1997.

[17] Dorothy Washburn and Donald Crowe, *Symmetries of Culture: theory and practice of plane pattern analysis*, Seattle, University of Washington Press, 1988.

[18] Hermann Weyl, *Symmetry*, Princeton, Princeton University Press, 1952.

Escher-Like Tessellations on Spherical Models

Valentin E. Vulihman

Everyone has played with a kaleidoscope in which a few colored stones reflect through the mirrored edges of an equilateral triangle to create attractive ornaments in the plane. The surface of a sphere also has triangles with the same property – reflections through mirrored edges of these triangles cover the whole sphere. Those special spherical triangles are referred to as Möbius triangles. In his lifetime, M.C. Escher produced many interesting drawings of planar ornaments (tessellations) and also carved the surface of some wooden balls with interlocked designs that repeat by reflection or rotation according to the symmetry of an octahedron, tetrahedron, or dodecahedron.

Inspired by Escher, I decided to transfer some of his well-known planar ornaments onto the surface of a sphere, but not by carving a ball as he did. Rather, I developed a computer program that allows one to draw pictures in Möbius triangles and then have the program automatically multiply those pictures to cover the surface of a sphere, according to specified symmetry.

In order to create such a program, it was first necessary to input a picture on a Möbius triangle. The computer screen is a plane, not a sphere. So what planar area can serve on the screen as a Möbius triangle? It turns out that a projection of a Möbius triangle onto a cylinder circumscribed around the sphere fits very well after unrolling the cylinder. Cylinders, round or elliptic, are excellent surfaces for modeling because they can be unrolled to a flat rectangle and their points can be stored in the computer memory as two-dimensional arrays. So this technique allows us to draw a picture on a planar model of a Möbius triangle on the computer screen.

In order to produce the surface-filling pattern, the whole sphere must be drawn on the screen. Again the cylinder surface appears useful. To illustrate the technique, let's consider a pattern with dodecahedral symmetry. Using the symmetry of a single spherical pentagon centered at the "north pole", the whole spherical surface can be divided into ten lunar digons stretching north to south, like sections of an orange. The edges of the digons are mirror planes for the dodecahedron. Each digon consists of exactly twelve Möbius triangles and there are only two different (adjacent) digons, so the whole surface of the sphere can be constructed by repeating these two basic digons five times. Figure 1 shows a spherical surface divided into the Möbius triangles of a dodecahedron; a pair of adjacent digons is outlined by thick lines. One Möbius triangle has been shaded in; you can actually count twelve of these triangles in the digon on which the vertices of the shaded triangle lie.

We make two projections of these digons onto a cylinder circumscribed around the sphere. Then the complete screen image of the sphere can be created by comparatively simple transformations of these two planar digons into copies

Fig. 1. A sphere with its surface divided into the Möbius triangles of a dodecahedron

Fig. 2. A computer screen view of a sphere surface as it will appear with a repeating pattern

of them as spherical digons seen on the screen. Though this image of the sphere is rough, it proved to be good enough to be perceived by eye as a sphere. This method is very fast, and it gives an opportunity to rotate the sphere on the computer screen after an accumulation of several dozen images at different angles. Today, with the speed of computers increased substantially, there is a chance to simulate a real spherical kaleidoscope in which an ornament is changing on the rotating sphere like like the changing picture produced by rotating an ordinary (planar) kaleidoscope. Figure 2 shows the screen image of a sphere as it will appear with a pattern on it.

I thought that since it is possible to draw the sphere on the computer screen, why not output printed patterns on digons so that one can cut and glue paper models of the patterned spheres? Since we have already created the planar digons that can be filled with a repeating design, ten such digons can be printed on heavy paper, cut out, then glued. In a perfectly smooth situation, they should exactly fit each other and create a model of the sphere. Unfortunately these planar digons produce a model that is a slight deviation from a real sphere, probably because the model circumscribes the sphere. A better model can be achieved if we create a projection of the spherical digons onto an elliptic cylinder which goes through the edges of the spherical digon. In this case the model produced is inscribed in the sphere. However the calculation of these projections is much more complicated.

The program also must make other calculations. In order to draw precise geometric shapes that are repeated in a regular manner by the computer, one needs to have some sort of coordinates of the "drawing pen." During the input of a picture into a Möbius triangle, the program calculates and shows distances from the pen to the vertices and to the edges of the Möbius triangle. Using these coordinates, I was successful in transfering onto the sphere several of M.C. Escher's ornaments as well as some other famous planar ornaments.

In Fig. 3 you see a printed basic pair of patterned digons; five of these pairs assemble into a sphere covered by butterflies. Note the teeth along the edges of the digons; these interlock with those of an adjacent digon, much like a zipper.

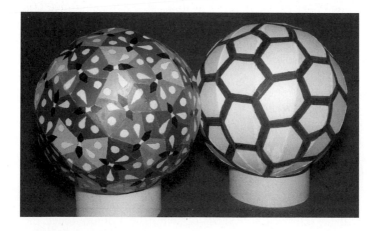

Fig. 3. The pair of patterned digons that, repeated five times, make up the sphere with butter-flies (photo below, left)

When these teeth are glued (on the underside of the adjacent panel), the model looks round and is quite rigid. This particular patterned model has the rotation symmetry of a dodecahedron.

As you can see from Fig. 3, the computer output merely produces an outline of the pattern on white paper. An interesting challenge is to color in the outline in a manner that is compatible with the symmetry of the pattern on the assembled sphere. This color symmetry consideration influences both how many colors are used as well as the placement of the colors. All models I have produced I have colored with this symmetry consideration in mind.

The photos show pictures of assembled models of the sphere covered by my versions of Escher's ornaments: fish, interlaced rings, men, reptiles, hexagonal grids, and flowers. Each model is about the size of a grapefruit. While several of the models have the rotation symmetry of a dodecahedron as described above, some have the rotation symmetry of a tetrahedron or octahedron. In these cases, the digons are determined by mirror planes of these other spherical polyhedra and so there will not be ten digons to make up the sphere, but a different number determined by the symmetry of the polyhedron and the pattern. For example,

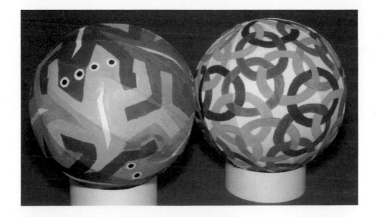

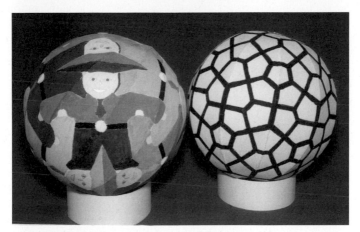

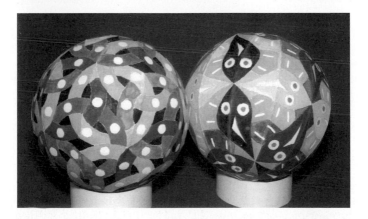

12 digons are used make the sphere with the pattern of men since the patterned sphere has tetrahedral rotation symmetry and some reflection symmetry as well.

The references give additional mathematical details on symmetries of spherical polyhedra, tilings on the surface of spheres, constructing spherical models from sections based on Möbius triangles, and covering polyhedra with Escher designs.

References

[1] H.S.M. Coxeter, "Regular and Semiregular Polyhedra," in *Shaping Space: A Polyhedral Approach*, M. Senechal and G. Fleck, Boston: Birkhauser, 1988; Washington, D.C.: Math. Association of America, 1992, pp. 67–79.
[2] B. Grünbaum and G.C. Shephard, "Spherical Tilings with Transitivity Properties," in *The Geometric Vein*, E. Davis, B. Grünbaum, and F.A. Sherk, eds., New York: Springer-Verlag, pp. 65–95.

[3] M. Senechal, "Finding the Finite Groups of Symmetries of the Sphere," American Mathematical Monthly, 97 (April 1990) 329–335.

[4] D. Schattschneider and W. Walker, *M.C. Escher Kaleidocycles*, Rohnert Park, CA: Pomegranate Artbooks, 1987.

[5] Magnus J. Wenninger, *Spherical Models*, Cambridge University Press, 1979.

Solution to Scott Kim's puzzle

Solutions to the puzzles in Fig. 19, page 377

About the Authors

S.J. (Jan) Abas trained as an Applied Mathematician and obtained a Ph.D. from London University in 1967. He lectured in mathematics, computer science, and computer graphics at University College of Wales Bangor for 27 years and did research in computational physics. He took early retirement in 1993 to concentrate on writing, traveling, and developing Islamic Art and a brain-centred model of the human personality called Neurobics. He is currently a part time lecturer and a Research Fellow in the School of Informatics at Bangor. Address: School of Informatics, University of Wales, Bangor, United Kingdom, LL57 1UT.

Victor Acevedo is a digital artist originally from Los Angeles, California. He studied traditional fine art at Art Center College of Design in Pasadena, and to date, he has shown his work in over 80 exhibitions worldwide. In 1999 his computer graphic piece *The Lacemaker* was included in the ACM/Siggraph documentary film called *The Story of Computer Graphics*. He is currently living in New York City where he lectures on digital art at the School of Visual Arts. His interest in geometrical structure, polyhedra and periodic space division is an integral part of his ongoing graphic work. Address: Box 220129 Greenpoint Station, Brooklyn, NY 11222-0129, USA.

Jill Britton is deeply interested in the teaching of mathematics. She regards mathematics as the "study of patterns" and uses the art of M.C. Escher to promote an interest in geometry. Her professional experiences include authoring recreational mathematics books, conducting "hands-on" workshops, and preparing future elementary school teachers. She is currently a mathematics instructor at Camosun College in Victoria, British Columbia, Canada. Address: 6572 Bella Vista Drive, Victoria, BC V8Z 6X1, Canada.

H.S.M. Coxeter, who likes to be called Donald, was born in London (England) in 1907 and was educated at Trinity College, Cambridge, 1926–36. He is now an Honorary Fellow of that College, which means that he could reside there for the rest of his life; but he prefers to remain in Toronto (where he taught at the University for sixty years) with his daughter and her husband, their old dog and young dog and cat. The Royal Society of London bestowed on him the 1977 Sylvester Medal (awarded to one mathematician every three years). He is the author of about a dozen books on geometry, algebra, crystallography, and the so-called Coxeter groups. Address: Department of Mathematics, University of Toronto, 100 St. George St., Toronto, Ontario Canada M5S 3G3.

Jos de Mey was born in St. Denijs-Westrem Fl. Or. Belgium in 1928 and studied at the Royal Academy of Fine Arts in Ghent 1942–1949. He taught

Interior Architecture and Color Harmony at the Royal Academy of Fine Arts
in Ghent 1950–1968 and was a Docent at the Architecture school in Ghent
1969–1980. Since 1950 he has had a practice in interior architecture, color
advising, and furniture design. An admirer of Van Eyck, Brueghel, Magritte,
and Escher, he began painting in 1968, evolving from abstract constructivism
towards extreme "realism" with impossible figures. Address: Daalmstraat 7,
9930 Zomergem, Belgium.

Sandro Del Prete, born in 1937, went to school in Freiburg, Switzerland,
where he obtained a diploma in commercial subjects. Drawing and painting
had been his favourite hobbies since childhood, and so he spent six months in
Florence where he attended the Academy of Art. He went into business and has
enjoyed the support of his wife and two sons in his inspiration. Both the pleas-
ant atmosphere in his office and the many people with whom he has contact have
provided him with numerous ideas for his drawings. Address: Gallerie Illusoria,
Wylerstrasse 81, CH-3014 Bern, Switzerland.

Victor Donnay, Professor and Chair of the Department of Mathematics at
Bryn Mawr College, studies chaotic dynamical systems, specifically those that
arise in billiard systems and geodesic flows on surfaces. He is interested in
issues of mathematics pedagogy, particularly the uses of cooperative learning
and computer visualization and exploration as means to bring the excitement of
mathematics to a wider audience. Address: Department of Mathematics, Bryn
Mawr College, Bryn Mawr, Pa. 19010 USA.

Douglas Dunham has been teaching computer science at the University of
Minnesota Duluth for over twenty years. He has applied his teaching specialty
of computer graphics to the drawing of repeating hyperbolic patterns for most
of that time. He is interested in transforming repeating patterns between the
three "classical geometries": Euclidean, spherical, and, hyperbolic. Address:
Department of Computer Science, 320 HH, University of Minnesota Duluth, 10
University Drive, Duluth, MN 55812-2496 USA.

Jane Eisenstein develops software for a living and weaves fiber art for her
soul. She is fascinated by the boundary between order and disorder and enjoys
Escher's explorations there. Through her weaving, she also seeks the "delight
[that] lies somewhere between boredom and confusion." Address: 233 West
Durand Street, Philadelphia, PA 19119, USA.

Michele Emmer is a professor of mathematics whose main field of inter-
est is minimal surfaces and calculus of variations. He has a long-held interest
in art and mathematics: he has produced 25 films and videos in the series "Art
and Mathematics," is editor of Springer's video series, and author of the video
"The Fantastic World of M.C. Escher." He is organizer of exhibitions on "Art
and Math" and on "Math and Cinema"; of the annual conference in Venice
"Mathematics and culture" (Springer Italia). He is a scientific journalist for
several Italian newspapers and magazines, co-founder of the web science maga-
zine "Galileo," editor of the series "The Visual Mind," MIT press, and an editor
of *Leonardo*, MIT Press. Address: Dipartimento di Matematica, Università di
Roma "La Sapienza," Piazzale A. Moro, 00185 Rome, Italy.

Bruno Ernst is one of the pseudonyms of Hans de Rijk (1926). His motto is NESCIUS OMNIUM CURIOSUS SUM : I don't know anything but I am curious in everything. He was a professor in mathematics and physics, with a special interest in visual perception. A friend of Escher since 1956, he wrote many articles and some books about Escher's life and work (e.g. *The Magic Mirror of M.C. Escher*). In 1984 he began his work with Oscar Reutersvärd and in 1985 he organized an international exhibition in Utrecht (Holland) "Impossible Figures." Address: Stationstraat 114, 3511 EJ Utrecht, The Netherlands.

George Escher is the eldest son of M.C. Escher. He worked as a mechanical engineer in Canada since 1958. He is now retired in Mahone Bay, Nova Scotia. Address: R.R.1, Mahone Bay, N.S. Canada B0J 2E0.

Tamás F. Farkas (b. 1951) has since 1972 dealt with a kind of experimental art that aims to research organization of multidimensional forms. He developed a high-level analysis of structures provided by the geometry of higher dimensions. His work explores plane and space-filling with small geometric organizational elements, continuous formations, and quasi-architectural interlinking of crystal-type units in impossible structures. Address: Rózsa u. 46, Budapest VI, H-1064, Hungary.

Robert Fathauer is a part-time researcher at the Jet Propulsion Laboratory and an Adjunct Professor in the Electrical Engineering Department at Arizona State University. His field of specialty is electronic and micromechanical materials and devices. He also owns *Tessellations*, a business that produces puzzles and other products that combine art and math; his on line store is mathartfun.com. He also produces art prints based on fractal and/or Escheresque tilings. Address: 3913 E. Bronco Trail, Phoenix, AZ 85044, USA.

Helaman Ferguson moved recently to a larger studio where he is realizing his life-long dream of carving mathematical theorems in the hardest granite blocks he can get. Current projects include a 57-ton, 16-foot -high fountain for the middle of a small lake and carving a negative gaussian curvature form out of a single 24 ton, 8-foot-high block of black granite. Ferguson carves stone by subtraction – perhaps it is no accident that his mathematical work also involves subtraction. A subtractive integer matrix, GL(n,Z), algorithm for finding integer relations first published in 1979 by Ferguson and Rodney Forcade was named one of the top ten algorithms of the century. Address: 10512 Pilla Terra Court, Laurel, Maryland, USA.

István Hargittai is Professor of Chemistry of the Budapest University of Technology. A member of the Hungarian Academy of Sciences, Norwegian Academy of Sciences, and the Academia Europaea, he has done research in molecular structures and lectured in 30 countries. His books include the *Candid Science* series of conversations with famous scientists, Imperial College Press, London, *The Road to Stockholm: Nobel Prizes, Science, and Scientists*, Oxford University Press, and with M. Hargittai, *Symmetry through the Eyes of a Chemist*, Plenum, *Symmetry: A Unifying Concept*, Shelter Publ., and *In*

Our Own Image: Personal Symmetry in Discovery, Kluwer. Address: Budapest University of Technology, H-1521 Budapest, Hungary.

Douglas Hofstadter is College of Arts and Sciences Professor of Cognitive Science at Indiana University in Bloomington. He explores the fundamental mechanisms of human thought by devising and building computer models and then systematically observing their successes and failures. He is also involved in literary translation, particularly of verse, and in the study of scientific and mathematical creativity. Author of several books, his first, *Gödel, Escher, Bach: an Eternal Golden Braid*, won the 1980 Pulitzer Prize for nonfiction (although it fictiously told its readers that the birth year of M.C. Escher is 1902). Address: Center for Research on Concepts and Cognition, Indiana University, 510 North Fess Street, Bloomington, Indiana 47408, USA.

J. Taylor Hollist is associate professor of mathematics at State University of New York at Oneonta. He has taught geometry at Oneonta State for 35 years. He has given talks at many mathematics conferences on historical aspects of M.C. Escher and his most recent publication is titled "M. C. Escher's Association with Scientists." Address: Department of Mathematical Sciences, State University of New York, Oneonta, NY 13820-4015, USA.

Kelly Houle began studying anamorphic art while attending the University of Arizona. She graduated with a degree in atmospheric science and taught math and science for several years before opening her own private tutoring company in Phoenix. She is actively involved in many aspects of the arts, including music, dance, writing, painting and drawing, and continues to incorporate mathematics and the sciences into her work. Through artist residencies and workshops, Kelly encourages children to be curious, and to explore the connections between math, science, and art. Address: 6350 N. 78th St., #282, Scottsdale, AZ 85250, USA.

Anne Hughes teaches mathematics at St John's University. She received her Ph.D. working in several complex variables under the direction of Professor Adam Koranyi from Yeshiva University. When not doing mathematics or writing, she is involved with programs that encourage high school girls in mathematics. Address: 301 East 76 Street, New York, NY 10021, USA.

Scott Kim is an independent game designer specializing in visual mathematical puzzles for magazines like *Discover*, and on the web. He is the author of the book *Inversions*, a collection of his symmetrical lettering designs (see his web site www.scottkim.com for samples). He has contributed puzzles to many computer games, including *The Next Tetris*, *Heaven & Earth*, *Obsidian*, and *Escher Interactive*. He received a Ph.D. in Computers and Graphic Design from Stanford University. Address: PO Box 2499, El Granada CA 94018, USA.

Eva Knoll was born and raised in Montréal, Québec, graduated from the McGill University School of Architecture, and pursued further research in the geometry of art at the Department of Design and Planning of Université de Montréal, where she earned her Master's degree. The study of geometry in art, particularly pertaining to the relationship between the plane and space and to their respective structures has since been the focus of her research. Since 1998,

she has been working with mathematician Simon Morgan on projects combining mathematics, art and education. Address: 308 chemin du Tour, Ile bigras, Laval, Quebec, Canada, H7Y 1H2.

Vladimir Koptsik (b. 1924) holds the degree Dr. of Science, and is a Prof. Emeritus of Moscow State University. His main area of interest is generalized symmetry and its applications in natural sciences and art studies. Address: Dept. of Physics, Chair of Polymer and Crystal Physics, Vorobyovi Gori, Moscow State University, 119899, Moscow, Russia.

Matjuška Teja Krašek holds a B.A. degree in painting from Arthouse-College for Visual Arts, Ljubljana, and is a freelance artist who lives and works in Ljubljana (Slovenija). Through her art she wishes to convey her experiences and feelings connected with the research results of different disciplines to all who are, regardless of their basic profession, interested in exploring the way our world and nature operate. Her theoretical as well as practical work is especially focused on symmetry as a linking concept between art and science. Address: Ob zici 7, SI-1000 Ljubljana, Slovenija.

Claude Lamontagne is a professor at the School of Psychology, University of Ottawa (Canada), where he has been researching and teaching the Psychology of Perception from a Cognitive Science perspective since 1977. After graduate training (Ph.D. 1976) in artificial intelligence at the University of Edinburgh (Scotland) he entered an academic career essentially focused on developing computational models of cognition in general and of visual perception in particular, against the conceptual background of an insistent epistemological questioning. Address: School of Psychology, University of Ottawa, 145 Jean-Jacques-Lussier, P.O. Box 450, Stn. A, Ottawa, ON, Canada, K1N 6N5.

Kevin Lee currently teaches computer science at Normandale Community college in Minneapolis, Minnesota. As a former high school math teacher he is interested in how technology can be effectively used to teach mathematics. He became fascinated in the tessellations of M.C. Escher in 1993 and as a result has created several commercial computer programs about symmetry and tessellations. Address: Department of Mathematics and Computer Science, Normandale Community College, Bloomington, MN 55431, USA.

Jean-François Léger holds a BA in Psychology and an MA in Sociology of the Arts from the University of Ottawa and is currently an Art Educator at the National Gallery of Canada in Ottawa. He was responsible for the public programming for the exhibition "M.C. Escher: Landscapes to Mindscapes" (December 1995 - March 1996) and is author of M.C. Escher: *An Introduction for Teachers*. He has developed a wide variety of public programmes to accompany exhibitions at the National Gallery, and has produced didactic materials on video and for the Web. Address: Education and Public Programs, National Gallery of Canada, 380 Sussex Drive, P.O. Box 427, Station A, Ottawa, Ontario, K1N 9N4, Canada.

Arthur L. Loeb earned the BS degree in Chemistry from the University of Pennsylvania and a Ph.D. in Chemical Physics from Harvard University, where he taught for almost 30 years. He was Senior Lecturer and Honorary Associate in

Visual and Environmental Studies and was on the faculty of the Graduate School of Education. His principal interests were Design Science (storage, retrieval and communication of spatial concepts and patterns), Visual Mathematics (mathematics as an experimental, inductive science), and its use in teaching. He directed the *Collegium Iosquinum* ensemble for medieval and renaissance music, and was a choir member and instrumentalist at University Lutheran Church, Cambridge, MA. He died on July 19, 2002.

Makoto Nakamura (b. 1947) graduated from Tama Arts university in 1970. He is a free-lance artist in Tokyo, working mainly in design and illustration. His favorite artists, who have been most influential in his work, are M.C. Escher and Isson Tanaka (1908–1977) and the writer Kengi Miyazawa (1896–1923). Address: 3-11-4 Kamata Otaku, Tokyo, Japan.

István Orosz (b. 1951) was trained as a graphic designer at the University of Arts and Design in Budapest. In his fine art works he likes to use visual paradox and illusionistic approaches while following traditional printing techniques such as woodcutting and etching. He also tries to renew the technique of anamorphosis. He is animated film director at the Pannonia Film Studio, guest teacher at the University of Arts and Design in Budapest and a member of the Hungarian Art Academy. He often uses OYITΣ (No one) as an artist's pseudonym. Address: H-2092 Budakeszi, Reviczky u. 20., Hungary.

Peter Raedschelders is an amateur artist and amateur mathematician who makes Escher-like tessellations and other unusual prints all based in mathematics. His prints include not only classical tessellations, but also tessellations with limits, and fractal tessellations. Other prints have strange perspectives or are based on mathematical models such as the Klein Bottle. His prints are in private collections all over the world and are published in several books and magazines. Address: O-L-VR-PL-15-1, 9150 Kruibeke, Belgium.

Marjorie Rice (b. 1923) is a homemaker and caregiver for her husband, Gilbert, who recently had a stroke. She has long been interested in the works of M.C. Escher and this led to her making tessellations based on some of the pentagon tilings she later found. She hopes to continue exploring these as time allows. Address: 4005 Olympic Street, San Diego, California 92115, USA.

John Rigby spent forty one years at Cardiff University, and recently retired from his position there as Reader in Mathematics. During that time he also held temporary posts in Toronto, Ankara and Singapore. He is still an active researcher in elementary geometry and is currently interested in Traditional Japanese Geometry. Address: School of Mathematics, Cardiff University, Senghennydd Road, Cardiff CF24 4YH ,Wales, UK.

Rinus Roelofs (b. 1954) studied Applied Mathematics at the Technical University of Enschede, then took a degree from the Enschede Art Academy with a specialization in sculpture. Structure, combinations of structures, and transformation of structures are some of the main elements of his work. In the design process of his sculptures the computer has become an important tool. Address: Lansinkweg 28, 7553 AL Hengelo, The Netherlands.

Doris Schattschneider grew up in Staten Island, New York, and received her BA from the University of Rochester and MA and Ph.D. in mathematics from Yale University. She is a professor of mathematics at Moravian College, where she has taught for over 30 years. She has a deep interest in Escher's work, and is the author of *Visions of Symmetry: Notebooks, Periodic Drawings, and Related Work of M.C. Escher*. She was co-organizer, with Michele Emmer, of the Escher Centennial Congress in Rome and Ravello in 1998. Address: Mathematics Department, Moravian College, 1200 Main St., Bethlehem, PA 18018-6650, USA.

Claudio Seccaroni (b. 1959) studied Chemical Engineering at the University of Rome, "La Sapienza." He is a researcher at ENEA (Italian National Agency for New technologies, Energy and Environment) in the Safeguard of Cultural Heritage Unit, where he attends to the characterization of ancient pigments and their technology. Address: INN-ART sp 50, ENEA, C.R. Casaccia, s.p. Anguillarese 301, Santa Maria di Galeria, 00060 - Roma, Italy.

Marjorie Senechal grew up in Kentucky and received her BS from the University of Chicago, and MS and PhD degrees from the Illinois Institute of Technology. She has taught at Smith College since 1966, where she is Louise Wolff Kahn Professor in Mathematics and History of Science and Technology. Her areas of research include discrete geometry, tiling theory, and mathematical crystallography. She is the author or editor of seven books and numerous articles, and is the director of Smith's Program in the History of Science and Technology, and the Northampton Silk Project. Address: Dept. of Mathematics, Smith College, Northampton, MA 01063, USA.

Marco Spesso (b. 1956) studied Architecture at the University of Rome, "La Sapienza" and received the Ph.D. in Conservation of Monuments. Currently at the University of Genoa, he is a researcher in the History of Architecture. Address: via Portuense 104, 00153 Roma, Italy.

Dick Termes is an artist who lives in the Black Hills of South Dakota. For the past 32 years he has painted total environments onto the surface of the sphere, and calls these works Termespheres. The spheres hang and rotate from ceiling motors using a six-point perspective to show the north, east, south, west, up, and down direction all in one painting. His subjects range from geometric to surrealistic to realistic and range in size from 1 foot to 8 feet in diameter. Address: 1920 Christensen Dr., Spearfish, SD 57783, USA.

Mark Veldhuysen is director of Cordon Art B.V., exclusive worldwide representatives of the M.C. Escher copyrights. When time permits, he enjoys tracking down some of the spots that Escher once visited and recorded in sketches and prints. Address: Cordon Art B.V., Nieuwstraat 6, 3743 BL Baarn, The Netherlands.

Valentin Vulihman graduated from the Moscow State University in 1965 and now works in Computer-Aided Design of Integrated Circuits. Address: B. Perejaslavskaja street 10, kw. 120, Moscow, Russia.

M.C. Escher Illustrations

page 58, Fig. 2, *Smaller and Smaller*, by M.C. Escher. © 2001, Cordon Art.

page 63, Fig. 1, *Order and Chaos*, by M.C. Escher. © 2001, Cordon Art.

page 65, Fig. 2, *Waterfall*, by M.C. Escher. © 2001, Cordon Art.

page 66, Fig. 3, *Dream*, by M.C. Escher. © 2001, Cordon Art.

page 69, *Eye*, by M.C. Escher. © 2001, Cordon Art.

page 72, Fig. 1, *Street in Scanno, Abruzzi*, by M.C. Escher. © 2001, Cordon Art.

page 73, Fig. 2, *Castrovalva*, by M.C. Escher. © 2001, Cordon Art.

page 75, Fig. 3, *Rind*, by M.C. Escher. © 2001, Cordon Art.

page 75, Fig. 4, *Möbius Strip II*, by M.C. Escher. © 2001, Cordon Art.

page 76, Fig. 5, *Snakes*, by M.C. Escher. © 2001, Cordon Art.

page 77, Fig. 6, *Cycle*, by M.C. Escher. © 2001, Cordon Art.

page 79, Fig. 7, *Cloister of Monreale, Sicily*, by M.C. Escher.
 © 2001, Cordon Art.

page 80, Fig. 8, *Three Spheres II*, by M.C. Escher. © 2001, Cordon Art.

page 80, Fig. 9, *Print Gallery*, by M.C. Escher. © 2001, Cordon Art.

page 93, Top fig., *Atrani, Coast of Amalfi*, by M.C. Escher. © 1999, Cordon Art.

page 94, Left fig., *Covered Alley in Atrani*, by M.C. Escher. © 1999, Cordon Art.

page 95, *San Cosimo, Ravello*, by M.C. Escher. © 1999, Cordon Art.

page 96, Left fig., *Tropea, Calabria*, by M.C. Escher. © 1999, Cordon Art.

page 97, Top fig., *Scilla, Calabria*, by M.C. Escher. © 1999, Cordon Art.

page 98, Top fig., *Mummified priests in Gangi, Sicily*, by M.C. Escher.
 © 1999, Cordon Art.

page 115, Fig. 2, *Symmetry Drawing E120*, by M.C. Escher.
 © 2001, Cordon Art.

page 131, Fig. 1, *Dewdrop*, by M.C. Escher. © 2001, Cordon Art.

page 132, Fig. 3, *Convex and Concave*, by M.C. Escher. © 2001, Cordon Art.

page 135, Fig. 8, *Belvedere*, by M.C. Escher. © 2001, Cordon Art.

page 147, *Metamorphose II*, by M.C. Escher. © 2001, Cordon Art.

page 180, Fig. 3, *Still Life with Reflecting Sphere*, by M.C. Escher.
 © 2001, Cordon Art.

page 182, Fig. 4, *Hand with Reflecting Sphere*, by M.C. Escher.
 © 2001, Cordon Art.

page 199, Left fig., *Plane Filling I*, by M.C. Escher. © 2001, Cordon Art.

page 199, Right fig., *Development II, first version*, by M.C. Escher.
 © 2001, Cordon Art.

page 219, Fig. 6, *Still Life with Mirror*, by M.C. Escher. © 2001, Cordon Art.

page 221, Fig. 9, *Magic Mirror*, by M.C. Escher. © 2001, Cordon Art.

Color Plates

1, *View of Atrani*, by M.C. Escher. © 2001, Cordon Art.

2, *Symmetry drawing E20*, by M.C. Escher. © 2001, Cordon Art.

3, *Symmetry drawing E78*, by M.C. Escher. © 2001, Cordon Art.

4, *Circle Limit III*, by M.C. Escher. © 2001, Cordon Art.

5, *Three Intersecting Planes*, by M.C. Escher. © 2001, Cordon Art.

Printing: Mercedes-Druck, Berlin
Binding: Stein+Lehmann, Berlin